Photography FOR DUMMIES®

2ND EDITION

by Russell Hart

With additional writing by Dan Richards

WILEY

Wiley Publishing, Inc.

Photography For Dummies®, 2nd Edition

Published by
Wiley Publishing, Inc.
111 River St.
Hoboken, NJ 07030-5774
www.wiley.com

Copyright © 2004 by Wiley Publishing, Inc., Indianapolis, Indiana

Published by Wiley Publishing, Inc., Indianapolis, Indiana

Published simultaneously in Canada

For general information on our other products and services or to obtain technical support, please contact our Customer Care Department within the U.S. at 800-762-2974, outside the U.S. at 317-572-3993, or fax 317-572-4002.

Wiley also publishes its books in a variety of electronic formats. Some content that appears in print may not be available in electronic books.

Library of Congress Cataloging-in-Publication Data:

Library of Congress Control Number: 2003105684

ISBN: 0764541161

Manufactured in the United States of America

10 9 8 7 6 5 4 3 2 1

About the Author

Executive editor at *American Photo* magazine, **Russell Hart** now takes more pictures with his point-and-shoots than with the assorted professional cameras he accumulated in over 20 years as a working photographer. Also a contributing editor to *Popular Photography,* he has been senior editor at both magazines, and has written for most other major photo magazines. He is also the editor of *American Photo On Campus.* Russell has written about photography for *The New York Times, Men's Journal,* and *Us* magazines, and is the author of a number of books on photographic subjects, including *The Photographic Essay* (Bulfinch Press), *Photographing Your Artwork* (North Light), and *The New Joy of Photography* (Addison-Wesley), as well as co-author of *Photography* (Prentice-Hall), a college textbook.

Before he began writing about photography, Russell made a living with it, shooting for publications such as *Boston* magazine, *The Boston Globe Magazine,* and *Inc.* magazine, as well as various advertising clients. His landscape photographs have been shown in galleries and museums across the country, and are in the permanent collections of Boston's Museum of Fine Arts; New York's Hudson River Museum; Lincoln, Massachusetts' DeCordova Museum; and the Reader's Digest Collection. He has been awarded several fellowships in photography, and has taught photography at Tufts University, the Boston Museum School, and Mount Ida College.

Eastman Kodak Company has provided technical information for this book. However, the opinions expressed are those of the author and are not necessarily those of Kodak.

Dedication

To Rena and Rachel, who endured it all, with my deepest love.

Acknowledgments

A book is a miracle. The miracle is that all its pieces ultimately come together to create something meaningful and attractive. But like most miracles, a book takes hard work. For all its simplifying, *Photography For Dummies,* 2nd Edition, is the sum of many people's hard work, and I'm grateful to them all. Families usually get thanked last, but mine comes first: my wonderful wife Rena, who sustained and organized me through unending months of double shifts, and my resilient daughter Rachel, who now gets back her silliest playmate. Thanks and love also to my forbearing parents, Lorena and Francis Hart, who provided a writer's hideaway and commented on early text in their uniquely intelligent way.

Great thanks to *everyone* at Wiley: most of all to my editor on the first edition, Kelly Ewing, who knew better than me how to structure the book, and whose unfailing good humor and organization are both powerful editorial tools; to Tami Booth, my Executive Editor on the first edition, without whose encouragement, understanding, and perspective I could not have finished the job; to the book's many sharp-eyed copy editors, including Kim Darosett; to the equally sharp-eyed Shelley Lea, who oversaw the color section; and last but not least, Karen York, Project Coordinator on the first edition. And the improvements and updating in this second edition would not have been possible without the persistence, patience, and understanding of my project editor Mary Goodwin and Managing Editor Tracy Boggier. My agent, Mark Reiter of IMG Literary — as affable as he is connected, a rare combination — made the whole thing possible by calling me first. Thanks also to IMG's Sophia Seidner, without whose cheerful help I couldn't have taken on this new edition.

Huge thanks to the able writers and photo industry friends who contributed to the book, including *Popular Photography* Senior Editor Pete Kolonia, Technology Editor Mike McNamara, and Managing Editor Mason Resnick; and the inventive Elinor Stecker-Orel. But my biggest debt of gratitude is to *Popular Photography* Senior Editor Dan Richards, whose way with words is matched only by his point-and-shoot comprehension. Also many thanks to *Popular Photography/American Photo* Publishing Director Burt Keppler for his continuing help and wisdom, and to my good friend Dave Schonauer, Editor-in-Chief of *American Photo* magazine, who gave me the opportunity to learn all about this stuff, and who shares my skewed view of the photo world.

I'm also grateful for the support provided by Eastman Kodak in the creation of the book's first edition; the company supplied not just film, cameras, and pictures from its remarkable KINSA archive, but also the amazing expertise of its people. Such help always comes through individuals: among them, Michael More, whose love of culture made him a corporate asset, and Terry McArdle, who threw his great intelligence and considerable energy behind the book. Thanks also to the many other helpful photo companies in this really not-so-big business; their dedicated press people provided both cameras and answers.

And last but decidedly not least in my gratitude are the many photographers who contributed pictures to *Photography For Dummies,* both in its original edition and this new one. They are my friends, not just colleagues — and all of them superb artists. They include John Isaac, Rick Sammon, Jonathan Barkey, and Steve Pollock; also Henry Horenstein, Allen Green, Jody Dole, Amos Chan, Shellburne Thurber, Bill Neill, Chris Rainier, Franklin Berger, Pete Kolonia, and Mark Ewing. Mark Harris shot top-notch example pictures at a moment's notice, and the gifted Pat O'Hara let me keep his lecture slides for months. This book is a tribute to the power of these photographers' vision — and to the simple pleasures of photography.

Publisher's Acknowledgments

We're proud of this book; please send us your comments through our Dummies online registration form located at www.dummies.com/register/.

Some of the people who helped bring this book to market include the following:

Acquisitions, Editorial, and Media Development

Project Editor: Mary Goodwin

(*Previous Edition: Kelly Ewing*)

Acquisitions Editor: Tracy Boggier

Copy Editors: Kim Darosett, Stacey Riebsomer

Technical Editor: Patrick Craig Manning

Senior Permissions Editor: Carmen Krikorian

Editorial Manager: Michelle Hacker

Editorial Assistant: Elizabeth Rea

Cover Photos: © Getty Images

Cartoons: Rich Tennant, www.the5thwave.com

Production

Project Coordinator: Nancee Reeves

Layout and Graphics: Seth Conley, LeAndra Hosier, Michael Kruzil, Lynsey Osborn, Jacque Schneider, Erin Zeltner

Proofreaders: Charles Spencer, TECHBOOKS Production Services

Indexer: TECHBOOKS Production Services

Special Help

Mary Yeary

Publishing and Editorial for Consumer Dummies

Diane Graves Steele, Vice President and Publisher, Consumer Dummies

Joyce Pepple, Acquisitions Director, Consumer Dummies

Kristin A. Cocks, Product Development Director, Consumer Dummies

Michael Spring, Vice President and Publisher, Travel

Brice Gosnell, Publishing Director, Travel

Suzanne Jannetta, Editorial Director, Travel

Publishing for Technology Dummies

Andy Cummings, Vice President and Publisher, Dummies Technology/General User

Composition Services

Gerry Fahey, Vice President of Production Services

Debbie Stailey, Director of Composition Services

Contents at a Glance

Table of Contents

Introduction

*1*f I asked you to name your most valuable possession, what would you choose? At first, you might say your wedding ring, your car, or your house. But after further thought (and a little coaxing from me), you would probably arrive at this conclusion: your photographs. Unlike most other earthly belongings, your personal photographs have a worth that can't be measured in dollars and cents. They're the one thing you would grab on the way out of a burning house — an irreplaceable record of the life you lead, of friends and family, and of the occasions with which you mark passing years. Photographs are the visual handmaiden to memory. They let you possess that elusive property called time.

The funny thing is, most people aren't entirely happy with their photographs. You may be one of these slightly disheartened shooters. You probably think your pictures could be better — if not more artistic, then more colorful, more interesting, or just plain sharper. You may wonder why you're not getting better results with your point-and-shoot camera, one of those auto-everything models that are supposed to make photography foolproof. And if you've made or are now making the transition to digital photography — to the brave new world of taking pictures filmlessly, with a camera that replaces that familiar little roll with a permanent electronic sensor — the technology itself may be an obstacle to your success.

But if you've been blaming your camera for your photographic unhappiness, I'm here to tell you that it's the least likely culprit. Whether they use film or not, today's point-and-shoot cameras are remarkably reliable devices, especially considering all the stuff they do. Yours is probably doing its job pretty well. So why aren't your pictures better? You may just not know the right button to push — and believe me, your point-and-shoot has a magic button or two. You may just not be using the right kind of film. Or you may not be getting the most from your photofinishing, a process that you have more control over than you think. But the main secret to better photographs is knowing what to shoot, when to shoot it, and how to shoot it: how to squeeze your subject meaningfully into the little patch of visual real estate called a print. You need *Photography For Dummies,* 2nd Edition, because it lets you in on this secret.

About This Book

If you think you can't get better pictures from your point-and-shoot, consider this: The most important photographs in this book were made with point-and-shoot cameras (including digital models) and reproduced directly from 4 x 6-inch commercial prints. You do not need a fancy single-lens reflex (SLR)

camera — those bulky, system-style models that take interchangeable lenses — to get good photographs. The problem is, nearly every book on how to make better pictures assumes that you're using a single-lens reflex. This focus on SLRs is a mystery to me, given that point-and-shoot cameras now outsell those models by many orders of magnitude.

This book is different. *Photography For Dummies assumes that you're using a point-and-shoot camera for all your pictures.* In fact, this book may well be the most complete guide available to taking pictures with a modern point-and-shoot camera (if I do say so myself). But even if you *are* an SLR user — and some avid point-and-shooters still like to get out their big guns — you can actually get more help from this book than from techier volumes. Why? Because most SLR cameras can now be operated in an entirely "point-and-shoot" manner, and that's the way most people use them. And because the better part of photographic skill has nothing to do with pushing buttons or turning dials.

Conventions Used in This Book

When I use the term *point-and-shoot,* I mean any of four different types of cameras. One is the 35mm point-and-shoot, which takes those familiar, funny-looking little cassettes with the spool and film strip poking out of them. (35mm is by far the most popular film in history, and most point-and-shoots are 35mm models.) The second type of camera in this book's mix is the Advanced Photo System (APS) point-and-shoot, which combines point-and-shoot operation with a cleverly interlinked film and photofinishing system. The third camera type is the one-time-use point-and-shoot, a streamlined model designed to expose a single roll of film, available in both 35mm and APS versions, and in stock almost anywhere chewing gum is sold. And the fourth camera type is the digital point-and-shoot, which, unlike the other three types, creates its pictures electronically — that is, without film.

This is important: Much if not most of what you read in this book applies to *any* of these four types of cameras.

If you read anything else about point-and-shoot cameras, you may notice two other terms for them kicking around. One term is *compact* cameras. The other is *lens/shutter* cameras. Neither term is as apt as *point-and-shoot,* and I don't use either one in this book. Point-and-shoot cameras sometimes aren't that compact, and plenty of non-point-and-shoot models have shutters in their lenses. (What's a shutter? See Chapter 2.)

Foolish Assumptions

Photography For Dummies, 2nd Edition, assumes that you're using a point-and-shoot camera for your photographs. But this book is just as noteworthy

for what it *doesn't* assume. This book does not assume that you have any prior knowledge of photography. It does not assume that you know the difference between a shutter speed and the speed of light. It does not assume that you know the difference between telephoto and television. And it doesn't assume, even if you're shooting with a digital camera, that you're willing or wanting to involve your computer in the photographic process. This book just assumes that you want to take better point-and-shoot pictures.

What You Can Skip

This book is not a novel. You don't have to read it from cover to cover to get better pictures. Open it to any page, and you can find useful information that doesn't presume any prior reading, let alone prior knowledge. So you can skip around. And you can skip the sidebars and the parts marked "Technical Stuff" entirely, if you like. I've made the book this way for two reasons: One, because my editors told me to; and two, because it's actually how I like to read novels.

How This Book Is Organized

If you want to take better pictures, you have to take lots of pictures. And taking lots of pictures is the *only* way that you can see for yourself the actual effect of the things this book asks you to try. So before I get into the nuts and bolts and pushbuttons of photographic craft, I do the basics, giving you just enough to get started shooting. Then after the nuts and bolts — after I basically tell you how many nuts and bolts you need, and how many you can stick in your mental basement — I get into the art and adventure of point-and-shoot photography, and how to shoot what you love.

Part 1: What You Need to Take Pictures

This part helps you through the steps and choices that go into just taking that first picture: how to choose a film (much simpler than you'd think), how to load a film cassette into the camera (no big sweat), and even how to hold the camera and press the shutter button. (Yes, there are right ways and wrong ways, whatever kind of point-and-shoot you're using.) It also offers a complete guide to dealing with your photofinisher — a far more important factor in getting good results than most people realize, *especially* in the digital age.

Part 11: Working with Your Point-and-Shoot

Read this part, and those buttons and dials you may now be afraid to push and turn won't intimidate you any more. Here, you find out about

modes — the different settings that make your camera do different things. You learn how to read and set a digital point-and-shoot's onscreen menu, which contrary to what you might think is in English. But you also discover, depending on your particular point-and-shoot model, that the menu, and many modes too, are best ignored! The exception is flash modes, the most important modes of all — which is why your camera's built-in flash gets a whole chapter to itself. Of course, you can't get a picture at all without a lens, so your lens gets two chapters of its own. In one, I explain why you have to *help* your autofocus camera focus the lens. In the other, I answer the important question "To zoom or not to zoom?" Last but not least — at least for Advanced Photo System devotees — is a quick primer on this interesting alternative to 35mm, and its special benefits and considerations.

Part III: The Art Part

More than anything, photographic artistry depends on these two skills: recognizing and exploiting the opportunities that light presents every day, and applying design strategies that give your subjects a visually appealing form. Think light is beyond your control? It isn't, and this part explains how to work with it. Think you can't compose in a way that's suitable for framing? You can. In this part's two chapters, you find powerful but simple suggestions for photographic "seeing."

Part IV: Shoot to Thrill

This part gets more focused, explaining how to shoot specific kinds of subjects — your own life first and foremost. And because people are probably the most important thing in your life, I begin with them. You *can* get shots that both flatter people and capture their personalities, and this part is where you find out how. (Just don't tell your local portrait photographer!) And because some people in your life may be moving pretty fast (kids, for example), this part is also where you find out how to stop action — photographically, at least. More contemplative photographers can seek this part's guidance on shooting landscapes. And because nearly everyone travels, whether across state lines or to the far side of the world, the special considerations of travel photography — visual and practical — are also covered.

Part V: The Digital Domain

Digital photography has exploded since the last edition of *Photography For Dummies,* becoming a viable and serious alternative to shooting in 35mm and APS. So after a brief look at how digital cameras are able to dispense with film, this expanded section gets into the pleasures and pitfalls of taking pictures

filmlessly. Although a digital point-and-shoot is still very much a camera — meaning that other chapters of this book apply to it as much as they do to its 35mm or APS cousins — for many people these new-age models have helped bring the magic back into picture-taking.

But 35mm and APS photographers shouldn't feel left out here, because Chapter 16 surveys the ways you can turn photos made on film into picture files that can be used in your computer just like those made with a digital point-and-shoot. And it explains that once they're in your computer, you can do the very same things with them that you'd do with pictures taken digitally, including e-mailing them, uploading them to the World Wide Web, manipulating and retouching them with software, and printing them on your desktop.

Part VI: The Part of Tens

The glue that holds this part together is tens: everything from ten great places to take pictures to ten things to try if your camera won't shoot. Point-and-shoot buying tips are also here for the plucking, including what to look for in a digital model. Last but not least: the top ten ways to make your pictures better. You also find out how to contact camera makers with your questions and problems, and I translate some of those funny-sounding photo terms into plain English.

Icons Used in This Book

The margins of this book are wide for a reason: They contain icons — cute little symbols — that identify particular kinds of photo hints and help. (No connection to the icons that your camera uses to indicate settings!) Here's what each icon means:

Follow this icon's advice (always simple and straightforward), and your pictures should hit the mark.

This icon's fuzziness suggests one possible consequence (blurred pictures) of committing the sorts of photographic *faux pas* that it describes.

I recommend picture-taking experiments throughout this book, highlighted by this icon. Call them exercises — sort of like photo aerobics.

Information for people who want to know photography's *whys* along with its *hows*, this stuff is really never very technical — so I hope everyone reads it.

The standard symbol for the Advanced Photo System (you find it on all APS point-and-shoots), the APS icon highlights text that pertains specifically to this relatively new picture-taking system, an alternative to standard 35mm.

Though most of the advice and information in this book applies to any kind of camera, sometimes digital point-and-shoot models have their own issues. This icon indicates text that tells you when and how your digital camera may differ from the 35mm and APS models used by most snapshooters.

Last but decidedly not least, this icon directs you toward the book's color section, where you'll find a great picture illustrating that particular point.

Where to Go from Here

Where to go from here depends on where you are — both physically and photographically. If you're sitting on a plane heading toward a vacation destination, you could start with Chapter 14, which is dedicated to travel photography. (You could also check out Chapter 13 for tips on shooting exotic landscapes.) If you're sitting in your kitchen, and never seem to get away, try Chapter 11, which is about all the photographic possibilities of staying at home.

If you're truly a photographic novice, or if you've just bought your first serious point-and-shoot camera, then start with Chapter 1 (and don't forget the film, if your camera needs it, and batteries). If your new camera is digital, you can go directly to Chapter 15 for a filmless primer. If you're an old point-and-shoot hand, you can skip the hands-on stuff in the first half of the book (Parts I and II) and go straight to the art and applications of photographic craft (Parts III and IV). Just want to have fun? Go directly to The Part of Tens, where you'll find photographic hot spots (both manmade and natural) and pointers (both amusing and practical).

Oh, and any time you need help with a photo term, turn to Appendix A for a definition — but don't think you have to master the medium's unique language. Fortunately, you don't have to know much more than the equivalent of *Hello, Goodbye, Please,* and *Thank You* — and sometimes *Smile* — to get the most from your point-and-shoot camera.

Part I
What You Need to Take Pictures

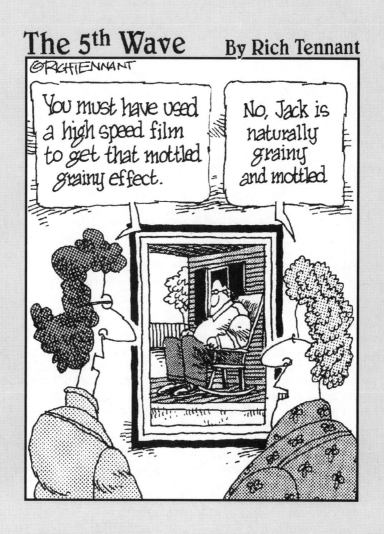

In this part . . .

You need three things to take pictures: your point-and-shoot camera, some film, and photofinishing. Wait a minute — those of you using digital point-and-shoots don't need film, but you still probably want to get prints. Those three basics are introduced in this part's three chapters, and digital photographers can skip the middle one. Of course, your camera may need no introduction — but I still take you through the steps required just to get to that first frame. Why? Because if you're like most photographers, you find some aspect of the process intimidating, and I want to unintimidate you.

I also talk about what film you should buy, if you're one of the great majority of photographers still using a film point-and-shoot. Those of you whose eyes glaze over as you stand in front of a camera store film counter will be shocked — *shocked* — at the simplicity of the choice.

Film-using and digital photographers alike will also be surprised by how much control you have over the way that your pictures are printed, even though the printing is done by a machine. Hey, machines are meant to work for *people* — your point-and-shoot included!

Chapter 1

Ladies and Gentlemen: Start Your Point-and-Shoots!

*Y*our point-and-shoot camera is practically an invitation to just start taking pictures. A wonder of automation, it uses advanced electronics and tiny motors to quickly execute the many separate steps that photographers used to have to do manually each time they wanted to take a picture. Point-and-shoots automatically advance the film from shot to shot, or, if they're digital, automatically store your pictures in their onboard "memory." And film or digital, they automatically compute the correct exposure — the exact amount of light that your film or digital camera needs to properly record the subject — and adjust their settings accordingly. They automatically turn on the flash in dim light. And they automatically focus the lens. Digital cameras take things a step further, using a built-in computer to convert each scene you shoot into a "file" of tiny dots of varying color and tone.

Actually, your particular point-and-shoot may not perform every one of these functions. And which ones it does perform depends partly (though not entirely) on what type of point-and-shoot you have. So I begin this chapter — a chapter otherwise devoted to getting you started taking pictures as quickly as possible — by describing the four different types of point-and-shoot cameras. The good news: You really don't need to know what kind of point-and-shoot camera you have to make it point and shoot. But knowing what kind of

point-and-shoot you have can actually help you make better pictures. That is, after all, why you're reading this book — right?

The Four Types of Point-and-Shoot Cameras

Like people, point-and-shoots have more in common than they do differences. This is especially true of the way you operate the cameras — what you push, slide, or twist to make them do specific things. But while they're operated in pretty much the same way, point-and-shoots differ both in the way the image is captured and in the mechanical and electronic complexity they bring to the job. Those differences make it possible to divide these cameras into four main types.

The 35mm point-and-shoot

Granddaddy of the point-and-shoot movement, the 35mm point-and-shoot uses 35mm film — the film that comes in the funny-looking little cassette with the perforated tongue sticking out at you. You grab that tongue of film to start the roll through the camera, as this chapter explains in detail. 35mm point-and-shoots come in every form from cheapo, check-out counter specials to expensive, full-featured models that rival 35mm single-lens reflexes (those professional-style system cameras) in their sophistication.

The Advanced Photo System point-and-shoot

A younger generation of point-and-shoot cameras, Advanced Photo System (APS) models look pretty much like their 35mm counterparts. But they take a different, smaller-than-35mm film cassette that has allowed manufacturers to create smaller cameras. The system also simplifies film loading, makes storage and reprinting easier, and gives you a shot-by-shot choice of three different print sizes, which you pick with a switch on the camera. See Chapter 8 for details on the Advanced Photo System.

The one-time-use point-and-shoot

They're everywhere. From drugstore counters to Disney World, one-time-use cameras are by far the most popular type of point-and-shoot, outselling reloadable models many times over. These inexpensive (usually $5 to $15, depending on the type) models are in some respects the ultimate point-and-shoot. You don't have to figure out how to insert film, for example, because they come preloaded with a roll. (In fact, you can get them in both 35mm and Advanced Photo System versions.) The same goes for batteries, also preinstalled. You needn't master any pushbuttons except for the shutter button and the flash

button, if your model has a flash at all. You don't even have to remember to bring your camera along, because you can buy a one-time-use camera on the way or on the spot. After you finish shooting a roll, you just give the camera to the photofinisher — no rewinding necessary. And last, but not least, one-time-use cameras are the only cameras with complete instructions printed on them! (See the sidebar "When to use a one-time-use camera" in this chapter for details.)

Don't buy and shoot with a one-time-use camera simply because you're intimidated by your regular, reloadable point-and-shoot. Read this chapter, and your regular point-and-shoot won't scare you anymore!

The digital point-and-shoot

Unlike the other types of point-and-shoot cameras, a digital point-and-shoot neither contains nor accepts film. How can it make photographs without film? The same way video camcorders do: With a permanently installed electronic light sensor, sometimes called a "chip." For clarity's sake, I refer to it as an *image sensor* in this book.

Unlike many camcorders, a digital camera stores photographs as digital files that can be downloaded directly and immediately to a computer for various purposes, including retouching, e-mailing, and printing. And most digital point-and-shoots store these files on *memory cards,* small plastic-and-silicon wafers that are (in some respects) the digital equivalent of film. Yet in terms of operation, digital point-and-shoots are essentially like film-using cameras — and again, most of the shooting advice in this and other chapters applies to them as well. Perhaps the main difference is that some camera settings (mostly less important ones) are adjusted on the same tiny, computer-like screen with which you view your subjects and review your pictures. These days, many people have both film and digital point-and-shoots in their homes. For specifics on working with digital models, see Chapter 15.

The Parts of Your Camera

Here are a couple of things to remember whenever you feel you're not quite getting the hang of operating your camera. First, for all its pushbuttons, dials, windows, and flashing lights, your camera is basically a lightproof box. It's lightproof to protect the film or image sensor inside it from any light other than what the lens gathers from the subject and uses to form a picture on the surface of the film or sensor. And second, the camera is basically an extension of your eye — a window on your subject. In fact, to view your subject you look through a little window on the camera back called the *viewfinder.* Most digital cameras have viewfinders, but also let you see the subject you're photographing on what I prefer to call *a viewing screen* — essentially, a little

computer monitor that's connected to the camera's image sensor. (There are other terms in circulation for this screen, but I think they're confusing.) For more about what you see when you look through the camera's viewfinder, read Chapter 5. And for specifics about a digital point-and-shoot's viewing screen, see Chapters 4 and 15.

Now for those pushbuttons. When it comes to the design and location of your point-and-shoot's controls, little standardization exists. In pictorial terms, two very different-looking controls in two very different places may do pretty much the same thing. But whatever the control configuration, most 35mm and APS models, and many though not all digital models, have an *LCD panel*. The LCD panel is a digital display on the top or side of the camera that indicates what settings you're making. Figures 1-1 and 1-2 show the location of camera controls and other basic camera features for a typical 35mm point-and-shoot. Figures 1-3 and 1-4 show the same for a typical digital point-and-shoot. The purposes of these controls and features are spelled out in Part II, and you can refer back to these figures for help in locating specific parts and buttons. But your camera may be different from the models shown — and the only way to know is to check your camera manual.

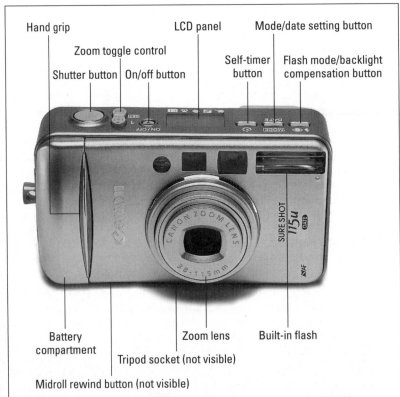

Figure 1-1: These controls and features are typical of a well-appointed 35mm point-and-shoot.

Your camera manual shows you which controls do what, and where they are. Sometimes it loses a little in translation, but your manual is an important photographic tool. It doesn't tell you how to take better point-and-shoot pictures; that's the job of this book. What it does tell you is where to find and how to operate the camera controls that can help you take better pictures.

Getting a Charge: The Pluses and Minuses of Batteries

Point-and-shoot cameras are chock full of little motors that do everything from advancing and rewinding your film to zooming your lens. These motors, along with other electrical demands — with digital point-and-shoots, the viewing screen is the biggest hog — consume quite a bit of electricity. Makers of kids' toys have a simple solution: Use more batteries. But because a point-and-shoot camera must remain compact, manufacturers have devised a different strategy: Use smaller, more powerful, longer-life batteries.

Lithium batteries

Most film-using point-and-shoots are powered by special *lithium batteries*. Made specifically for cameras, these cells are shorter than the familiar AA battery, but a lot more expensive.

There are two common types of lithium batteries. One is a three-volt cell that goes by proprietary designations such as KL123A, CR123A, or DL123A (a 123A is always in there) and costs as much as $7, sometimes more. The other is the shorter, thinner three-volt CR2 lithium battery, which costs about the same. Some cameras need two three-volt lithium batteries. And some take double-barreled six-volt batteries, either the 223A or, infrequently, the bigger 2CR5. These batteries can cost up to $13. And their prices may go even higher, depending on what the market will bear — and in tony or touristy areas, it will bear a lot.

More and more digital cameras use proprietary rechargeable batteries, but a number of these models take the CRV3 lithium battery. It looks like two familiar AA cells just stuck together, but don't be fooled: It costs up to $25, though you can sometimes find it for less than $20. See the sidebar, "Batteries and digital point-and-shoots."

Fortunately, you get what you pay for: Lithium batteries last much longer than alkaline AA cells. But the number of pictures you actually get from a lithium battery depends on the power needs of your camera; the more motorized it is, the fewer the rolls. Most 35mm and APS models give you within the range of 10 to 25 24-exposure rolls per battery, assuming that you use flash about half the time. (Lithiums also don't conk out in freezing weather as fast as AA cells, a good thing if you like taking pictures in the snow.)

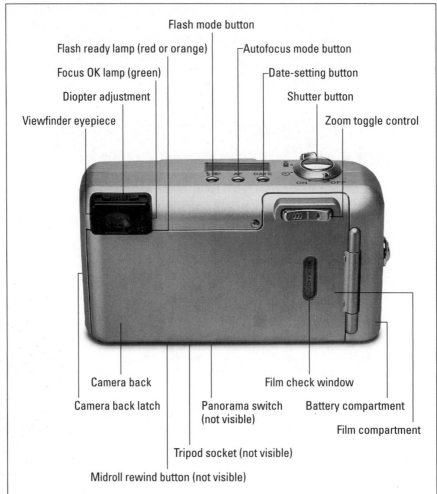

Flash mode button

Flash ready lamp (red or orange)

Autofocus mode button

Focus OK lamp (green)

Date-setting button

Diopter adjustment

Shutter button

Viewfinder eyepiece

Zoom toggle control

Figure 1-2:
The photographer's view of the controls and parts on a typical, full-featured 35mm point-and-shoot.

Camera back

Film check window

Camera back latch

Panorama switch (not visible)

Battery compartment

Film compartment

Tripod socket (not visible)

Midroll rewind button (not visible)

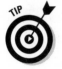

When you need to buy a new battery, always bring the old one — or better yet, your camera — to the store. Given all the different types of batteries, not knowing which type you need can drive clerks crazy. And by bringing your camera to the store and putting in the new battery there, you're immediately reassured that the new battery brings your camera up to snuff.

Lithium batteries are sometimes hard to find in out-of-the-way places. Suburban camera shops are a dependable source, but if your camera loses power in Timbuktu, you're in trouble. Even if you can find the right lithium battery, you may have to pay a black-market price for it.

Shutter button

Still/Video/Self-timer switch

Zoom toggle buttons (not visible)

On/off button Speaker

Self-timer lamp

Viewfinder window

Figure 1-3: From the front, a digital point-and-shoot doesn't look much different than a 35mm or APS point-and-shoot.

Battery compartment

Microphone

3X Zoom lens

Built-in flash

Memory card slot (not visible)

AC power adapter connector (not visible)

USB/TV connections (not visible)

Shooting insurance: Pack an extra battery

If your point-and-shoot takes lithium batteries, you should always keep an extra one (or two, if that's what the model requires) on hand. To prolong the battery's shelf life, keep it in the refrigerator, in its original packaging inside a baggie. (Never freeze it.) Just avoid putting the battery straight into your camera from the refrigerator; give it a half hour to warm up.

Take an extra battery with you to weddings, graduations, bar mitzvahs, or any other occasions that you want to photograph. These events are flash-intensive, and using flash a lot reduces the number of pictures you get from a battery. If you take an extra battery along, you don't have to stop shooting if the one in your camera peters out. Just be sure to refresh your memory about

how to install it, in case you need to do it fast. (See "Loading batteries — the right way," later in this chapter, for the details.)

A different kind of recycling

As a battery weakens, your camera's flash takes longer to *recycle* — to recharge itself for the next flash picture. (See Chapter 7 for more on flash recycling.) This sluggishness becomes a practical problem if, as with most point-and-shoots, your camera won't let you shoot until the flash has mostly recycled. Have you ever tried to take a picture right after turning on the camera or to take flash pictures in quick succession, only to find that when you press the shutter button it just doesn't respond — and you have to keep pressing and pressing to get it to fire the camera? Sometimes the problem is due to the camera's inability to focus, but more often than not, it's caused by an overly long recycling time — the direct result of a low battery.

You can turn off the flash (which otherwise powers up automatically every time you turn on the camera) to sidestep this problem. But I think flash is one of the most valuable photographic tools on your point-and-shoot, and I encourage you to use it generously — even outdoors! So please read Chapter 7 for ways to deal with flash recycling woes and to find out about the flash-ready lamp, which alerts you when the flash is ready to fire again.

If your camera's shutter button won't let you take a picture, don't keep bearing down on it. The camera may still be recycling the flash, preventing you from shooting to reduce the chance of a bad picture. Release the pressure, wait a few seconds, and then press again.

The good old AAs

Some point-and-shoots get their power from AA (or AAA) batteries, the same size that goes into most battery-powered gizmos. With 35mm and APS cameras, it is often the less expensive models that use AA and AAA cells. If you have such a camera, be sure to use alkaline AA (or AAA) batteries rather than the standard cheapo AA (or AAA) batteries. Alkalines last way longer than regular batteries, and most battery makers offer alkalines that are specially formulated for use in digital cameras and other power-hungry electronic devices. Some cameras actually accept both AA batteries *or* the smaller three-volt lithiums. Now *there's* a great idea, especially if you're going to Timbuktu. (Pack extra AAs anyway.)

And if you really *are* going to Timbuktu, or even somewhere less exotic, consider buying *lithium* AA batteries, not to be confused with the small lithium cells made specifically for cameras. Lithium AAs look the same as regular AA batteries but last up to three times as long as alkaline AAs. They're also three times as expensive as alkaline AAs. But you don't have to change them half as

often, which means you're less likely to see a great photo opportunity disappear before your eyes as you struggle with batteries.

Lithium AAs are especially valuable with digital cameras because of their energy-sapping viewing screens. But you certainly can use them in your regular film point-and-shoot if it accepts AAs. Another option is to use dual-celled CR3V batteries, which fit in cameras that take AA cells. (You'll need one for models that take two AAs, and two for models that take four AAs.) An expensive solution, but you won't be changing batteries for a long time.

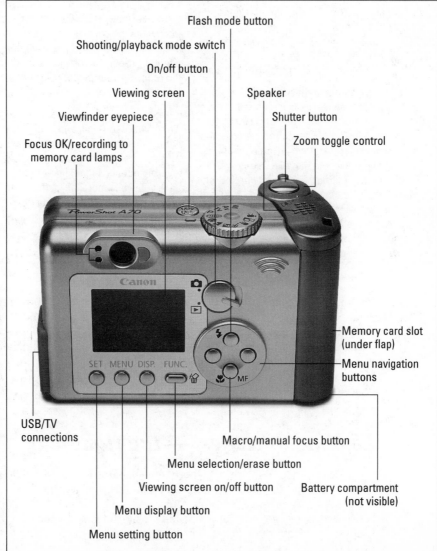

Figure 1-4: The most prominent feature on the back of a typical digital point-and-shoot is the viewing screen, used for both composing and reviewing pictures.

Flash mode button

Shooting/playback mode switch

On/off button

Viewing screen

Speaker

Viewfinder eyepiece

Shutter button

Zoom toggle control

Focus OK/recording to memory card lamps

Memory card slot (under flap)

Menu navigation buttons

USB/TV connections

Macro/manual focus button

Menu selection/erase button

Battery compartment (not visible)

Viewing screen on/off button

Menu display button

Menu setting button

Batteries and digital point-and-shoots

Digital point-and-shoots don't accept the scaled-down lithium batteries used by better film models. The reason for this, as far as I can tell, is that these newfangled cameras have enormous power needs — so special lithium batteries would make them prohibitively expensive to operate. Most early digital point-and-shoots used four AA batteries, and some still do, eating them like they're going out of style. Many models use just two AAs to stay small, if they don't come with a proprietary rechargeable cell.

The big power drain in these cameras is their little viewing screens. These mini-monitors are intended not just for playback of pictures that you've already shot, but also for viewing and composing your subject while you're shooting. Though many models have a window-type viewfinder in addition to the viewing screen, others have no such viewfinder and force you to use the viewing screen for shooting. Every minute the screen is on, even if you're not taking pictures, it's sucking your batteries dry.

If your digital point-and-shoot makes you shoot with the viewing screen, turn the camera on *only when you're ready to take pictures*. Turn it off as soon as you're done shooting. This habit extends the life of the batteries.

If your camera has both a window-type viewfinder and a viewing screen, you can get much more life out of your batteries by shooting with the regular viewfinder and saving the viewing screen for playback only. Oh, and if you're taking your digital point-and-shoot to an occasion — or on a trip — pack at least two changes of batteries.

When you use flash *and* a digital point-and-shoot's viewing screen for your pictures, you consume batteries even more quickly. But the several seconds digital point-and-shoots often make you wait before taking the next shot aren't always battery-related: During this interval, the camera is processing the information from the image sensor.

If your camera takes AA batteries and you feel guilty about throwing them away, you can get rechargeable AA cells. Some digital point-and-shoots — the ones that don't use specially-shaped, proprietary rechargeables — actually come with AA rechargeables and a charger. Or purchase an inexpensive plug-in AA recharger and at least two sets of cells — four cells if your camera takes two batteries, eight cells if it takes four. That way, you can alternate charging them and always have a freshly charged set.

Loading batteries — the right way

If you've ever had to figure out where to stick batteries in your child's latest electronic acquisition, then loading batteries in your point-and-shoot shouldn't be a challenge. Turn off your camera when you install the batteries; otherwise, it may go crazy opening and closing its lens. (Some cameras turn themselves off after you install new batteries, so you have to turn them back on to shoot.)

With big point-and-shoot models, you typically have to open a latched cover on the camera bottom to install batteries. On more compact models, the battery compartment is often under a door or flap incorporated into the side or grip of the camera (see Figure 1-5). Sometimes you have to pry open such doors with a coin or key. This design is annoying when you don't have any change and break a fingernail trying to do it.

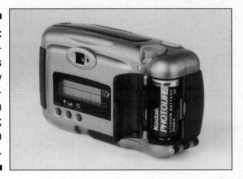

Figure 1-5: This point-and-shoot's battery compartment is on the side; others are in the bottom.

More annoying are camera-bottom battery covers that you open by loosening a screw. (You need a coin for this type, too.) And most annoying are battery covers that aren't hinged. They come off completely when you unscrew them. If you have one of these covers, don't change batteries when you're standing over a sewer grate, in a field of tall grass, or on a pier!

With digital point-and-shoots having proprietary rechargeable batteries, the battery slot and the memory card slot are often under the same door on the side of the camera. This is especially true of compact models.

Whether you're loading four AA cells or just a single lithium, make sure that the batteries are correctly oriented as you insert them. You'll find a diagram and/or plus and minus markings, usually within the compartment or on the inside of the door. The bump end of the battery is its positive (+) terminal; the flat end is its negative (–) terminal. The batteries also have plus and minus symbols on their sides. AA (and AAA cells) usually don't go in all facing the same way; you may have to reverse every other cell. Always follow your camera's diagram.

If you don't install batteries in their correct orientation, your camera won't start up when you try to turn it on. If this happens, remove the batteries, reinsert them correctly, and then try to turn the camera on again.

If your camera doesn't turn on and you're sure the batteries are correctly installed, then the problem may be that the batteries have lost their punch from sitting on a shelf too long. Which brings me to the battery icon. If your camera has an LCD panel or viewing screen, the icon tells you when battery power is low.

After you turn on your camera or load film, your camera may display a battery-shaped icon, usually in a corner of the LCD panel or viewing screen. (See Chapter 4 for more on the LCD panel and viewing screen.) If the icon's shape is fully darkened, the battery has sufficient power. If it's half darkened, you've already used a good portion of its juice — and may have noticed already that the flash recycling time is increasing. If the icon is barely filled in and/or blinking, you need a new battery. (See Figure 1-6.) Many models won't display the icon at all until the battery is on its way out.

Figure 1-6:
Typical
battery
power
icons.

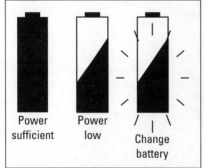

Power
sufficient

Power
low

Change
battery

Some models may display battery status all the time. And other models may have a pushbutton battery check. Pushing the button makes a light glow. But however your camera displays battery status, if it does, check the status regularly. If you're planning to shoot a special event or going on a trip, check it before you go. If the battery needs replacing, do it now.

By the way, changing batteries when film is in the camera is perfectly okay. The LCD panel goes blank during the change. Even though the LCD is battery-dependent, the camera "remembers" how many pictures you've taken — or how many are left, depending on your model — and restores the display after you power up again. Models with mechanical counters remain unaffected. The camera ordinarily *doesn't* remember specific settings that you previously made, however. (See Chapter 4 for more on setting camera modes.)

If you have a roll of film in the camera, be sure to leave the old battery in it until you're ready to put in a new one. Left too long without a battery, the camera may forget how many pictures have been taken.

Models with *quartz date* capability, which allows them to imprint the time and/or date on your prints, generally do not use the camera's main battery to keep time. They use a tiny *button cell* — a watch battery — that either comes with the camera or is factory-installed. This battery usually lasts many years. You can replace it after it dies, though some models may need to be returned to the manufacturer for this service. Check your manual! (And see Chapter 3 for the pros and cons of putting the time or date on the front of your pictures.)

If you don't use your camera for long periods of time — a couple of months or more — remove the batteries to prevent the possibility that they will start to leak corrosive fluids. (Just remember that you lose the frame count — but then you shouldn't be leaving film that long in the camera anyway!) Leakage, most likely with AA batteries, can seriously damage your camera's innards. The solution: Take pictures more often!

Loading Film — the Painless Way!

Probably the single greatest source of photographic anxiety, loading film is much easier than it used to be — and, thanks to point-and-shoot innovation, easier than most people think. Nearly all reloadable point-and-shoots (one-time-use cameras not included) have automatic film loading, and the Advanced Photo System's film cassette and drop-in loading makes something easy even easier. (See Chapter 8 for details.)

But first, here's all that you ever need to know about loading film into a 35mm point-and-shoot. Nothing gives away an amateur like tentative or prolonged film loading. Master this stuff, and you'll look like a pro.

After you close the back of a 35mm point-and-shoot, the camera automatically advances the film to the first frame. (With some low-budget models you may have to advance the film manually with a little fold-out crank; see "Counting up — and down," later in this chapter, for details.) But what cows people is the film *leader* — the little strip of film that protrudes from the cassette's lightproof lip (see Figure 1-7). The leader starts out perforated on both sides (as is the film inside the cassette), but tapers to a short half-width strip with perforations only on one side. After the cassette is in position inside the camera, you pull the leader across to the film *take-up spool,* which automatically engages it after you close the camera back.

Figure 1-7:
An
Advanced
Photo
System film
cassette
(left) and a
35mm film
cassette
(right).

Here's how 35mm loading works:

1. **Open the camera back.**

 You do this with a latchlike sliding switch (usually marked with an arrow or the word *open*) on the side or back of the camera. Sometimes you have to hold down a locking button as you move the switch; this double catch lessens the chance that the back would accidentally pop open and ruin your film when you're shooting. The back clicks open on the latch side; lift it up so that you can put in the film. (The camera can be off or on when you load the film.) (See Figure 1-8.)

 In the middle of the inside of the camera is a rectangular opening though which you can see the back of the lens. This rectangular opening is where each frame of film rests as you shoot it. On either side of this rectangle are two chambers. The large, empty one is where the film cassette goes. With some models, it's on the left; with others, it's on the right.

2. **Nestle the film cassette into the empty chamber.**

 You can't just drop the film cassette in. Notice that the cassette has a small cylindrical protrusion at one end, called the spool hub. This protrusion must fit into a small recess in the film chamber. Notice, too, that there's a little spindle extending into the film chamber, from the top or bottom. You have to slip the flat end of the cassette — the end opposite the spool hub — over this spindle as you fit the cassette into the chamber. The process sometimes takes a little nudging and wiggling.

Figure 1-8:
The view inside an open 35mm point-and-shoot. The loaded cassette's film leader has been extended to the film tip mark.

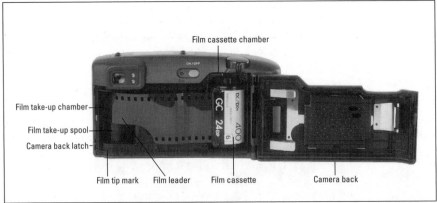

Film cassette chamber

Film take-up chamber

Film take-up spool

Camera back latch

Film tip mark Film leader Film cassette Camera back

3. **Grasp the leader and pull enough film from the cassette so that the leader's front edge lines up with the** *film tip mark* **in the opposite chamber.**

The film tip mark is often, though not always, colored orange or red. Pull gently on the leader, keeping a finger on the cassette itself so that it doesn't lift out of the chamber. Lie the film flat across the rectangular opening to see if it reaches the mark. If it doesn't, pull it out a little more.

After you get more comfortable pulling film out of the cassette, use your thumb to press against the top edge of the film and push it along its path, as shown in Figure 1-9. This technique helps you gauge how much film to pull out. Just be sure not to press against the rectangular opening.

Figure 1-9: One way to extend 35mm's film leader is to slide it across with your thumb.

With compact cameras, you don't need to pull the film out more than a few perforations' worth; with bigger models, rarely more than ½ or ¼ of an inch. But you don't have to be especially precise about the amount of film you pull out. Some models seem more able than others to handle excess film. None, however, can grab the leader if it's physically too far away. So err on the side of more film rather than less.

4. **Now press the whole film strip flat against the rectangular opening, double-check that the cassette is snugly seated, and then close the camera back with firm pressure until it clicks.**

The camera's take-up mechanism and winding motor should engage the film and advance it to the first frame. The camera's frame counter or LCD panel then displays the number *1*.

If nothing happens after you close the camera back, your camera may be the type that must be turned on to advance the film. Turn it on. If it still doesn't advance the film, try pressing the shutter button once. (A few inexpensive models may require that you push the shutter button repeatedly until the number *1* appears in the frame counter.)

If you pull too much film out of the cassette when loading it — or not enough — the camera may not advance the roll to the first frame (see Figure 1-10). If this happens, you must open the back and reload the film.

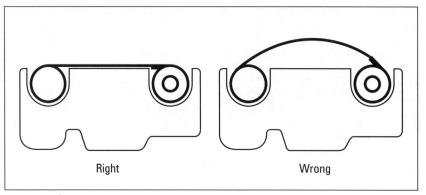

Figure 1-10:
Don't pull
too much
film out
of a 35mm
cassette
when you're
loading it —
or too little.

Right Wrong

Fortunately, most 35mm point-and-shoots tell you (after you close the back and they attempt to engage the leader) if you pulled out too much film — or if you didn't pull out enough. They give you this warning, if they have an LCD panel, by blinking an icon of the film cartridge and/or the number *1* or an *E* (for empty). Models without LCD panels simply fail to move their mechanical frame counters to 1.

To fix the problem, open the camera back. Pressing the film flat against the camera, check again to see whether the leader lines up with the film tip mark. If it's short, just pull out a little more film and close the camera back again.

If you pulled out too much film, take out the cassette. Hold the cassette between the thumb and fingers of one hand and point the spool hub toward you. Grasp the spool hub with the thumb and forefinger of your other hand and rotate it counterclockwise *to draw the leader back into the cassette* (see Figure 1-11). This rotation may not appear to have an effect until the coil of film inside the cassette begins to tighten up. Continue to turn the spool hub until the half-width portion of the film is a few perforations away from the cassette's lip. Rotate it *slowly,* so that you don't accidentally pull the whole leader back into the cassette.

Now load the film as I describe earlier in this section. If you pull out too much film again, just repeat the process.

Do not rotate the film cassette's spool hub in a clockwise direction. It puts up a lot of resistance if you try, and doing so may cause damage to the film.

Some 35mm point-and-shoot brands use a drop-in loading system that is fairly foolproof, as such things go. The cassette slips into a shaped compartment on the *bottom* of the camera. You do have to pull out the film leader a bit so that the camera can engage it after you close the door, but the compartment is shaped so that you can clearly see how to insert the cassette.

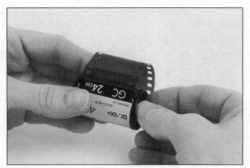

Figure 1-11:
To draw excess film back into a 35mm cassette, rotate the spool hub slowly counter clockwise.

Counting up — and down

After you load the film, the camera automatically advances it from one shot to the next. If your camera is a one-time-use model or an older, inexpensive reloadable, you may have to advance the film by rotating a thumbwheel after every shot. You can't overwind: The wheel, which is located in the upper right of the camera back, stops when the next frame is lined up.

Most 35mm models count exposures upwards — 1, 2, 3, and so on, all the way to the last frame on the roll. (Rolls of 35mm film come in 12-, 24-, and 36-exposure lengths.) Displayed either by a mechanical counter under a small window (usually on the camera top) or by the camera's LCD panel (if it has one), the frame number is actually the number of the frame that you're *about* to shoot (see Figure 1-12). If it says 18, you've taken 17 pictures and are about to take number 18. To know how many pictures are left on the roll, you have to know the length of the roll, and deduct this number from it. If you've forgotten the length of the roll that you loaded, don't worry: With almost all 35mm point-and-shoots, a narrow vertical window on the camera back lets you read vital statistics off the side of the loaded film cassette, including the length of the roll. (See Figure 1-13.)

By contrast, some 35mm models count down — 24, 23, 22, and so on, all the way to 0. The number that they display actually tells you how many frames you have left on the roll.

If you mistakenly open your camera in the middle of a roll (thinking it's empty or that the film has been rewound), *close it immediately.* Your cue to close the camera is if you see *any* actual film at all; if the film has been rewound, it should *all* be back inside the cassette. (See the following section.)

Figure 1-12:
To display the frame count, your point-and-shoot uses either its LCD panel (left) or a separate window (right).

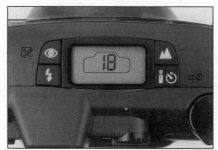
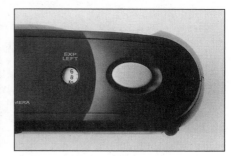

Fogging film (say it ain't so!)

When you open the camera back before the film has been fully rewound, the resulting exposure to incoming stray light is said to fog the film. *Fogging* basically clouds up, discolors, mars with streaks, or completely obliterates the pictures that you've shot — assuming that you go on to get them developed.

Figure 1-13:
You can tell whether 35mm film is loaded by looking at a window on the camera back.

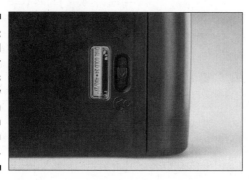

Fogging almost certainly ruins your most recent shots. But if you close the camera back quickly, some of the earlier pictures on the roll may be salvageable. They may be okay because the film is opaque before development and forms a tight coil on the take-up spool as you shoot — the top loop or loops protecting the film beneath. But the longer you leave the back open, the more damage is done. And the brighter the surrounding light, the more immediate the damage. You don't know how bad the damage is until you have the film processed, which is worth doing. The photofinisher does not print badly fogged frames, so you don't have to pay for them.

If you open the camera in the middle of the roll, the film you *haven't* used yet is still safe in the cassette and, with the exception of a frame or two, should be unfogged. In fact, after you reclose the back, the camera might behave as if you've loaded a new roll and advance the film to what it thinks is the first frame — in the process pulling out enough film to reach the unfogged portion. But just to be safe, fire off a few blank frames (shots of nothing in particular) to advance the roll farther, and you're ready to continue shooting. (That is, if you're not so anxious to assess the damage that you choose to rewind the film and have it processed immediately!) Keep in mind that because the frame counter is reset to 0 after you open and close the back, unless you can remember how many frames were left on the roll, you don't know exactly when it will end.

35mm models that count frames *down* rather than up may actually prewind the film. *Prewinding* means that right after you load the cassette and close the camera back, these models advance the film all the way to the *last* frame. You hear their motors whirring for quite some time, and you may see their counters counting up along the way. Then, as you take each picture, they draw the film, a frame at a time, back into the cassette. (Rewinding is short, because at the end of the roll only a few inches of film are left!)

The thought behind prewinding is sensible: Should you open the camera back accidentally in the middle of the roll or should you drop the camera and the back pops open, the frames that you've already shot are safe inside the cassette. With a prewinding camera, the only film that would be fogged by the light you let in is the film that's still *outside* the cassette — which has no pictures on it.

So if you have a prewinding camera and accidentally open the back in the middle of a roll, close it and rewind the film. (Check out "Rewinding Film (Congratulations!)", later in this chapter, for instructions on midroll rewinding.) Do *not* shoot any more pictures; you'd be taking them with fogged film, and they probably wouldn't come out. If you shut your camera really fast, you may have a few good frames toward the end of the roll, but why take the chance? The photofinisher doesn't print what you don't shoot and certainly doesn't print fogged negatives. Film is cheap.

Loading film into an Advanced Photo System camera

Being well thought-out machines, APS cameras make loading film effortless. Photographers who've moved from a 35mm point-and-shoot to an APS model have probably noticed that the APS model doesn't have a camera back to

open up for film insertion, only a small door. This door — call it the *film-compartment door* — is usually on the bottom of the camera. On a few models you may find it finagled into the side or even the top. You usually open it with a latchlike sliding switch or a flat lever.

With some models, you have to press a button to unlock the switch; with others, you must push the switch up or sideways before it fully slides to open the film-compartment door. Such designs are meant to protect against accidental opening of the door, which would fog your film. In fact, if you open and close the door without rewinding the film (or with some models, even if you move the switch), the camera may go ahead and rewind the film for you as insurance against any possibility of shooting on fogged film. (See "Fogging film (say it ain't so!)" for more details.)

By the way, I've found that the film-compartment switch or lever on APS cameras often takes more pressure to move than the camera-back switch on 35mm models.

As for the APS cassette, you'll notice not only that it's smaller and differently shaped than a 35mm cassette, but that it lacks 35mm's leader — the annoying little strip of protruding film. (Are you happy?) The film is entirely within the cassette and is actually *pushed* out of the cassette to the take-up spool (which you can't even see) after you close the film-compartment door. Loading an APS cassette is about as simple as sliding a VHS cassette into your TV's VCR.

As you throw the switch, the door pops open. Lift the door up if it doesn't open all the way on its own. Then just push the film cassette into the camera, end first. If one end doesn't fit, put in the other end first.

You can't accidentally load an Advanced Photo System film cassette backwards. The cassette is specially shaped so it fits only one way.

With some APS models, you may encounter a slight, springy resistance as you slide in the cassette. If you do, push the cassette all the way down; it may click into position. But if the cassette rides up a little in the compartment, just push it down with the film-compartment door when you close it.

After you close the film-compartment door, which takes firm pressure, the camera automatically advances the film to the first frame. Most APS models automatically advance the film whether they're on or off. They take more time than 35mm cameras to accomplish this task — quite a long time, which can be frustrating if you're in a hurry to get more pictures. But don't let all this motorized whirring and whining lead you to think that the film is being prewound. You may get that idea because most APS cameras (though not all) count frames *down,* starting at 15, 25, or 40 frames — the standard APS roll lengths.

The Advanced Photo System cassette

Part of the Advanced Photo System's appeal is that its film cassette has no visible leader — so you don't have to worry, as you do with 35mm, about engaging a leader to load the film. But this lack of a visible leader also means that you can't tell with a quick look whether you've shot a roll of film. Instead, you have to look at icons on the end of the cassette. These icons are especially useful because with the Advanced Photo System, your processed film is returned in the original cassette, where it remains for long-term storage and future reprinting.

The icons — a circle, a half circle, an *X*, and a rectangle — surround the opening in the middle of one end of the cassette (see figure). To keep their proper sequence perfectly clear, they are numbered 1, 2, 3, and 4 (respectively), and arrows point from one icon to the next. The icons are actually small, shaped cutouts in the cassette surface, and a white indicator appears beneath the appropriate cutout to tell you the roll's status. With a new, unexposed cassette, the circle appears white (left cassette in figure). With a cassette in which only a portion of the

roll has been shot, the half circle appears white. (This status is only possible with the few APS models having mid-roll film change capability, which I explain in the section "Rewinding Film (Congratulations!).") With a cassette that is fully exposed (that is, all the frames have been shot) but unprocessed, the *X* appears white (center cassette). And with a processed cassette, the rectangle appears white (right cassette).

If you inadvertently load either an exposed but unprocessed APS cassette or a processed APS cassette, your APS camera does not advance the film. This protection prevents double-exposure and shooting pictures that would not come out.

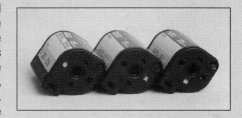

Loading digital cameras

Digital cameras don't need film, silly. That's why you can't hear the familiar whir of the film-winding motor after you take a picture. The silence of digital point-and-shoots is disquieting to some film-oriented photographers. When digital cameras first came out I facetiously suggested to manufacturers that they put a little computer chip into them to fake this noise, just to make it seem as if something is really happening. Something is happening, of course — quietly and electronically. And now most models provide such sound effects.

Actually, you do "load" digital cameras in one sense: With most models, to get photographs you have to place a *memory card* into a slot on the camera body. The memory card is where your pictures reside until you put them somewhere else, and depending on its storage capacity, you may need more than one. When a card fills up with pictures, you either have to remove it and replace it with another or transfer its pictures to your computer and erase it so you can start putting new pictures on it. (For more about this, see Chapter 15.)

Turning the Camera On — and Off Again

Most point-and-shoots, whether 35mm, Advanced Photo System, or digital models, are turned on with a single pushbutton on the top or back of the camera, marked on/off. You push it once to turn the camera on and again to turn the camera off. Other models may turn on and off with sliding switches, also placed on the top or back. Some switches have two positions; others have a spring mechanism that returns them to a single position. (You slide them once to turn the camera on and again to turn the camera off.) Some cameras have sliding on/off switches on the front, usually below the lens. These switches also open the camera's built-in protective lens cover, so you must slide them back to close the cover and turn off the camera.

Still other models, both digital and film-using, are turned on and off with a large, sliding front panel that doubles as a lens protector. It's sometimes called a *clamshell* cover, a term inherited from older cameras that actually had swing-out front covers. This design is very sensible. To open up and turn on the camera, you simply use the flats of your fingers to slide the cover to the side. (The cover usually has a ridge to help you grasp it.) To turn off the camera, you slide the cover back over the lens. With some designs, you have to wait a moment for the lens to retract into the camera before you can slide the cover all the way over.

One other style of on/off switch is fairly common. It is built into a thumb-controlled dial on the back or top of the camera. The dial has various settings on it, but rotating it one click away from its off position, to a setting marked *A* or *Auto,* or sometimes just plain *On,* turns on the camera. (This setting may be color-coded green, for *go.*) Rotating the dial back to *Off* turns the camera off.

How to press the shutter button

Don't treat your shutter button like a hot potato! Many point-and-shooters wait for pictures with their finger hovering above the shutter button, "stabbing" it to take the shot. This bad habit causes you to jerk the camera — and that unintended movement is one of the main causes of unsharp pictures.

Instead, keep your finger resting lightly on the shutter button. When you want to take a picture, slowly, smoothly bear down on the button until you hear the shutter click. Then release the button without completely removing your finger from it. Get yourself to do this by pretending that your shutter-button finger is glued on: Keep it there before, during, and after snapping a picture. Practice with an unloaded camera to get a feel for it. Watch yourself in a mirror: You should see no movement of the camera at all.

This technique is also crucial to mastering the shutter button's two-step operation — pressing it halfway to lock the autofocus and then all the way down to take the picture. See Chapter 6 for more on the shutter button two-step.

As you turn the camera on, the first thing that happens is that the lens is uncovered. This function may be strictly mechanical, as it is with sliding front panels or below-the-lens sliding switches. In other cases, it's accomplished with motor-driven spring action.

Some lens covers are just large, flat doors that are flush with the front of the camera; after you turn off the camera, they hide the entire lens, cylindrical barrel and all, within the camera body. (You find them mainly on nonzooming models.) Other lens covers are made of delicate blades that are built into the lens barrel and spring open to uncover just the glass portion of the lens. Whatever the design, the lens cover protects the front glass surface of the lens from smudges or scratches. But if your camera has a bladed cover, be advised that if you leave it in a purse or carryall, the cover blades can catch on something and be pulled open, subjecting the lens to scratching from keys and so on. If you stash your camera in a bag, keep it in a fitted pouch.

Point-and-shoot cameras with sliding front covers are a smart idea. The lens is more protected than with other designs, making the camera ideal for slipping into a pocket or purse.

After you turn your camera on, it may extend the lens, especially if it's an autofocus model. (Many cameras extend the lens as the cover is opening.) The lens is extended with a small motor. Extending the lens readies the camera for shooting, and with 35mm zoom models, sets the lens to its shortest (most wide-angle) focal length — which is generally 35mm or 38mm, though sometimes 28mm. (Note that these settings are different for APS cameras; for more on focal lengths, check out Chapter 5.) You can then zoom to the setting of your choice. If your camera does not have autofocus capability, the lens may not need to move at all.

Get a Grip: Holding Your Camera

Point-and-shoot cameras are often so small — and therefore so crowded with buttons, dials, windows, and other doodads — that you usually don't have much leeway in terms of how to hold them when you're taking pictures. You basically have to pinch each end of the camera between your thumb and fingers, except that with the right hand, your index finger must rest on the shutter button, on top of the camera. Your remaining three right-hand fingers form a sort of wedge against the front of the camera. Many models incorporate a curved or ridged grip on the right side, which makes for a more secure grasp and, coincidentally, a nice little space for the battery compartment.

Your right thumb should rest vertically against the back of your camera. With most zooming models, you find the zoom control at the tip of your thumb, in the upper right of the camera back. But some models have their zoom controls on the top of the camera, where they must be operated by the right index

finger. You have to get used to moving your finger back and forth between these zoom controls and the shutter button. You will.

You have a little more flexibility in how you use your left hand, though the best way depends partly on the specific design of your camera. The worst thing that you can do is to stick a finger over the flash, which definitely ruins indoor pictures (see Figure 1-14, top left). Find a comfortable way of grasping the camera that avoids this problem and use it consistently.

An easy way to determine whether you're covering the flash when you hold the camera — a real no-no — is simply to look at yourself in a mirror while sighting through the camera's viewfinder.

As far as your left thumb goes, one thing that you can do with it is pretty much to match the position of your right thumb: point it up and slightly inwards. The front of the camera then rests against the side of your index finger (see Figure 1-14, top right). But my preferred left-hand grip places the thumb against the bottom of the camera, and, preferably, the index finger across the top (see Figure 1-14, bottom left). You just have to hold your other fingers away from the camera (again, to avoid blocking the flash) either by folding them in tightly or splaying them out, which looks a little ornate.

Figure 1-14:
The steadiest grip on the camera is often the most comfortable one, but there are right ways and wrong ways — and you should never cover the flash (top left). See text for details.

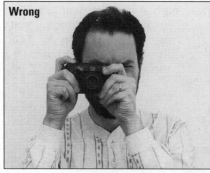

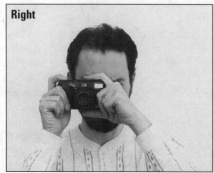

I think this technique is more secure, lessening the chance that hand tremors will make your pictures unsharp. However, if your camera has a flash that pops up from the top of the camera or it has pushbuttons there that you may accidentally press, you can't use this technique, so go back to Plan A. For vertical shots with flash, try to place the camera's built-in flash at the top rather than the bottom; this creates a more flattering effect with people pictures (see Figure 1-14, bottom right).

Rewinding Film (Congratulations!)

When a 35mm or APS point-and-shoot camera reaches the end of a roll of film, it automatically *rewinds* it — that is, the camera draws the entire roll of exposed but undeveloped pictures back into the cassette. (Less expensive models may require manual rewinding with a crank; read on.) Sometimes the camera squeezes in an extra shot or two at the end of a roll, depending on the brand of film and the winding system; you may get 37 exposures instead of 36. The standard roll lengths in 35mm are 12, 24, and 36 exposures; in the Advanced Photo System, 15, 25, and 40.

If you have a 35mm camera, it has a little window on the back through which you can see a small portion of the outside of the loaded film cassette. This window allows you to read the number of frames off the cassette, should you forget the length of the roll that you loaded. If the camera counts exposures upwards (1, 2, 3, and so on), as most do, this information lets you determine when you're nearing the end of the roll. If you have an Advanced Photo System camera, you probably don't have to figure out how many frames you have left, because most APS models count frames *down* — in other words, they tell you how many exposures are *left* on the roll. (Digital point-and-shoots count down too, and you can go straight to Chapter 15 for more on that.)

Knowing how many frames are left on a roll is useful, not because of anything to do with rewinding — the camera rewinds the film only after it senses the tug at roll's end — but because it lets you plan your shooting. If you're about to leave for a wedding with a 24-exposure roll in your 35mm point-and-shoot and the frame counter says 23, you know you're not going to have enough film to get the pictures you want. At the very least, you should bring an extra roll.

I say at the very least because I have a better idea: Put a new roll of film in your camera *before you go.* That way, you won't have to stop and reload after shooting two frames — possibly just when you have a perfect picture in sight. It's not worth losing a great picture to save a frame or two of film. Film is the cheapest part of photography, and photofinishers don't print frames that you don't shoot — nor can they charge you for prints that they don't make.

To put in a new roll of film before the last one is finished, you have to push the rewind button. With most point-and-shoot cameras, it is a tiny pushbutton (usually the smallest of any button on the camera) that is recessed to prevent accidental rewinding. Its location varies totally from camera model to camera model; yours may be on the bottom, sides, back, or top. (The only place that you won't ordinarily find it is the front.) The button is almost always marked with a symbol that combines double arrows and a stylized film cassette (see Figure 1-15). The capability is often called *midroll rewind*.

Figure 1-15:
The film
rewind icon.

There are other reasons to rewind film before roll's end. For one, you can get pictures back sooner — for example, to be able to send out promised prints of a special event. Even if you waste five or ten frames (a buck or two's worth of film), it's worth the satisfaction of sharing those important images when the event is still fresh in peoples' minds.

Another good reason to rewind film before the end of a roll is to switch to a different type of film for a different purpose, occasion, or lighting condition. The switch can be aesthetically motivated — a change from color to black and white, for example. Or it can be practical — switching to a faster film (one with a higher ISO number) when you want to take pictures by low existing light. (Read Chapter 2 for more on different types of film.)

To rewind your film:

1. **Turn the camera on, if it's not on already.**

 Some models may be able to rewind when they're off, but turn them on anyway.

2. **Push the rewind button.**

 To push the rewind button, you probably need a pencil or pen or bobby pin — a straightened paper clip also does the job — though some cameras may incorporate a little groove that allows you to use your fingernail. After you push the button, the camera starts rewinding the film with its motor, just as if it had reached the end of the film on its own. Most but not all models count down the exposures. If you have a mechanical frame counter, you see it slowly move backwards from the last exposure (say, 24) to 0; if your camera displays frame numbers on its LCD panel, it counts backwards frame by frame.

After the camera rewinds the film all the way back into the cassette —
and with some models, this process can take as long as 45 seconds with
a 36-exposure roll — the motor stops. (Cameras with an LCD panel usu-
ally blink the icon of the cassette with the number *0* or the letter *E* — for
empty, not error.)

If pressing the rewind button doesn't start the rewind motor or if the
winding stops in the middle, *do not open the camera.* First, if the camera
is off, turn it on and push the button again. If that procedure doesn't
work, replace the battery. You don't have to hurry to replace it; the film
is safe. If replacing the battery doesn't get the rewind going (push the
button again, if need be, after it's installed), bring the camera to your
local photo dealer or photofinisher to have the film rewound. (See
Chapter 3 for more on choosing a photofinisher.)

3. **After the motor stops, open the camera back or film compartment and
take out the film.**

 With 35mm, rewinding draws the film entirely inside the cassette, leav-
 ing no film leader outside. In fact, that's how you can tell if a 35mm roll
 has been shot: If the perforated film leader is visible, the roll is ready to
 shoot; if the film leader is not visible, the roll is exposed and ready for
 processing. (See Figure 1-16.)

Some rewind variations (What else is new?)

A few point-and-shoots replace the single
rewind button with a sliding switch that clicks
back into position when you open the camera
back to remove the rewound film. And a few use
a two-button combination for rewinding. With
one of my favorite models, actually, you have to
hold down what is normally the self-timer button
for a couple of seconds to make the LCD panel's
rewind symbol flash, and then you push the
shutter button to start the rewind. I definitely
needed my manual to figure this one out. So if
you can't find a rewind button anywhere on your
camera, check your manual!

If you have a bare-bones 35mm point-and-
shoot, it may not have a rewind motor at all —
just a manual crank on the camera. You flip out
the crank and rotate it to rewind the film into the
cassette. In order to start rewinding, you usu-
ally first have to push a small (and sometimes
recessed) button, normally on the camera
bottom. Pushing this button unlocks the film-
advance mechanism. Be sure to turn the crank
in the direction of its indicating arrows (usually,
but not always, counterclockwise). Hold the
camera body firmly (keep those fingers off the
lens!) and rewind smoothly and slowly until you
feel a little tug or click, which is the film leader
disengaging from the take-up spool. Then you
feel a reduction in the pressure needed to turn
the crank. Turn the crank a few more times to
draw the film completely into the cassette.
(Don't worry — you can't overdo it.) Finally,
open the camera back to remove the film.

Figure 1-16:
If a 35mm cassette's film leader is visible (left), the roll is ready to shoot; if the leader's inside the cassette (right), the roll has been shot.

If you've read this chapter and still face the ultimate frustration — your camera just won't shoot — go directly to Chapter 20. There you find ten succinct suggestions for getting your point-and-shoot shooting again.

When to use a one-time-use camera

Some people call them disposable cameras. That isn't entirely fair, because about 85 percent of their content (by weight) is reused or recycled by manufacturers, including the battery, flash, and lens. Some people call them single-use cameras, but the companies that make them don't like that term either because its acronym is SUC. (They don't think these cameras suck, and neither do I.) So as the popularity of these one-roll wonders has burgeoned, the photo industry has settled for OTUC — an acronym for one-time-use camera.

OTUCs are bare-bones cameras that come already loaded with a roll of film. You don't even have to *unload* them, because when you've finished the roll you just turn in the *camera* to a photofinisher. It's ironic that the world's best-selling camera uses the same consumer paradigm as the original 1887 Kodak — the camera invented and introduced by company founder George Eastman, AKA the Great Yellow Father.

Purchased with a roll of black-and-white film preloaded, the Kodak was advertised with the slogan "You Press the Button, We Do the Rest." Sounds like an OTUC, the difference being that you had to send the Kodak camera itself back to the factory for processing, and it was mailed back to you with the prints — reloaded with a fresh roll of film.

Unlike the Kodak, you can buy a one-time-use camera nearly anywhere, so it's a fallback if you've left your reloadable point-and-shoot at home. In my book there's little excuse for that. (See Chapter 10 for a list of ten really lame reasons for not taking your camera with you.) If, on the other hand, you're going to the beach and don't want to expose your good camera to sand and salt spray, an OTUC is just the ticket. Or if you're worried that flashing your good camera in a questionable neighborhood might invite theft, an OTUC can allay your fears. (Why are you taking pictures in a questionable neighborhood?)

Sometimes an OTUC can mean the difference between getting and not getting photographs. Lose or damage your reloadable camera on a trip? Buy an OTUC and you can still bring pictures home. Spouse or kid run off with the reloadable camera when kitty is doing something adorable? Keep an OTUC in the house and you can grab it.

When you buy an OTUC, you have to choose between a model with a built-in flash and one without. Flashless OTUCs are a bit cheaper, ostensibly designed for outdoor photography only.

Even if you're planning to shoot outdoors with an OTUC, I suggest getting a model with a built-in flash. Firing the flash when you're shooting in bright light helps lighten dark shadows, for more flattering pictures of people. And having flash available lets you keep shooting when outdoor light gets low or you move into deep shade. Besides, you never know when you'll be heading indoors, and that way you won't have to stop shooting.

Don't take indoor pictures with an OTUC that has no flash! If they come out at all, the quality is usually terrible.

For more about OTUCs and flash, plus how (and why) to make the flash fire even when you're in bright light, see Chapter 7. And keep in mind that unlike other types of point-and-shoots, an OTUC can't figure out when flash is called for. *You* have to decide if flash is needed or useful, and if it is, push a flash-activation button that is usually located on the front of the camera.

Even if there's a regular point-and-shoot in your pocket, an OTUC can be valuable. That's because one-time-use cameras now come in many varieties for specific purposes. These include:

- **Sports OTUCs.** Chunky, "ruggedized" models with extra weatherproofing, these often have rubbery body panels that make them easier to grip in wet conditions. They aren't, however, waterproof!

- **Underwater OTUCs.** A thick, sealed plastic housing lets you take these models to depths of 10 or 15 feet, sometimes even deeper. But because they lack a flash, I recommend staying close to the water's surface, where the light is stronger. (The lower you go, the bluer your pictures will usually be.) Great for snorkeling. Also fun at the pool!

- **Panoramic OTUCs.** Shoot with one, and you'll get back wide-screen prints measuring the usual four inches high but 10 or 11 ½ inches wide, depending on the processing. They're terrific for shots of scenery and landscapes, and it's fun to use them vertically for pictures of trees, big-city buildings, and other tall subjects (your gangly teenager?). Just keep in mind that even though the camera itself doesn't cost more, panoramic-format prints will add considerably to your photofinishing bill. A panoramic print often costs two or three times as much as a standard 4 x 6.

- **Advanced Photo System OTUCs.** A mouthful of an acronym, the APS OTUC benefits from the system's smaller-than-35mm film size, which allows the camera to be more compact than its 35mm cousins. Some models even give you a choice between two of the three different print formats that APS provides, selected with a switch on the camera. In either case, your film comes back respooled in the APS cassette rather than in loose strips like 35mm. (See Chapter 8 for details.)

- **Black-and-white OTUCs.** These models come loaded with a special film that produces black-and-white images yet can be processed in the same chemicals as your usual color film. Drop it off at your usual photofinisher and you'll get back black-and-white prints, a nice photographic change of

(continued)

(continued)

pace. (See Chapter 2 for more about "thinking" in black and white.)

✔ **Ultrawide-angle OTUCs.** The sweeping view you get with this unusual model fits twice as much of a scene into your picture as you'd get with a regular OTUC from the same vantage point. That ability makes it well-suited to common travel subjects such as landscapes and city scenes, but you can also use it to create interesting, wacky perspectives with everyday subjects.

Because these special-purpose one-time-use cameras have particular talents lacking in your regular, reloadable point-and-shoot, you might want to take one or two along even when you're carrying your regular camera. Yet for all their variations, OTUCs are primitive cameras by today's technological standards. They don't have autofocus. They can't zoom to make a subject bigger. Their viewfinders are less accurate than regular point-and-shoots, giving you only a close approximation of what will end up on film. And they don't advance the film automatically, as do nearly all reloadable models.

There's nothing you can do about the latter; you just have to remember to spin the little grooved film-advance wheel between each shot. But there are remedies to the other three problems.

✔ **Stay at least four feet from your main subject.** Since an OTUC can't autofocus, the lens is prefocused by design to make everything sharp at that distance and beyond. If your main subject is closer than three or four feet, it will look unsharp in the print.

✔ **If you want to make your subject bigger in the picture, just get closer.** Since an OTUC can't zoom, your legs have to do the zooming for you. And for reasons I explain in Chapter 5, moving closer is usually a better way to make the subject bigger than zooming in.

✔ **To keep the subject from ending up too small in the picture, move closer to it.** Sounds sort of like the same tip as the one before, but it isn't. Since an OTUC's primitive viewfinder shows you more than what you actually get in the final picture, move in a little closer than where your feet first land. This may feel a bit uncomfortable at first, but it will make the subject fill the "frame" more effectively.

All that said, the point-and-shoot simplicity of an OTUC makes it the ultimate test of your photographic eye. Because you have little or none of the control possible with reloadable point-and-shoots, the success of a picture depends almost entirely on nontechnical things: the moment that you capture; the colors, tones, shapes, and textures that describe it; and the effectiveness of your composition.

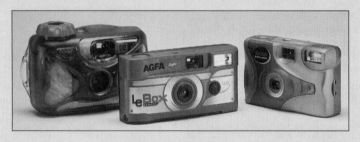

Chapter 2

How to Pick the Best Film

*F*ilm is a magic substance that captures the moments, people, and places that you choose to photograph — the recording medium to which all your 35mm or APS camera's pushbuttons and dials are dedicated. Unlike a digital point-and-shoot, which translates your subject into a bunch of numbers representing tones and colors, film records an image of the subject that you can directly see, though it's small. And for all the new technology, film is still the cheapest, most high-quality way to create a photographic image. For practical purposes, a 35mm point-and-shoot costing $50 can give you picture quality on par with a $500 digital point-and-shoot, and you don't need computing power to do things with its pictures. That's why most people who take pictures still use film. If you're one of those people, this chapter is for you. (See Chapter 15 for details about digital point-and-shoots.)

Kodak has reported that the average 35mm snapshooter spends at least two minutes agonizing at the store over what kind of film to buy. But you can whittle that time down to about two seconds if you know what to look for. The choice begins with the *type* of film — though for the most part, you'll only use one type. And each type of film is usually available in different *speeds* — degrees of sensitivity to light, indicated by something called an ISO number. (By the time I'm through with you, you may only be using one speed!) Using different types of film can make your point-and-shoot experience more fun and artistically rewarding; using different film speeds can enhance your ability to capture certain kinds of subjects, and also affects image quality. Film brand and roll length are also part of the equation. So in

choosing a film for your photography, you really have to consider four things: type, speed, length, and brand. Fortunately, these decisions are not complicated, and this chapter guides you through them.

Finding a Film That's Your Type

The photographic image formed by most commonly used films is a *color negative:* a tiny, transparent picture in which tones and colors are the opposite of what they were in the original subject. After developing your film to make this negative visible, your photofinisher enlarges the negative to make a positive image — the print that you get back. Because it's meant for making prints, film that produces a color negative is usually called *color print film.* That's the term I use for it in this chapter and throughout the book.

Nearly 99 percent of all film used is color print film, and point-and-shoot cameras are made to order for it. But you can get other types of film (see Figure 2-1) and use them in point-and-shoot cameras with varying degrees of success. I have deliberately left out slide film because many point-and-shoot cameras simply can't give it the precise exposure it needs. (See the sidebar "How your camera gets the right amount of light to the film.")

Photofinishing has as big an influence on the quality of your prints as the film you choose — sometimes bigger. Lack of care or attention, whether on the part of a minilab or a mass-market processor, can make prints from a great film look terrible. Good photofinishing, on the other hand, can pull excellent prints from run-of-the-mill film. A good brand-name film will give you rich color and detail, even with a pretty inexpensive camera. If it doesn't, then you should consider switching to a different photofinisher or minilab. (See Chapter 3 for more on choosing a photofinisher.)

Figure 2-1:
Films come not just in different brands and speeds, but in different types, including color print film, color slide film, and black and white.

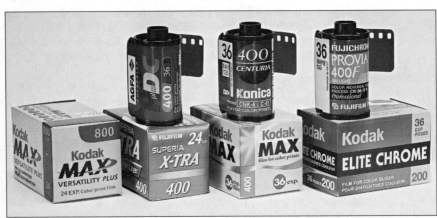

Color print film

Most snapshot photographers use color print film because it gives them both color and prints — color for the sake of realism, prints for the sake of viewing convenience and ease of sharing. Therefore, color print film is the film on which both minilabs and mass-market photofinishers base their voluminous business. It is also the film in which manufacturers invest the most money, time, and effort. So color print film is, generally speaking, the most technologically advanced film you can buy.

Color print film is also known as a *forgiving* film. This description means, basically, that it's good at backing up your point-and-shoot camera, like a catcher who can pull in a pitch from way outside and make it look like a strike. Even if your camera doesn't expose color print film perfectly — that is, if it doesn't get the right amount of light from the subject to the film — you can still get a print of acceptable quality. This ability is called *exposure latitude,* and color print film has more of it than either color slide or black-and-white film. (For more about film exposure, see the section "A Question of Speed," later in this chapter.)

Fortunately, you don't have to know what exposure latitude means to benefit from it. But as an example of its worth, imagine shooting a landscape at dusk. Even if your point-and-shoot opens up the little window in its lens as much as possible (that is, sets its widest *lens aperture*) and keeps the window open for as long as possible (that is, sets its slowest *shutter speed*), it may not get enough light to the film for a correct exposure. (See the sidebar "How your camera gets the right amount of light to the film.") With slide film, which I tell you about in the next section, you'd get an overly dark result. But with color print film, the resulting underexposed negative may produce an acceptable print, if your photofinisher takes care. And, in fact, color print film actually gives *better* results when it is somewhat overexposed. (I talk more about the pluses of overexposure in Chapter 9.)

So in some situations, too much or too little light pushes your camera to its limits. Sometimes, though, your camera just makes a mistake and doesn't get the exposure quite right — and this is when color print film's exposure latitude is most valuable. Color print film's flexibility extends to the actual *color* of the light, too. The film is able to cope well with subjects in which the lighting is different from the daylight for which the film is technically designed. It provides accurate, or at least acceptable, color in a variety of lighting situations.

Color negatives have a strong reddish or reddish-orange cast to them. (35mm users can see this cast because they must handle actual negative strips; Advanced Photo System users cannot, because the processed film remains inside the cassette.) Formed by dyes during processing, this odd tint actually helps the printing paper produce more faithful color.

Part of color print film's forgiving nature has to do with the fact that, unlike color slides, the negative must be printed to produce the final positive result.

How your camera gets the right amount of light to the film

Some subjects are bright, and others are dim, but for best results a specific film needs to receive pretty much the same amount of light every time you take a picture. Your point-and-shoot knows how much light the film needs — an amount called the *correct exposure* — and does its best to get that quantity to it. (The light entering your camera is actually an image of the subject, with brighter and darker areas, but the light's overall brightness is variable.) The camera automatically controls the amount of light reaching the film with a tiny, adjustable window in the lens. Two things determine how much light gets through the window: the shutter speed and the lens aperture.

- **Shutter speed:** The shutter speed is the length of time the window in the lens remains open. Because today's photographic film is so sensitive to light, the window doesn't have to stay open very long — usually somewhere between 1/60th and 1/500th of a second.

- **Lens aperture:** The lens aperture is basically the size of the window in the lens, when it is open. The opening can be enlarged or reduced to let more light or less light into your camera. (Regardless of the opening's size, the lens still forms a full image of the subject on the film.) As with the shutter speed, your point-and-shoot camera automatically controls the lens aperture, though some high-end models allow you to choose it yourself.

And in printing, exposure adjustments and *color filtration* (adding or subtracting color from the light used to make the print) make each print the best that it can be — theoretically. Photofinishers actually have a lot of leeway in this process. Their mechanized, automated printing machinery may not produce a good print, especially from an iffy negative, on the first try — that is, the first print that you get back. But getting a better result is usually possible. (See the sidebar "Print problems? Try, try again.")

Black-and-white film

Color pictures have become the norm pretty recently in the grand sweep of photographic history. Before color became practical and affordable, black and white *was* photography. The great photo-essays that appeared in the first decades of *Life* magazine were all in black and white — and no one questioned their realism. In its grittiness, black and white actually seemed more true-to-life — less decorative — than color. That perception persisted even after color became the norm for magazine reproduction.

Now, though, black and white seems a bit exotic to the eyes. By reducing a subject's colors and textures to shades of gray, and in the process making the subject more abstract, black-and-white film seems to take the photograph a

step away from reality. For most people, the very absence of color gives black and white the stamp of art. But that absence also demands special visual attention when you're shooting black and white. (See the sidebar, "Tone and texture: Thinking in black and white.")

Compare the way that black-and-white and color films render the same subjects. Before loading a roll of black and white, save a few frames at the end of the color roll that's already in your camera. Choose a couple of subjects around your house and yard — be sure to include some nonflash subjects — and then finish off the color roll on them. Immediately load the black-and-white film and reshoot the same subjects. Examine the prints that you get back. Which do you prefer?

Which black-and-white film to choose

Just as with color print films, most black-and-white films are made to produce a negative. This negative must then be printed. (A few black-and-white slide films exist, but they require special processing that you must either do yourself or that is available only at very few specialty photo labs.) But unlike color print films, you first have to choose between two different kinds of black-and-white print film (see Figure 2-2).

One option is to use a black-and-white film that must be processed in conventional black-and-white chemicals, a classic such as Kodak's Tri-X Pan film. Black-and-white chemicals are quite different from those used for color processes, and minilabs don't have them. So whether you take your exposed roll of Tri-X to a minilab or a drugstore that uses mass-market processing services, it has to be sent out for processing. Good conventional black-and-white processing can be hard to find, though, so don't give up after an unhappy first attempt. You may have to shop around.

Print problems? Try, try again

If you get a print from a photofinisher that is too light or too dark or in which the color is way off, take it back and ask for a new, corrected print. The photofinisher should redo it for free. If they manage to convince you that they aren't responsible, paying for a reprint may be worthwhile — on the condition that they try to do a better job. If they refuse, or try and don't succeed, take the negative to a different photofinishing service — especially if the print is important. But in fairness, remember that some negatives simply don't print well.

You'll probably have more difficulty getting satisfaction on such second tries from mass-market, drugstore- and discount-store-type photofinishing services. If you want this kind of special attention, you're better off patronizing a minilab or other facility that does its work on the premises so you can convey your wishes directly to the technician who operates the printing machinery. For more information on setting up such a relationship, see Chapter 3.

Tone and texture: Thinking in black and white

Color is often the first way that you describe the world around you. A car is red; a shirt is green; eyes are blue or brown. Color tends to overwhelm all other visual properties. And its very absence is what makes black-and-white photography such a great medium.

Yet the absence of color also makes black and white a great photographic challenge. Not everything lends itself to black and white: Fall foliage, an intense sunset, wildflowers, and a brightly frosted birthday cake just don't cut it without color. Point-and-shoot flash pictures may look especially bad in black and white because their frontal light can't provide the range of grays on which it mostly depends. If dim light forces you to use flash with black and white, set your camera to its slow-sync flash mode (or if it has none, to fill-flash mode). (See Chapter 7 for more on flash modes.) This flash mode causes more of the existing light to be included in the picture, not only improving background detail but giving a better sense of shape to things in the picture.

Light is especially important in black and white. Look for light that has character but is neither too strong nor too flat. Good light for black and white is directional enough to make textures stand out and give shading to things in the picture; a subject that doesn't show any sense of light's direction tends to look flat in a commercial print. Just as with flash, getting a good black-and-white picture of a subject in direct, hard sunlight is difficult. Part of the problem is that commercial prints often don't retain detail in both the brightest and darkest parts of the subject.

Composition is also key to black and white. In my experience, black-and-white photographs must have a clear visual structure — more of a design aspect than with color. Yet you can experiment with abstract, strongly graphic composition more easily in black and white than in color. With only tones to go on, people tend to "read" black-and-white photographs less quickly and easily — which can actually make them more interesting to look at!

Your usual processing outfit may even bounce you and your roll of Tri-X to a custom black-and-white lab, one that specializes in black-and-white developing and printing. Don't go unless you're very serious about your black-and-white work — enough to spend some money on it. A custom lab may develop the film for a reasonable sum, but it probably won't have the automated machinery needed to make large numbers of inexpensive prints. Each print is basically handmade and priced accordingly. For more about custom labs, see Chapter 3.

Knowing the quality gamble and costs involved — and wanting more creative control — I process and print all my own conventional black-and-white film. I always rented an apartment and (eventually) bought a house with an extra bedroom so I could have a darkroom without appropriating my family's bathroom on Sunday afternoons. But I don't get into the darkroom much these days, and I do love black and white. So here's what I do: I shoot *chromogenic* black-and-white film. (See the following section to find out more about this film.)

Figure 2-2:
Black-and-white print film comes in two basic versions, conventional (top) and chromogenic (bottom).

Chromogenic black and white

Chromogenic black-and-white film is a much easier way than conventional black-and-white film to get black-and-white pictures. Several such films are available, including Kodak Black & White +400, Ilford XP-2, and Konica Monochrome VX 400, all of very good quality. The *only* black-and-white film sold for Advanced Photo System cameras is chromogenic: Kodak's Advantix Black-and-White +400.

Don't be alarmed by the term chromogenic; *chromo* is just old Greek for color. In fact, chromogenic black-and-white film is designed to be processed in the very same chemicals that minilabs and other photofinishers use for color print film. You can give the photofinisher a roll of chromogenic black-and-white film and a roll of color print film, and he or she can send both rolls through the processing machine at the same time. One roll comes out as color negatives and the other as black-and-white negatives.

In contrast to conventional black-and-white processing, the processing for color print film is highly standardized — no two ways about it. So chromogenic black-and-white film, processed just like color print film, actually gives you more dependable, consistent negatives than conventional black-and-white film.

Because chromogenic black-and-white film uses color technology to create its black-and-white negative image, it also benefits from many of the same characteristics as color print film. For example, it's more forgiving of exposure errors than conventional black-and-white film. And it actually gets finer grain and better shadow detail when you deliberately or inadvertently *overexpose* it than when it's exposed normally!

Here's an easy way to give chromogenic black and white a try — without ever taking the color film out of your point-and-shoot. Get a black-and-white one-time-use camera. These cameras are available from Ilford, Kodak, and Konica, and they're preloaded with chromogenic black-and-white film. All you do is shoot the roll and hand the camera over to your photofinisher. He or she should know what to do with it!

Because chromogenic black-and-white negatives don't have any color in them, you might assume that you get no color in prints from them. This isn't always true. Sometimes you get a reddish-brown, yellowish, or (worst case) greenish or bluish cast. But a good photofinisher should be able to get the color out altogether, for a strictly neutral tone. If you're told that getting all the color out is impossible, the truth is just that it's too much trouble — requiring some extra twiddling of dials to tweak color settings. Just tell the folks at the lab that I sent you and that I expect them to make neutral prints for you, if that's what you *do* want. In fact, a little brown or yellowish cast can be nice, similar to the effect of sepia-toned prints (that warm coloration you sometimes see in very old family pictures). It's probably not the right feeling, though, for pictures of a new baby or the stealth jet at the air show.

If you have existing 35mm black-and-white negatives that were processed *conventionally,* you can have your minilab print them on their usual color paper. If you come across a stash of old family negatives, for example, you can get prints from them for family keepsakes, albums, and so on. For details, see Chapter 3.

A Question of Speed

Probably the most frequently asked question about film is "What speed do I need?" Your choice of film speed can have both practical and visual consequences for your picture-taking, but the answer is simpler than you may expect. First, a definition and some reassurances.

A film's *speed* is photo jargon for its sensitivity to light. This sensitivity is indicated by its *ISO rating,* which is printed on the box and on the film cassette itself. The higher the number, the more sensitive the film and the less light the film must gather from the subject to create an acceptable image of it. With color print film, these speeds are typically ISO 100, ISO 200, ISO 400, ISO 800, and (though you may not be able to find it everywhere) ISO 1600. Oddball speeds such as ISO 50, ISO 160, ISO 640, ISO 1000, and even ISO 3200 are also available.

Film speed numbers are surprisingly straightforward in their meaning. ISO 200 film is twice as sensitive to light as ISO 100 film. ISO 400 film is twice as sensitive to light as ISO 200 film. And ISO 800 film is twice as sensitive to light as ISO 400 film. (ISO 800 film is therefore *eight* times as sensitive to light as

ISO 100 film.) And the higher the number, the more easily you can get pictures without flash in dim light.

Not to worry. *You yourself don't have to set the film's ISO speed on your point-and-shoot.* The camera does it for you, by reading a metallic bar code on the film cassette. Using this *DX code,* the camera can calculate how much light the film needs for a *correct exposure* — again, to produce a negative or slide that makes the subject neither too dark nor too light, and in the case of color print film, to create a negative that will make the best possible print. The camera gets the right quantity of light to the film by adjusting the size of the lens aperture (the window in the lens) and the shutter speed (the length of time that window is open).

For example, the camera usually sets a higher shutter speed if you're using a higher-speed film because the film needs less light for a correct exposure than a lower-speed film. Most point-and-shoot cameras don't let you manually control lens aperture or shutter speed settings, of course. But your choice of film speed is still very important in terms of getting the best picture quality.

Before I tell you more, let me make an important suggestion — possibly the most valuable point-and-shoot suggestion this book has to offer. Ordinarily I just drop in tips unannounced, but this one deserves a fanfare. *Use ISO 400 film as your standard print film.* Use films of other speeds only for particular situations, lighting conditions, and printing requirements (see Table 2-1).

Well-intentioned photo store clerks may try to dissuade you from using ISO 400 film, which along with ISO 800 film is called a *fast* film because of the speed with which it reacts to light. They may tell you that you need a *slower* film — ISO 200, even ISO 100 — for best results. They may argue such advantages as finer grain, better color, and greater sharpness. But this advice is largely outdated, lingering from times when using fast films involved considerable compromise in picture quality.

In truth, you're unlikely to see much, if any, difference in quality between a snapshot-sized print from an ISO 400 film and the same from an ISO 100 or ISO 200 film. ISO 400 color print films are just so spectacularly good that using them involves little tradeoff. For specific technical reasons, in fact, you usually get *better* results than with slower film — greater overall sharpness, improved color, and richer detail. In truth, you can even use ISO 800 color print films as your standard "load," which I find myself doing more and more. (In fact, the preloaded film in most one-time-use cameras is ISO 800 film.) Even in bright light, the camera's lens aperture and shutter speed range are such that overexposure is unlikely to be a problem — and the film tolerates overexposure very well anyway. (Chromogenic black-and-white films only come in ISO 400 speed.)

Table 2-1	Film Speed Buying Chart (Color Print Film)		
Film Speed	*Pros*	*Cons*	*Best Subjects/ Light*
ISO 100	Finest grain of all; improves smoothness and detail in big blow-ups (11 x 14 and larger); helps soften distracting backgrounds in outdoor portraits	Increases the risk that hand tremors blur or soften the entire picture; reduces flash range and background detail in indoor flash shots; may not stop action outdoors	Landscapes in sunlight; beach and snow scenes; portraits in bright light; close-ups with flash
ISO 200	Reasonable compromise between fine grain and speed; less risk of blur due to hand tremors than with ISO 100 film; increases flash range by 40 percent over ISO 100 film	Still too slow for much low-light shooting; considerable risk of blur due to hand tremors at long zoom settings	All-around outdoor shooting in moderate overcast to bright sun; outdoor portraits in soft light; flash shots at medium distances
ISO 400	Best all-purpose film; fine-grained but *fast,* provides excellent picture quality in standard-sized prints; permits higher shutter speeds for better action stopping and reduced risk of blur from hand tremors; more faithful color in mixed (indoor/ outdoor) light; doubles the flash range of ISO 100 film	May suppress flash in indoor shots, making you *force* the flash when you don't want to shoot by existing light; shows grain in big blowups (11 x 14 and larger)	All-around shooting in conditions ranging from deep shade and existing indoor light to bright sun; indoor flash shots at greater distances from subject
ISO 800	Excellent all-purpose film combining high speed and surprisingly fine grain; good fail-safe film for must-get shots; provides two-and-a-half times the flash range of ISO 100 film; offsets hand tremors due to long zoom settings; best film in mixed light	Expensive; may suppress flash in indoor shots or create flash *ghosts;* shows grain in blowups (8 x 10 or larger)	All-around outdoor shooting from dawn to dusk; outdoor portraits in less favorable light; indoor existing-light shots; distant flash subjects

Switching to a fast film may mean that you have to get that slower film (ISO 100 or 200) out of your camera. But don't shoot off the remainder of a roll on any old thing — subjects you wouldn't ordinarily shoot — just to use it up. You have to pay for the prints, and you don't pay for prints of negatives that you don't shoot. Get over it and push the midroll rewind button. (It's marked with a double arrow/film cartridge symbol and is usually recessed or otherwise squirreled away so you don't push it accidentally.) And as you do this, remind yourself that film is photography's cheapest ingredient. (For more on midroll rewinding, see Chapter 1.)

The connection between film speed and "grain"

One thing that does differ from one film speed to another is the film's *grain*. Grain refers to the clumps of silver crystals that form the image during the film's development. Faster films (again, those with higher ISO numbers) have larger grain than slower films (those with lower ISO numbers), allowing them to capture light quickly. (A wide bucket catches more rain than a narrow one.) And the larger a film's grain clumps, the more visible their texture is in the print. Thus, fast films are said to be *grainier* than slow films. But the new ISO 400 films still have exceptionally fine grain, and most photographers are blithely unaware of the texture their larger grain produces.

Film speed's effect in panoramic prints

One place that you may notice the effect of a film's grain is in a panoramic print. (You can find out more about getting panoramic prints in Chapter 3.) The grain is larger because panoramic prints, which measure either 4 x 10 or 4 x 11-1½ inches (depending on who does the printing), require a much higher degree of enlargement of the negative than 4 x 6- and 4 x 7-inch prints — in fact, about as much enlargement as a full-sized 8 x 10-inch print. (Think of a panoramic print, basically, as an 8 x 10- or 8½ x 11-inch print with the top and bottom cut off.)

I am most aware of grain with panoramic prints from ISO 400 and 800 Advanced Photo System film. (Because the APS negative is smaller, it must be enlarged more, so the grain is enlarged, too.) But only if the film is underexposed, or the printing is sloppy, does it really bother me.

The thing is, unless you're doing a side-by-side comparison of the sort that I suggest in the previous section, you're unlikely even to notice such things. And there is much more to print quality than just fineness of grain. A mediocre lens or inaccurate autofocus is likely to be a bigger factor, causing a loss of sharpness especially noticeable in enlargements. And even those factors aren't the biggest threat to image quality!

Film speed and shake: an important relationship

Far more important than film speed's effect on overall picture quality is film speed's effect on overall *sharpness*. In general, the faster (higher ISO) the film you use, the *sharper* your point-and-shoot pictures will be.

This relationship between film speed and sharpness has nothing to do with the lens or its focusing accuracy. It has to do with *shake* — camera movement due to your involuntary hand and body tremors.

Shake can cause an unwanted blurring of your pictures. But the effect is not always an outright blur. It's often just an annoying lack of crispness — an unexplained softness. My experience tells me that unsharp point-and-shoot pictures are more often due to shake than incorrect focus or a third-rate lens.

How does a faster film lessen the risk of shake? By making the camera set a higher shutter speed — that is, shorten the length of time the window in its lens stays open for the exposure. The longer the window stays open, the greater the chance that shake will blur the image (see Figure 2-3).

Looking for grain: An experiment

If you're nearing the end of that roll of ISO 400 or ISO 800 color print film that I encouraged you to get, buy a short (12- or 15-exposure) roll of ISO 100 film and have it on hand. Then choose a subject and shoot the last few pictures of the ISO 400 or ISO 800 roll. After rewinding the roll, immediately load the ISO 100 roll and shoot some pictures of the same subject, or subjects, in the same lighting conditions. Try to include a smooth area in the pictures — a blue sky or a colored wall, or even just a prominent face. Smooth areas are where a film's grain is most visible.

After you get the prints back, first mark the film speed on the back of every print. Then shuffle them thoroughly. Now, compare: Decide which prints you like better and/or which have finer grain. I think you'll be hard pressed to tell the difference. I have a feeling you'll like the ISO 400 shot better, for reasons unrelated to grain!

You're more likely to see differences in quality between different speed films if and when you make a big blowup of your picture — 8 x 10 or 11 x 14 inches. In addition to making everything in the picture bigger, enlargements also make the grain bigger. Personally, I'm more than happy with big prints from my ISO 400 negatives; I can see the grain, but it doesn't bother me or interfere with the sense of detail in the image. And I'd rather not limit myself to slower film just for the sake of the occasional negative that I may want to blow up bigger than 4 x 6 or 4 x 7 inches.

Figure 2-3: Even in reasonably bright light, shooting with a slow film — here, ISO 100 — can cause camera shake to blur the image (left). Shooting with an ISO 400 film (right) lessens that risk, making pictures sharper.

© Mark Harris (2)

Here's how to tell whether a picture's lack of sharpness is due to shake or incorrect focus. If the main subject is unsharp but the background or foreground (or any other part of the picture) is sharp, then the problem is due to incorrect focus. (See Chapter 6 for ways to ensure correct focus.) If, on the other hand, the entire image is unsharp or blurry, the problem is usually due to shake. At its most severe, shake creates a streaky, directional blur.

Using a faster film is all well and good, but don't let it make you lazy about holding your camera as steady as possible. Steadying the camera may take concentration and practice. You can even brace the camera by resting it on or pressing it against something.

Shake is personal. Some people are steady as a rock; others, like me, are the jittery type. Shake's effect also depends on the individual specs of your point-and-shoot — how slow a shutter speed it can set, for example, or at what light level it turns on the flash. Because a flash burst is so short, flash pretty much kills shake; in fact, if you're at all shaky about shake, just force the flash (see Chapter 7 for details). Of course, there may be times when you want to turn *off* the flash to keep it from firing and overpowering the quality of the existing light. And that situation is when a fast film makes all the difference.

Room to zoom: matching film speed with focal length

Your lens's focal length plays a big part in shake. *Focal length* is a number used to describe both a lens's *magnification* (how big or small it makes the subject) and its *angle of view* (how much or how little of the scene it puts on film). The farther in you zoom (that is, the longer your focal length), the more your lens magnifies the subject — pulls in your novice soccer player or the steeple on an old cathedral, for example. But the more the lens magnifies your subject, the more it also magnifies your shake. (See Chapter 5 for more on focal length.)

Point-and-shoot cameras hit you with a double whammy here. At longer zoom settings, the lens is forced to use a smaller aperture (that is, it reduces the size of the window that admits light to the film). The camera has to make up for the resulting reduction of light by setting an even slower shutter speed (that is, it increases the length of time the window is open). It does this, alas, just when it's most harmful — when you're zoomed way in.

Basically, the more you zoom in to fill the frame with a subject, the greater the chance shake will make your picture unsharp. So if you're in the habit of taking pictures with the lens zoomed way in, keeping a fast film in your camera — at least ISO 400, and maybe even ISO 800 — is all the more important (see Figure 2-4).

I know, I'm harping on the fast film. But with point-and-shoot photography, it solves a *lot* of problems. In its efficiency and quality, fast film gives your little camera a big advantage.

How Long a Roll Should You Buy?

A roll of film is measured not by the yard but by how many pictures fit on it. For this purpose, each frame of film is called an *exposure*. (Exposure is also the term used to describe the quantity of light that strikes the film when you take a picture.) The available roll lengths for 35mm cameras are 12 exposures, 24 exposures, and 36 exposures. (Types of 35mm film other than color print film may not come in 12-exposure rolls.) With 35mm rolls, you sometimes get an extra exposure or two at the end of a roll. Don't worry if your roll seems to be going a shot or two longer than its official length. If your camera is working properly, it automatically rewinds the film when it senses the tug at the end of the roll.

Figure 2-4:
Long zoom settings (left, 135mm) increase the risk that shake will blur your pictures. Shorter settings (right, 38mm) reduce that risk, resulting in sharper pictures. But if you like to zoom in a lot, use an ISO 800 film.

© Mark Harris (2)

 If your frame counter indicates that you've reached the end of the roll but the camera keeps taking picture after picture, its end-sensing mechanism may not be working. If this situation occurs, don't take any more pictures; they probably won't come out. Push the rewind button to rewind the whole roll. (See Chapter 1 for more on midroll rewind.)

One-time-use 35mm cameras, which come with a roll of film already loaded, have odd roll lengths, by the way. The shortest length is usually 15 exposures; the longest is usually 27 exposures. (Basically, you get three extra shots.) Shorter roll lengths make sense for one-time-use cameras, because these models are best used occasionally. You buy them to shoot a particular event or place or to temporarily fill in for your regular point-and-shoot.

 Film for Advanced Photo System point-and-shoot cameras comes in different roll lengths than 35mm. You can get rolls of 15 exposures, 25 exposures, and 40 exposures. One-time-use models using APS film usually come in 25-exposure models — no bonus shots included.

What roll length should you buy? You need to consider two things: cost and convenience. Film is like hamburger or laundry soap: The more you buy, the cheaper it is, per pound or per exposure. A 36-exposure roll of ISO 400 35mm film selling for $6.18 costs about 17 cents per exposure. A 24-exposure roll

selling for $4.59 costs just over 19 cents an exposure. Twelve-exposure rolls are particularly expensive per frame. But you shouldn't buy long rolls just to save money on film. If you want to save money on film, buy multiple-roll pack deals; they can actually save you a couple of dollars a roll, depending on where you buy them.

Keep unused extra rolls in the refrigerator, in their original box, in a plastic bag or container. Refrigeration extends the shelf life of film and actually protects it in hot climates without air-conditioning. When you plan to do some shooting or are coming up to the end of a roll, get a new roll out of the fridge and let it warm up for an hour or more before loading it.

Convenience and practicality are more important considerations than cost. Say that you promised to send photos of your 40th-anniversary outing to your children. Now, because I firmly believe that the more pictures you take the better you get, I'd prefer that you shoot off an entire 36-exposure roll on such an occasion. But I'll be realistic. If the film that's already *in* your camera is a 36-exposure roll on its 25th exposure or a 25-exposure roll on its tenth exposure, you probably have enough film left to take the pictures you need. So you can finish off the roll, get it processed right away, and send those prints off. (Not to needle you, but there's always that chance you'll see a great picture after you've used the last exposure. So bring an extra roll.)

If, on the other hand, you have just a few shots left on the roll in your camera, or if your camera is empty, you may want to buy a 12- or 15-exposure roll and dedicate it entirely to your anniversary. Why? Because even if you only shoot ten pictures, you can have the roll processed right after the occasion, instead of waiting weeks to finish it. And you can get the prints off to your children before they start nagging you.

If you still have a few extra frames at the end of a roll you devote to an occasion, shoot them off if you can find worthy subjects — but remember that you don't *have* to. The photofinisher or minilab doesn't print frames that you don't shoot, and you only pay for pictures that get printed. To get the film to rewind before the end of the roll, push the midroll rewind button (see Chapter 1). Wasting a few frames of film on a short roll of film is still cheaper than buying a 36- or 40-exposure roll and "using it up" to get your money's worth.

Film is much cheaper, per shot, than prints. Don't take pictures that you don't need or want!

Now that I've told you when and why it's okay to use a short roll of film, I confess that I myself never, ever, shoot rolls shorter than 36 exposures. I shoot so many pictures that the film never stays in my camera for very long. And I'm talking about pictures that I take around the house and in the neighborhood. But you're not me, and the right roll length for that kind of all-around shooting depends on your personal photographic habits. If you're really trying to keep a visual diary or if you're in no particular hurry to get particular pictures back, then go with longer rolls. If you're the photographer about whom

the staff at the local minilab jokes — the sort with two different Christmas trees on either end of the roll — then stay with shorter rolls. You don't want to be the brunt of that joke. Leaving film in the camera for that long, however, may cost you more than a few barbs from photofinishers.

Don't leave film in your camera for extended periods, especially if it's already exposed. Process film within a month or two of shooting it. Leaving film exposed and unprocessed for longer than that period may cause a deterioration in picture quality.

If you don't plan to have a roll of film processed fairly soon after removing it from your camera, store it in the refrigerator, in its original canister, in a plastic bag or container. No pockets, purses, or glove compartments, please! Take the canister out of the refrigerator an hour or so before you deliver it to the photofinisher so that it can warm up.

Whatever your day-to-day picture-taking routine, you should certainly buy a long roll or rolls for a once-in-a-blue-moon expedition — a whale watch, perhaps. Otherwise, you may find yourself reloading film just as that long-awaited humpback is breaching.

And buying long rolls for your vacations and travels goes without saying. But don't kid yourself into thinking a single 36- or 40-exposure roll is all the film that you need. Always keep two or three extra rolls of film on hand. You never know when you're going to have a shooting spree.

On the other hand, short rolls allow you to switch more regularly between different types, speeds, or even brands of film. This flexibility may give you more creative freedom — the ability to mix in black-and-white pictures with your color shots or to experiment with different film brands. Or you can switch to film of a different speed to suit different kinds of subject matter and lighting conditions, or specific printing and display purposes.

Which Brand Should You Buy?

In choosing a film, you have to decide what type, speed, and roll length you want. But you also have to make one more decision: which brand to buy. I save this decision for last because in my view it's probably the least important. I can tell you, with little reservation, to shoot 36-exposure (40-exposure, if you have an APS camera) rolls of ISO 400 color negative film, for reasons of cost, picture quality, practicality, versatility, and motivation. But I can't tell you that one brand of film is necessarily better than another.

I'm not saying, however, that film manufacturers don't compete to make their films better than their competitors' film. They do so aggressively, and the results have been very, very good for photography — to the extent that truly bad films are few and far between.

Can film go stale?

When I buy a carton of milk, I dig around for the one that's stamped with the latest "sell by" date. Actually, film has similar dating information stamped right on the box. Called the *expiration date,* it appears next to printed words such as *Develop before.*

You should definitely shoot and develop a roll of film before the date stamped on it. If you don't, it may not give you the best quality, diminishing your pictures' contrast and color brightness.

Some merchants discount film that's past its expiration date; if I were you, I wouldn't buy it. It's not worth gambling on your pictures to save a buck.

Refrigeration can help keep film "fresh" both before and after you actually shoot it. But never, ever store film in a place where it can get hot; this actually accelerates its aging, and may even cause prints to be discolored or otherwise flawed.

In fact, film manufacturers hold endless focus groups to figure out what their customers look for in a film. Those qualities seem obvious enough. People want their pictures to be sharp, brightly colored, as detailed as possible, and to have realistic skin tones. Getting all those features in a single film is not easy, but current color print films — especially the fast ISO 400 and ISO 800 films that I recommend — come pretty darn close.

Once upon a time, different manufacturers' film tended to have different personalities — to render color and detail in visually distinctive ways. Modern film technology has minimized those differences, but that doesn't mean they don't exist. Those differences in color and detail are more evident in slide films than color print films, but it's still worth experimenting with various brands of print film to see whether one in particular gives you results that are more to your taste. For most purposes, you'll probably find little visible difference in sharpness or graininess between one maker's film of a particular speed and type and another's. Where you may see subtle differences, however, is in the films' contrast or color saturation.

Contrast refers to the tonal scale of a photographic image — specifically, the difference between light and dark values. That difference is easier to discern in black and white than in color, though you may see it especially in the ability of a film to render textures. But color *saturation* — the overall intensity with which a film renders color — is another story. Some films appear to produce redder reds, greener greens, and bluer blues than other films and are said to have *higher* color saturation. It sounds great, but higher saturation can come at the expense of a loss of texture and detail in brightly colored areas, and it may even cause an unattractive ruddiness in skin tones. Color saturation, the sense of texture, and the fidelity of skin tones are important qualities to evaluate in your pictures. Because they're more variable than graininess and sharpness, they're really *more* important.

Buy two short (12-exposure for 35mm, 15-exposure for APS) rolls of ISO 400 print film, each a different brand. Load one and do your usual all-around shooting, saving the last few frames. For those frames, choose a subject that has a variety of colors, tones, and textures. If you like, choose two subjects close by — one for a shot with flash, one for without. (Throw in a person for some skin tones.) Shoot the subject(s) with the last few frames of the roll.

Immediately load the other roll and shoot the same subject(s). (You can even put a card in each shot with the film brand written on it, so you don't have to look at negative strips to get that information.) Have your usual photofinisher process and print both rolls, and then compare the prints from each. Do you like one better than the other? If so, then stick with that brand — but just to be fair, periodically shoot another brand to confirm your preference!

Premium films: Are they worth it?

If you buy your film at photo shops rather than in drugstores and supermarkets, you may have noticed that the big-brand films sometimes come in premium versions. Available in more or less the same choice of speeds as the standard line, premium films are often marketed as special-purpose or special-occasion films — films for once-in-a-lifetime sorts of pictures.

Suspicious consumers may dismiss premium film as a marketing scam, but it really isn't. Real differences exist between a given maker's premium and standard films. The question, as usual, is whether you can see those differences; I think you'll be hard pressed to in a standard 4 x 6-inch print. Differences are more visible, if you have an attentive eye, in an 11 x 14-inch blowup for your family room wall. And, after all, important shots are the ones that you're more likely to be enlarging. But if you don't want to pay the price premium for premium films, don't feel as if you're taking chances with your most important pictures. Photofinishing often has more to do with the quality of the results than differences between films — certainly between films that are already very good (see Chapter 3).

Private label films: Are they any good?

Private label films are the films that big drugstore and supermarket chains sell under their own names, so I call them store-brand films. Rest assured that Well-Mart and Pharmaceuticals R Us don't have a thing to do with the actual manufacturing of the films. In most cases, reputable photo companies make these films.

Store-brand films can be very attractive because they're often part of a discount pricing scheme in which you get cheap processing, sometimes double prints for free or just a little extra, and perhaps a new roll of film each time that you drop off a roll for processing. In fact, the idea is to get you to keep

coming back to the store — to buy more film, to drop it off for processing, and to pick up the processing. That's three chances to sell you lawn chairs.

You don't have to have store-brand color print film processed by the store where you buy it. You can give it to any minilab or other photofinisher.

If you've been using store-brand films and are happy with your results, then don't let me dissuade you from continuing — especially if the low cost encourages you to shoot more, which is my main agenda. But these stores do rely on mass-market photofinishing, which is variable in quality. If you feel that your store-brand pictures aren't turning out as well as they should or are even just a little dull-looking, consider a foray to a reputable minilab or an outfit that sends its film to labs directly associated with the name-brand film companies. Getting good photofinishing is especially important if you're handing in once-in-a-lifetime pictures or if you want big blowups.

Keep an eye out for *gray-market film.* This film is manufactured in various countries other than the United States and then imported when currency exchange rates give it the highest profit margin. You can sometimes tell gray-market film by its different-looking box, which is printed in other languages along with English.

The film itself may be fine to begin with; indeed, it's usually the same brand-name film that you ordinarily use. But gray market film's global wanderings may subject it to less-than-ideal storage conditions and improper handling, and you won't discover such ill effects until you shoot and process the film. At the very least, you shouldn't pay the same price for gray-market film as you do for the U.S. version of the same film, because the dealer usually gets it at a considerable discount.

Name-brand films sold in the United States are, of course, often made in other countries — Fuji in Japan, Agfa in Germany. But they're made for immediate import under ideal conditions, rather than shipped around according to financial whim or stockpiled until the dollar is strongest. Here's the bottom line: If a film's box indicates that it's manufactured outside the United States, shoot it only if it says "made for sale in the U.S." and has a U.S. proof of purchase.

Chapter 3

Making Your Photofinisher Work for You

*T*here comes that time when you press the shutter button, take a picture — and hear the telltale *whirrr* of the camera rewinding. (Well, not if you're using a one-time-use camera or a digital point-and-shoot, but give me some artistic license here!) When you hear that sound, you've finished the roll.

In fact, though, you've hardly started. Because then you must take your little film cassette to a business — aptly named a photofinisher — that transforms it into an envelope full of bright, colorful prints. (If you shoot with a digital camera, a growing number of photofinishers can make prints directly from the little memory card on which it stores its pictures. That wasn't possible when this book first came out!) If you're like many picture-takers, what really happens between handing your film over to a lab and getting your prints back might as well be voodoo. What mysterious processes go on once your film cassette is pried open? And how many times, after taking important or memorable photographs, have you crossed your fingers and prayed under your breath, "I just hope the pictures come out"?

Well, I'm here to tell you that photofinishing is not voodoo. It is magic, like all of photography. But it is dependable, repeatable, easily understood magic.

It is also magic that you, the photographer, can help perform. Your involvement with your pictures shouldn't end when the rewind motor kicks in at the end of the roll. If you dutifully follow this book's advice — or at least its most important suggestions, like locking the focus and using fill flash and shooting fast ISO 400 or 800 film — you'll see a noticeable improvement in your pictures. But believe me, there's a good bit you can do *after* you've pressed the shutter button to get better pictures, too.

This chapter goes into detail about how prints are made from your film. Having this understanding should help you figure out how bad prints happen, and how to get more good prints.

A lot of my explanations and suggestions apply as much to prints from digital point-and-shoots as they do to prints from film-using models. In fact, your photofinisher may use the same machine for both types of printing. So you filmless types may want to scan this chapter, then proceed to Chapter 16 for more details on photofinishing services for your picture files.

Some Day My Prints Will Come

The pictures you've taken on the roll of film in your camera are invisible until you get the film processed. Even if you could look at the film after you snap a picture (you can't, because opening up the film cassette to light would obliterate the pictures), you wouldn't see anything anyway. Well, yes, you'd see a piece of film with perforations, and a grayish coating all over it — but certainly no pictures.

The picture you took is present on the film only as an invisible image, known in photo jargon as a *latent image*. When you pressed the shutter button, the light that entered your camera caused an invisible chemical change in the film's light-sensitive coating, known in photo jargon as the *emulsion*. Think of the latent image as kind of a shadow on the film. It's the job of the photofinisher to turn that shadow into a visible, permanent image called a *negative*.

Photofinishing is the broad term covering everything that goes into making the film you've shot — or, if you're a digital photographer, your picture files — into commercial prints and/or other visible, usable forms. Conventional photofinishing has two main components. The first, *development*, is the chemical process that makes your film's invisible images visible and then makes these images permanent. In other words, it changes the film into negatives — those translucent reddish-orange strips you get back in the envelope with your prints, or, if you're using an Advanced Photo System camera, the single strip

that comes back rolled up inside the cassette. The other major photofinishing step, *printing*, is the process of taking those negatives and reproducing their tiny images in a bigger size on photographic paper, either as standard-sized prints or blowups (more correctly known as *enlargements*). The combination of film development and printing is also sometimes referred to as *processing*, and I sometimes refer to it that way, too.

How would you like your prints?

Many photofinishers offer two choices that greatly influence the appearance of the prints they make for you. One concerns the print's *surface*. The other is whether to have the print made with or without a *border*. First things first.

Unless you tell him otherwise, your photofinisher ordinarily makes your prints on *glossy* paper — that is, paper with a shiny surface. But you can also ask for nonglossy paper, which usually goes by the name *matte*. Matte paper has little to no shine, and may also have a slight texture, as opposed to glossy's glassy smoothness. A matte surface seems artier — somehow less commercial-looking — than a glossy surface. And it definitely hides fingerprints. But glossy prints are the standard in photofinishing because they *usually* make your photographs look better than matte prints. The extra shine brightens colors, adds crispness to the subject's tones, and makes the picture actually appear sharper.

You may have a particular reason for wanting a matte print. It could have just the right look for a homemade greeting card, or lend a more impressionistic feeling to a particular image. But otherwise, I'd stick with glossy.

I'm probably dating myself by saying this, but when I was growing up there was no such thing as a borderless commercial print — a print in which the image "bleeds" off the edge of the paper, filling it completely. (This was also the heyday of the 3½ x 5-inch print, before 4 x 6.) Over the years borderless prints have become

the norm, and at some labs the only choice. But the border — a thin white margin all the way around the image area — has recently made a comeback. I've talked with photofinishers who tell me that more people want it than don't.

If your photofinisher offers you a choice between border and borderless, which should you choose? Ultimately it's a matter of taste, but here are a few considerations. To create a borderless print, the photofinisher has to make the actual picture bigger than the sheet of paper, so a portion of it is cut off — cropped out, to use photo jargon. Usually it's an acceptable loss. But other times, sloppy photofinishing can crop the image too much, or crop it more on one side than the other. This may cut off things you meant to include at the edges of the frame.

That said, a borderless print makes the picture transparent, in a sense: It's all about the image, not the paper it's printed on. By contrast, a print with borders has an artier, more precious quality, its thin white margin helping to "frame" your image. A border also tends to lessen fingerprints along the edges of the print, and can help protect the actual image area from damaging skin oils. Prints with borders typically involve less cropping of the image than borderless prints, so you get more of what you saw when you took the picture. (Things in the picture will be slightly smaller in size, however.)

Is a matte print with borders high art? Experiment and see.

Several things make color-print photofinishing highly reliable. For one, the development process for color print film, which goes by the bland designation C-41, is a universal, worldwide standard. The C-41 process is the same in Bangkok as in Brooklyn. For another, developing and printing are highly automated, controlled by sophisticated computers. To develop a roll of film — 35mm or APS — a photofinishing technician needs to do little more than put the cassette into a machine, which, after chugging and churning, spits out a sparkling strip of negatives. Printing is likewise performed and monitored by very smart machines.

All this motorized magic may lead you to think that humans have no say in the process. Not true. Photofinishing isn't entirely robotized, nor can it be. At the very least, its processes must be watched by people who make sure the machines are operating correctly, that the chemicals are fresh, and that the film and paper are running through the system smoothly.

And during printing, human operators — call them photofinishing technicians — can exert still more control. They can even override the decisions of the machines' computers, if need be. In fact, the technicians fiddle with those decisions on a regular basis. This brings me to an important point — the most important point of this chapter, really, and one that many people often overlook.

 There is no one, single way to print a color negative or digital picture. Prints from the same single negative or picture file can be made lighter or darker. They can have their colors changed — made less blue, for example, or more reddish. Prints are not simply copies of the original negative; they are more like interpretations of the negative. And you, as a photofinishing customer, can request a different interpretation, when you first get prints made, or anytime later. This is equally true of pictures taken with digital cameras.

With cameras that use film, the negative is the very picture you shot, from the roll that ran through the camera when you were photographing. The camera took those big, real-world scenes you "framed" and recorded them as little rectangles on that strip of film. Again, development just makes all those little pictures visible and safe to handle in the light of day. But after development is done, the negative can't be changed. Prints are a different story. Prints are enlarged versions of that negative — with the difference that tones and colors are reversed to recreate your original subject. But you can think of printing really as taking a *picture* of the *negative,* much like taking a picture of a scene with your camera.

Just as you can shoot two, three, or more pictures of a scene with your camera, the printing machine can be set to make multiple prints of a negative, or of all your negatives. (That's how it does those double-print orders I suggest getting in the sidebar "Double your pleasure," later in this chapter.)

DIGITAL

Something old, something new: Picture restoration

You're looking through an old photo album, and there it is: That picture you asked Great Aunt Gretyl to shoot of you with your parents at your high-school graduation. But it has faded, and the color has taken on a weird pinkish hue. Can this photograph be saved?

If you have the original negative, almost always. Negatives usually withstand the ravages of time better than prints. If you can dig up the negative, just take it to a photofinisher and get a new print. Even if there's some fading or color change in the negative itself, a photofinisher can usually adjust for it quite well in printing.

Can't find the negative? The computer can come to the rescue. Digital print restoration services are increasingly available through local labs or mail-order. They scan your old print and then use special photographic software to get colors back to their old selves; remove marks, stains, creases, and cracks; or even sharpen up the picture a bit. They then print the retouched image file on a photographic-quality color inkjet printer or color laser printer. Quite frankly, the results can be amazing.

By the way, it's also perfectly feasible for you to do this electronic photo restoration yourself, on a moderately capable home computer. If you have one, but don't have a flatbed scanner for it, you'll need to have a photofinisher scan the print for you and "write" it on a CD or other digital storage medium that you can access with your computer. Once this is done, you can do restoration work on that old picture with inexpensive image-editing programs. If your computer setup doesn't include a printer that gives you high-quality color output, you can take the digital file back to your photofinisher for printing. For more on this, see Chapter 16.

Inside job: Store-brand photofinishing

One of the more economical ways to buy film is at a store that sells film under its own brand name. These private label films, which I describe in Chapter 2, are made by major manufacturers and are usually quite good in quality. Stores that sell private-label films usually offer photofinishing, too, often at a deep discount. The work is done by a mass-market lab under contract to the store.

One argument for store-brand photofinishing is that the store's lab may do a better job with store-brand film because it's more familiar with it. A lab that processes thousands of rolls of store-brand film every week may optimize its methods to do a more consistent job with this film than would another mass-market lab, or even a minilab.

I've seen good results from store-brand processing, and the price is right. If you're satisfied with this combination, stick with it. But I've also seen plenty of mediocre (and worse) store-brand photofinishing. Keep in mind that you don't have to get store-brand film processed by the store; you can take it to a minilab, and you might try getting a roll (or a few reprints) done there just to see the difference. I know people who economize on film by buying store brands and then splurge on good minilab processing — at least for important pictures.

You can get prints made right after you've had the film processed, which is the usual practice. Or you can get them made 25 years later. (In fact, getting a new print from an old negative is the best way to "restore" faded pictures. See the sidebar "Something old, something new: Picture restoration.")

But keep in mind that whenever you choose to make another print, *the printing machine can be told to make it differently.* The printing machine's computer brain — or the human operator — can command the machine to alter the light that makes the print, so that the print comes out lighter, or darker, or different in color. And this is as true of prints from a digital camera's image files as it is of prints from negatives.

Types of Photofinishers

Three kinds of businesses do color-print photofinishing: mass-market labs, minilabs, and custom labs. To varying extents, all three now offer services for digital pictures, too. Amateur photographers use mass-market or minilab processing almost exclusively, so this chapter concentrates mainly on them.

Custom labs cater to professional and advanced amateur photographers, so they're expensive. They may also be hard to find. The work of top-notch custom labs, though, is routinely superior to the best automated

photofinishing. Custom labs also provide services that are unavailable at popularly priced labs. If you think you might want to use a custom lab, refer to the sidebar "The customs of the country" later in this chapter.

The big guy: Mass-market photofinishing

Mass-market labs are what they sound like: industrial-sized places that develop and print lots and lots of film. Many of you are familiar with their services as "drugstore" photofinishing, not because the drugstore actually does the work but because you drop off your film at a retail store like a drugstore or, these days, perhaps a supermarket or discount store. From there, your film is picked up by van and whisked away to the big lab, developed and printed, put in envelopes, and then sent back to the retail store. These facilities may also be known as regional labs because they serve entire regions, perhaps several states. The processing offered by merchants of store-brand films (see the sidebar "Inside job: Store-brand photofinishing") is mass-market photofinishing. Drive-through, drop-off photo booths in shopping-mall parking lots, though they are fast disappearing, are the retail outposts of mass-market photofinishers.

The great advantage of mass-market processing is low cost: High volume allows these outfits to do photofinishing at very competitive prices. For the same reason, mass-market labs almost always offer good deals on double-print orders, as well as frequent promotions — free or low-cost reprints and enlargements if you have them process a certain number of rolls, for instance. These labs' drop-off points are probably also very convenient for you. They may be in the supermarket where you always shop, or in the shopping mall you pass every day on your way to work.

These labs do take a day (or two, or three) to process film. (Some drugstore operations offer same-day service if the film is in by a certain time, but you still have to make two stops.) Picking up your prints may be an inconvenience if you don't have food shopping or mall errands to do. And while most mass-market labs are careful about handling film, the possibility of loss is greater with them than it is with minilabs (see the following section), which do their processing right in the store.

But by far the greatest disadvantage of mass-market labs is that you get no personal service. You may hit it off with the sales clerk at the counter, but that person is just a sales clerk. If you ask to get a print redone — and if I have any say in the matter, you'll be asking more often — the negative goes back into an envelope and is returned to that big, anonymous lab. There, a person you'll never meet reads your instructions (or whatever else the sales clerk has scribbled on the envelope) and takes a guess as to how much lighter or darker or less blue you want your print. And then the negative and print make yet another trip back to the store.

The little guy: The minilab

If you have a minilab in your neighborhood or town — and chances are you do — you've probably noticed that it has its own developing and printing machinery right on the premises. You drop off film there, it's processed there, you pick up your prints there. As a result, minilabs tend to provide much faster service, typically an hour or two. (That's not hard and fast; I've used a few pokey minilabs that take a full day to get the job done.) The real tipoff of the minilab, though, is not turnaround time but equipment. The printing machine is almost always right out in the open. It's about the size of a large office photocopier, with a place at one end for an operator to sit at a kind of control panel and viewing screen. Some minilabs arrange their hardware so that you can see the uncut strip of fresh prints feeding into a bin in the store window!

And right there is the great advantage of the minilab: Your prints are done in-house, not at some factory-sized lab 50 miles away. If you're dissatisfied with a print and want to get it reprinted, you can get it done there and then, right after you've looked through your envelope of prints. You can probably even talk to the person who was running the printing machine. If you have a question, or a complaint, or a suggestion, or just want to chew the fat about film and cameras, the minilab is where it's at. Photography is the minilab's business, not lawn chairs or cosmetics or groceries.

People like minilabs for their fast service. It's great to drop off film on your way to lunch and pick up prints on the way back. I like this, too, but another big selling point of the minilab is quality. Overall — and as with everything in photography, there are lots of exceptions — minilabs do a better job of printing than mass-market labs. And even if a minilab print doesn't look so hot, it's a simpler, faster, and more personal process to get it reprinted. Should a negative really prove impossible to print well — it happens — a good minilab operator will take the time to explain it to you, perhaps even showing you what's wrong with the negative.

What you get with a good minilab, to put it plainly, is a relationship. A good minilab operator wants your business and wants your pictures to improve, because that will only increase his or her business. And you want good printing (including courteous reprinting) and knowledgeable service. When you find the right minilab, you've found a partner in good picture-taking. So a minilab may be worth the search.

Minilabs have some drawbacks, of course. You may have to go out of your way to get to a good one. Minilabs are typically more expensive than mass-market labs, anywhere from a few cents more per print to twice as much. (The average seems to be about 30 to 40 percent higher, which, for a 36-exposure roll of film, may put a bite in your wallet.) Minilabs usually don't offer

the cut-rate promotions common with mass-market labs, although they do offer double-print orders for a small premium, and sometimes freebies like an 8 x 12-inch enlargement with every roll of film processed. Some minilabs may also farm out certain services to mass-market labs, like blowups over 8 x 12.

It is now my sad duty to report that there are crummy minilabs, too. I've dealt with minilabs for whom customers are merely another jingle of the cash-register bell. They're the ones who blame obvious bad printing on you or your camera. Or refuse to do makeup reprints at no extra cost. Or charge you plenty, but make prints no better than the cheapest drugstore service. Or give you back whole rolls of film printed off-color or too light or too dark. And so on. My advice in these circumstances is to make your objections known, find another lab pronto, and don't hold the actions of such a business against the many conscientious minilab operators out there.

The mail-order option

Astute shooters may be thinking, hey, he's left out another kind of photofinisher: mail order. Well, not really. Mail-order photofinishing is simply a variation of mass-market photofinishing. The only difference is that you send your stuff to the processing lab directly, via the mail, rather than using the intermediary of a drugstore or supermarket. In most instances, mail-order labs provide you with *mailers* for your film. (You frequently find them bound into magazines as promotions). These mailers may be *prepaid,* which means you buy empty envelopes at retail (or by mail order) and then send in your film as you shoot it. The envelope itself is your proof of payment.

Double your pleasure

Sharing pictures with family and friends is easier if you take advantage of photofinishers' doubles service. For a few bucks more a roll, photofinishers will make two prints of every frame at the time that you have your film processed. (Some photofinishers give free doubles as a promotion; others may charge as much as half of the original price on the second set of prints.)

If you get doubles, you can immediately send off or give away the extra prints of shots that are worth sharing — and have copies for yourself as well, no reprinting required. Otherwise, given your busy schedule, you may never get around to having reprints made. Or by the time you find the time, the pictures may seem outdated, and you won't bother.

Getting doubles of a whole roll is no more expensive than getting several reprints — and if the roll is full of great pictures worth reprinting, it's cheaper. But the real point is that you don't have to go to the extra trouble of ordering reprints. Of course, if you want to send print copies to two or more people, you have to deal with reprinting, not such a big deal when you know what you're doing.

Although the mail-order approach has all the disadvantages of mass-market photofinishing (including increased possibility of film loss and an even greater time delay), it has some real advantages. Mail-order photofinishing is convenient for people who live far away from a photofinishing service. (The turnaround time is usually a week, though that depends on what kind of week the post office is having.) And some people just see mail-order photofinishing as less of a fuss. In fact, many travelers enjoy dropping film in the mail as they shoot it, so that prints are waiting for them when they get home. (This saves you carrying around exposed rolls of film, though mailing film is ill-advised in corners of the world with dicey postal services.)

Many mail-order outfits offer aggressive promotions, like cheap or free film, or extra reprints or double prints at low cost. But again, if you want a reprint, or have some other problem, Who you gonna call? Some mail-order photofinishers do have customer-service phone lines. But nothing beats face-to-face service.

How to Get Good Prints

Getting good prints starts with taking the pictures. Here are the four most important ways to get the technically good negatives on which good printing depends:

- **Lock the focus.** If your negative isn't focused on what you want sharp, the best photofinisher in the world can't make it look sharp in a print. (See Chapter 6 for more on focusing.)

- **Use fast film.** I mean ISO 400 as standard, ISO 800 if you're shooting a lot of pictures in dim light, or of moving subjects, or with a long zoom setting. (Since the first edition of this book, ISO 1600 film has even become a viable alternative.) If your negative is blurry due to movement — either in the subject or the camera — a photofinisher can't sharpen it. Fast film is the best insurance against this kind of blur. (See Chapter 2 for more on film.)

- **Stay within flash range.** Your built-in flash has limited power; even with ISO 400 film, the greatest distance at which it can light a subject is usually around 20 feet, if that. Take a picture from farther away and too little light will bounce back to the film, producing a muddy-looking print that lacks detail. This is a *very* common cause of bad prints. (See Chapter 7 for more on flash.)

- **Use fill flash.** Even outdoors on a bright day you can get pictures that lack detail in critical areas — people's faces in particular. This often happens with backlit subjects, those in which strong light is coming from behind. The best cure for it is to set your point-and-shoot to fill-flash mode (also known as "flash-on mode"), which adds light to your subjects' faces. (See Chapter 7.)

A prints-ly sum: How much it all costs

Most photofinishers use à la carte pricing — that is, you pay for processing on an item-by-item basis. A 24-exposure roll of 35mm film costs me $10.66 (plus taxes) to have developed and printed at my favorite minilab, or $8.99 at the local supermarket that sends out to a mass-market lab. (These are fairly typical big-city prices for these services; prices may vary in your area, but probably fall within this range.)

Those prices break down this way. The minilab charges $2.50 to develop the film, plus 34 cents for each print. The supermarket also charges $2.50 to develop the film, but only 27 cents for each print. The minilab price, though, includes a "free" second set of prints as a special promotion.

Panoramic prints skew the picture. My minilab charges a lot more than the supermarket for panoramic prints on the original order — $1.00 apiece versus 52 cents. So if ten of the pictures on a roll are panoramic shots, the minilab charges me $20.09, while the supermarket is quite a bargain at $14.28.

When the supermarket charges for second prints, they are generally about 7 cents each — $1.68 extra on a 24-exposure roll. My minilab charges 10 cents extra for second prints, or $2.40 more for a 24-exposure roll. With APS film, *C* or *H* second prints are 17 cents at the minilab,

13 cents at the supermarket. So whatever type of lab you use, double prints are the best bargain in photofinishing.

This is especially clear when you look at prices for reprints from already-processed film (your existing negatives). My minilab charges 50 cents for a 4 x 6 reprint from a 35mm negative, the supermarket 35 cents. Why more for a reprint than the original print? One argument is that the negatives are now cut into short strips, so they require more handling to print. But the real reason is that the labs get a bigger markup on the smaller orders.

Note that most mail-order labs also have à la carte pricing, even if you pay a set price for a roll up front. To reimburse you for negatives they can't print (or for a roll you didn't fully shoot), these labs usually include credit vouchers for reprints in your returned order. So if you have a high proportion of unprintable negatives per roll and don't cash in these vouchers on later rolls, you may not be getting much of a bargain!

The bottom line? Check prices before you assume mass-market labs are cheaper. If you're an APS user look for one-price-fits-all deals, which may also be available for 35mm users. And get double prints. If you give prints away (of course you do!), you'll save a fortune in the long run.

The last two items on that list are remedies for what is far and away the most common kind of unsatisfactory print: the so-called *muddy* print. You've seen muddy prints, and you know them when you see them. But it's important to define the problem clearly.

The term *muddy* is pretty descriptive as it stands, but it has a distinct meaning when applied to color prints. First of all, muddy prints have very poor *contrast;* in other words, there's not much difference in tone between areas that were bright and areas that were dark in the original subject. Both come

out as dull, in-between tones, neither bright nor dark. A muddy print also has muted colors, typically brownish-beige (like mud). Muddy prints lack detail — a sense of texture and dimensionality — especially in parts of the scene that were in shadow. (Muddy prints have little sense of *light* in them.) Finally, muddy prints look much more "grainy" than you'd expect, with an unattractive gritty appearance to them. FYI, most muddy prints are the result of underexposure: Not enough light made it to the film when the picture was taken, so the film couldn't produce enough detail in the processed negative.

Two mistakes are responsible for almost all muddy prints. Number one is taking a flash picture of a subject beyond the limited range of your built-in flash. (I discuss this topic in Chapter 7.) Number two is taking pictures in light too dim for your camera or film to record. A common example is shooting the end of a sunset with a fairly simple camera loaded with ISO 100 speed film. This slow film needs a lot of light to make a good picture, but the sunset can't provide it — nor can a basic model point-and-shoot keep its shutter window open long enough to get enough light to the film. Result: Those beautiful reds look soupy beige in the print.

Finding a Good Photofinisher

Got your shooting procedures in order? Now it's up to the lab. Do you have a good one? Chances are, you've been going to a certain photofinisher because it's convenient, or your friends and family have been going there for years, or it's in the drugstore and you assume that's where you're supposed to take film. If you're satisfied with your prints, by all means stay with the photofinisher you're using. If not, maybe you should look for another. Or maybe, just maybe, you don't know how good photofinishing can be — and should try out another lab, just to see how its work compares with that of your usual place.

You can generally find or identify a good photofinisher in three ways, as follows. (Note that the communication involved in some of these suggestions makes them applicable mainly to minilabs.)

- **Word of mouth:** Somebody you know shows you some prints, and they look better than yours. Ask her where she gets her film processed and give the place a try when you're finished with your next roll. Or test the photofinisher with a few reprints.

- **Step right up:** One way to tell whether a minilab is good is simply if it does a good business. Busy labs are usually good labs. Walk in, say you're looking for a new photofinisher, and ask to see sample prints. While you're looking them over, check out the store, too. Is it neat, well-organized, clean? If an operator is actually working at the printing machine, does he appear to fuss a lot with the controls? (That's a good thing.) Is the store stocked with a good variety of film? Do the customers seem satisfied with their prints? Ask them!

✔ **Test prints:** Probably the best method. Somewhere in your possession you should have some prints you think are top-notch, with rich color and crisp detail. Now dig up the negatives for them. (See the section "The Match Game: Finding the Right Negative for a Reprint," later in this chapter, if you're having trouble figuring out which negative goes with which print.) It's best to choose four or five such negatives, taken of different subjects in different kinds of light. Now bring them to the lab you want to try and ask for 4 x 6-inch reprints. This test will cost you no more than a few dollars, and regardless of the outcome you'll have some reprints of favorite pictures.

By the way, it's okay to tell the lab people that you're testing them — that you're looking for a good lab and want to see how they do. Why not? You want the best work they can do, so put them on their toes!

Several things can happen with your test negatives. First (the best!) is that the prints come back, and they're simply smashing. If the shop's prices are within your means, try them for your next full roll.

You might also get prints back that are quite good overall, with maybe one that's not quite up to snuff. One bad print is no reason to reject the lab. Go back, show the lab the print, and ask whether it can improve upon it. (The section "Photo Communications 101" in this chapter tells you how to make such a request.) If the lab is good, its staff should try hard to get you a better print. If the lab's employees say they can't make a better print, ask them to show you the problem with the negative. Good labs do that, too. If the second try is up to your satisfaction, again, give the lab your next full roll. And if that's printed well, you just may have found your lab.

By now a nagging little voice in your head may be saying, "Gee, I remember those pictures of Uncle Clive that were all blue . . . maybe they shouldn't have been" or "I was wondering why those last vacation pictures were so light . . . could they have been fixed?" Indeed, maybe they could have been.

Which brings me back to the central point of this chapter. There is no single way to print a negative. If you are dissatisfied with a print for some reason — you feel that it's too light, or too dark, or that the color is off — you can request that the lab make a reprint. But there are limitations to what you can get in a reprint, and there's one limitation you need to understand right off.

A minilab or mass-market lab can only make prints lighter or darker overall or change the color overall. A print-machine technician can't make one part of the print darker and another lighter. She can't make one part of the print less blue and another part more blue. (Custom labs, on the other hand, can do some of these things. See the sidebar "The customs of the country," later in this chapter.)

Now, I have to confess that I wrote that last paragraph in the first edition of this book, and it still holds true for much commercial photofinishing. But there are now *digital* minilabs and *digital* mass-market labs — labs using photofinishing machinery that scans your negative then makes a print from the resulting digital file — that can actually make different parts of a picture lighter or darker relative to each other. One of these services is Kodak's "Perfect Touch" processing. Using computer software, such systems can lighten dark shadows without lightening the whole print, or preserve detail in really bright areas without making the whole print too dark. They can even sharpen up a picture that's a little fuzzy. In my experience such systems don't perform miracles, but are certainly worth a try.

In general, though, you can think of a printing machine's controls as something like the tint and brightness controls on your TV. When you turn the brightness down to make one part of the picture to your liking — a face, perhaps — you may make some other parts too dark. If you adjust the color to get the western sky a brilliant blue, you may make John Wayne's face look a little blue, too.

This all-or-nothing photofinishing principle is behind a number of annoying print problems. I describe these problems later in this chapter, in the section "Things That Can Go Wrong — and Do," a list of common printing snafus. This list should help you identify your prints' problems. But to get those problems fixed, you first have to know how to talk to your photofinisher.

Photo Communications 101

Let's face it — a lot of people are meek consumers. They usually take what they get. But as a photo consumer advocate, I have an obligation to discourage you from caving in when it comes to your important photographs.

As a photofinishing customer, you have a right to prints as good as can be made from your negatives.

Some photofinishing companies make a big deal about good print guarantees — that they'll reprint a picture at no extra charge if you're not satisfied with the print. Well, they're *all* supposed to do that. Satisfactory prints are what you're paying for when you hand your money to a photofinisher.

But just to reiterate, bad negatives do happen to good people. And when negatives are bad, it's impossible to get a good print. Photofinishers see a lot of bad negatives.

This is where that minilab relationship I keep talking about can come in handy. If you go to a minilab on a regular basis, it knows you. It knows you can take pretty good pictures. It knows you're not a crank. If you have a

not-so-good but important negative, the minilab should be willing to try a couple of print variations for you to see what looks best to you. For your part, if the lab gives the print its best effort, there comes a time to acknowledge that the picture may not be a "keeper." Even professional photographers have their share of "dumpers."

And *good* negatives can be hard to print. A classic problem is a picture with bright sky above green foliage. A print with lots of leafy detail and bright color in the foliage will probably have a blank white sky. A print with a nice blue sky tone may have dark, nearly black trees. Here, a good photofinisher can compromise — adjusting the print's exposure to give you a reasonable balance between the two areas.

As with any relationship, the key is communication. Based on my experience with good minilabs, I've put together these guidelines.

- **Always bring the negatives!** The negatives are the real pictures, remember? The print is just one rendition of the negative. How do you know whether it's a bad rendition of a good negative (the lab's fault) or a pretty good rendition of a bad negative (your fault, or your camera's)? You don't. The only way to troubleshoot a bad print is to look at the original picture — the negative — with the help of your friendly lab staff. (Looking at the negative is really only an option with 35mm, because APS film is hard to withdraw from that little cassette.)

- **Be specific about your complaints.** Point out the exact objections you have to a print. This doesn't require any technical lingo. Use direct visual descriptions: "too yellow," or "too blue," or "too light," or "too dark," or "I can't see any detail in my aunt's face," or "My Uncle Clive just came back from Florida, and he's nowhere near that pale" are just fine. (Being explicit is particularly important with mass-market photofinishing, because you will have to write reprint instructions on the envelope. "Print is no good" is not a very clear set of instructions.)

- **Ask to be shown the problem.** If your photofinisher says a negative can't possibly print any better, ask him to show you, in the negative, exactly what's not up to snuff. The photofinisher may be right. Then again, when he looks at the negative, he may see detail that can be brought out in a print.

- **Be firm, but reasonable.** If you really don't like a print or reprint, say so. Labs depend on satisfied customers, and good labs will want a second chance. At the same time, don't throw a fit because one or two prints are a little off in a batch of 72. No lab is perfect all the time.

- **Warn the lab about unusual shooting circumstances.** If you've shot a roll almost entirely under household light or office fluorescents — both of which can produce color casts — be sure to inform the lab when you drop off the film. This way, the machine's operator will know to watch

for these pictures and adjust the color to make the prints look more natural. Likewise, if you have a 35mm camera that can shoot panoramic pictures and you've taken some shots in this format, tell the lab beforehand so that the technicians can retool and print them in the correct shape and size. That way, you get panoramic prints with your original order and don't have to have them reprinted at extra cost.

✔ **Learn from mistakes — yours *and* the lab's.** If you've gotten some muddy prints because you've taken flash pictures from too far away, get closer for your next flash shots. (Or use a faster film, ISO 800 instead of ISO 400.) And if your lab made an honest goof in printing some beach pictures — say it made them too dark, so that the sunny scene looked overcast — you can alert them next time you take similar pictures so they print them accurately.

Things That Can Go Wrong — and Do

Here's a rundown of common problems with color prints, their likely cause, and suggested remedies, if any. For specific issues with getting prints from a digital camera, see Chapter 16. And remember, if you're going back to the photofinisher, always bring along the negatives.

✔ **Problem: Outdoor daylight picture is too light. This problem is common with subjects having a lot of foliage.**

- *Likely cause:* The printing machine (or its operator) tried too hard to hold detail in the leaves and overdid it.

- *Can print be fixed?* Almost always.

- *What to do:* Go back to the photofinisher and ask for a darker reprint. It might help if you bring along another print of the same scene that you think looks right and leave that as a guide.

- *Note:* Don't confuse this kind of print with a muddy print. What I'm talking about is a print with lots of detail that's just very light, but with good bright colors. A muddy print has dull colors and poor detail.

✔ **Problem: Outdoor daylight picture is too dark — it looks like it's overcast instead of sunny. Especially common with beach pictures.**

- *Likely cause:* Photofinishing machine saw very large, bright areas and tried to compensate for them by making the print darker.

- *Can print be fixed?* Almost always.

- *What to do:* Go back to photofinisher and ask for a lighter print. Tell her it was a bright scene.

- *Further glitch:* A lighter print might have a hint of muddiness because it's possible your camera didn't get quite enough light to the film.

- *Note:* Scenes like this benefit from fill flash when parts of the scene (or people) are within flash range. (See Chapter 7 for more on fill flash.)

✔ **Problem: Picture taken of a snowy scene is grayish and muddy.**

- *Likely cause:* A double whammy. Your camera's light meter was fooled by all that white stuff and gave the negative too little exposure. Then the printing machine saw the same thing and made the print darker still.

- *Can print be fixed?* Only a bit.

- *What to do:* Go back to the photofinisher and ask whether any improvement is possible. The print usually can be made a little lighter, but it won't be bright and snappy (see Figure 3-1).

- *Further glitch:* The lighter you make the print, the muddier the shadows and other dark areas will look.

- *Note:* When shooting snow scenes or other predominantly light-toned subjects, add exposure with backlight compensation or exposure compensation, if your camera offers these modes. (Check out Chapter 4 for more on exposure compensation.) Always use fill flash with people pictures. (This problem also occurs when you shoot people standing in front of a very light background such as a sunlit white church.) (See Chapter 7 for more on flash.)

Figure 3-1: Snow trips up your light meter, causing a grayish print (left) that can be lightened in a reprint (right).

© Russell Hart (2)

✔ **Problem: Indoor shot has funny yellowish, reddish, or brownish overall color.**

- *Likely cause:* You were taking pictures with fast film indoors under conventional household light. Your flash didn't fire because the light was sufficient — or else you deliberately turned off the flash for a natural light effect. (Household tungsten bulbs produce a very warm color on film.)

- *Can print be fixed?* Pretty much, although not always totally.

- *What to do:* Take the negative back to the photofinisher and ask for a reprint. The printing machine's color filtration can be adjusted to make a new print less yellow, more natural-looking.

- *Further glitches:* Sometimes the negative has recorded so much yellow and so little light of other colors that you can't get it all the way back to a normal color rendition without muddying dark parts of the picture. Also, getting the yellow out can make darker areas look bluish.

- *Note:* Some people like the added warmth.

✔ **Problem: Indoor picture has an objectionable green cast.**

- *Likely cause:* You were shooting without flash under fluorescent lights.

- *Can print be fixed?* Pretty much, though not always totally.

- *What to do?* Ask your photofinisher for a redo with different color *filtration* to make the print less green. (This means that he will change the color of the actual light used to make the print.)

- *Further glitches:* Sometimes the negative has recorded so much green and so little light of other colors that you can't get it all the way back to a normal-looking rendition without muddying dark parts of the picture. Also, getting the green out can make darker areas look pinkish.

If you're shooting people under fluorescents, set your point-and-shoot to its fill-flash (flash-on) mode. This will add light of a more normal color to people's faces, though the background may still end up green. (For more on flash, see Chapter 7.)

✔ **Problem: Person's face in the foreground or bottom of a flash shot is *burned out* — that is, too light.**

- *Likely cause:* The printing machine saw all the dark area above or behind the person and overcompensated by making the picture too light (see Figure 3-2).

- *Can print be fixed?* Almost always.

- *What to do:* Ask the photofinisher for a darker reprint. Explain that you want the person's face to be normal in tone.

Figure 3-2:
A flash subject against a dark background can end up too light in the print (left), but is easily darkened in a reprint (right).

© Russell Hart (2)

- *Further glitch:* Making the person's face darker will make the background, or the top of the print, darker as well. If no one is visible in these areas, the darkness makes no difference. But anyone above or behind the main subject will appear darker in the reprint.

- *Note:* This is a very common problem in group shots made with flash. One way to avoid it is to move people around or reposition yourself so that everybody is about the same distance from the camera. (See Chapter 10 for more on positioning subjects.)

✔ **Problem: Outdoor nighttime flash shot is very muddy, lacks detail.**

- *Likely cause:* You were just too far away. The built-in flash in your camera has limited reach; most run out of steam by 20 feet, some even less.

- *Can print be fixed?* Almost never.

- *What to do:* Ask your photofinisher if a slightly lighter or darker print would look better. You may see a small improvement.

- *Further glitch:* If you simply leave your camera set on autoflash mode to take pictures outdoors in low light, it curses you with a double whammy. Autoflash usually won't allow the camera's shutter — the window in the lens — to stay open very long. So besides the inadequate illumination on your main subject, the background of the picture doesn't get enough light, either.

- *Note:* This is probably the most common cause of muddy prints among amateur photographers. Your point-and-shoot's built-in flash may be the best thing about it, but it isn't a cure-all. In this

case, deliberately setting the slow-sync flash mode (also called night flash), or even turning off the flash entirely (hold the camera steady!), will probably give you a better print. (See Chapter 7 for more on flash techniques.)

✔ **Problem: Picture of person against a bright background is near-silhouette, has almost no detail in face.**

- *Likely cause:* Strong backlight told your camera's meter that there was lots of light, so it automatically reduced the amount of light reaching the film. As a result, the picture's darker areas — including the person's face — didn't get enough light.

- *Can print be fixed?* Sometimes.

- *What to do:* Ask your photofinisher to make a reprint, this time with reduced exposure to lighten the person's face or figure. Sometimes the face or figure has enough detail to allow a decent rendition, though if the backlight was strong, the detail may appear quite muddy.

- *Further glitch:* Even if the photofinisher can salvage some detail in the face, this will make the rest of the print much lighter and possibly washed out.

- *Note:* The best way to keep detail in a backlit portrait is to use fill flash, as I describe in Chapter 7. You can also add exposure — that is, get more light onto the film — by using either the backlight compensation or exposure compensation modes, if your camera offers them. (See Chapter 4 for more on modes.)

✔ **Problem: Print has small, randomly scattered white shapes — sometimes spots or blobs, sometimes hairlike.**

- *Likely cause:* Dust on the negative. Dust blocks the light with which the printing machine exposes the print, whiting out whatever part of the subject it lands on.

- *Can print be fixed?* Nearly always.

- *What to do:* Take negative back to photofinisher, point out dust spots, get a redo.

- *Further glitch:* If dust falls on negatives while they're still wet out of the processing machine, it can get embedded in the film. Special film cleaner may be required; consult your photofinisher.

- *Note:* If you have a recurring problem with dust spots on your prints, it's time for a serious talk with your photofinisher. Or maybe an introductory conversation with a new photofinisher. The same holds true if you seem to be getting frequent scratches in your negatives; see the following two problems.

✔ **Problem: Thin, straight white or black lines run lengthwise through the picture.**

- *Likely cause:* Scratches due to grit inside the camera or in the processing machinery; may also be caused by metal burrs or nicks inside the camera or processing machinery.

- *Can print be fixed?* Sometimes.

- *What to do:* If lines are white, they're on the back of the film and may be lessened in a reprint with an application of *nose grease.* No, I'm not making this up. Printers have been doing it for years. Just don't try this at home!

- *Further glitch:* If lines are black, they're on the film's emulsion side, in the image itself. In this case, your only recourse is retouching — if the picture is worth it. (Consider digital retouching software, if you're computer-ready; see Chapter 15.)

- *Note:* Here's what to do to avoid the problem in the future. First, buy a small can of compressed air from your photo shop. Then open your camera's back or film compartment and carefully blow out its interior to remove any grit or dirt. (Don't tilt or shake the can or you'll squirt propellant.) If the scratches persist, then they may be due to poor maintenance of the photofinishing machinery. Try another lab to see whether the problem goes away, and if it does, stick with the new lab.

✔ **Problem: White or black line(s) or gouges run through picture, often at a diagonal.**

- *Likely cause:* Scratches due to mishandling of negatives, by you or the lab.

- *Can print be fixed?* Sometimes.

- *What to do:* If lines are white and not too thick, try the nose grease remedy (see the preceding problem).

- *Further glitch:* If lines are thick or black, retouching may be the only way to save the picture.

- *Note:* Handle 35mm negative strips with extreme care.

✔ **Problem: People photographed against a colored wall or strongly colored background have a weird cast in their faces.**

- *Likely cause:* The printing machine saw lots of one color in the negative, thought it was a problem, and tried to fix it by making it more neutral.

- *Can print be fixed?* Almost always.

- *What to do:* Ask your photofinisher to reprint with more attention to the face tones in the picture.

- *Note:* This phenomenon is often called the *red barn effect* because it often shows up in pictures of people standing in front of big, brightly colored things like red barns. The printing machine looks at all that red, thinks it's a problem, and then tries to reduce the red. This results in people looking pallid, or even a bit blue, in pictures. But a careful print-machine operator won't let prints like this through.

✔ **Problem: Outdoor shot has great sky, but the ground (or water) below is too dark. Or the opposite — the ground (or water) looks fine, but the sky is nearly white.**

- *Likely cause:* The printing machine identified the predominant tone in the print and made it look the best. If a picture has lots of light sky, a printing machine makes the print darker to richen it — and the lower part of the image will look too dark. If a picture has lots of dark ground (or water), a printing machine makes the print lighter to preserve its detail — resulting in a washed-out sky.

- *Can print be fixed?* Sometimes.

- *What to do:* Ask your photofinisher to print for more tone in the area you want. Keep in mind that if the photofinisher lightens the ground (or water), the rest of the print gets lighter. If the photofinisher darkens the sky, the rest of the print gets darker.

- *Further glitch:* If your camera exposed the film properly for a big expanse of sky, the negative may actually be underexposed in the ground (or water) areas. If this is the case, adjusting the print to make these areas lighter can make them muddy.

- *Note:* Extreme differences in tone are a recurring problem with prints of landscapes. If a scenic shot is really important to you, and you want a print with good tones in both sky and ground, you might want to take your negative to a custom lab. (See the sidebar "Customs of the country.")

Second Time Around: Getting Reprints

Possibly the most underused service at the photofinisher, *reprinting* just means getting another standard-size print (usually 4 x 6 inches, or, with Advanced Photo System cameras, usually 4 x 6 or 4 x 7 inches) made from the original negative. (A few labs still do the old 3½ x 5-inch prints.) Reprints are inexpensive — mostly under 50 cents apiece. In my experience, reprints also tend to get a bit more attention from minilabs than prints made in the first develop-and-print order. There's a good chance you'll actually get a better print when you get a picture reprinted.

The customs of the country

If your local minilab or favorite mass-market lab is like a good family-style restaurant, a custom photo lab is like a gourmet chef you personally hire for a special dinner.

Good custom labs can cook up color enlargements that will give you a new appreciation for the limitations of automated photo processing. The key to custom printing is that it foregoes rapid-fire printing machinery, instead using old-fashioned enlargers — essentially precision projectors. An enlarger allows a custom lab technician to make *local* adjustments to your print. Unlike the operator of an automated printing machine, she isn't limited to making the whole print lighter or the whole print darker. The custom printer can make one part of the picture lighter and another part darker, to get every part of the print perfect, and not just a compromise.

A good example is that scenic shot on a brilliant day with blue sky at top and dark foliage below. If your regular photofinisher prints this picture, you'll get either a nice blue sky with nearly black trees, or detailed, richly colored trees with a chalky sky. A custom printer, though, will expose the print to get good tree tones and then *burn in* the sky — that is, allow more light to hit just the sky part of the print, to make it darker. Result: A beautiful print with a blue sky and green trees.

Now suppose that you had someone posing in the foreground of that picture, in shadow. The preceding enlargement might leave the person's face a little too dark. So the custom printer can hold back or *dodge* the face — that is, allow less light to hit that one small area. Result: The tones in the face are lightened enough to retain some detail.

Custom lab printers can also make very fine adjustments in color. And labs offering black-and-white services can make prints in which the overall contrast — the degree of difference between various tones — is adjusted to suit your taste. They can even make high-quality prints directly from slides. Custom labs offer a range of other services, notably in-house slide processing (often in less than three hours).

Before you run out and get all your negatives done up at a custom lab, remember that there's a price for this sort of mastery: A standard 8 x 10-inch custom color print can run $15 to $20, or more. An 8 x 10 done to exhibition standards can cost as much as $75. You're paying not just for manual labor, but for a practiced photographic eye.

Custom labs tend to be concentrated in cities with a substantial professional photo trade. You won't find them everywhere. If you're looking for one, start with the Yellow Pages, but you might also check with professional photographers in your area to see whether they know of one close by. (Some custom labs will work by mail or overnight delivery services.)

Many custom labs now do this kind of work entirely digitally, by scanning your film, using special software to manipulate the image on the computer, and printing it on a digital printer. And many of them do a great job with this new technology.

Finally, a warning: The word custom is a very popular marketing buzzword. Some run-of-the-mill mass-market photofinishers advertise custom enlargements. But if they can't offer lightening or darkening of individual areas of the prints, custom they ain't.

One reason people shy away from getting reprints is that they're intimidated by the business of figuring out which 35mm negative matches up with which print. (Reprinting is much simpler if you order an *index print,* which shows numbered thumbnails of each image on the roll. Index prints are a standard part of APS processing.) That reluctance is understandable, given those loose strips of negatives stuffed into the envelope holding your prints.

Most minilab staffers will help you figure out which negative should be used to make the reprint you want. If you use mass-market photofinishing, the counter people may have some idea how to match negative to print — though they may not always pick the right one. With mail-order, of course, you're going to have to figure it out for yourself.

You can get reprints made from *prints.* If you've lost the negative for a print — or can't bear the thought of rummaging through a dozen shoeboxes to find it — any photofinisher, minilab or mass-market, can make a print directly from an existing print. Most labs do this by scanning the original print, then making a digital copy from the scan. (Photo kiosks, described in the section "Print Vending: The Photo Kiosk," later in this chapter, work in much the same way but let you make your own high-quality prints within a minute or two.)

Making a print from a print can't give you the picture quality that your original negative or digital image file would provide — though it may come close. On the other hand, big enlargements made from prints rather than original negatives (or image files) will be noticeably poorer in quality.

The Match Game: Finding the Right Negative for a Reprint

Okay, you have a great 35mm picture of Great Aunt Gretyl with her prize-winning quilt, and you want six reprints of it, one for each branch of the family. You find the envelope from your original photofinishing order, no small task in itself. But the envelope contains nine orange strips — each with four negatives on it. How do you figure out which negative is the one you need for the reprints?

Thankfully, 35mm negatives are numbered. The numbers are on the edge of the film, right next to the perforations. (Some brands of film have numbers running along both sides.) These numbers are called *frame numbers.* If you hold up a negative to a window, you'll see frame numbers running in this sequence: 1, 1A, 2, 2A, 3, 3A, and so on up to the total number of exposures on the roll. Each strip picks up where the previous strip leaves off; one ends with 12A, and the next begins with 13, for example. Some brands may start with zero, but otherwise they work the same. (If the numbers are backwards, just flip the negative strip over.)

You'll notice a couple of other things. One is that an awful lot of frame numbers are on the negatives — about twice as many numbers as there are frames! Another is that the frame numbers don't always line up very well with the pictures. They might be at the edge of a frame or at the mid-point of the frame or anywhere in-between. Don't wonder why!

Now, about that negative of Great Aunt Gretyl and the quilt. Finding it is truly easy if your photofinisher prints the frame numbers on the back of the print. (I commend this practice highly!) In this case, you'd simply flip the print over and look for printing that reads something like <No. 13A>. Now go through the negatives and find the strip that has 13A on it. At the photofinisher, simply present the negative and request six reprints of number 13A. It's also not a bad idea to offer your original print as a reference and say whether you want any adjustments on the reprints.

It's not always this easy. Many photofinishers don't print frame numbers on the backs of prints (or offer index prints), in which case you'll have to match negative and print by looking at the actual picture. First of all, check whether your negatives are in protective sleeves. Most photofinishers use transparent or frosted sleeves that let you see the negative pretty clearly. If that's what you've got, there's no reason to take the negatives out. Some photofinishers, however, just put the bare negatives into your print envelope. (I do not commend this practice!) If this is what you find, handle the negatives very gingerly, by their edges only.

Handle unsleeved negatives by the extreme edges only; never put fingers on the picture area. Greasy fingerprints will cause dust to adhere to the film, which will mar your reprints. Even more injurious, the oils in your skin can discolor or fade the image. (Eventually, perfect FBI-style fingerprints may be etched into the negative!) Always wash your hands thoroughly (with soap, please!) before handling negatives. That way, if you do accidentally touch the picture area, you won't be leaving as much of a damaging residue behind.

Now, hold each negative strip up to a bright window or other wide, even light source (lampshades work well). After you get used to the reversed tones and weird colors, you can tell which negative produced which print by looking at shapes and position. If there is only one negative of Great Aunt Gretyl, for example, it will be easy to identify. Now note the frame number. My practice is to pick the number that is as close as possible to the very middle of the frame. (Depending on how your camera winds film, the numbers may be upside-down in relation to the image.) If you're going to a minilab, bring the original print for reference, if you still have it.

Things can get trickier. Suppose that you're an enthusiastic shooter and you took six or seven very similar frames (see Figure 3-3). To find the right one for the reprint, you'll have to rely on subtle visual clues. Gretyl's head may be

tilted a slightly different way in each frame. Or her hands may be in different places on the quilt. Or you may have composed some frames a little differently; Gretyl could be more to one side, or higher or lower in the frame. You may need your reading glasses — or a magnifier — to really spot the differences.

Figure 3-3:
To pick the right 35mm negative for a reprint, study each frame for slight differences.

Once you've determined what you think is the right negative, note the frame number. Once at the photofinisher, physically point out the negative to the counter person, to see whether he agrees with your choice.

I hate to bring this up, but you can run into another problem. Suppose that you separated your picture of Gretyl from the envelope of prints — you put it in an album or on your refrigerator. And when you opened up the desk drawer to look for the negative, you found 17 envelopes of prints. In this case, you'll have to go though considerably more negatives. You can narrow your search by checking the dates on the envelopes — they're almost always dated — and you can usually recognize the right roll after looking at a few prints in an envelope. But you can prevent this drudgery.

Be a matchmaker with 35mm prints and negatives. Before you separate any print from its envelope and negatives, put a reference code on the back of the print and on the envelope. (Use a china marker, also known as a *grease pencil,* to mark the print. Felt-tip markers can bleed through to the front of the print, and ballpoint pens can emboss it.) You might mark an envelope Vacation/Birthday 2003 and then mark the same on the back of the print. If you have more than one envelope of the same subject, distinguish them with A and B or some such designation. Now when you flip over the print, you'll know right off in which print envelope you'll find the negatives.

For a small extra charge — usually around $2 — some photofinishers will make an *index print* for a roll of 35mm film. (Not all photofinishers provide this service, but those that do may even offer it free, as a promotion.) Created by digital scanning of processed negatives, the index print is a sheet

the same size as the prints themselves containing tiny, numbered "positive" images of every shot on the roll. Because each image's number corresponds to the frame numbers on 35mm film strips, negatives can be quickly and easily identified for reprinting and blowups, with no need to scrutinize them. You simply look at the index print for the picture you want reprinted, and note the frame number beside it. Index prints are a standard part of both Advanced Photo System processing orders (see Chapter 14 to find out what an index print looks like) and "Picture" CDs (see the section "The Electronic Photofinishing Revolution," later in this chapter).

Never cut 35mm negative strips into single frames! If you do, your photofinisher may refuse to reprint them. Negatives must remain in strips of four or more for handling purposes during printing.

Getting Enlargements

Enlargements — popularly known as blowups — are simply reprints made in a bigger size. They're great for display purposes: propped up on your desk, hanging on the wall, in big albums. (Gifts, too.) To get an enlargement made, you need to find the right 35mm negative, of course. (See the preceding section.)

Because blowups are just big reprints, all the problems and remedies described in the section "Things That Can Go Wrong — and Do," earlier in this chapter, apply to enlargements as well. The main decision you have to make concerning blowups is how big they should be — a simple function of how and where you want to display them.

Don't blow up too much! What looks like a minor flaw in a 4 x 6-inch print (or something not visible at all) can turn into a big wart in a big print. Even fast films now have incredibly fine grain, so grain is usually not the problem but, rather, sharpness. (See Chapter 2 for more on film grain.) Something a bit out of focus on a 4 x 6 can look annoyingly unsharp in an 8 x 10- or 11 x 14-inch print. Slight blur from subject motion or camera shake will likewise be magnified as you go up in size. So before you get carried away and make a super 20 x 30-inch blowup, check the negative — not the print — with a strong magnifier. A minilab should have special magnifiers, called *loupes,* that are made for looking at negatives. Ask your photofinisher to help you evaluate the negative's enlargeability.

Standard enlargement sizes (for both 35mm and APS) include 5 x 7, 6 x 8, 8 x 10, 8 x 12, 11 x 14, 12 x 18, 16 x 20, 16 x 24, 20 x 30, and 24 x 36 inches. Most minilabs can make enlargements to 5 x 7 or 6 x 8, a few to 8 x 12, with same-day or overnight service. If you want larger sizes, they have to send out your negative to a mass-market lab, and it will be gone at least a couple of days. Really big sizes (20 x 30 or 24 x 36 inches) are typically special orders and can take as long as ten days, depending on where they're printed.

You may have noticed those differing print size shapes — 8 x 10 and 8 x 12 inches, for example. The 8 x 10-inch size is traditional, but it isn't a very good fit either for a 35mm negative or the APS *C* format, let alone the even-longer APS *H* format. Because an 8 x 10's proportion of length to width is less elongated than that of these negatives, a negative blown up to fit the 8-inch side of the print will make an image too big for the long side — sort of like a tall person's feet overshooting the bed. The photofinisher will have to *crop off* the short sides of the picture — that is, leave out a portion of the actual image — to fit it onto the 8 x 10-inch printing paper. And so the 8 x 12-inch print size — which fits the 35mm frame and APS *C* format just about perfectly — has become very popular. The same holds true with larger sizes such as 16 x 20; the longer print shape allows a more full frame print of your 35mm negative.

A number of 35mm point-and-shoots allow you to take panorama-format pictures. Some photofinishers print panoramas as a narrow strip on standard 4 x 6-inch paper, with dark bands above and below — the image itself relegated to a tiny area. True panoramic prints (4 x 10 or 4 x 11½ inches) are really enlargements, so you need to find out whether your photofinisher can make them, at least on the premises. Always alert the photofinisher when you bring in a roll of 35mm film with panoramas on it. The lab technicians will have to print the regular-shape pictures (if there are any on the roll) and then switch to another machine to make the panoramic prints.

Always mark 35mm rolls containing panoramic shots. If you have a 35mm point-and-shoot that shoots panoramas, get yourself a writes-on-anything fine-point marker. Keep it handy so that you can mark the cassette with a *P* when you finish shooting the roll. Then you'll remember to alert the photofinisher about the panoramas.

Getting panoramic prints with Advanced Photo System cameras and photofinishing is no sweat. APS photofinishing machines automatically make the correct-sized print (again, 4 x 10 or 4 x 11½ inches) with any pictures for which you set the camera to the *P* print format. Even though panoramas are one of the system's standard print formats, they do require a greater degree of enlargement than the other APS print formats, which is why I mention them in this section.

Just as you can get full frame enlargements from your negatives, you can get both 35mm and APS panoramic shots enlarged. These prints are available in sizes such as 6 x 18 and 8 x 24 inches. Their effect can be dramatic.

A point to keep in mind, though, about panoramic blow-ups: Because the top and bottom of the negative area must be cropped to create them (whether physically, as in a 35mm camera, or just in printing, as with APS), a standard

4 x 11½-inch panoramic print requires about the same degree of enlargement as an 8 x 12-inch blowup. And an 8 x 24-inch panoramic blowup is the equivalent of a 16 x 24! So it's especially important to make sure your negative is sharp. You may even want to shoot slightly slower films (like ISO 200) than my recommended ISO 400 if you specifically intend to get big panoramic enlargements, because the film's grain texture will be less visible with them. (See Chapter 2 for more about film speeds.)

The dating game

Many point-and-shoot models have the ability to automatically print all sorts of things on the front or back of your pictures. The most common way of doing this is with the so-called *date back* or data back, found on 35mm point-and-shoots. In fact, some 35mm models can be bought either with or without a date back.

A date back is basically a built-in quartz watch (in fact, these models' names often have "Quartz Date" or "QD" attached to them) that imprints the date, the time, or both in the picture area each time you take a shot. Some models also let you choose one of a half-dozen or so standard captions, like Happy Birthday or Happy Holiday. The printing is done with tiny lights (actually, light-emitting diodes, or LEDs) that expose the numbers onto the light-sensitive emulsion of the film. The numbers usually appear in the lower right corner of the image — and cannot be removed. In my opinion, these numbers ruin good photographs.

But many photographers, especially those for whom the picture is really just a record, love having that date on there. If you're one of these people, consult your manual to see which buttons must be pushed to set the right date and/or time. You usually refer to a small adjacent LCD panel to do this.

If you have a date-back model and don't want the date or time on your pictures, be absolutely sure

to turn off the imprinting. (I've had whole rolls imprinted with an incorrect date by date backs that were set wrong. A few years from now, that's bound to be confusing!) To turn it off, you have to toggle through the settings until the LCD panel shows a series of dashes, like this: - - - - -. This does not mean a series of dashes will print. It means nothing will print. Needless to say, that's where my date-back cameras are set!

Advanced Photo System imprinting is an entirely different story. Most good APS cameras come with a built-in, quartz-controlled date feature — but, mercifully, the system puts the date and/or time on the back of the print, not in the picture itself. These models record the date and time electronically, on the film's invisible magnetic layer, using their built-in magnetic recording head. When you get your APS film processed, the printing machine reads the stored date and time, and captioning if available, and imprints it onto the back of the print.

A fair number of photofinishers, minilab as well as mass-market, now routinely imprint the date on the backs of prints. This date is the date of processing, not the date an individual picture was taken. But as with other photographic record-keeping and organizational features — at least those that don't mar photographs — it's still a very useful thing in my book.

You can buy special *chromogenic* black-and-white film that can be processed and printed with standard color-print photofinishing machines, both at mini-labs and mass-market labs. (See Chapter 2 for more on this unique material.) Chromogenic black-and-white film is available in both 35mm and Advanced Photo System cassettes. Photofinishers offer enlargement services as well for these films.

The Electronic Photofinishing Revolution

The digital revolution in photography isn't limited to people who have film-less digital cameras. All sorts of electronic fun can now be had with pictures from conventional film cameras, as I describe in Chapter 16. The key is *scanning* your photographs — either negatives or prints. Scanning is the process that translates a photograph into an electronic form that can be understood by your computer, stored on CDs or other removable media, and even e-mailed. See Chapter 16 for details.

A growing number of photofinishers, both mass-market and minilab, offer inexpensive scanning services in conjunction with regular film processing:

✔ **Scan-to-CD:** Your pictures can be scanned and stored on a compact disc (CD) from which you can retrieve pictures with your computer's CD drive (see Figure 3-4). It has much, much greater storage capacity than a floppy disk. This means not only that you can put more pictures on it, but that you can store them at much higher resolution — at a much higher level of quality. Because of this high quality, the files on a "Picture" CD, as it's often called, can be used for serious retouching with your home computer, and for digital printing.

Labs that offer this service generally scan a roll of film to a "Picture" CD as a package deal with develop-and-print orders. (An index print is included with the CD.)

✔ **Online photofinishing and Web sharing:** With this increasingly popular service, your pictures are scanned as part of a develop-and-print order — but instead of coming back to you on a disk, the scans are transmitted to a Web site where you can view them online after entering a password. You can order prints online, and they will be mailed to you. You can give the password to friends and relatives, too, so that they can visit the site and look at the pictures, and order prints of the ones they like. You can use the site to send the pictures by e-mail. And you can download the scans to your home computer for extended storage and manipulation.

Figure 3-4:
The "Picture" CD is an affordable way to get high-quality digital files of your 35mm or APS photographs into your computer.

Print Vending: The Photo Kiosk

Yet another photofinishing option is the do-it-yourself booth, or *kiosk*. Many different companies now make these, and you now find them stationed in hotels, theme parks, and supermarkets in addition to photo stores (see Figure 3-5). Fortunately, kiosks have become virtually self-explanatory and so easy to use that you usually don't need a clerk's assistance. And in addition to accepting negatives and prints, many contain slots for various digital media, including "Picture" CDs and memory cards from your camera.

With these computerized machines, you put a negative, memory card, or CD into a slot, or a print onto what looks like a photocopier window. Then you view your picture on a video screen and use the machine's controls to make various modifications. For example, you can crop the picture (that is, cut out unwanted parts of it to concentrate on the important area), remove red-eye (that devilish glint caused by the reflection of flash in your subject's eyes), or do other simple retouching. You can set up the sheet so that you get one large picture or a page of smaller or different-sized ones. Other options include adding fancy borders or printing your photograph as a greeting card or calendar.

If you're new to photo kiosks, you may want to have a store clerk guide you through the process. The great advantage of these systems is speed. Depending on the machine, you might be able to get an enlargement, with retouching, in just minutes.

Figure 3-5:
A photo kiosk lets you make your own prints in a variety of sizes from sources that include negatives, prints, and digital cameras' memory cards.

Keeping them forever (or nearly forever)

Nothing is forever, and photographs are no exception. Over time your prints (and to a lesser extent, your negatives) can suffer a considerable amount of deterioration — even if they're safely tucked away in an album.

Most deterioration takes two forms. One is fading, in which the print gets lighter and loses color and contrast. (Basically, it starts to look like a muddy print, as described earlier in this chapter.) The other is staining, in which the print starts to pick up some unwanted color, especially in irregularly shaped patches. (Yellow is a frequent intruder.) Prints can also dry up and crack. They can even get mildewed from damp storage conditions.

Part of the problem is stuff in the prints themselves. The leftover chemicals in prints can,

over time, injure the photographic image. The other part of the problem is environmental. Sunlight, humidity (or lack of it), air pollutants, temperature, and substances in albums, boxes, and envelopes can either attack prints directly or accelerate the chemical damage already going on in them. And it may come as a shock to you that some kinds of *digital* prints, especially those made on inkjet printers, are much less stable than conventional prints — sometimes showing visible changes in color or tone in a matter of months. This situation is improving, but for better results stick with conventional paper or dye-sublimation prints (see Chapter 16 for details).

The good news is that modern films and papers are far more long-lived than they were 20 or

even 10 years ago. But it's still worth taking some steps to keep your prints from deteriorating prematurely.

✔ Never use any kind of sticky stuff on the surface of a print. I've seen prints fading and crumbling in albums with transparent overlay stickum pages after a year. Choose albums that have separate sleeves for the prints — and are made of archival materials. (See the following item.)

✔ Use archival materials. *Archival* is photo jargon that means a storage material or system that is minimally injurious to photographs. To be archival, for example, an album must have acid-free paper, if it has paper pages. (Acid is a prime culprit in print deterioration, and cheap paper contains lots of it.) If the album has plastic sleeves, they should be made from chemically inert plastics such as polyethylene, polypropylene, and polyester. (Never buy storage sleeves made of polyvinyl chloride, also known as PVC — it's the stuff that smells like your kids' pool toys.) Any other materials you use with albums — mounting corners, glues, slipcases, and so on — should be labeled acid-free or archival quality, too.

By the way, shoeboxes are about the worst place you can put prints or negatives. They're usually made from pulp cardboard, which is full of acidic sulfur compounds. Use plastic boxes, ring binders, or recipe-card boxes instead. Or order special archival storage boxes from companies such as Light Impressions. (See Appendix B.)

✔ Keep the negatives safe. If the negative is safe and sound, you can always get a new print from it should your existing one fade, discolor, or be damaged. Photo shops and companies that sell archival storage and album materials also carry clear, photographically correct plastic pages with sleeves for individual negative strips. I transfer my negatives into these from the

photofinisher's sleeves, which you never really know the content of.

You can get sleeved pages that fit three-ring binders. And if you happen to keep your prints in plastic pages in three-ring binders, this is also a great way to store negatives and prints together; just keep the negatives right behind the pages holding the prints for that roll. (Then there are the advantages of the Advanced Photo System, in which your negatives are safeguarded in a cassette of inert plastic.)

If you're especially anxious, like me, about the security of your negatives, you might also consider getting a fireproof safe. Special models are available specifically for *media* (often called media safes), which, in addition to photographic materials, include floppy disks and magnetic tape.

✔ Keep pictures out of the sun. The ultraviolet component of sunlight is incredibly injurious to photographic prints, as it is to human skin. It's fun to hang pictures on the wall, yes — but try to place them so that they aren't in direct sun at any time of day. And look for frames with anti-UV (ultraviolet) glass or acrylic cover plates, which help filter out light's most photographically harmful components.

✔ You digital photographers aren't off the hook just because you don't have negatives. The computer file created by your camera is, in fact, a "digital negative," and also needs care and feeding. If you think a digital photograph is safe once you download it to your computer's hard drive, think again. What if your computer has a fatal crash? Your priceless pictures will be instantly reduced to electrons floating in the ether. Digital image files should be backed up on stable removable media — ideally, a CD — just like other kinds of important computer files.

Part II
Working with Your Point-and-Shoot

The 5th Wave

By Rich Tennant

In this part . . .

Your point-and-shoot camera is made to point and shoot. Turn it on, point it at something, press the shutter button — and it focuses automatically, figures the exposure, fires the flash if needed, and (if it uses film) speeds the roll along to the next frame, ready to start all over again. You can get acceptable pictures this way, but they often won't be the best pictures that you can get. And this is where those little pushbuttons come in. If you know which buttons to push, you can get a good picture, and maybe even a great picture, instead of a merely acceptable one.

Pushbuttons and dials (which are back with a vengeance) control modes, and modes are what make the camera do your visual bidding. But even if your point-and-shoot has many modes — and Chapter 4 describes just about all you can possibly have — you really only need a few. Which few? The flash modes, which is why that little built-in flash gets special attention in Chapter 7. Everything in between those two chapters concerns the lens — the little glass sandwich that actually forms the image (whether on film or a digital camera's image sensor), and without which those pushbuttons would be like the light switches in your basement that turn nothing on.

And then there's the Advanced Photo System (APS), which gets its due in Chapter 8. Designed by manufacturers from scratch just a few short years ago, it's a self-contained photographic system that ingeniously links camera, film, and photofinishing. APS hasn't ended 35mm's reign as the king of point-and-shoot land, as some manufacturers originally thought it might. But it has many ardent users — and, hey, *Photography For Dummies* is a full-service book!

Chapter 4

Pictures à la Mode

A funny thing happens when you show good pictures to people. Ever notice it? You take out some well-focused, colorful, nicely composed photos, pass them around to your friends, and they oooh and aaah. "Wow!" they say. "What a great camera you have!"

As if you, the one pushing the button, had nothing to do with it. But be honest with yourself. How many times have you excused your not-so-good pictures the same way? "Oh, geez," you say. "Would you look at what this lousy camera did again!"

The fact of the matter is that your camera has a great deal to do with how your pictures turn out. And so do you. You and your camera are a partnership. But you have to be the major partner. You can't always leave all the decisions up to your minor partner, the camera, if you want to get beyond okay-but-not-great pictures. *You* have to call the shots — or should I say, push the buttons.

Button, Button, Where is the Button?

You have a lot more say than you might think in the many decisions your all-automatic camera makes each time you take a picture. And the way you get your say, on most point-and-shoots, is with those pushbuttons.

Most point-and-shoots have several buttons that you can push besides the most obvious one, the shutter button. You frequently find these buttons right next to the camera's *LCD panel* — the silvery little screen that counts your pictures for you, among other things. (LCD stands for *liquid crystal display.*) This panel is commonly on the top of the camera, but you may also find it on the camera's back. Regardless of the panel's location, you'll probably find additional buttons in other places — next to the camera's viewfinder, on the side of the camera, or even squirreled under a sliding or hinged cover. If you're shooting with a digital point-and-shoot, you'll find buttons next to its viewing screen, which displays the camera's menu. Figure 4-1 shows a typical array of pushbuttons. Some models have buttons on nearly every flat surface!

Many point-and-shoots now have dials instead of pushbuttons. Dials do the same thing as buttons; they just show you more of your optional settings at a glance (see Figure 4-2). And while most digital point-and-shoots let you change settings with buttons or dials, some models may relegate the adjustment of useful functions to the camera's menu screen. (See the sidebar, "The menu, please.")

Why all the extra buttons or dials? To let you get out of the camera's default settings and set modes according to your pleasure, creative needs, and photographic purposes.

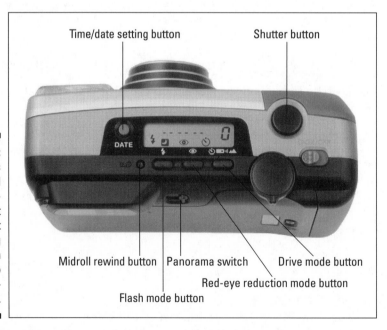

Time/date setting button Shutter button

DATE

Figure 4-1: Pushbuttons on a typical point-and-shoot let you set everything from flash modes to the self-timer.

Midroll rewind button | Panorama switch Drive mode button

Red-eye reduction mode button

Flash mode button

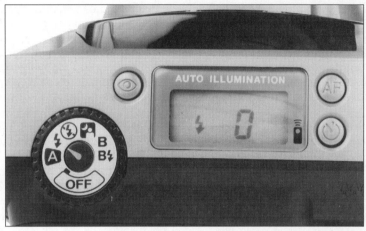

Figure 4-2:
Many point-and-shoots substitute dials for pushbuttons, usually making operation easier.

Default in photography doesn't mean that you've missed a credit-card payment on your camera. Default refers to a setting, or a group of settings, that the camera always returns to on its own — if you don't deliberately set it to do something else. For example, almost all point-and-shoots default to *auto-flash* mode after you shut them off and turn them on again.

I can hear you griping already. You're saying, what's the point of getting this newfangled, auto-everything camera if you actually have to understand something about how it works?

Look at it this way. A car with automatic transmission, power everything, and cruise control is also a marvel of computer automation — but it can't drive itself. You still have to make a lot of decisions and operate a bunch of controls (even push some buttons!) to get where you're going.

The deal is pretty much the same with point-and-shoot cameras. Now, if you use your point-and-shoot wrong, it won't crash and burn, though some of your more photophobic subjects may threaten you with mayhem. But understanding its different modes, features, and functions allows you — with no muss or fuss — to get a much higher percentage of keepers. Those people looking at your pictures may actually exclaim, "What a great photographer your camera has!"

Mastering Your Camera's Modes

Mode is a modish word in photography today. Even a fairly simple point-and-shoot can have several flash modes, and focusing modes, and drive modes. . . . So just what is a mode anyway, and why is it important?

A *mode* is simply a set of instructions that tells the camera to operate in a certain way. Point-and-shoot cameras may seem pretty smart, but like computers, they're really very dumb. Cameras, like computers, have to be *told* to do every single thing they do — every time they do it. In fact, a small computer in your point-and-shoot actually carries out a mode's electronic instructions. You could just as easily call modes *programs,* and some camera makers do just that!

Even if you've never touched any control except the on/off switch and the shutter button, you've already set the camera to a mode — many times, in fact. When you first turn your camera on, it sets *itself* to its default mode. This mode is usually called *autoflash* because it automatically fires the camera's built-in flash, if it's needed. You can also call the mode *all-auto* because everything else is automated, too. Either way, the default mode is probably the one that you'll be using the most.

Merrily We Toggle Along

The most typical way to change a mode is to press a button on the camera and watch as different symbols or words representing each mode appear on the LCD panel. Repeatedly pressing the button to move through the modes is called *toggling.* If you keep pushing the button, you eventually return to the default mode and can start all over. You can toggle through the modes as many times as you like to arrive at the one you want.

An *icon* is a symbolic representation of a specific point-and-shoot mode — not to be confused with the icons used in this and other *For Dummies* books! An icon can appear on an LCD panel, beside a button, along the edges of a dial, or on a digital point-and-shoot's viewing screen. But modes may be represented by words or letters, too, so for the purposes of this book, icon simply means any representation of a mode that your camera uses.

If your point-and-shoot uses a dial (or dials) rather than pushbuttons, the mode icons are printed around the edge. This arrangement lets you see all the icons at once, instead of having to view them sequentially as you do with a pushbutton. You simply rotate the dial to the icon for the mode that you want. Another kind of dial actually changes the icon on the LCD display or moves an LCD pointer from icon to icon as you rotate it.

Mode buttons on some point-and-shoots are so small that they're hard to press, especially for ham-handed photographers. If your fingernails don't do the job, try a pen or pencil. Better yet, get yourself a paper clip — not a regular-size one, but one of those two-inch jobs — and loop it around your camera's neck or wrist strap. When you want to change modes, unbend the free end and use it as a button-poker.

The menu, please

The little viewing screen on the back of a digital point-and-shoot really has three purposes. One is to show you the subject so that you can compose it and click the shutter at the moment that catches your fancy (though as you discover in the next chapter, as well as Chapters 1 and 15, there are reasons not to use it for this purpose, at least not all the time). Another purpose is to let you review the pictures you've taken, at least the ones residing on the camera's memory card (that is, until you transfer them elsewhere and/or erase them from the card). But the third purpose of the screen is to show you the camera's menu.

Accessed by pushing the menu button (usually adjacent to the viewing screen, and marked with that word), the menu is a computer-like interface that contains a list of different camera functions you can scroll through and select. You

usually make these selections with a four-way control on the back of the camera next to the screen. I explain more about how to operate the menu, and some of the digital delicacies it offers, in Chapter 15.

Fortunately, most good digital point-and-shoots allow you to change and operate their major/basic functions with pushbuttons and dials — no need to access the menu to adjust these functions. Changing basic settings would be much more complicated and time-consuming if you had to do it in the menu. (You would have to turn on the menu, find the function, select it; find the setting you want in a submenu, then select it; then turn off the menu.) But the menu is the place to go for functions you don't change that often, many or most of which have to do with the computer side of a digital point-and-shoot.

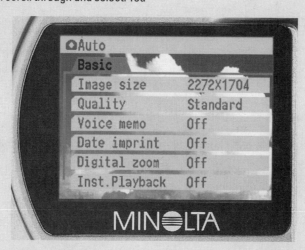

A fairly common arrangement on point-and-shoots is to have one button that toggles through the flash modes and a second one that toggles through all the remaining modes. Some cameras have a dial only for flash modes (because they're so important and should therefore be easier to access), relegating other modes to a button. Some cameras have two dials. Some have two dials and a button. Some have four, five, or six buttons. . . .

Mode map for Zarkon SuperBlitz 105 Zoom

No, there is no Zarkon camera. I simply made up a typical fair-to-middling zoom point-and-shoot, much like one you may already own. Here's a typical personalized "mode map" that a user of this camera might jot down on an index card to take along when shooting. The instructions describe what each mode is good for as well as precautions to take when using them.

Flash button

Auto: Fast shooting on the run; always-ready position. (Turn camera off and then on to get back to this mode!)

Fill flash: Fires flash all the time. Portraits in bright sun; backlit subjects.

Flash-off: Prevents flash from firing. Dark scenes far away; existing light shots with fast film. (Hold camera steady!)

Night flash: Fires flash all the time, together with slow shutter speed. Outdoor portraits in evening; indoor shots with distant backgrounds. (Hold steady!)

Red-eye reduction button

Red-eye reduction on: Fires rapid preflashes before the flash for the actual picture. (Tell subjects to wait for final flash!)

Red-eye reduction off: Kills annoying preflashes.

Clock face button

Self-timer: Takes picture ten seconds after shutter button is pressed. (Watch flashing light!)

Remote control ready: Sets up camera for hands-off firing. (Keep remote in camera case!)

Infinity lock: Far-away focus; use to shoot through window. (Turn off after use!)

Alas, no standard point-and-shoot control configuration exists; every manufacturer uses its own arrangement. Nor have camera manufacturers ever settled on standard icons for different modes — which means that one model's icon for landscape mode may look suspiciously like another model's icon for backlight mode, and one's slow-sync flash may look an awful lot like another's flash-off. The only surefire way to find out what the icons on your particular camera mean is to check the manual.

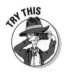

Map your modes! Get out your camera and its instruction manual, plus an index card and a pen. Push every button and turn every dial on the camera. As you do, refer to the manual and to the rundown of different modes that follows in this chapter. On the index card, write down the location of each button or dial, and underneath, list the modes it toggles or rotates through in the order they appear. Next to each mode, write a brief description of what it does and what it's good for. For example: "Fill flash: Fires flash all the time. Portraits in bright sun; backlit subjects." If you can't find your way out of a mode, just turn the camera off and on again.

You can also add little customized reminders and bits of advice about using each mode (see the sidebar, "Mode map for Zarkon SuperBlitz 105 Zoom"). After you complete your mode map card, keep it in your camera case or slipped into a wallet or pocketbook so that you can refer to it "in the field," as pros say. This project may sound a bit like schoolwork. But you won't need to use the card for long before you know exactly which button does what and when to use a specific mode.

Millions of Modes?

Actually, I've counted all the modes that you can find on recent point-and-shoots, and they add up to about 30. Fortunately, no one camera has them all, though some fancier models come pretty close.

You can divide modes into groups, depending either on what part of the camera they control or what kind of picture they're designed to help you take, and I've done just that in the following explanation of different modes. *Note that words (or letters) in quotes are actual words (or letters) that may appear on the camera's LCD display or dial(s).* Refer to Chapter 7 for more specifics on all-important flash modes. And again, remember that camera makers can and do use all sorts of nonstandard icons — so let your manual be your guide!

Most point-and-shoots have no more than a half-dozen modes, not including the computer-oriented modes (often obscure) accessed through a digital point-and-shoot's menu screen. Even if your camera has more than that, you'll use only a few with any regularity. I mark these modes with an asterisk (*) in the following list. Some modes, on the other hand, you may never use at all. But to find out which modes you can ignore, you first have to figure out which ones your particular point-and-shoot has and what they're good for, or at least intended for. So now's the time to sit down with your camera and manual. Do it, and you can skip the descriptions of modes that your camera doesn't have!

Flash modes

Flash modes let you change how and when the flash fires — or let you turn it off entirely. If a point-and-shoot has any modes at all, the flash modes usually get their own button or dial. They're that important. Find out how to use

flash modes well, and you'll see noticeable — maybe even astonishing — improvements in your pictures. Flash modes are by far the most useful modes on your camera. For this reason, I devote Chapter 7 to them.

✔ **Autoflash mode.*** *Typical icons: no icon at all; lighting bolt with "Auto"; "Auto" (see Figure 4-3).* You find this mode on just about any camera above the one-time-use level. Autoflash is the universal default mode. Autoflash gives you flash when needed, turns the flash off when the light is bright, and does its best to keep shots from blurring. When in doubt, leave your camera in autoflash mode. It's the grab shot mode — just turn on the camera and shoot!

Figure 4-3:
Typical icons for autoflash mode.

✔ **Fill-flash or flash-on mode.*** *Typical icons: plain lighting bolt; lightning bolt with sun symbol; "Fill-flash"; "Flash-on" (see Figure 4-4).* Fill-flash mode is present on point-and-shoots above the most basic level. This mode turns on the flash and keeps it on, no matter what the lighting conditions — whether you're shooting in the dark or by blazing sun. Fill flash is the mother lode of modes — perhaps the single most important camera setting within your control. It's essential for lightening harsh shadows in outdoor portraits and the best choice for brightening subjects lit from behind.

Figure 4-4:
Typical icons for fill-flash mode.

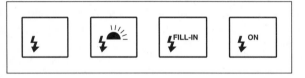

✔ **Flash-off mode.*** *Typical icons: lighting bolt with cancel sign through it; moon and star(s); "Flash-off" (see Figure 4-5).* Found on most models above the very basic, this mode turns off the flash and keeps it off no matter what the lighting. Use it to preserve interesting natural light when flash would overpower it. Of course, if the light is bright enough,

the flash turns itself off in autoflash mode. But flash-off mode is a way of ensuring that the flash won't fire. Definitely set it for low-light scenes that are beyond the range of flash — a sunset, for example.

On some camera models, the flash-off icon may be combined with other symbols — and if it is, setting it may do more than just turn the flash off. If the flash-off icon is paired with a sun symbol, it probably means you're getting backlight compensation. If it's paired with a mountain symbol, you may be getting a landscape setting.

Figure 4-5:
Typical
icons for
flash-off
mode.

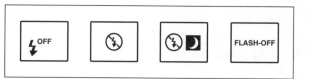

✔ **Slow-sync flash mode or night flash mode.*** *Typical icons: lightning bolt with moon and stars; "Night"; "Slow sync"* (see Figure 4-6). A feature on many cameras at the $100 and higher level, slow-sync flash mode works just like the fill-flash mode, except that it's designed specifically for low light. (*Night flash* is a popular name for it, though the mode is just as valuable indoors during the day, as I explain in Chapter 7.) In addition to firing the flash, slow-sync allows the shutter (the window in the lens) to stay open longer than usual — helping the film capture more of the existing light behind and around your subject. In practice, this mode improves background detail. (On some cameras, slow-sync flash automatically adds red-eye reduction.) Great use: a portrait in front of city lights or a sunset.

Figure 4-6:
Typical
icons for
slow-sync
flash mode.

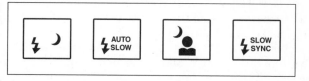

✔ **Red-eye reduction mode.** *Typical icons: an eye; a double lightning bolt* (see Figure 4-7). Present on most cameras above very basic models, red-eye reduction is designed to lessen the reddish glint a subject's eyes often pick up in a flash picture. With many models, you can add it to any

other flash mode (autoflash, fill-flash, and so on), in which case it may have its own on/off button. Red-eye reduction usually takes one of two forms, depending on the brand of camera (see Chapter 7).

Figure 4-7:
Typical
icons for
red-eye
reduction
mode.

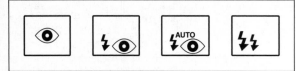

Print-format modes

Everyone's familiar with the 4 x 6-inch shape of standard commercial prints. (The 3½ x 5-inch size, once the standard and still available, has similar proportions.) But a few 35mm cameras and *all* Advanced Photo System cameras (with the exception of some one-time-use models) let you choose a differently shaped print called a *panorama.* Panoramic prints are long and narrow — 4 x 10 inches or 4 x 11½ inches, depending on who does the photofinishing. With the right subject, an occasional panorama can be lots of fun. (Try verticals!) But for most of your picture-taking, the 4 x 6-inch size, or with APS, either the 4 x 6- or standard 4 x 7-inch size, is best — and the most economical choice. If you're an APS user, Chapter 8 helps you figure out when to switch print formats.

✔ **Panorama mode (on 35mm cameras).** *Typical icons: "Panoramic"; "P"; a long, narrow rectangle* (see Figure 4-8). You see this mode on a handful of current 35mm cameras; you set it by sliding or rotating a marked switch. With most models, doing so immediately reshapes the viewfinder to match panoramic-format prints, allowing you to compose accordingly. (With some models, you have to compose using lines within the viewfinder frame.) Note that the panorama setting on 35mm cameras physically blocks off the top and bottom of the negative, so after you shoot a picture this way, you can't go back and get a normal full-frame 4 x 6 print from this negative. Shoot a second, nonpanoramic picture if you have second thoughts. Depending on your photofinisher, getting panoramic prints can also be a bit of a hassle (see Chapter 3).

Figure 4-8:
Typical
icons for
panoramic
mode.

✔ **C, H, P switch (on APS cameras).** *Typical icons: choice of "C," "H," and "P"; rectangles of each format's respective shape* (see Figure 4-9). Advanced Photo System (APS) cameras let you choose from three different print formats for each picture you take; you change formats by sliding a switch or rotating a small dial to the desired selection. The choices are Classic *C* (a 4 x 6-inch print), HDTV *H* (a 4 x 7-inch print), or Panoramic *P* (a 4 x 10-inch or 4 x 11½-inch print, depending on photofinishing). Unlike the panorama switch on 35mm models, changing APS print size does not change the actual negative, only the way it's first printed. If you decide your panoramic composition of Uncle Clive sacked out on the sofa would be better as a regular old 4 x 6, you can get it reprinted that way. (See Chapter 8 for details on having APS pictures redone in different-shaped prints.)

Figure 4-9:
Typical icons for APS print format modes.

Drive modes

Even very inexpensive 35mm and APS point-and-shoots often have motorized film winding, and most people take it for granted. Shoot a picture, and the camera goes "BZZZZT," speedily advancing the film to the next blank frame. But drive modes, if your model offers a choice of them, let you alter the way the camera goes about the business of winding. They also include ways to fire your camera without your finger on the shutter button, such as the self-timer.

✔ **Self-timer mode.*** *Typical icons: clock face; "Self"* (see Figure 4-10). Found on nearly all point-and-shoots other than one-time-use models, the self-timer mode just delays the picture by a set interval, typically 10 or 12 seconds. You place the camera on a nearby secure surface — a table (indoors) or a rock (outdoors), for example — aim it, and then press the shutter button and double-step to get into the picture yourself. The ability to include yourself in your pictures makes the self-timer much beloved by vacationers and party-goers, but it's useful in another way, too: It lets you keep your hands entirely off the camera when it fires. It's a good handmaiden to the flash-off mode, because it eliminates the risk that your shaky hands will blur the picture when the camera sets slow shutter speeds for low-light shots.

Figure 4-10:
Typical
icons for
self-timer
mode.

TIP

The self-timer isn't just for group shots and travel photos. Use it for more mundane pictures, too — the kind that you'd take for the visual diary I propose in Chapter 9. Get a shot of yourself going about holiday dinner preparations. Or with Bowser on your front porch. Or with a toddler in your lap. Or with your freshly waxed sports car.

✔ **Sequential self-timer or multi-self-timer mode.** *Typical icons: overlapped clock faces; a clock face with a numeral next to it* (see Figure 4-11). You find this feature on many point-and-shoots in the middle-to-high price range. It works just like the self-timer, except that it takes one or two more shots after the first one, spaced apart by a second or two. (With flash pictures, the spacing may be lengthened by the time needed for the flash to recharge.) This mode is great for group shots — take one formal shot and then act up for the second!

Figure 4-11:
Typical
icons for
sequential
self-timer
mode.

✔ **Remote control mode.*** *Typical icons: remote controller shape with waves or beams coming out of it; "Remote"* (see Figure 4-12). This mode is available on many cameras over $75, though the remote controller itself is usually an extra-cost accessory. Remote control functions much like the self-timer, eliminating the need for hands-on firing of the camera. It works like your TV remote: You take the picture by pointing the remote controller at the camera and pushing a button, which fires the camera almost immediately rather than after a delay. Setting the remote control mode activates the camera's *remote receptor* (that's a little electric eye on the front of the camera that can see the beam from your remote controller) and tells it to look out for incoming photons.

Using your self-timer — without yourself in the picture!

If you've never used your camera's self-timer for a low-light shot, now's the time. Load up your camera with fast print film (ISO 400 or 800) and find a scene that you've always wanted to capture in low light. It may be the sun setting behind a patch of woods, the twinkling lights of a downtown skyline, or maybe just your house at dusk.

Turn on the camera and set it to flash-off mode. Then place it on a solid support — a fence railing, car top, or window sill is fine, as long as you can see through the camera well enough to aim it. Now set the camera to self-timer, press the shutter, and hands off! You'll probably be pleased with the result.

Figure 4-12:
Typical icons for remote control mode.

Steady the camera on a rock or branch, and you can use remote control to get candid shots of local fauna in your backyard, as you hide behind a tree or look through a window. But keep in mind that the remote's beam range is usually limited to 20 feet or so, and the controller must be in a direct sight line with the camera. (Some remotes even allow you to zoom the lens back and forth.)

You can use your remote control to steady the camera for any low-light photograph, just as you would with the self-timer, by placing and firing the camera on a secure surface rather than holding it. And remote control is faster: You don't have to wait 10 or 12 seconds for the camera to fire as you do with the self-timer.

✔ **Continuous wind mode.** *Typical icons: "C"; "Cont"; three overlapping rectangles* (see Figure 4-13). Found on a fair number of cameras, this mode sets the camera to keep shooting picture after picture (automatically advancing the film after each shot) for as long as you hold down the shutter button. Normally, to take more than one shot you have to release pressure from the shutter button and press down again, which causes the camera to refocus. Because continuous wind eliminates the need for

the camera to refocus for each shot, you can take sequences of pictures a bit faster than you can by shooting a single picture at a time — which is why this mode is good for fast-changing action. (Did you say kids acting up in the pool?) But you do have to make sure that your subject is approximately the same distance away for all your sequence shots. And how fast you can really capture the action is limited in other ways.

Figure 4-13:
Typical icons for continuous wind mode.

Even in continuous wind mode, most point-and-shoots can't take pictures at an especially fast rate to begin with. They chug along at maybe a picture per second — one frame-per-second (1 fps), in photospeak. Some models can do a frame-and-a-half per second (1.5 fps). And the occasional model has a special *burst* capability that allows perhaps four shots — bam bam bam bam — in a second. But generally, you're better off developing a ready eye and quick finger than depending on the law of averages to get a few good shots out of a rapid-fire sequence.

✔ **Interval timer or intervalometer mode.** *Typical icons: "Int"; "Interval"* (see Figure 4-14). You find this somewhat obscure mode on feature-packed point-and-shoots at midrange price and above. It takes a sequence of shots, unmanned or unwomanned, one at a time at specific intervals. For example, you may be able to set the camera to take eight pictures over two hours, one every 15 minutes. (You usually can set intervals anywhere from ten seconds to one hour.)

Figure 4-14:
Typical icons for interval timer mode.

Typically, you ready the camera for interval shooting by pressing a button to toggle through drive modes until you get to the intervalometer mode. Then you use a separate button (or, on some cameras, the zoom lever) to toggle through different intervals, which are displayed on the

LCD screen — 10 sec, 20 sec, and so on. You set the number of frames that you want in the same way. The procedure is very much like setting a VCR or a digital watch (simple, right?), but you'd better have your manual handy! Most cameras with this feature also cleverly shut themselves off between shots to conserve power.

An interval timer can be fun for time-lapse photos of that prize bloom opening in the backyard. Also a gas at parties: Set the camera up in a busy corner to take a shot every few minutes!

Focusing modes

Less expensive point-and-shoots use a fixed-focus lens design that basically tries to make everything reasonably sharp from around four feet on out. These focus-free models, as they're often sweetly called, do eliminate the need to think about focusing. You get better results with cameras that focus their lenses automatically. But you have to give focusing some thought — and know when to push the right button — to fully reap their benefits. (See Chapter 6 for more on focusing.)

Autofocus cameras usually have a central focus point in the viewfinder, marked with lines or brackets. You place the focus point on the most important part of the scene (the main subject) to make the camera focus there. When you press the shutter button halfway, the camera locks the focus on that part and holds it until you release pressure. If you want your main subject to be off-center, you may have to recompose before shooting. But increasingly point-and-shoots have wide-area autofocusing systems that allow them to correctly focus subjects that are a little off-center in the frame. Even if your camera fits this description (check the manual), locking the focus is a good idea (see Chapter 6). And whether your camera has this feature or not, it may have other focusing modes that let you tinker with how it goes about focusing.

✔ **Infinity lock mode or landscape mode.** * *Typical icons: a mountain(s); the sideways-8 infinity sign; "Landscape"* (see Figure 4-15). Infinity lock sounds like a doohickey on the warp drive of the Starship Enterprise, but it's actually a feature on most autofocus point-and-shoots and really a very simple thing. It basically overrides the camera's autofocus, setting the lens to focus far away — no ifs, ands, or buts. *Far away* in photographic terms just has a fancy name: *infinity.* Infinity is the distant point beyond which an autofocus camera doesn't have to fiddle with focus anymore. Use this mode when photographing a landscape that doesn't have any important foreground detail or when shooting through glass, which can confuse many autofocusing systems. (Infinity lock/landscape mode usually turns off the flash because it might reflect in a window — and isn't powerful enough to light a distant landscape anyway.)

Figure 4-15:
Typical
icons for
infinity lock
mode.

✔ **Spot autofocus mode.** *Typical icons: Small, solid circle inside a rectangle;
"Spot"; "Spot AF"* (see Figure 4-16). Many point-and-shoots now feature
wide-area or *multipoint* autofocus. In this default focusing mode, the
camera can often tell when the subject is not perfectly centered in the
frame, correctly focusing it when other models may mistakenly focus on
the background. But what if you're a Nervous Nellie (or Ned) and want
to be absolutely sure that the camera focuses exactly where you tell it
to? Setting spot autofocus disables the wide-area autofocus and limits
the focus point to a smaller, central area instead, giving you greater pre-
cision in the placement of the focus point. (Note that spot autofocus is
often automatically set in tandem with another mode, spotmeter.)

Figure 4-16:
Typical
icons
for spot
autofocus
mode.

✔ **Snap mode.** *Typical icon: "Snap"* (see Figure 4-17). You find this
mode on very few point-and-shoot cameras. It overrides the autofocus,
like infinity lock, but instead of focusing the lens far away the camera
sets it to a medium distance (usually in the 6- or 8-foot range), which is
where the main subject is likely to be in a typical quick snapshot. The
point? Snap mode lets you shoot faster because the lens doesn't have
to refocus for each picture. Some snap modes set the camera to continu-
ous wind; zoom models may also keep the lens locked at its most wide-
angle setting, where you have a better chance of getting sharp pictures.
If you're interested in the sort of quick, off-the-cuff candid photography
of people that enthusiasts call *street shooting,* snap may be your mode.
Remember, though, that your subjects may have to be in that snap range
of 6 to 8 feet to be acceptably sharp.

✔ **Macro mode.** *Typical icons: tulip; "Macro"* (see Figure 4-18). Still present on a fair number of mid- to high-priced cameras, macro mode lets the camera focus closer than it ordinarily can at standard settings — call it a close-up mode. To use macro mode, you normally have to stay within a certain narrow distance range from your subject. (Check your manual!) You can stay within this range by looking through the viewfinder and pressing lightly on the shutter button while watching the green focus-OK lamp, which blinks if you're too far or too close. Some macro modes also trigger the flash — even when the subject is pretty bright — to make sure it gets enough light.

Figure 4-17:
A typical icon for snap mode.

If macro mode sounds like kind of a pain, well, it is. More and more cameras simply shift automatically into a macro-type range when you aim the camera at a close object — a much more convenient system. But if your camera does have macro mode, check the manual carefully to determine how to use it.

Figure 4-18:
Typical icons for macro mode.

✔ **Manual focus mode.** *Typical icons: "manual focus"; "MF" with numerical readout of the distance* (see Figure 4-19). You're unlikely to see this mode on your camera unless you have a pricey designer model. It allows you to manually focus at, say, 3 feet or 5 feet or 7 feet. Although not especially useful, manual-focus capability does let you set focus on a certain distance and keep it there for a series of shots without refocusing, which can be helpful if you're taking a lot of shots of the same scene or portrait. This is focusing the old-fashioned way, except that you're likely to have to do it with pushbuttons or a dial instead of the focusing ring found on the lenses of traditional, non-autofocus cameras.

Figure 4-19:
Typical
icons for
manual
focus mode.

Subject or picture modes

The idea behind subject or picture or program image modes (all three mean the same thing) is simple: Optimize the camera's various settings for a certain kind of subject, whether portraits, action, or landscapes. In practice, though, using subject modes can get kind of complicated. Usually what the camera is doing here is setting several modes in combination — a combination that you may not necessarily want. And in most cases, the camera isn't doing anything that you can't do by adjusting the individual modes. But don't let me turn you off subject modes. If you're still puzzling over all your camera's flash and drive and focus modes, setting, for example, portrait mode when you're taking a portrait gives you a quick starting point without fussing and fuming over a bunch of buttons. So if you try a subject mode and really like how it works, use it!

✔ **Action mode.** *Typical icon: running man* (see Figure 4-20). You find this mode on a number of higher-priced point-and-shoots, and it's one of the few modes that has a nearly standardized icon. Too bad the mode itself isn't standardized: How it works varies widely from camera to camera. With almost all models, action mode sets the drive mode to continuous wind. With some models, it also turns off the flash, which makes sense; waiting ten seconds for the flash to recharge is hardly the way to snap fast sequence pictures.

Figure 4-20:
A typical
icon for
action
mode.

If the light is low, on the other hand, having no flash may very well result in blur with a fast-moving subject. Contrary to what that running man icon may lead you to think, action mode does not usually make the

camera set a higher, more action-stopping shutter speed. Point-and-shoots are pretty much designed to set as high a shutter speed as they can *in any mode,* given the light level and the film speed.

The best way to stop action is not by setting action mode. Action mode can help you capture moving subjects, but the only surefire way to get your point-and-shoot to set a higher, more action-stopping shutter speed is to use a faster film (see Chapter 2).

On a few high-end models, action mode does trigger a special auto-focusing trick. In it, the camera focuses continuously — that is, it keeps readjusting the focus to keep a moving subject sharp. Such models may even have *predictive* autofocus, which actually anticipates the subject's distance at the moment the shutter fires — and focuses accordingly! Note that you can't lock the focus when you're in this mode — nor would you want to. Check your manual for details.

✔ **Portrait mode.** *Typical icon: person's head and shoulders* (see Figure 4-21). Often found on the same upper-crust cameras that have action mode, portrait mode is another anything-goes mode that varies in operation from model to model. But with many models, this mode sets an *autozooming* or *autoframing* function. (Some models even call it "Autozoom" mode.) Autozooming? Yes. Touch the shutter button lightly to focus and the lens automatically zooms to produce a half-height portrait. It basically frames your subject for you, from about the waist up — though the smaller your subject, the more you get. (With toddlers, you may even get the whole kid!) Having the zoom lens zip in and out on its own is a little disconcerting, I find. Anyway, who says a waist-to-head shot is always the best portrait framing?

Portrait mode may, in some cameras, also automatically trigger fill flash, which is usually a good thing — but what if you think the portrait would be better with existing light? Something else to keep in mind: Portrait mode is designed for photographing people. Focus on a tree at a middling distance, and it will zoom in to get a shot of the trunk, which can drive you a little crazy after a while. So make sure to switch your camera out of portrait mode after you're done with the people shots!

Use portrait mode when you're handing the camera to someone else to take your picture or perhaps when you let a child use the camera. Other times you're usually much better off making your own decisions about zooming and flash.

Metering modes

Using its built-in light meter, your point-and-shoot actually measures the light level in the scene you're photographing. The meter uses this information to set the camera so that the film (or in the case of a digital camera, the light-sensing chip) receives the amount of light it needs for a correct exposure.

Point-and-shoot meters can be quite sophisticated; they may be able to detect strong backlight, for example, and automatically tell the camera to fire the flash or add exposure to compensate for it. But in certain lighting situations, the camera may botch the exposure. And in other situations, you may just want the picture to look different — to be a silhouette, for example, or a *high key picture* (the sort where all the tones are light, for a soft, airy look). Metering modes allow you to change the way that the camera evaluates light or to actually second-guess that evaluation.

Figure 4-21:
A typical
icon for
portrait
mode.

✔ **Spotmeter mode.** *Typical icons: small, solid circle in a rectangle; "Spot"* (see Figure 4-22). This mode sets the camera's light meter so that it reads just a small area of the scene, rather than the whole thing. The area is almost always in the center of the viewfinder frame, often indicated with a little circle surrounding the central focus point. After you set the camera to spotmeter mode with the correct button (and the LCD icon), you place the spotmeter circle over the area you choose — usually the most important part of the scene — and press the shutter button halfway to lock in the exposure settings. Then you frame up your final composition and press the shutter button all the way to take the picture.

Figure 4-22:
Typical
icons for
spotmeter
mode.

The spotmeter mode is most useful for fussy shooters. If your subject has strong sunlight coming from behind, for example, you can place the spotmeter circle directly on his or her face to make sure that the camera measures that exact tone, not the brighter sun behind. Spotmetering can also be valuable with slide film, which requires more accurate exposure than easygoing print film. Its drawback: It's almost always set in conjunction with spot autofocus.

If your camera pairs spotmetering with spot autofocus (check the manual), you can make a big boo-boo if you don't pay attention. Suppose that you're shooting a portrait against some beautiful fall foliage in the distance. You want to be sure the trees are properly exposed, so you aim the spotmeter at them and press the shutter halfway to lock exposure. Then you recompose to take the portrait. What do you get? A beautifully exposed picture with your main subject out of focus, because the camera also *focused* on those distant trees when you locked in the exposure. This example is one reason why I prefer point-and-shoots that have just a plain spotmeter function, but those models are few and far between.

✔ **Manual backlight compensation mode.** *Typical icons: sun behind a person; "+1.5 EV"; "BLC"* (see Figure 4-23). Some point-and-shoots automatically compensate for backlight by increasing the exposure — the amount of light the film receives. But this mode, found on a fair number of point-and-shoots, allows you to make sure that it's happening. By pressing this marked button (or rotating a dial to the icon), you make the camera add a certain amount of exposure. The amount is almost always 150 percent more, which is expressed photographically as +1.5 EV. (For more on backlight compensation, see Chapter 9.)

Figure 4-23:
Typical icons for manual backlight compensation mode.

✔ **Exposure compensation mode.** *Typical icon: "EV" and a plus- or minus number* (see Figure 4-24). This mode, seen on some high-end point-and-shoots, does backlight compensation one better. It lets you dial in (or press in) a specific amount of variation from what the camera says is correct exposure — twice as much (indicated by +1 EV), half as much (indicated by –1 EV), and so on. Exposure compensation is mainly useful for photographers who are experimenting with slide film (see Chapter 2). Most others should leave this mode alone.

Figure 4-24:
A typical icon for exposure compensation mode.

✔ **Aperture-priority autoexposure mode.** *Typical icons: "AV"; "Aperture" plus an f-stop number* (see Figure 4-25). This advanced mode lets you set the exact size of the lens aperture, the window in the lens that lets light into the camera. (A specific-sized window is called an *f-stop*.) One thing is certain: Aperture-priority autoexposure mode gives the advancing shooter a new level of camera control. But because you find this mode on only a few high-end point-and-shoots and you don't *have* to use it with them, I suggest not worrying about it for now.

Figure 4-25:
Typical
icons for
aperture-
priority
autoexpo-
sure mode.

Creative modes

Modes can't really be creative — you're the creative one, right? But when you're feeling inspired, so-called creative modes let you play with exposure, or flash, or focus, for unusual, arty, or just plain far-out effects. The effects are quite tasty, but a steady diet can lead to pictorial indigestion. You find most modes that I list here on just a few cameras in the mid-to-high price range.

✔ **Bulb mode.** *Typical icons: "Bulb"; "B"* (see Figure 4-26). Named after the old-time airbulb cables with which our photographic forefathers often snapped their shutters, this simple mode opens the shutter after you press the shutter button and keeps it open for as long as you bear down. It closes the shutter only after you let up on the shutter button. Bulb mode lets you take time exposures of ten seconds, ten minutes, or more. If you put the camera on a steady support and photograph moving traffic at night, for example, it gives you those saucy red and white streaks of glowing spaghetti. If you live or work near an airport, it's also interesting for shots of planes landing at night. Best bet: Use print film, because it forgives exposure errors.

Figure 4-26:
Typical
icons for
bulb mode.

A *time exposure* is a picture made with the shutter kept open deliberately for a long time — usually more than one second. Long exposure times allow nonflash photography of a very dark scene or create interesting streaky effects with moving objects.

🗸 **Multiple exposure mode.** *Typical icons: two frames overlapping one another; "Multi"* (see Figure 4-27). In a way, this feature can also be considered a drive mode. What it does is actually stop the film from advancing so that you can deliberately expose one piece of film with two or more different scenes. Depending on your tastes, you may like what you get — somebody's face hovering in the sky, or your wife standing on two sides of the same tree. And depending on your eye, you can actually plan the exposures so that they work together. (For that shot of your wife standing on both sides of a tree, for example, you have to keep the camera in the same position for both exposures. Keeping the camera in one exact place is best done with a tripod, although positioning the camera carefully on some other firm support would work, too.)

Figure 4-27:
Typical
icons for
multiple
exposure
mode.

MULTI

If multiple exposure sounds like a dicey mode, you're right. All cameras that have it immediately default back to the previous mode after you've made two exposures, which, as you may guess, is called a *double exposure.* However, most such models let you take still more exposures on the same frame, as long as you keep resetting the multiple-exposure mode.

Getting in the Mode

Phew! If you perused the previous section on all the different modes you might find on a point-and-shoot camera, you may have gotten the idea that point-and-shoots are pretty darn complicated. Trust me, they're really not. I made that long list only so that you can go back and refer to the specific modes your camera has and understand what your model can and cannot do. An important suggestion, though: Familiarize yourself with how your camera cancels or doesn't cancel mode settings. Some cameras cancel infinity lock

mode, for example, after one shot. Others stay in infinity lock until you change the mode or turn off the camera. Do yourself a favor: With your empty camera, set each mode and snap the shutter to see whether the mode remains active or is canceled.

You may also be muttering to yourself, "Gee, they put all these modes on the camera and a lot of them are no big whoop." Exactly. Much of current camera design, unfortunately, is the result of marketing considerations rather than concern for user-friendliness. The thinking is that a camera with 12 modes is better (both more salable and more profitable) than a camera with six modes. But *you* know that it isn't better if those half-dozen extra modes do things you'll never need.

Do you suffer from *moditis?* This affliction comes from taking a picture with an unwanted or incorrect mode setting. For example, if you shoot a portrait in infinity lock mode, your main subject will be utterly unsharp. If you leave the camera in action mode when you come indoors, you may miss a great shot because the flash won't fire. Keep in mind that most cameras reset themselves to default mode(s) after you turn them off and on again. If you're in doubt about the modes you're using, don't hesitate to do this.

So just don't fret about modes. And don't get button-happy, either. Photography is mostly about *seeing* and self-expression, not pushing buttons. Think about changing modes when you're in specific situations: When the light is very bright, or very dark, or the difference between what's bright and what's dark is big, or when something like a window comes between you and the picture. Your most important weapons are the flash modes, infinity lock, and the self-timer. If you get adept at using a few other modes for creative effect, that's gravy. And don't forget: You always have autoflash!

Shoot first and ask questions later. Don't miss a picture because you're worrying about what mode to use. If you see a picture possibility, grab the camera, turn it on, and take the shot — in autoflash. Autoflash covers most photographic situations. After you're sure you've gotten a shot, slow down and think what else you could do. Would fill flash add detail to the picture? Would the scene be more dramatic in panoramic form? Then set that mode and take another picture. After a while, your second guess will come faster and faster. And you'll see the change in your pictures.

Chapter 5

Seeing through Your Camera

● ●

● ●

*Y*ou've probably noticed that when people ask to see your camera, the first thing they do is look through the viewfinder — not at the camera. It's a reflex. They seem to understand that the viewfinder is your window on a world of photographic possibilities, and far more important than any button or dial on the camera.

Within this window's frame, of course, is where you arrange your pictures. In some cameras, that frame is defined by the opaque black edges that you see when you look through the viewfinder. In other cameras, it may be indicated with light or dark lines just inside the black edges; these are called, fittingly, *frame lines*. And in some very simple cameras (one-time-use models, for example), the frame may be nothing more than a rectangular opening in a piece of cardboard or plastic — a window without glass.

Digital point-and-shoots have complicated my window analogy. Though most of these high-tech models have a viewfinder, most also have a small, TV-like color screen — it's the most prominent feature on the camera's busy back — with which you can frame your subject. For simplicity's sake I call it the *viewing screen,* but it's sometimes called a "color LCD monitor" in photo books and magazines. This screen also displays a menu with which you adjust a number of camera settings, as I explain in Chapter 4, and can be used for reviewing pictures you've already taken.

The viewing screen and the viewfinder share a single purpose: to show you what part of a scene your camera's lens will put on film, or on the image sensor, when you press the shutter button. Of course, you're the one who really determines what the lens puts on the film or image sensor, by looking through the viewfinder or at the viewing screen and moving yourself and the camera, and, in some cases, by zooming the lens. This process, and its result, is called *composition.* (For more about the art of framing your subject, see Chapter 10.) But before you can even think about composition, you have to understand just how the viewfinder or viewing screen works together with your camera's lens. That's what this chapter, and the next, are all about.

Changing the Picture

You can change the view through your point-and-shoot's viewfinder window, or on its viewing screen, in a variety of ways. Move closer to something, and that object gets bigger in the frame. Move back, and the object gets smaller. The object's appearance also changes when you tilt the camera up or down from a low or high position, which of course requires a little squatting or scrambling. But if you have a *zoom lens* on your point-and-shoot, you can change the view in another way — without moving at all.

When you turn on a point-and-shoot with a zoom lens — call it a zoom point-and-shoot — it starts out just like a nonzoom model. Look through the viewfinder, or at the viewing screen, and you see that it's filled with a good-sized chunk of the scene in front of you. By zooming, you can get a closer view of parts of that scene. First, though, you have to figure out where your zoom controls are. Perfectly smart people own point-and-shoots for years without ever touching these controls!

Be sure that you know where your viewfinder's frame edges are. (See Figure 5-1.) In cameras that have frame lines, you must compose a picture within the lines. If you don't, you may inadvertently cut off part of the subject. (The top of someone's head is the most common casualty.)

Do you have a zoom lens?

If you don't know already, first make sure that you *have* a zoom point-and-shoot. Turn the camera on. Generally, zoom lenses protrude a little more than nonzoom lenses when the camera starts up, though that's not a hard-and-fast rule. And zoom models have writing on their lenses with two numbers rather than one: *35–70mm* or *38–115mm* is a zoom; just plain *38mm* or *35mm* or *32mm* is not a zoom (see Figure 5-2). But the giveaway is a control lever or buttons for the zoom lens. Here's what to look for; check your manual if you're still not sure.

Figure 5-1:
With some point-and-shoot viewfinders, you use the opaque black edges of the window to "frame" your subject (left). With others, you use "frame lines" just inside the black edges (right).

Most zoom point-and-shoots' zoom controls take the form of a rocker or toggle switch, usually on the back of the camera behind the shutter button. You operate this kind of switch by rocking or sliding it from side to side with your right thumb. But some models have two little buttons on the right side of the camera top, near the shutter button; you press one and the other alternately with your shutter-button finger to adjust the zoom. (Using these buttons requires that you remove your finger from the shutter button, obviously.) And some models have similar buttons on the left side of the camera top, designed to be operated by the forefinger of your left hand. (You can press these buttons without removing your finger from the shutter button, not a bad idea.) A few cameras have a little nub near the shutter button; you wiggle it back and forth to adjust the zoom. (See Figure 5-3 for typical zoom controls.)

Figure 5-2:
If your lens has one number (left, 34mm), it's not a zoom. If it has two (right, 30-60mm), it's a zoom.

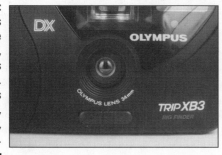
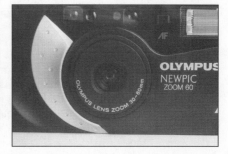

No matter what shape or form your zoom control takes, rocking or sliding or pressing or wiggling it causes the lens to extend or retract, most often by way of telescoping tubes. If you look through the viewfinder window, or at the viewing screen, while you're adjusting the control, you can see that the view changes: Things seem to get closer or farther away, depending on which way you move the zoom switch or which button you press — without even moving your feet!

Figure 5-3:
Zoom controls come in all shapes and styles, from rocker switches (left) to push-buttons (right).

Zooming in versus zooming out

Adjusting a zoom lens to make things look bigger in the frame is called *zooming in,* because its effect is something like physically moving in toward the subject. Adjusting a zoom lens to make things look smaller in the frame is called *zooming out,* because its effect is something like physically moving out, away from the subject.

What's confusing is that when you zoom in — that is, adjust the zoom lens to make the subject bigger in the frame — the lens actually extends farther *out.* And when you zoom out — that is, adjust the zoom lens to make the subject smaller in the frame — the lens actually pulls back *in,* retracting toward the camera body. My suggestion: When I talk about zooming in and zooming out, ignore what the lens is physically doing. Just pay attention to what's happening in the frame!

Though you can plainly see these changes through your viewfinder, or on your viewing screen, the zoom controls are often marked to tell you which direction or button makes the subject bigger or smaller. Many models use tree symbols. Slide a zoom rocker switch toward a single, large tree symbol, and it zooms the lens in, making your subject bigger in the frame. Slide a zoom rocker switch toward a cluster of (usually) three small trees, and

it zooms the lens out, making your subject smaller in the frame. Some models' zoom controls are marked with the letters *T* and *W,* which stand for *tele* and *wide,* terms that I explain later in this chapter. And some zoom controls are imprinted with those full words. Slide the switch toward *T* or Tele, or push the button marked *T* or Tele, and your subject gets bigger. Slide the switch toward *W* or Wide, or push the button marked *W* or Wide, and your subject gets smaller. Again, though, the best way to see what happens when you zoom is to just look through the viewfinder or at the viewing screen.

Angling for Better Pictures

On zoom point-and-shoots, the viewfinder window is really just like a small, second zoom lens. When you zoom your camera's lens to make things bigger or smaller, the viewfinder zooms right along with it. The same is true of a digital point-and-shoot's viewing screen; the difference is that because the viewing screen is electronically connected to the image sensor, it shows you the actual picture formed by the lens. Either way, you see what the lens sees at every zoom setting. And here's the good part: You can take a picture at *any* of those settings — zoomed all the way out, zoomed all the way in, or anywhere in between. These different settings are called *focal lengths.*

Focal length is a number used to describe both a lens's *magnification* (how big or small it makes the subject) and its *angle of view* (how much or how little of the scene it puts on film), two closely related photographic properties. The number is always followed by *mm,* which stands for millimeters.

Please don't choke on the term *angle of view.* I'm not talking philosophy or politics here. For photographic purposes, angle of view simply refers to how big a piece of the scene the lens takes in. If it takes in a big piece — as a zoom lens does when it is zoomed out — it has a wide angle of view. If it takes in a smaller piece — as a zoom lens does when it's zoomed in — it has a narrower angle of view.

A short focal length — say, the 38mm setting on your 35mm zoom point-and-shoot — reduces magnification, giving the lens a wider angle of view. In other words, by making everything in the scene smaller, it can put more of it on film. (Sort of like looking out through the peephole on an apartment door.)

A long focal length — say, the 105mm setting on your 35mm zoom point-and-shoot — increases magnification, giving the lens a narrower angle of view. In other words, by making everything in the scene bigger, a long focal length can't fit as much of the scene on film. (Sort of like looking through a telescope or binoculars.) Keep in mind, though, that focal length numbers can mean different things depending on what kind of camera you have — 35mm, Advanced Photo System, or digital. (For the full scoop, see the sidebar, "Film format: The long and short of it," later in this chapter.)

Don't confuse focal length numbers (which are always followed by mm, for millimeters) with the 35mm film format used by most point-and-shoot cameras. When a camera is said to be a 35mm model (as opposed to an Advanced Photo System or digital model), 35mm simply refers to the width of the strip of film in the standard cassette that it's designed to accept.

When a camera is said to have a 35mm lens (as many nonzoom 35mm point-and-shoots do) or to have a 35–70mm zoom lens, 35mm is a reference to the lens's focal length. Focal lengths come in all different numbers; 35mm is just one of them, but the main source of this confusion. So when I talk about a 35mm point-and-shoot, that's simply a reference to the film the camera uses. And when I talk about a point-and-shoot with a 35mm lens, that's a reference to the camera's focal length. In fact, I may even talk about a 35mm point-and-shoot with a 35mm lens, which happens to be a very popular combination!

Remember that even nonzoom point-and-shoots have a focal length — one focal length. For this reason, they get the gee-whiz name of *single-focal-length* models. This term is just a fancy way of describing what is, in camera terms, the plain-vanilla version. If you want, you can call a zoom model a multiple-focal-length or a variable focal-length camera. But you don't have to, because that jazzy little word *zoom* says it all.

An important note to folks with nonzoom, single-focal-length point-and-shoot cameras: There's no need for zoom-lens envy! A zoom is a great tool for picture-taking, as this chapter explains. But you can vary your lens's view enormously with a single-focal-length camera. You just have to use that most valuable of photographic accessories, your feet. In fact, a serious *disadvantage* of zoom cameras is that they encourage photographic laziness: People plant their two feet wherever they may be, hoist the camera to their face, and just stand there and wiggle their zoom levers (in public, no less) to change the picture in their viewfinder or viewing screen. This is why the little exercise in the sidebar "Using your own built-in zoom — your feet" is just as much for zoom shooters as nonzoom shooters.

But sometimes changing position just can't change your angle of view as much as you want. Say that you're trying to get your whole backyard in the viewfinder. You probably keep stepping back and stepping back until your back is against the side of the garage. Even when you can get as close as you want, it's sometimes too close. If you want a close-up of your daughter's face as she concentrates on a chess match, you can move the camera until it's right in her face — but that would destroy the moment, let alone her concentration. Or if, being a more athletic type, she's playing catch, you can move the camera in until you're right next to her — but you would interfere with the game, and quite possibly get bonked.

Film format: The long and short of it

Point-and-shooters have three self-contained photographic systems available to them: the traditional 35mm film system, which has been around for decades; the Advanced Photo System (APS), with its smaller, encapsulated film; and digital cameras, which don't use film at all. Each system offers much choice in lenses. And the area of lenses is where their differences are most confusing. To whit: A 38mm focal length on a 35mm camera is somewhat wide-angle. On an APS camera, it's a normal focal length. And on a most digital point-and-shoots, 38mm would be a super telephoto focal length!

Isn't a wide-angle a wide-angle a wide-angle? Nope. The angle of view of a lens depends not only on its focal length, but on the size of the piece of film (or, in a digital point-and-shoot, the size of the image sensor) that it is expected to fill. Of the amateur photo systems, 35mm uses the biggest piece of film, comparatively huge at an inch by an inch and a half per frame. The smaller APS film frame is about two-thirds that size. And an image sensor commonly found on digital point-and-shoot cameras is a sub-dinky $\frac{3}{16}$ x $\frac{1}{4}$ inch — not quite the size of the fingernail on your pinky!

The bigger the piece of film, the more of the lens's image it can record. Imagine the postage-stamp-sized piece of film in a 35mm camera, with an image formed by the lens projected on it. Now imagine the smaller piece of Advanced Photo System film in the middle of the 35mm film. It records a smaller section of the lens's image than the 35mm film, and if you were to print that image as a standard-sized print, it would show a narrower slice of the subject than the 35mm film. Next, imagine a digital point-and-shoot's tiny digital chip sitting in the middle of the APS film. (You could probably fit a dozen or more such sensors on it!) The sensor records only a very small center portion of the lens's image, and if you were to print *it* as a standard-sized print, it would look like a big blowup of the center portion of the APS or 35mm print.

As a result, the normal focal length for a typical point-and-shoot image sensor — in other words, one that would produce a middling angle of view, not a super telephoto one — is around 7mm or 8mm. Normal for Advanced Photo System film is around 40mm. And normal for 35mm film is around 50mm.

When you go to buy an APS or digital point-and-shoot camera, in fact, you will often see the lens's focal length expressed as an *equivalent*. This terminology means the manufacturer has figured out what focal length it is closest to in the familiar 35mm system — the one that gives you about the same angle of view. To further that effort, I offer the following table of typical focal lengths that you find on these three kinds of point-and-shoot cameras, and their equivalents.

Format	Wide-Angle	Moderate Wide-Angle	Normal	Tele	Long Tele
35mm	28–30mm	34–45mm	45–55mm	60–100mm	105–160mm
APS	22–24mm	26–35mm	35–45mm	48–80mm	85–125mm
Digital	*	4.5–6.5mm	6.5–8mm	8.5–14mm	15–23mm

*As of this writing, few digital point-and-shoots come with lenses having true wide-angle focal lengths.

These situations are when you want to change focal length: to slide or push those zoom controls, if your camera has them. To capture that gargoyle on your neighbor's house, the solution is to zoom in. (In photo jargon, you're changing to a longer focal length setting, same thing as telephoto.) If you want to get more of your backyard in the viewfinder frame, you need to zoom out as much as possible. (In photo jargon, you're changing to a shorter focal length setting, same thing as a wider angle of view.) For that close-up of your chess whiz, zooming in is also the way to go — in this case, not because you can't get closer but because you want to keep a greater distance between the two of you so as not to distract her. And you can stay clear of that game of catch, and still get your shot, by zooming in. In giving you all these other chances for a picture, zoom lenses are like magic feet.

Going Wide — and Long

Once upon a time, if you wanted to change the angle of view of your camera's lens, you had to have a camera with interchangeable lenses. You had to twist off one lens and replace it with another one having a different angle of view. Replacing the lens was the only way you could switch from the short focal length that was best, say, for scenic photos, to the long focal length that was best for the close-up portrait that you now wanted to shoot. Many a good picture was lost in the time you spent making the switch.

The zoom lens put an end to that struggle. More than a convenience that lets you change your angle of view without changing lenses, it also lets you fine-tune your focal length. Say you have a 38–90mm zoom, very common on 35mm point-and-shoots. You can zoom to, and take pictures at, 38mm and 90mm, of course. But you can also shoot at 45mm or 70mm or any other intermediate setting. Even 56½mm. And these multiple settings can help you not just fit the subject in the frame, but quickly tweak composition when you can't take the time to move in and out.

A zoom lens is described by its *focal length range,* an indication of its shortest and longest focal length settings. A 38–90mm zoom point-and-shoot has a focal length range of 38–90mm; you would say this aloud as "38 to 90 millimeters," or for short, just "38 to 90." A 38–105mm zoom point-and-shoot is said to have a focal length range of "38 to 105," with the 105 pronounced "one-oh-five." (Focal lengths beyond 100mm are pronounced this way; 135mm would be "one-thirty-five," for example.)

Keep in mind that when you turn on a zoom camera, its lens starts out just like the lens on a single-focal-length camera. It has the same, or a very similar, focal length setting — perhaps 35mm or 38mm for 35mm cameras, 28mm or 30mm for APS cameras — as a single-focal-length model's single focal length. Likewise, a zooming digital point-and-shoot with an actual focal length range of 7–21mm would start out at a focal length of 7mm.

Using your own built-in zoom — your feet

No matter what kind of lens you have on your camera — zoom or nonzoom — that lens can provide you with all sorts of different views of a single subject. Turn on your camera and look through the viewfinder, or at the viewing screen, at a scene that you want to photograph — something simple like a friend in your backyard, an unusual house on your street, or your kids in a local park. (If you have a zoom model, leave the zoom controls alone for now.) Frame the scene in the viewfinder the way that you normally would. All set?

Now do everything that you usually *wouldn't* do. Get low to the ground — I mean low — and see how that changes the scene in the viewfinder. Get up high — maybe stand on a chair or step stool, or the ladder of your kids' slide, or a deck or balcony — and see how that changes the picture. Move in closer. Now closer than that. Move back. Now farther back. See something

that looks interesting, or even a little strange, from one of these different positions or angles? Take the picture! The point here is to discover how many different ways you can frame a picture, regardless of what kind of point-and-shoot you have. Even the simplest camera gives you a lot of framing options. (And check out Chapter 10 for framing tips that apply to *any* kind of camera.)

If you do this exercise thoroughly, though, you'll notice that you can't get some pictures simply by changing your position or angle. That curious architectural detail just below the roofline of your neighbor's house? You can't get close enough to fill the viewfinder with it just by moving yourself. (Maybe you can do this with a long ladder, but unless you're a house painter or roofer, you're unlikely to have one — and your neighbor would be suspicious!) With subjects like this, a zoom lens does come in handy.

Smart thinking is at work here. This moderate wide-angle setting is extremely useful for most kinds of pictures snapshooters take. You can take pretty close shots with it; you can step back a bit and still get all of a nice big landscape in the picture. It's a fine focal length for group shots and grab shots. It works as well on vacations as around the house. In short, it's a good compromise.

Like any compromise, though, a moderate wide-angle setting doesn't serve every purpose. If you want to fill the frame with a subject, you do have to be physically pretty close. (You have to use those feet of yours, and walk right up.) Moving in close is no problem if you're photographing blossoms in your backyard garden. People, on the other hand, aren't so thrilled when you put a camera inches from their nose, especially if they're crocheting a sweater or changing spark plugs. What's more, the picture you get when you photograph someone that close will more than likely be unflattering — marred by a big-nose effect that I tell you about shortly.

This sort of situation is when zooms are so useful. Fine, you're thinking, but how do I know when to zoom the zoom? Do I just zoom back and forth until the subject looks right?

Well, the fact of the matter is some focal length settings are better for certain kinds of pictures than others. You'll begin to understand which focal lengths are better for certain subjects as you shoot more pictures with a zoom point-and-shoot (see Figure 5-4). Choosing an appropriate focal length quickly becomes second nature.

The easiest way to understand focal length numbers is to break them up into three categories: wide-angle, normal, and telephoto (or just the abbreviation *tele*).

- Wide-angle focal lengths are the smaller numbers.
- Normal focal lengths are the in-between numbers.
- Tele focal lengths are the numbers that are bigger still.

With 35mm point-and-shoots, for example, the widest focal length I've seen is 24mm, the longest tele, 200mm. This range is different for Advanced Photo System and digital models, as you see in the sidebar "Film format: The long and short of it."

In fact, because the focal length numbers for digital point-and-shoots are so much lower than those on 35mm and APS cameras, the zoom lenses on these models are usually described instead by a *zoom ratio,* indicated with an X. There's nothing occult about it. The X is basically a times sign that, together with a number, tells you the relationship between the lens's longest focal length and its shortest — how much the zoom increases in focal length from start to finish. For example, a 38–115mm zoom can also be called a 3X (pronounced three-X) zoom because it roughly triples its starting focal length (3 x 38 = 114) when you zoom it all the way in. Likewise, a 38–80mm zoom can be called a 2X (pronounced two-X) zoom because it roughly doubles its starting focal length (2 x 38 = 76, which is close enough!). You can figure out your zoom ratio simply by dividing the bigger mm number by the smaller one.

Most zooming digital point-and-shoots have 2X, 3X, or sometimes 4X zooms. A 4X zoom on a digital point-and-shoot is the equivalent, in a 35mm model, of about 38–145mm. In fact, makers of digital point-and-shoots often describe their zooms' ranges as a "35mm equivalent" rather than by the actual, small focal length numbers that suit their small image sensor.

A simple way of thinking about the X-factor is in terms of magnifying power, much like binoculars. Zoom a 2X zoom all the way in, and it doubles the original size of the subject in the frame. Zoom a 3X zoom all the way in, and it triples the subject's size (see Figure 5-5). And so forth. Indeed, a few digital point-and-shoot models parallel common binocular magnifications in their zoom ranges, such as 6X, 10X, and even 12X.

Like most 35mm or APS point-and-shoots, digital point-and-shoots usually don't tell you what focal length you've set. They sometimes display a small zoom graphic along the edge of the viewing screen, one in which a tiny cursor moves along a bar marked "W" on one end and "T" on the other. About all it tells you is that you're somewhere in between the widest and the longest settings, but it may be somewhat helpful as you read on about wide-angle, normal, and tele focal lengths — each of which takes a different view of things (see Figure 5-4). Here's the long, medium, and short of it.

The whole wide world

Any fan of *National Geographic* magazine has seen photos along these lines: a white-water raft and its struggling crew against a background of towering Grand Canyon cliffs; the interior of a huge cathedral, from nave to chapel; a window view of a teeming street. These kinds of pictures are what you can get with a short focal length, also known as a wide-angle focal length.

A wide-angle focal length lets you take pictures when you're short on space — when backing up any further is impossible because you're against a wall, or on the edge of a cliff, or actually *in* that raft on the Colorado River. Thinking of these lenses as *reducing* lenses may help, because they make things look smaller than things do to your naked eye, and can therefore squeeze more stuff into the picture. As I mention earlier in this chapter, what wide-angle focal lengths do is sort of like looking through one of those peephole viewers in a door. The shorter the focal length setting, the more the lens can squeeze into the picture; a 28mm focal length on a 35mm camera can squeeze in much more than a 38mm, just as a 24mm focal length on an Advanced Photo System camera can squeeze in much more than a 30mm. Similarly, a digital point-and-shoot fits more of the subject in at 6mm than 8mm, though these models generally don't go as wide as their film-using counterparts.

A wide-angle focal length's mission in life may be to get more stuff on your film, but it does other things in the process. For one, it tends to exaggerate the size of objects or people in the foreground, and to make things in the background look farther away than they actually are. (See Chapter 9 for an example of this.) In producing this effect, a wide-angle focal length can help create a strong sense of depth or three-dimensionality. In extreme cases, foreground objects, photographed up close with a wide-angle lens, may seem to bulge out of the picture at the viewer.

You may think this is some weird optical effect, but it's actually the way your eyes work, too. Don't believe me? Recruit a cooperative family member or friend and put your face right up to his or her face. See the bug eyes and bulging nose? That's what the lens sees, too — and it's a good reason not to take close portraits of people with a wide-angle focal length.

Figure 5-4:
When you turn on your 35mm point-and-shoot (here, a 38–105mm model), you see a pretty big piece of the scene through the viewfinder. The lens automatically sets its shortest focal length — in this case, 38mm — to provide the widest view of your subject (top pair). Zoom the lens to the 70mm setting, and you get a tighter shot — one that looks as if you'd moved closer (center pair). Zoom to 105mm, and the framing is tighter still (bottom pair).

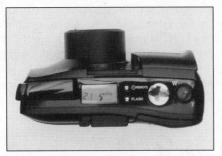

Lens set to 38mm

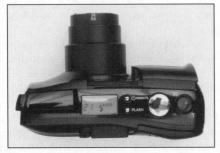

Lens set to 70mm

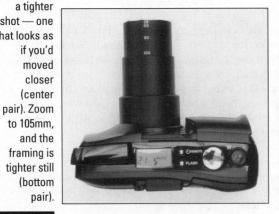

Lens set to 105mm

© Mark Harris (3)

Figure 5-5: When you turn on your digital point-and-shoot (here, a 3X zoom model), you see a pretty big piece of the scene through the viewfinder or on the viewing screen. The lens automatically sets its shortest focal length to provide the widest view of your subject (top pair). Zoom the lens halfway in, and you get a tighter shot — one that looks as if you'd moved closer (center pair). Zoom it all the way in, and the framing is tighter still (bottom pair).

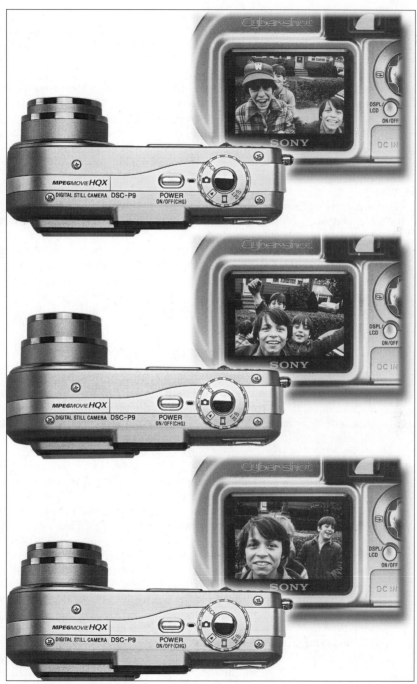

© Russell Hart (3)

But wide-angle focal lengths are supremely useful for all sorts of point-and-shoot pictures: the four kids and three pets acting up in the backyard, the (big) family gathering in the dining room, the den by window light, and, of course, your vacation shots.

Indeed, if you have a nonzooming (remember, single-focal-length) point-and-shoot, or if your zoom is set to a wide-angle focal length, you can still take good portraits — provided you shoot from the waist up, and no closer. In fact, the wide-angle is often the focal length of choice for a special type of people picture called an *environmental portrait*. No, it's not an ecological statement. It's simply a portrait photograph that includes a meaningful background or surroundings — an environment that says something about the person.

A picture of Grammie surrounded by the well-seasoned iron pots and pans of her cluttered kitchen tells you something about who she is, not just what she looks like. A picture of Uncle Clive seated at his workshop table with various parts for his vintage radio collection makes him more of a personality than if he were just standing by the garage door. Because people's personal environments are often small and enclosed, a wide-angle focal length helps show the main subject more in context.

The normal view

As you zoom your point-and-shoot's lens to slightly longer focal lengths, you get into the *normal* range — on 35mm models, about 45mm to 55mm, and on APS models, 35mm to 45mm. With most digital point-and-shoots, you get to this setting by zooming in just a little; if your camera displays zooming on a little bar graphic, as I describe earlier, its little cursor should be no more than about a third of the way from W to T.

The term *normal* actually has a technical meaning that I won't bore you with. Easier and more useful, just think of it this way: Normal focal lengths give you the most natural-looking rendition of the subject. Pictures taken at normal focal lengths appear neither magnified nor reduced. They neither exaggerate depth, like a wide-angle focal length, nor flatten the scene, as happens with tele focal lengths. And precisely because normal focal lengths give you no visual gimmicks to fall back on, you have to work especially hard with what's inside the viewfinder frame. You have to arrange the elements of the picture in an interesting way, or wait for the telling gesture, or take the shot in just the right light.

Many point-and-shooters, though, have the habit of using their zoom lenses at only two settings — zoomed all the way out and zoomed all the way in. They completely ignore the focal lengths in between, which include the normal range.

When what you see is not what you get

You may have noticed that when you look through your point-and-shoot camera's viewfinder, you're looking through a window that is above and/or to the side of the lens. This separation doesn't seem like much — maybe an inch — but it's enough to make the slice of the scene that you get on film a slightly *different* slice than what you see through the viewfinder. In extreme cases, things or people can be unexpectedly cut off. This effect is called *parallax error,* and digital point-and-shooters can avoid it altogether (and skip the rest of this sidebar) simply by composing close subjects with their camera's viewing screen.

For a quick demonstration of parallax error, close your left eye and look at something in the distance with your right eye. Now raise a hand to block your view of that distant object. Then close your right eye and open your left eye. See how your view shifts so that you can see the distant object again? Basically, that's parallax error. With your eyes, its effect is beneficial because it allows you to see things in stereo — three dimensions. But imagine what would happen if one eye were the viewfinder of your camera, and the other eye — with a very different view of things — were the lens.

The longer your lens zooms, the worse parallax error gets. And it's compounded when you're shooting something at a fairly close distance. In tight portraits taken with a point-and-shoot zoomed way in, you can end up cutting off part of the person's face in the picture — even though you can see his full face in the viewfinder.

The telephoto touch

Long focal length settings — those beyond 60mm on a 35mm point-and-shoot, or about 50mm on an Advanced Photo System model — are also known as *telephoto* focal lengths. With a zooming digital point-and-shoot, these settings start just shy of 2X; anything 2X and beyond is considered telephoto.

You use long focal length settings when you need to capture a subject that's at a distance, either because you can't get closer or because getting closer would call too much attention to your photographic intentions. Tele focal lengths magnify the subject — that is, they make it look bigger than it does to your naked eye. The longer the focal length, the greater the magnification. Think of looking through binoculars (basically, a pair of matched telephoto lenses).

Professional 35mm sports and wildlife photographers use telephoto lenses with focal lengths way longer than the longest one on your point-and-shoot's zoom — often 300mm, 400mm, and beyond. These high-powered, high-priced lenses allow them to fill the frame with a subject even though they must remain at a considerable distance from it. For technical reasons, 35mm and APS point-and-shoots can't approach this degree of magnification.

Digital point-and-shoots *can*, and a few (though not many) actually *do* reach the degrees of magnification available in supertelephoto lenses for 35mm cameras. These models' zooms go to 6X, 7X, and beyond.

When you zoom in with your camera, you're simply changing the focal length to a telephoto setting. But more is going on than simple magnification. Telephoto lenses tend to *flatten* or *compress* a scene. Things behind your main subject, in the background, seem to move up closer to it. Those greeting-card shots with a huge sun or moon looming on the horizon behind the lighthouse are extreme instances of this effect. (See Chapter 9 for other examples.) Telephoto compression is, in fact, the flip side of the effect that you get with a wide-angle focal length, in which the background seems to shrink in comparison to the main subject.

This flattening effect makes moderate telephoto focal lengths — those from about 70mm to 100mm with a 35mm zoom point-and-shoot, and from 55mm to 80mm with an APS model, or a zoomed-in digital point-and-shoot — highly prized for portraits. Because you can fill the frame with a face without getting physically all that close (arm's length or better), you don't get big noses or bug eyes or jutting jaws. (Well, let's just say the lens doesn't make what nature gave people any worse!)

Focal lengths from 70mm to 100mm with 35mm, and from 55mm to 80mm with the Advanced Photo System, are often described as *portrait telephoto*, for the flattering proportions that they bring to tight shots of people. In a digital point-and-shoot, the equivalent range is 2X to 3X.

Telephoto focal lengths are valuable if not essential for other subjects, of course — sports (your sprinting little soccer player), nature (the gorgeous cardinal in the backyard), distant scenes, and candid shots. They're often useful for close-ups because their extra magnifying power lets you stay at a reasonable distance from the subject instead of getting right on top of it for a tight composition. Shooting a skittish butterfly at three feet with your lens set to 105mm is easier than shooting it at one foot with the lens set to 35mm.

When zoom point-and-shoots are set to longer focal lengths, however, several problems can occur. One of them is called *parallax error*. Read more about parallax error, and its remedies, in the sidebar, "When what you see is not what you get."

Shifty business: Getting close to a subject at telephoto settings

If you take fairly close pictures with a point-and-shoot zoomed to a long focal length, your subject will end up shifted or even cut off in the actual pictures. If you have a digital point-and-shoot, you can sidestep this problem by composing with its viewing screen. To prevent this problem with a 35mm or APS model, you must use the viewfinder's *close-up correction marks*.

Close-up correction marks (also called a *close-up frame*) are a set of lines, or sometimes a corner-shaped bracket, inset within the clear area of the viewfinder window. You should use these marks when you're taking a shot from fairly close to the subject, and/or when you're using a long focal length setting. Here's how.

First, compose the picture as you normally would. Note what's at the top edge of the viewfinder — say it's the uppermost daisy in a flower arrangement. Now tilt or raise the camera up slightly, so that the daisy falls just under the horizontal close-up correction line, or under the invisible line that the corner bracket defines. Then take the picture (see Figure 5-6).

If your camera's close-up correction marks include a corner bracket or a vertical line, you may also have to shift the camera slightly to the left before you shoot. This shifting repositions the part of the subject that was at the left-hand edge of the viewfinder so that it's just inside the vertical close-up correction line. But please: Check your camera's manual for details about using its particular close-up correction marks. Instruction manuals almost always have information on shooting close-ups, with illustrations.

Using close-up correction marks is a clumsy business, and they aren't even particularly accurate. (By the way, if your camera is a focus-free model, it probably won't have them because the lens doesn't zoom, and you can't shoot from closer than about four feet anyway.) Some point-and-shoots have a much better system: As you focus close, and/or zoom in to a longer focal length, translucent bands (usually dark, but light in some models) appear at the top and sometimes the left side of the viewfinder. These translucent bands warn you not to put any part of the picture there. This system isn't limited to zoom cameras; my $100 single-focal-length model has it, as do a couple of comparable models. If you like to shoot really close, consider buying a camera with this feature, sometimes called LCD viewfinder framelines or LCD viewfinder correction marks. And if you have a digital point-and-shoot, be sure to use the viewing screen to compose if your subject is fairly close.

Shrinking away: Telephoto settings and the lens aperture

Here is one last note on zoom point-and-shoots that offer longer focal length settings. At these settings, the lens aperture gets much smaller, which means that less light reaches the film. The camera may try several things to make up for this lack of light. It may fire the flash, which you may not want — or if the subject is too far away, may not help. Or the camera may set a much slower shutter speed — the length of time the window in the lens stays open. This longer shutter speed increases the risk that shake will blur the picture. (I explain this problem more fully in Chapter 2 because one remedy for it is to use a film with a higher ISO, and also in Chapters 11 and 15 because you can compensate for it by raising the ISO on a digital point-and-shoot, if the camera allows it.)

Figure 5-6: Shooting up close with the lens zoomed in can cause a subject to be cut off at the top (top), and sometimes the side. To prevent this, aim the camera up to keep the subject within the viewfinder's close-up correction marks (middle) and then shoot. The subject will be correctly positioned in the print (bottom).

© Russell Hart (3)

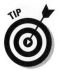

You may have noticed that I keep telling you to break the rules. Well, here I go again. Even though certain focal lengths are good for certain picture-taking situations, no photographic law exists that says you have to follow the focal length rules all the time. Just for the fun of it, zoom to another setting and try a picture there. Wide-angle close-ups of kids' faces, in particular, can make for zany shots — even though they are, technically, taken at the "wrong" focal length for portraits.

The Four Types of Point-and-Shoot Cameras — This Time by Their Lenses!

If you read the previous sections in this chapter, now you know your focal-length ABCs, which should help you understand the four broad categories of point-and-shoot cameras — classifications that are based entirely on the camera's lens and zoom focal-length range. These groups are *single-focal-length, compact zoom, standard zoom,* and *long zoom.* Here are a basic rundown and some quick pointers on the use of each type. (If you're shopping for a new camera, also check out Chapter 17.)

The single-focal-length (nonzoom) point-and-shoot

On 35mm models, a nonzoom lens typically has one focal length somewhere between 32mm and 40mm; a 35mm focal length is perhaps most common. On Advanced Photo System models, a nonzoom lens usually falls somewhere between 26mm and 30mm. (All one-time-use cameras are single-focal-length models.) And on a digital point-and-shoot, it's usually around 7mm or 8mm, though it may be even less with models having physically smaller image sensors. These moderate wide-angle lenses are good for everything from waist-up portraits to fairly wide-open landscape shots. The better models have *fast* lenses that are able to let in more light; you can therefore use them without flash in dimmer light than is possible with most zoom cameras. And virtually all of these models are small enough to fit in a pocket, so you never have an excuse not to take them where you're going.

The major drawback to these cameras is the big-nose effect that you get when you take a close portrait. The funny thing is that many of the *autofocus* models in this group can actually focus quite close (14 or 15 inches is common), so it's tempting to move in. That's fine — for anything but a flattering face.

Following are some of the pluses and minuses of single-focal-length point-and-shoots:

✔ *Watch out:* Stay at arm's length for portraits.

✔ *Best choice for:* Traveler, photo diarist, serious shooter who wants a pocket camera.

✔ *Not so good for:* Frequent portrait shooters, doting parents.

✔ *Sometimes you see:* A true wide-angle focal length, usually around 28mm or 30mm (on 35mm models), 22mm or 24mm (on Advanced Photo System models). These lenses have a still-wider angle of view, so they are even better for shots of wide-open spaces outside or cramped quarters inside. But they can make the big-nose effect even worse, so arm's length or more for people!

The compact-zoom point-and-shoot

Compact-zoom models usually have 2X zoom lenses, which means their magnifying power is doubled as you zoom from the shortest to the longest focal length. With 35mm models, 35–70mm zooms are the norm in this category. With Advanced Photo System models, 30–60mm is most common. Some very nice cameras in this group are hardly bigger than the most compact single-focal-length models.

A compact-zoom model gives you the very useful 35mm setting; the natural look of a normal focal length; and, at 70mm, a setting that is long enough for a very pleasing portrait. But it does have drawbacks. Toward the long end, the lens admits less light than at the wide-angle position, forcing flash or slower shutter speeds. And you also start to see parallax error with models that can focus pretty close. (Check out the sidebar "When what you see is not what you get," earlier in this chapter, for more on parallax error.)

✔ *Watch out:* Flash may be triggered in low light when you're zoomed in, so zoom out to wide-angle when you want to shoot by existing light. And mind the close-up correction marks when you get close to a subject.

✔ *Best for:* Traveler, photo diarist, doting parents.

✔ *Not so good for:* People who want an even tinier camera or a longer zoom.

✔ *Sometimes you see:* Compact zooms that start at a true wide-angle focal length, such as 28–56mm or 28–70mm on 35mm cameras, and 24–48mm on APS cameras. These cameras give you the great advantage of a wider angle of view, plus a longish normal setting at the other end of the zoom range that's pretty good for people pictures.

The standard-zoom point-and-shoot

The standard-zoom point-and-shoot has come up in the world, with 38–90mm zooms almost universal among 35mm models, and 30–75mm zooms common among Advanced Photo System models. And some 35mm models zoom out to about 120mm (90mm with APS models). Many of these cameras are also quite compact. The standard-zoom point-and-shoot is pretty much the ideal family camera, combining moderate wide-angle, normal, and true portrait telephoto focal lengths. Zooms of this range, though, usually admit a lot less light as you zoom to longer settings — same as compact-zoom models, only worse. And parallax error may be greater still.

- ✔ *Watch out:* The longer focal length settings usually trigger flash in lower light. And if you turn off the flash in that situation, you may get blur due to camera shake.

- ✔ *Best for:* Mom and Dad, general point-and-shooters, portrait enthusiasts.

- ✔ *Not so good for:* People who want a tiny camera or a faster lens.

- ✔ *Sometimes you see:* Zooms that go from true wide-angle to portrait tele-photo: 28–90mm on 35mm models and 25–100mm on APS models. This phenomenally useful zoom range is ideal for point-and-shooters — yet is, ironically, the least popular. Go figure.

The long-zoom point-and-shoot

Quite a few point-and-shoots come with focal-length ranges like 38–135mm, 38–140mm, up to 38–160mm. (In the Advanced Photo System, that translates to about 30–130mm.) Unfortunately, their long-zooming lenses admit a *lot* less light when they're zoomed way in, forcing them to set very slow shutter speeds when you're shooting without flash. Translation: The chance of blur is quite high, even if you're using ISO 400 films in decent light. ISO 800 print films should be considered *standard* films for these models — yes, for outdoor, daylight use — if you shoot often at the longest focal length settings. (ISO 1600 films may do an even better job if your camera zooms really long.) These models also have greater parallax problems than any other kind of point-and-shoot camera, when you take pictures at their longest settings.

A long zoom should come in handy, though, for your budding sports star or your backyard fauna. And you can get really tight portraits with a more comfortable distance between you and your subject. Just be aware of the lim-itations, and keep in mind that you can often get as tight a picture, and as flat-tering, at a more moderate tele setting such as 70mm — simply by moving in with your feet. If you're shooting without flash, moving in also lessens the risk of shake-induced blur.

✔ *Watch out:* Pack ISO 800 film if you plan to use that longest focal length. Pay particular attention to close-up correction marks or viewfinder warnings.

✔ *Best for:* Mom and Dad, gadget enthusiast, outdoor sports fan.

✔ *Not so good for:* Anyone looking for a more compact camera, a casual snapshooter.

✔ *Sometimes you see:* Models that go as long as 200mm. Also, translucent LCD framelines in the viewfinder that automatically adjust to show you correction for parallax, which is described in the sidebar "When what you see is not what you get."

After all is zoomed and done, though, what makes you a good photographer is not how many focal lengths your camera has. It's how you use the ones that you have — how you translate your lens's view into your view of the world.

Chapter 6

Focus Pocus: The Lens and Optical Magic

*F*ocusing was the last great hurdle of camera automation. Automatic film advance, automatic flash, automatic exposure — these amenities have long been a fact of point-and-shoot life. Automatic focusing — *autofocus,* for short — is a more recent innovation. But autofocus was worth the wait, relieving one of the great anxieties of snapshot photography. Autofocus has saved lots of pictures that otherwise would have been lost to the vexing back-and-forth of old-fashioned manual focusing.

So I kind of hate to tell you this, but you — and only you — must make sure that your point-and-shoot's lens is properly focused when you take a picture. I know what you're saying. "There he goes again, telling me I have to do something that the camera does automatically."

I'm the first to admit that a point-and-shoot will take a good percentage of sharp pictures if you just aim it at something and snap away. Left to its own devices, your camera will, indeed, focus automatically. It will focus automatically on whatever chance places in its path. But you simply can't leave focusing to chance. That's how bad pictures happen to good people.

The term autofocus is really a misnomer. Power-assisted focus, or maybe computer-aided focus, would be more accurate. Autofocus cameras simply help *you* in carrying out the function of focusing the lens. So this chapter tells you how you can help yourself when it comes to autofocus.

The Sharper Image: How Autofocus Works

So what is focusing, really? People tend to use the term pretty blithely; they at least seem to know that it has to do with making a photograph sharp. Basically, *focusing* is the process of moving the lens in and out until it forms the sharpest possible image of the subject on the film, or, if you have a digital point-and-shoot, the camera's image sensor. Focusing is necessary because for every subject at a different distance from the camera, the lens must be at a different distance from the film, or image sensor, to create the sharpest possible image.

An autofocus point-and-shoot uses sophisticated technology to measure the distance to the subject. It relays this information to a motor in the lens. The motor then moves the lens to the proper distance from the film or image sensor.

Though their mechanism is different, your eyes autofocus, too. They do so with such precision and speed, in fact, that you don't even have to think about it. Well, at least until you start needing glasses to find your glasses, or wishing you had arm-extenders to read.

To see how your eyes autofocus, put your hand as close to your face as you can and still see it clearly. Now look right past your hand at a distant object — something across the room from you. Keep looking at that distant object and try to see out of the corner of your eye (that is, without looking directly at it) what your hand looks like. Blurry, isn't it? Now look back at your hand. Again, out of the corner of your eye, see what the far object looks like. Now *it* is blurry. Your eye refocuses automatically when you look at something that's at a different distance — rather like an autofocus point-and-shoot.

When you look through an autofocus point-and-shoot's viewfinder window, though, you don't see that focusing process, even though it's happening inside the camera. What you see in the viewfinder remains sharp regardless of where the lens actually focuses. For most people, this fact isn't bothersome. And it's a different story if you're looking at the scene on the viewing screen of a digital point-and-shoot. As with a similarly equipped video camcorder, the screen shows you what the lens itself "sees" — a view that's relayed to it electronically. With a viewing screen, you can see one part of the scene become sharp and another become blurry as the lens refocuses, just as you did with your hand and that distant object. But if you're using the viewfinder, you just have to trust that your point-and-shoot is doing its autofocus thing!

It wouldn't be photography if there weren't an exception to this. Long-zooming digital models — those that zoom beyond about 4X — sometimes have an *electronic viewfinder*. (See Chapter 5 for more on zoom ratios.) This means that when you put your eye to the viewfinder, instead of looking through a miniature zoom lens you're actually looking at a tiny version of the viewing screen — the same arrangement as with any video camcorder. With these

relatively few models, which tend to be the more advanced and costly ones, you actually *do* see the subject get sharper and blurrier.

Autofocus versus Fixed-Focus

Autofocus is not a necessity for good pictures. Tons of less expensive (under $50) 35mm and APS point-and-shoots, *all* one-time-use cameras, and even some inexpensive digital models rely on what is often called *focus-free* operation. This term should really be *fixed focus,* because it means that the lens's focus was permanently set at the factory. This fixed setting gives you pretty sharp pictures if your subject is at an average snapshot distance (8 feet or so), and less-sharp-but-acceptable pictures if your subject is a little closer or farther away. But if you get too close to something, it will appear unsharp in your print. With fixed-focus, focus-free cameras, four feet is about as close as you can get and still take reasonably sharp snapshots.

The best way to tell whether you have an autofocus or a fixed-focus point-and-shoot is simply by looking through the viewfinder. If you have an autofocus model, you'll see a small set of marks — often in the form of brackets or a cross shape — in the center of the frame. These marks, called the *focus point,* tell you where the camera is focusing. Sometimes the focus point is a circle; sometimes a pair of square or rounded brackets; and sometimes lines that intersect to form a cross, not unlike a gun sight's crosshairs.

Most autofocus digital point-and-shoots have a focus point indicated on the viewing screen as well as in their viewfinder, usually with brackets. You may need to touch the shutter button lightly to make the brackets appear. (Remember that some models have no viewfinder, requiring that you compose with the viewing screen.) With a number of models you can actually turn the brackets off and on by pushing a button or going into the menu. If by chance your particular model has no focus point indicated, it may help to imagine one in the middle of the viewing screen as you shoot.

If you have a fixed-focus point-and-shoot, its viewfinder lacks the focus point (see Figure 6-1). A fixed-focus camera also lacks the green *focus-OK lamp* found on autofocus models. (See the section "Making sure the focus is locked," later in this chapter.) (Fixed-focus models can, and often do, have a flash-ready lamp, usually red.) The lamp is adjacent to the viewfinder eyepiece or just inside the eyepiece frame; occasionally it's on the bottom of the eyepiece. Wherever it is, you can see it out of the corner of your eye when you look through the viewfinder.

Still not sure? Camera makers endeavor to promote their products' features, so if your point-and-shoot has autofocus, it probably says so somewhere on the camera or at least on the box. Sometimes camera makers use the initials *AF* to indicate autofocus capability.

 If you have a fixed-focus, focus-free point-and-shoot, don't get too close to your subject. You usually need to be at least four feet away from something to make it sharp in the print; anything closer may appear blurry. Check your manual to see what minimum distance the manufacturer recommends.

Advanced Placement: Using the Focus Point

Autofocus point-and-shoots produce terrifically sharp pictures when you use them properly. But getting sharp results sometimes requires *telling* them where to focus.

The camera automatically focuses on whatever part of your subject the focus point is covering when you press the shutter button. If you're photographing a friend who is six feet away and the focus point covers the friend's face, your camera autofocuses six feet away. If you're photographing mountains that are a mile away and the focus point covers them, then the camera autofocuses, well, way out there. (Beyond a certain distance, everything ends up sharp anyway. "Way out there" in photo jargon is called "infinity," and you can read more about it in Chapter 4.)

 You can't assume, however, that the viewfinder's or viewing screen's focus point will always fall in the right place. Imagine photographing two friends standing six feet away from you with those mountains in the background. Your friends are smack in the middle of the frame. But between the two of them is a little gap, and the focus point falls neatly into it — covering a little piece of distant mountain. Not noticing this little gap, you point, and shoot. Guess what happens: The camera focuses on the mountains, and your friends end up unsharp in the print.

That scenario is an example of purely accidental misfocusing. But its more common variation is when you deliberately place a subject off-center in the frame. Say you want to compose the shot of your friends and the mountains this way. You ask your friends to stand to the right so that they block less of

the background, giving the mountains center stage in your composition. You point and shoot. Guess what happens: The camera focuses on the mountains, because that's where your composition has landed the focus point. Once again, your friends end up unsharp in the print. Call it *tunnel focus.*

The same thing can happen just about anywhere, and on a smaller scale. Say you're photographing your spouse sitting across from you at a restaurant table. If the focus point happens to fall on the far wall, the camera focuses there — not on your beloved.

Unintentional focusing on the background is, along with unwanted camera movement, the main cause of unsharp point-and-shoot pictures. And here's a simple way to avoid it — a photographic one-two punch called *locking the focus.* It's the only sure way of getting the camera to focus on what you consider the most important thing in your picture.

How to lock the focus

You should lock the focus any time your composition does not place the viewfinder's or viewing screen's focus point on the most important part of the scene you're shooting. Locking the focus means that you deliberately make your camera focus on an important object in the scene — a person, or something interesting in the foreground — and keep the focus locked at that exact distance until you take the picture. Here's how you lock the focus:

1. **Look through the viewfinder, or at the viewing screen, and position its focus point on the most important part of the scene — your main subject.**

 In effect, you center that subject in the frame.

2. **Press the shutter button halfway down, until the green focus-OK lamp in the viewfinder eyepiece glows steadily.**

 See the next section, "Making sure the focus is locked," for more on the focus-OK lamp. Some models (and most digital point-and-shoots) can also be set to beep when the subject is in focus. And if you're composing with a digital point-and-shoot's viewing screen, you can often tell when a subject is focused just by looking at the screen, though watching the focus-OK lamp or listening for a beep is a safer bet.

3. **Holding the shutter button halfway down, reorient the camera so that your desired composition appears in the viewfinder or on the viewing screen.**

4. **Press the shutter button all the way down to take the picture.**

For example, say you want your main subject to be off-center to the right in your composition. (See Chapter 10 for more on composition.) With those friends and the mountains (see preceding section), you lock the focus by

aiming the focus point at your friends (which temporarily puts them in the center of the viewfinder or viewing screen) and pressing the shutter button halfway. Then, holding the shutter button halfway down, you swing the camera left to place your friends off-center to the right (see Figure 6-2). Now press the shutter button the rest of the way to take the picture.

You may need to use this technique with vertical composition, too. Say you're standing on a rock to shoot a vertical picture in which your friends are at the bottom of the viewfinder or viewing screen and the mountains in the background are at the top. Your composition causes the focus point to cover the mountains, not your friends — and if you were to go ahead and take the shot, your friends would end up unsharp in the print. But knowing this might happen, you first aim the camera down to place the focus point over one of your friends' faces (which temporarily cuts off the mountains at the top) and press the shutter button halfway. Then, holding the shutter button halfway down, you swing the camera back up to include the mountains and reestablish your desired composition. Now you press the shutter button the rest of the way to take the picture.

 Regardless of your composition — centered or off-center — you should always keep your eye on where the focus point lands. Remember those two friends with the gap between them (the ones I describe in the preceding section)? With newfound vigilance, you observe that the focus point has landed in the gap, covering that little piece of distant mountain. To take the picture, you first "aim" the focus point so that it's on one friend's face and then press the shutter button halfway down. Holding the shutter button halfway down, you reorient the camera to center your friends. Then, and only then, do you press the button the rest of the way to take the picture.

Particularly if you're a landscape fan, you may be wondering what happens to distant objects when you lock the focus on closer objects. "If I focus on my friends in front of the mountains, instead of the mountains," you ask, "then won't the mountains be out of focus?" Good question. Here's the important answer.

With most scenes in which you photograph a relatively close object (human or inanimate) in front of a distant background, if you focus on the close object, the background will be reasonably sharp in the print. But the reverse is not true. Focus on the background — those mountains — and the close object simply won't be sharp. Don't worry about why!

Making sure the focus is locked

As I explain earlier in this chapter, when you lock the focus you can't actually see the subject getting sharp in the viewfinder. However, you can verify that

your point-and-shoot has autofocused on something by looking at its *focus-OK lamp* (see Figure 6-3).

Figure 6-2:
To prevent your point-and-shoot from focusing on the background with an off-center subject (top), simply center the subject (middle) and lock the focus by pressing the shutter button halfway. Then pivot the camera to re-establish your composition before pressing the button all the way to take the picture (bottom).

© Mark Harris (3)

Figure 6-3:
The view-finder's green focus-OK lamp glows steadily to confirm the focus.

The focus-OK lamp lights up whenever you press the shutter button halfway. If it glows steadily, it's telling you that the camera has successfully focused. If the focus-OK lamp blinks, or doesn't light, or lights briefly but then goes out or starts blinking, it's telling you that the camera can't focus.

Some models — many digital point-and-shoots and even a few film-using types — will also emit a beep to confirm that they've achieved focus. This can be handy if you don't want to keep your eye on the focus-OK lamp, but it can also be very annoying. You usually can turn this feature on and off; with digital point-and-shoots, you'll have to go into the camera's menu to do so.

If the camera can't seem to focus, more often than not it's because you're too close to the subject. Fix the problem by easing up on the shutter button, stepping back a foot or two, and then pressing the shutter button again. If this tactic doesn't do the job, the autofocus system may be getting tripped up by a difficult subject or tricky light. See "The Commandments of Good Autofocusing," later in this chapter, for details.

When you move, the focus doesn't

Locking the focus is vitally important to getting consistently sharp pictures. But you should remember that with nearly all point-and-shoot cameras, when you have that shutter button pressed halfway, the focus doesn't budge. If you ask your subject to move closer or farther away, or *you* move closer or farther from it to adjust your composition, it's no longer in focus. So, if for any reason the distance to the subject changes after you've locked the focus, you must let up on the shutter button and repeat the focus-locking procedure. Small changes in distance aren't always worth worrying about, however, especially when you're fairly far from the main subject or when refocusing would cause you to lose the moment. Also, if you or the subject moves *sideways,* you needn't refocus.

Zoom before you lock the focus. With most point-and-shoot cameras, locking the focus also prevents you from adjusting the zoom. If you want to zoom in or out after locking the focus, let up on the shutter button, adjust the zoom, and then lock the focus again. (Check out Chapter 5 for more on zooming.)

Far and Away: When to Use Infinity Lock

Sometimes you want to make the camera autofocus as far away as possible — and can't. For example, you may want to photograph a distant subject, but worry that the camera will focus on a jumble of detail in the foreground. A more common situation: You may just want to take a picture of a scene through a window.

A window may look transparent to you, but many point-and-shoots see it as solid. They focus on the glass, rather than what's on the other side of it.

The solution to this problem is to use your camera's *infinity lock* mode. This mode is also sometimes called *landscape mode* because it works best with subjects that are far away. When you set the camera to infinity lock, it basically overrides the camera's autofocus, setting the lens to focus as far away as it can. (See Chapter 4 for more on the infinity lock mode.)

To make sure that you get correct focus when shooting through a window, the best strategy is to open the window. If opening the window isn't possible — or moving your prize African violets from the window sill would take too long — then use infinity lock (see Figure 6-4), if your camera has this feature. If it doesn't, try putting the camera right up to the glass to shoot, although I suggest testing this method before a picture opportunity happens. Shoot one frame of a distant object through the window and then see whether the resulting print is acceptably sharp. If it is, you can use this technique for future shots.

Touch and go: Focus locking and the shutter button

The idea of pressing the shutter button halfway may sound tricky to you. How do you know what halfway is? How do you avoid pushing too hard when you're just trying to lock the focus and accidentally taking the picture? Manufacturers have anticipated your worry.

On autofocus point-and-shoot cameras, the shutter button is specifically designed for the two-step operation needed to lock the focus.

Press it lightly — I prefer to say *press it halfway,* because that's how it feels — and the camera autofocuses, locking the focus on whatever the focus point is covering in your viewfinder. Press it fully — I prefer to say *press it all the way down* — and the camera takes the picture.

Getting the hang of this technique takes a while. If you're shooting film, you may even waste an occasional frame. So it's a good idea to practice

(continued)

(continued)

the autofocus two-step with an empty camera. On some models, you can actually hear the lens quietly click or zip into position when you press the shutter button halfway.

Keep your finger glued to the shutter button. To master its two-step operation, you must lose the worst habit of point-and-shooters: stabbing the button to take a picture. Don't wait for a shot with your finger poised in the air. Your finger should remain in contact with the shutter button before, during, and after you take a picture.

By not stabbing the shutter button, you accomplish two things: First, you lessen the risk that you will shake the camera, which reduces the chance that your picture will be blurred. Basically, you can keep the camera steadier. And second, more crucial to focusing, if you change your mind about where you want to lock the focus, all you have to do is let up on the shutter button a little, re-aim the focus point, and then press the button halfway once again.

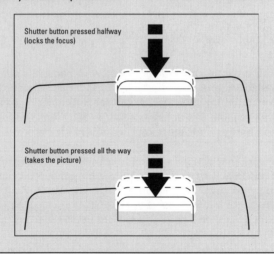

Shutter button pressed halfway
(locks the focus)

Shutter button pressed all the way
(takes the picture)

Extra Points: Widening Your Autofocus Horizon

To lessen the chance that your camera accidentally focuses on the background rather than your main subject, point-and-shoot manufacturers have come up with a clever technology called *wide-area autofocusing*. This feature also goes by *multibeam* or *multipoint autofocus*. (See Chapter 4 for more on this feature.) Many if not most point-and-shoot models now have some variation of this system.

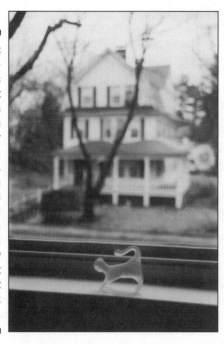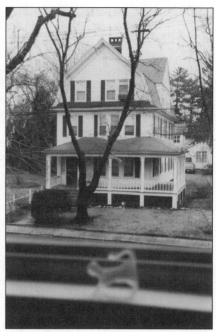

© Russell Hart (2)

Figure 6-4: Many point-and-shoots can't autofocus anything on the other side of a window, focusing on the glass instead (left). If you can't open the window to prevent this, set infinity lock (right).

Generally, wide-area autofocus is sensitive to the central one-quarter to one-third of the horizontal picture frame. This extra spread allows the camera to correctly focus subjects that are a little off-center. If, for example, the camera detects more than one thing within the focusing area (for example, two friends), it focuses on the thing closest to the camera. And if your two friends are an equal distance from the camera, it will focus on them, not the mountain behind them. It's well-suited to grab shots — those pictures with which you have just enough time to turn on the camera and snap.

But focusing mistakes are still possible with wide-area focusing. Someone or something may be a little too far to the side for it to catch, in which case the camera focuses on something in the background anyway. And how do you know if it's screwing up? You don't. The little green focus-OK lamp glows steadily, because the camera has focused just fine on something far away.

So my thinking is, why take the chance? If you have the time — and you don't need much — always lock the focus. Lock the focus whether your camera has wide-area autofocus or not. (See the section "How to lock the focus," earlier in this chapter.)

Some cameras, by the way, let you switch from wide-area focusing to *spot autofocus* — in other words, from multiple focus points back to a single,

central one. (See Chapter 4 for details on spot autofocus.) Switching to spot autofocus isn't a bad precaution if focus is extremely critical to a picture. For example, if you think unimportant foliage in the foreground may cause a wide-area autofocus system *not* to focus on something more important in the distance, you can switch to spot autofocus to define the focus more narrowly — to see beyond the foliage. But in most cases, locking the focus and recomposing takes care of things.

The Commandments of Good Autofocusing

You're getting off easy — I'm handing down only nine commandments, not the usual ten! And even if you follow only the first three, you'll get well-focused pictures almost all the time. The first three are super-important; the others are for finessing your particular type of autofocus system.

To get the most from these tips, you need to know whether your camera has an active or passive autofocus system. *Active autofocus* bounces infrared beams off the subject so that the camera can determine the distance to it and set the lens's focus accordingly. *Passive autofocus,* on the other hand, determines the subject's distance by analyzing the image itself and adjusting focus until subject details are as sharp as they can be. Nearly all digital point-and-shoots use passive autofocusing.

Before you get flustered by these techie-sounding terms, here's a simple way to figure out which one your camera uses — in case you've lost your manual, which should tell you what you've got in the "specifications" section. Outside, in daylight, aim the viewfinder's focus point at a patch of open, featureless sky, no electric wire or clouds allowed. Press the shutter button halfway. If you get a blinking focus-OK lamp (meaning focus is not possible), you probably have passive autofocus. If you get a steady lamp (meaning focus is okay), you have active autofocus.

With all types of autofocus

Here are the three commandments of good autofocusing that should help you get sharp focus regardless of what kind of system you have.

 ✔ **Thou shalt lock the focus:** Locking the focus should be utterly reflexive. Don't count on multibeams or any other gizmo your camera may have. (Check out the section "How to lock the focus," earlier in this chapter, to find out how.)

 ✔ **Thou shalt watch thy focus-OK lamp:** The focus-OK lamp glows steadily if focus has been achieved, and blinks if something is amiss. Quite a few cameras use different rates of blinking to tell you what's up: Fast blinking usually means the camera can't find the focus; slow blinking

may mean you're in a special close-up range or that you're just too close. Check your manual to be sure which is which. (For more on the focus-OK lamp, see the section "Making sure the focus is locked," earlier in this chapter.) And, yes, thou can also listen for the focus-confirmation beep, if your camera makes one.

✔ **Thou shalt use infinity lock, if thou hast it:** Even if you're pretty sure your camera can focus accurately at great distances, setting infinity lock is a good precaution when you're shooting far-away scenes — but only if there's no important foreground. (For details, see the section "Far and Away: When to Use Infinity Lock," earlier in this chapter.)

With active autofocus

When you lightly touch the shutter button of an active-autofocus camera, before you press it all the way down an infrared beam shoots out of a small window on the camera's front. (Infrared is the same invisible "light" that allows a remote control to operate your TV.) This beam is reflected back to the camera by solid objects, just like visible light. (If your camera sends out a *visible* beam of light, that's another story — one for another time!) A little window on the front of the camera actually senses this bounced-back beam, and the camera can calculate the angle at which it bounced off the subject or object. From that information, it actually computes how far away an object is and sets the lens to focus at that distance.

Active autofocus has some great *advantages,* which is why you can find it on the vast majority of 35mm and APS point-and-shoots:

✔ Active autofocus works in the dark — even pitch black. So it's great for party pictures in dim basement rec rooms.

✔ You don't have to aim a camera with active autofocus at a detail in the subject. It can focus on a blank wall just as well as it can on Uncle Clive's plaid leisure suit — and do so very quickly.

And you know active autofocus is bound to have drawbacks, right? Ironically, the biggest of these drawbacks is that active autofocus can focus just about anything. It's indiscriminate, which leads off its *disadvantages:*

✔ Active autofocus can focus right past a subject that isn't in the middle of the frame. If Uncle Clive is standing off to the side and you don't first lock the focus on him, your single-minded little robot focuses right on the wall behind him.

✔ Active autofocus doesn't have a very long range. The infrared beam that shoots out of the camera is weak; it can't accurately figure the distance to the subject if it's more than about 25 feet away. The limited range usually isn't a problem except with longer zoom lenses, which need to be focused more precisely at far distances.

To make the most of your active autofocus, follow these three commandments whenever you can.

✔ **Thou shalt not focus on bright reflections or dull black objects.** Because active autofocus depends on the camera's ability to see the reflection of a dim infrared beam, very shiny objects (or very bright lamps) can overpower the reflection and cause incorrect focus. Likewise, a dull black object (or an actual hole) can swallow up the infrared beam and cause misfocusing.

✔ **Thou shalt not confuse thine autofocus with fences.** If you try to take a picture of something on the other side of a fence with an open grid pattern, active autofocus may focus through the fence — then again, it may focus on the fence itself. How can you tell? You can't. If you want to take a picture of something on the other side of the fence, poke your camera through the bars so that the lens, the viewfinder, and all those little windows on the front of the camera are clear.

✔ **Thou shalt not focus through glass without infinity lock.** Active autofocus works by bouncing a beam off solid objects. Windows may be transparent, but they're solid. So active autofocus focuses right on the pane of glass, not on your kids washing the dog outside. (See the section "Far and Away: When to Use Infinity Lock" for more on taking pictures through windows.)

With passive autofocus

To overcome some of the drawbacks of active autofocus, camera makers equip better 35mm and APS point-and-shoots with passive autofocus. And with digital point-and-shoots, the image sensor does double duty as passive-autofocus aid. Passive autofocus works something like your eyes, analyzing what's in plain view. When things are in focus, you can easily tell the difference between light and dark details; when things are out of focus, though, light and dark areas tend to blend together into gray. What passive autofocus does is move the lens until it finds the point at which contrast is greatest — or, to put it in real-life terms, where Uncle Clive's plaid leisure suit has the most snap to it.

Passive autofocus has some nice *advantages:*

✔ Passive autofocus is not limited in distance. It can focus two miles away as easily as two feet away because it doesn't depend on a wimpy beam, the way active autofocus does. That's why you most often find passive autofocus on point-and-shoots with long zooms.

✔ Passive autofocus can focus through glass because it sees through the window to objects on the other side.

Smudge patrol: How to clean your lens

Point-and-shoot cameras get a lot of manhandling — womanhandling, too. In changing film or batteries, sampling a piece of wedding cake, or just holding the camera between pictures, you can easily smudge the lens. And with a big smudge on the lens, you probably won't get sharp pictures. In fact, a smudged lens is a major cause of unsharp results.

So you should inspect your lens routinely, before you take a picture and even as you're shooting an event. To inspect your lens, turn the camera on so that the lens's front surface is uncovered. Hold the camera in your hands so that the surface reflects a strong light source — a window, the sky, a lampshade — and then tilt it slightly back and forth to move the reflection around the lens (see figure). You can spot smudges, accumulated dust, and other crud quite readily this way. Given the small size and recessed position of most point-and-shoot lens surfaces, any smudge is likely to be smack in the middle — the worst place. If you see a smudge, clean the lens.

To clean the lens, you need lens cleaning solution, available in small bottles at your local camera shop. (Never use water or window glass cleaners.) While you're at the shop, pick up some lens cleaning tissue, too. Actually, I find that cotton swabs (sterile, please) often work better than tissue for smaller lenses, but you probably have them at home already.

First, use your breath to blow off the lens lightly. Don't get it wet. If you're particularly fastidious, you can blow off the lens with a photographic blower brush or a can of compressed air; these items are available at camera stores, too. Blowing the lens off before cleaning is important, because it removes any grit or dust that may scratch the lens's surface as you wipe it.

Next, place a drop or two of lens cleaning solution on the end of a cotton swab. Gently wipe the lens surface with the swab, starting in the middle and spiraling out to the edges of the lens. Then, even more delicately, apply the dry end of the swab in the same pattern to polish out any streaks.

Inspect the lens surface again. If smudges or streaks remain, repeat the process. And if the cotton swab doesn't seem to be removing the smudge and/or polishing out the streaks, fold a piece of lens cleaning tissue over on itself a few times, wet it with a few drops of lens cleaning fluid, and use its flattest portion to wipe the lens with a concentric pattern. (If the lens surface is recessed and hard to reach, you can even use a cotton swab to push the tissue around the lens surface.) Repeat the process with dry tissue. You can also use this method to clean the viewfinder window, should it get smudged or accumulate dirt.

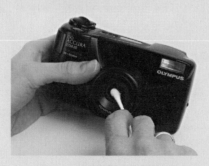

Indeed, passive autofocus's single great advantage is that it's particular, unlike that unfussy slob active autofocus. If you aim your viewfinder's focus point at the blank wall behind Uncle Clive and Great Aunt Gretyl, passive auto-focus blinks a warning lamp or balks outright — which brings me to the *disadvantages* of passive autofocus:

✔ Passive autofocus can't focus on areas without detail.

✔ Passive autofocus can't focus in the dark because it doesn't have enough light to see — and it can be slow even when it does.

To make the most of your passive autofocus, follow these three commandments whenever you can:

✔ **Thou shalt not place the focus point on blank areas.** Passive autofocus must see detail — an area with contrast to it — to be able to focus. If your focus point lands on something featureless — a patch of Aunt Daisy's well-ironed, solid-color dress, for example — the camera either refuses to take the picture or takes a misfocused shot.

✔ **Thou shalt aim the focus point at vertical lines.** Most passive autofocus systems are sensitive primarily (or exclusively) to vertical detail — assuming that you're holding the camera horizontally. (If you're holding the camera vertically, they're sensitive to horizontal detail.) The best thing to aim at with a human subject is the edge of a face, or with closer shots, an eye.

✔ **Thou shalt not focus in the dark.** Passive autofocus needs to see well enough to analyze the sharpness of a detail. While many passive autofocus cameras are equipped with an autofocus-assist lamp (basically, a little built-in red or white flashlight), you're best off shooting in decent light, if it's available. (Turn on room lights if you're in doubt.) Autofocus-assist lamps don't help much beyond 20 or 25 feet.

Chapter 7

A Flash of Inspiration

*T*he pint-sized electronic flash in your point-and-shoot camera is definitely not your father's flash. If you're a baby boomer, your unfortunate father had to screw a lightbulb-sized flashbulb into a soupbowl-sized metal reflector every time he wanted to shoot a flash picture of your youthful achievements. If you have a newer model dad, he may have taken his first photographs of you with flashcubes. Remember those? A simple spring mechanism rotated the flashcube through four small bulbs — and then you had to yank out the cube (being careful not to burn your fingers) and attach a new one.

When it comes to flash photography, there *were* no good old days. Though it may be smaller than a postage stamp, your camera's built-in electronic flash just keeps going and going, letting you shoot as many pictures as your film and batteries allow. And when it comes to improving the quality of your photography, your flash is a far more helpful and sophisticated device than the blinding bulbs and rotating cubes of yore.

Yet all the innovation in this itsy-bitsy, teeny-weeny marvel actually simplifies taking pictures with flash. Your camera's flash system fully automates the exposure calculations that once made flash photography so mind-numbing and getting good flash pictures such a gamble — and it does this with remarkable dependability.

Whether you're using a 35mm point-and-shoot, an Advanced Photo System point-and-shoot, or a digital point-and-shoot, your camera will in almost all cases have a built-in flash — and feature flash modes, functions, and icons.

Autoflash Mode: No-Fault Photo Insurance

Whether they pop up, slide out, or just stay put when you turn on the camera (see Figure 7-1), most built-in flash units fire *automatically* when the camera senses there's not enough light on your subject for a good exposure. But this isn't to suggest that you have no creative control. Unless your camera is a very basic model, you have an array of up to five or six flash modes at your command. Most point-and-shoots offer at least three flash modes — *auto-flash, fill-flash,* and *flash-off.* Most also offer *red-eye reduction* flash. And a number of models offer *slow-sync* flash.

Figure 7-1:
Some built-in flash units pop out when you turn on the camera, but most just stay put.

These various modes make your flash the single most important creative tool on your point-and-shoot. But if at first you feel intimidated by such choices — or if your camera offers a limited number of flash modes, or no choice at all — you must remember this: Left to its own devices, your point-and-shoot camera's thoroughly modern flash will fire whenever it's needed.

When you turn on your camera, it immediately sets itself to autoflash mode. Now, say you're shooting the kids and dog running through the sprinkler on a bright July day. Your camera's lightmetering system sees all that sun and tells the flash it's not needed. So the flash doesn't fire. (See Figure 7-2.) Follow the inevitable trail of mud back into the house, though, and the camera detects the dimmer light — automatically triggering the flash to compensate. (See Figure 7-3.)

With fast-moving subjects in fast-changing conditions (did I say kids and dogs?), don't worry about setting flash modes. Indoors or out, just turn on the camera and shoot.

Watch those fingers. Even autoflash can't do its job if you inadvertently stick your fingers over the flash tube; you get a dark or unevenly lit result. Find a comfortable way to hold your camera without covering the flash, and use this position every time. (Check out Chapter 1 for details on how to hold your camera.)

© Allen Green

Figure 7-2:
In autoflash
mode,
bright light
automati-
cally tells
the flash not
to fire.

Figure 7-3:
In autoflash
mode, dim
light
automati-
cally tells
the flash
to fire.

© Russell Hart

Autoflash is no-fault photographic insurance. It's just what you need when you don't want to fiddle with the camera while your kids trash the new carpeting. Use it, and you're almost guaranteed a sharp, colorful, well-detailed picture. But here's the surprise: *There are times when you should use flash in bright outdoor light. And there are other times when you should turn the flash off in dim light.* I cover these topics later in this chapter, in the sections "Fill-Flash Mode: Out of the Shadows" and "Flash-Off Mode: To Flash or Not to Flash."

Buttoning Down Flash

To make the flash fire outdoors and not fire indoors — or to make it do any of the other interesting things it can do — you need to push the flash mode button. This button is usually marked with a lightning bolt. Repeatedly pushing this button *toggles* you through the flash mode icons, which are displayed on the camera's LCD panel. If your digital point-and-shoot has no separate, small LCD panel on its top, refer to the viewing screen to see the icons. (If the screen is off, push the screen-on button, which is usually marked with an icon that looks like an old-fashioned rounded TV screen.) Get out your camera and try toggling through its flash modes. If getting out your camera inspires you to take some pictures and you can't figure out how to get back to autoflash, simply turn the camera off and on again. With nearly all point-and-shoot models, doing this resets the camera to autoflash.

If the flash mode button isn't on top of the camera, look for it on the back or sides, or even under a little door. Different models set and indicate flash modes in different ways. With some models, pushing the flash mode button moves a pointer along printed icons adjacent to the LCD panel. With others, you have to rotate a thumbwheel to select the mode (represented by an icon) that you want. Sliding switches are another, though less common, type of control. I do my best to cover the permutations, but do me a favor: Check your manual! (See Figure 7-4.)

Whatever you push or rotate to choose a flash mode, let the icons be your guide. (See Figure 7-5 for examples of autoflash icons.) And keep in mind — this is important — that your particular camera may display no icon at all when it's in autoflash mode. This is your camera's way of telling you it will take care of things. On other models, the LCD panel or viewing screen displays the actual word *auto,* often paired with a lightning bolt. So if you've taken the camera out of its autoflash mode, you can get back simply by pushing the button repeatedly until auto reappears — or the flash icon disappears altogether! Just remember that the order in which flash modes are displayed varies from camera to camera.

Figure 7-4:
The way
you change
flash modes
depends on
your
particular
point-and-
shoot.

 To make the flash fire with one-time-use cameras, before you take the shot you must press a separate flash-charging button and hold it down until the flash-ready light comes on. This button is usually on the front of the camera, as shown in Figure 7-6; some models have a little slider switch that pokes out to remind you that you've turned the flash on. Be sure to wait for the flash-ready light to come on before shooting.

Figure 7-5:
Typical
icons for
autoflash
mode.

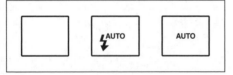

Fill-Flash Mode: Out of the Shadows

With many point-and-shoots, the first push of the flash mode button causes a plain lightning bolt to appear on the LCD panel or viewing screen. If your camera already displays a lightning bolt (and the word auto) in its autoflash mode, this first push may cause the word to disappear, leaving just the bolt. Sometimes the lightning bolt is paired with the words *fill, fill-in,* or just plain *on.* And sometimes it appears with a graphic of the sun (see Figure 7-7).

Thoughtful manufacturers add the sun to remind you that in this mode, which most point-and-shoots call *fill flash,* the flash fires even in bright light.

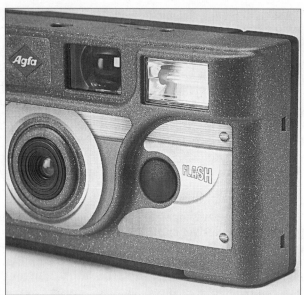

Figure 7-6:
With a one-time-use camera, the flash will not fire automatically in low light. You have to press a separate flash-charging button.

Some point-and-shoot models call this mode *fill-in flash,* both on the LCD panel (or viewing screen) and in their manuals. Others use names like *flash-on, anytime flash,* or my personal favorite, *forced emission.* All mean the same thing: that the flash fires every time you take a picture.

Why would you want flash when the subject is bright already? To *fill* unwanted shadows with light. High sun in particular creates unattractive hollows under facial features. For example, Great Aunt Gretyl hobbles to your Fourth of July cookout wearing an old-fashioned, wide-brimmed hat. You want to document what could be her last earthly appearance, but the brim of her hat throws her entire kindly face into darkness. Add flash, and that shadow lightens up. Send her the flattering results, and she may bequeath you her classic 1939 Super Kodak Six-20, though you won't be able to find film for it.

Fill flash is really as much a no-brainer as autoflash — and no less automatic in its operation, pumping out the right amount of light for the occasion. You have to select fill flash with the flash mode button, of course. But once you do, you can leave fill flash on, and if you go indoors, it does the job there, too.

Figure 7-7:
Typical icons for fill-flash mode.

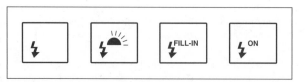

And how do you get fill flash if your point-and-shoot doesn't have <u>any</u> way to display a fill-flash icon? Even cameras with few controls often have a fill-flash button, usually marked with a lightning bolt. But to get fill flash, you must hold down this button until the flash-ready light comes on, and only then take the picture. (The button is usually on the side of the camera opposite the shutter button, so you can push it with the fingers of your left hand; see Figure 7-8.) You can do the same thing with one-time-use cameras; see the sidebar "What? Fill flash with a one-time-use camera?" later in this chapter.

Figure 7-8:
Simple 35mm point-and-shoots having no LCD panel may still offer fill flash. You just hold down a separate button as you take the picture.

Fill flash is also called *daylight sync* or *synchro sun flash* (though if your point-and-shoot's maker uses these terms at all, they appear only in your manual, not on your camera's LCD). The terms refer to the fact that you are *synchronizing* the flash with an exposure for the existing light, thereby mixing the two together. The terms sound retro-techy, but fill flash is actually the more fashionable one.

With some models, the sequence of flash modes may include a setting for backlight compensation. The icon for backlight compensation may be something like a stylized sun, so don't confuse it with fill flash. (If the icon has no lightning bolt, it's not fill flash — in fact, the flash won't fire at all.) Backlight compensation can be useful, but fill flash is a better problem-solver. (See Chapter 9 for more on backlight compensation.)

Fill flash compensates for the inability of photographic film, or the image sensor in a digital point-and-shoot, to capture good detail in both the brightest and the darkest parts of some subjects. Though fill flash adds the same amount of light to both highlight and shadow areas, the extra light is more visible in the shadows because shadows are less bright to begin with. This

effect actually reduces *contrast* — the difference between the scene's lightest and darkest parts — keeping it within the range of brightnesses the film or image sensor can record. (You get a free piece of photo jargon — *contrast* — for reading this Technical Stuff paragraph.)

When to use fill flash

Fill flash is a perfect remedy for the small, scattered shadows that can make portraits taken in direct sun so ghastly. Fill flash lightens the eye sockets and nose shadows that would otherwise end up as black as the black hole of Calcutta (see Figure 7-9), whatever it may be. (I've always been afraid to ask.) It can help you turn a guaranteed failure into a flattering portrait. Fill flash is mainly an outdoor flash mode, but it even helps with sun coming through a window.

In addition to retrieving eyes from their sockets, fill flash adds *catchlights* to them. Catchlights are tiny, pinpoint reflections of an actual light source — in this case, the flash tube as it fires. Without catchlights, a subject's eyes can look dull and lifeless. Look at any good studio portrait, and you'll find catchlights, created quite deliberately by the photographer.

When you're shooting outdoors in daylight, just leave the camera set to fil flash. Move from sun to shade and back as you shoot, and you'll be pleasantly surprised at the consistency of the results. If you turn the camera off between shots, remember to reset it to fill flash when you turn it back on.

Fill flash is also made to order when the entire main subject is in shadow against a much brighter background (see Figure 7-10). To picture this scenario, think of shooting a portrait under the shade of a gazebo. By flashing your subject, you lessen the difference in brightness between her (the foreground) and the unshaded area outside the gazebo (the background). In these situations, fill flash makes the foreground and background appear more balanced.

When the background is much brighter than the main subject or the light is actually coming from behind the subject, the subject is *backlit*. Some point-and-shoots have the ability, in their autoflash mode, to sense that difference in brightness and fire the flash to compensate for it. These models automatically fire the flash even though the overall light is bright — a condition that would cause most other models to turn the flash off when in autoflash mode.

This feature is usually called *automatic backlight compensation*. It's clever — a sort of automatic fill flash — but it usually doesn't work with a subject that has scattered shadows. Check your manual to see whether your camera has this ability, but don't think of it as a substitute for setting fill flash.

Figure 7-9: The harsh shadows produced by direct sun can be very unflattering (left). Fill flash lightens those shadows (right) for a more pleasing portrait.

© Mark Harris (2)

 If your camera has a backlight compensation setting (as opposed to automatic backlight compensation), this setting has nothing to do with flash. Choosing backlight compensation just tells the camera to increase the amount of light reaching the film or image sensor, to offset the underexposure that backlight may otherwise cause. This feature certainly improves detail in a shadowy main subject (think of the gazebo example I describe earlier in this section), but the price of that gain is a washed-out background. Use fill flash instead of backlight compensation, and you can have it both ways — good detail in both the main subject and the background.

If I seem to be charmed by fill flash, well, I am. Not only does fill flash give outdoor photos a professional look, but it can also save pictures that harsh light would otherwise ruin.

When not to use fill flash

At times, however, fill flash won't have much effect and may do more harm than good. For example, fill flash won't have much effect if your subject is too far away for the flash to "reach." (To find out about your flash's range, read the sidebar "Flash range: Throwing light on the subject," later in this chapter.) Fill flash won't fill the shadows in a big landscape, for example.

Keep in mind, though, that the loss of effectiveness is progressive. If there are objects in the foreground of the big landscape you're shooting (and as you find out in Chapter 13, including foreground objects in your composition isn't

a bad idea), they may benefit from fill flash, so fill-flash mode is worth setting. Fill flash is almost always preferable to using no flash. And outside, *in reasonably bright light,* fill flash has little down side. Even if you goof and use flash from too far away, the scene is well-lit to begin with, so you still get a decent picture. Shooting an indoor subject or a night scene beyond the flash's range, on the other hand, is a real no-no: You get a dark or muddy print with loss of detail.

All that said, you can maximize your fill flash by staying as close to the subject as practical. If your camera is a zooming model, avoid longer focal length settings, which force you to move farther from the subject to fit it all in the frame. Instead, zoom to the shortest focal length setting that the subject permits. A shorter focal length lets you get closer but still fit everything in the frame. (See Chapter 5 for more on the lens and focal length.)

Figure 7-10:
Subjects in the shade against a bright background are tailor-made for fill flash. Without it (top), you get a dark subject, a washed-out background, or both. With it (bottom), the subject is brightened without sacrificing background detail.

© Russell Hart (2)

What? Fill flash with a one-time-use camera?

You may think one-time-use cameras, being so basic, offer no choice of modes. But those versions with a built-in flash actually have a second mode: fill flash. Of course, these models don't have autoflash to begin with; when light is dim, you must activate the flash yourself by pushing a button on the front of the camera. (If you don't, you probably won't get an acceptable picture.) But you can also push a one-time-use camera's flash button for *outdoor* shots — portraits in direct sunlight or subjects with their backs to the sun — the same way that you'd set fill-flash mode on a reloadable point-and-shoot. By forcing the flash to fire in these conditions, you lighten dark shadows, which can otherwise mar a portrait, or any other subject within the flash's range. Note that some very simple point-and-shoots operate much like one-time-use flash cameras: They have just one button (or switch) besides the shutter button, which makes the flash fire regardless of the light.

I don't mean to be too cavalier about fill flash. It can actually be harmful when part of a subject's appeal is in its quality of light. Fill flash may destroy that quality. How can you tell if it will? Read the section "Flash-Off Mode: To Flash or Not to Flash," later in this chapter.

Always keep a fresh extra battery on hand. I've been practically begging you to use flash, and flash takes a lot of battery power. Heavy flash use reduces the number of pictures your camera can take before it needs more juice.

Flash-Off Mode: To Flash or Not to Flash

If you're a sports fan, you've probably noticed that each big play at a night game ignites a thousand points of flash in the grandstand. Professional photographers joke about the phenomenon, because they know most of those pictures won't come out. They know that there's just no way such a small flash can light a stadium.

Alas, your point-and-shoot has no way of knowing that the subject is too far away to light. It just sees the lack of adequate illumination and flashes blithely away. It pumps out every particle of light it can muster, but just overexposes the heads of the people in front of you, turning them into hairless wonders. Distant sports action ends up darker than the mood of a losing quarterback.

What to do? Just turn the flash off! Don't be shy. Press the flash mode button until you arrive at a lightning bolt slashed through by the universal "no" symbol — a circle around a diagonal line. On some models the canceled bolt

Flash range: Throwing light on the subject

Built-in flash units vary in power, affecting the distance range within which they can adequately light a subject. Check your manual's specifications section to find out your point-and-shoot's flash range. (The range is often stated in meters, marked by an *m;* just multiply the number by 3.3 to convert it to feet.) Many of the indoor photos that you take will fall within your flash range, especially if you follow my advice and stick with fast films (check out Chapter 2 for more on film speeds). But another way to increase your camera's flash range is by zooming to a shorter (more wide-angle) focal length. This setting not only allows you to shorten the distance between you and your subject, but also causes the camera to set a bigger lens aperture. And the bigger aperture lets the camera gather more light from the flash.

may also be accompanied by a moon or star symbol. On a few models you may get no bolt, only the moon and/or star (see Figure 7-11). Whatever the icon, the idea is that you're turning the flash off in dim light — oddly enough, in light that would otherwise cause it to fire automatically.

Figure 7-11:
Typical
flash-off
icons.

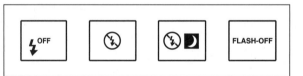

Your manual probably calls this mode *flash-off.* (If the camera isn't flashing, is flash-off really a flash mode? You made your point.) By turning the flash off, you force the camera to take the picture by the artificial illumination of the stadium itself. So the camera must gather in as much of the existing light as it can.

Knowing how to turn the flash off is also valuable because at some events (circus finales, Ice Capades) you may be prohibited from using flash. This restriction is often the case at gymnastics competitions, for example, yet every dismount brings on a fireworks display of flash. These snapshooters probably don't mean to flout the rules. They just don't *know* how to turn off their cameras' flashes. And they almost certainly will be disappointed by their pictures.

I don't mean to suggest that sporting events are the only occasions on which to turn off your flash. Here are some other times and places when and where you should also consider setting the flash-off mode.

✔ **When you're shooting far-away subjects that would otherwise auto-matically trigger the flash** — a landscape at dusk, for example. More than a few cameras offer a *landscape,* or *infinity,* mode (sometimes part of the flash mode sequence) just for such occasions. Setting your camera to landscape or infinity mode tells it that it can't light the whole scene, so it turns off the flash for you — usually. If your camera is one of those wacky models that thinks its flash can light a landscape, firing anyway, turn off the flash yourself.

Keep in mind that a landscape or infinity setting also locks your focus at infinity. If you have things in the foreground, they may end up unsharp. In that case, just turn off the flash.

✔ **When the quality of light is an essential part of the picture that you want to create.** Say that you're photographing the play of late-afternoon sun across rippling sand. (Forgive the cliché, but I can't argue with nature.) You get in close, for an abstract effect. The light may be low enough to activate the flash in autoflash mode, especially if you're using an ISO 100 film. (Remember, I told you not to.) And flash will probably ruin such a shot by lightening the shadows — both big shadows cast by ripples and tiny ones cast by grains of sand — that provide its eye-catch-ing sense of texture. Interesting, angular, atmospheric light is often low light, and low light is the flash's cue.

If that's the kind of image you want to create, turn the flash off. And what if you forget? Problem is, you don't always notice the flash firing when you're outdoors. So if you think it might have fired, turn the flash off and take another picture of the same thing.

When in doubt about whether to use flash, shoot the subject with and without it. Doing so also gives you two shots for comparison, helping you figure out what works and what doesn't (see Figure 7-12). Please don't be frugal. Saving the cost of one more print is no compensation for a disappointing picture.

✔ **When you're shooting through a window.** If you don't turn the flash off, the reflection of the flash may obscure or obliterate your subject. You can eliminate the reflection by pressing the camera right up to the glass as you shoot. Be warned, though, that doing this may cause the camera to focus incorrectly. The only way to find out whether your camera's focusing is thrown off by shooting through a window is to *try* shooting through a window, and to see how your prints turn out. If your camera can focus correctly, you're in luck. If your camera doesn't focus cor-rectly, try wiping off a clean patch on the window. Better yet, just open the window. (See Chapter 6 for specifics on shooting through a window.)

If you can't get right up to the glass, you can sometimes take a picture through a window with flash by shooting at an angle to it. This method is more likely to work if the window is clean. Shooting at an angle also lets you shoot into a mirror with flash without wiping out your subject.

Figure 7-12:
The flash fired automatically to brighten this shady shot, over-powering the soft light and sense of texture (top). Turning the flash off (bottom) preserved these qualities.

© Russell Hart (2)

Keep in mind that turning your flash off can introduce complications. If you're shooting in a dimly lit stadium, especially with a slower film (ISO 100 or 200), the camera may set slower shutter speeds to make up for the inadequate light. With some models, such speeds may be as long as a second or more. These speeds make freezing a moving subject difficult or impossible. But just as significant, slower shutter speeds increase the likelihood that hand tremors (which you don't even notice) will blur the image (see Figure 7-13).

Not to worry. I show you ways to deal with shake, which is arguably a more common cause of unsharpness than incorrect focus, in Chapter 2.

The waiting game: Flash recycling

No, flash recycling is not the latest form of environmental correctness. After your little flash fires, it takes a moment to accumulate enough juice for another pop. This interval, which can range from a couple seconds to a seeming eternity, is called the *flash recycling* time. It's a major source of aggravation to point-and-shoot photographers who like to take a second shot right after the first, because the camera locks up the shutter button until the flash is pretty much fully recharged.

Some cameras take longer than others to recycle the flash. But if the delay is just impossible, the cause is more often than not a weak battery. Installing a fresh battery is a smart idea if you're planning a people flash blitz, allowing you to quickly take the second or third shot that always seems better than the first. (Check out Chapter 1 for more on batteries.)

By the way, the little orange or red lamp in your viewfinder eyepiece (the green one confirms the focus) tells you whether the flash has recycled, which is why it's called the *flash-ready lamp* (see figure). It usually blinks when the flash is recycling and stays lit when the flash is ready. More advanced point-and-shoot models may do this with a glowing lightning-bolt icon in the viewfinder, in the dark area just below the frame.

The flash-ready lamp is good to keep your eye on, because if you're taking quick pictures you can shoot as soon as it stops blinking. But you can't hurt anything by pressing the shutter button when the lamp is blinking, since the camera locks up the shutter button until the flash has recycled anyway. If the camera won't let you take a picture, at least you know why — and that you may need a new or recharged battery.

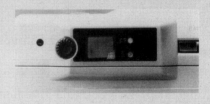

Slow-Sync Mode: The Flashiest Kind of Flash

Slow-sync flash is one of the most useful effects you can get from your point-and-shoot camera. It's also just about the flashiest. Alas, not all models have a slow-sync flash mode, but I think they should. Those that do may call it *night* or *night flash* or *night scene* or even *night portrait* mode. (More techie-sounding possibilities include *slow-speed sync, slow shutter speed synchro,* and the like.) Slow-sync flash mode's LCD panel icon is usually a lightning bolt paired with a moon or star and occasionally a little head-and-shoulders figure (see Figure 7-14). Sometimes the word slow — even auto slow, since it still does all the calculations automatically for you — accompanies the lightning bolt.

 Slow-sync flash may only be available as part of a subject or program mode that sets other camera functions. For example, you may get red-eye reduction in the bargain, on the assumption that you're photographing people. Check your manual for details.

Figure 7-13:
If your camera withholds flash and sets a shutter speed too slow to counteract hand tremors, it may blur your picture (left). Setting fill-flash mode may give you a sharper picture (right).

 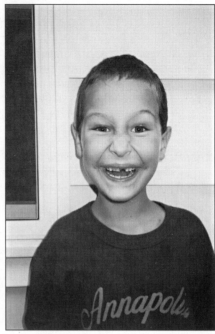

© Russell Hart (2)

How can I convey the contribution that slow-sync flash can make to your photography? Get your snapshot shoe box and sift out your most disappointing pictures. If you're a digital shooter, turn on your computer and take a look at some of the shots you've never shared or printed. These photos are probably something along the lines of a friend or family member posing against city lights or some other lively nocturnal scene. Or at least that's the way you remember it, because the actual picture consists of a washed-out figure in a black void. Photofinishing is a co-conspirator in this ghostly quality. Photofinishing machinery tries to compensate for all that black by making the print, and therefore the main subject, too light. (See Chapter 3 for more on photofinishing problems.)

Take my word for it, slow-sync flash puts an end to this annoying phenomenon. But don't let a starry-looking icon lead you to believe that you can only use it at night. Read on for other good times to use it.

Figure 7-14:
Typical slow-sync flash icons.

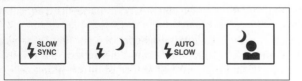

Slow-sync flash mode balances your flash-lit main subject with a dimly lit background in an ingenious way: by combining flash with a slower shutter speed than flash ordinarily needs.

In autoflash mode, the shutter stays open just long enough for the split-second flash burst that lights the main subject. In slow-sync flash mode, the shutter stays open longer so that a good amount of the scene's existing light is recorded on the film, or a digital camera's image sensor, along with the flash. Recording more existing light makes the background brighter, because it's often too far away for the flash to affect it.

Lucky for the suburbanites among you, slow-sync flash isn't just for glitzy city lights. Slow-sync flash is also effective indoors, day or night. Use it instead of autoflash, and you get better background detail in your flash shots. Slow-sync flash improves the sense of a room and the other people or things in it (see Figure 7-15).

Slow-sync flash can also produce a pleasant *warming* of the image — a sort of golden yellow tinge. This effect happens when some or all of the existing light is *tungsten,* meaning from ordinary household bulbs. Tungsten sources also include popular high-wattage halogen lamps, as well as much of the lighting used in malls, galleries, and other commercial spaces. You see the effect of this warming mostly in the background, along with the improved detail, because the foreground (where the main subject is) is dominated by the flash, which your film or digital camera interprets pretty much the same way as daylight.

Color print film is balanced for daylight — that is, it's designed to produce faithful color in natural, outdoor light. Flash illumination looks pretty much the same to the film as daylight. Tungsten light, on the other hand, looks warmer than daylight to the film — so it contributes a yellowish tinge to slow-sync flash pictures.

If you turn on slow-sync flash in fluorescent lighting (often used in schools, offices, factories, and some stores), you may turn your backgrounds green. Unlike your ever-adjusting eyes, film thinks fluorescent light is green because it has weird gaps in its color spectrum. Personally, I don't mind the effect; the main subject's color is kept clean by the flash, and I'd rather have greenish background detail than none at all. So I guess this effect is a blooper only if you feel differently. (Note that many newer color print films actually reduce this greenish cast on their own.)

Warming or not, I have to issue a warning about slow-sync flash: Its slower shutter speed increases the chance of blur. Not blur in the main subject, which almost certainly ends up sharp thanks to the quick blitz of the flash, but blur in the background. (This blur is usually more of a streakiness due to subject or camera movement.) If the main subject picks up any blur from slow-sync flash, it usually takes the form of a streaky fringe around its edges.

Figure 7-15:
In dim indoor light, autoflash (top) sets such a high shutter speed that you usually don't get much background detail. Slow-sync flash (bottom) sets a slower shutter speed, which allows the film to record more ambient background light.

© Russell Hart (2)

I like the effect of the blur. It's arty. It adds energy and a sense of movement to flash pictures. You've probably seen this background blur effect in magazines, because professional photographers have seriously cultivated it, often making it part of their style. How much blur you get depends partly on the technical particulars of your point-and-shoot — for example, how slow a shutter speed the camera is able to set.

If, on the other hand, slow-sync flash gives you too much blur for your taste in normal room light, try a faster film (ISO 400 or 800) — if you're not already using one, as you should be. And make more of an effort to keep your camera steady, bracing yourself against a doorjamb and digging your arms into your chest as you shoot. If your pictures are still too trippy for your increasingly conservative standards, then just go back to autoflash.

If you absolutely want a sharp background in a slow-sync flash shot, you can use a tripod. A tripod will not keep *moving* people from blurring, however,

and will also limit *your* freedom to move around the subject and shoot quickly and spontaneously.

Red-Eye Reduction: Getting the Red Out

Yes, your kids can be devils. But that's not why they sometimes have glowing red eyes in your flash pictures. Point-and-shoot cameras are especially susceptible to a photographic affliction called, matter-of-factly, red-eye. Red-eye is the price of a point-and-shoot's compactness: Its flash is so close to the lens that it actually reflects off your kids' (or others') *retinas,* the backs of their beady little eyes. Red-eye is unpredictable, but it's more likely to occur with blue-eyed people in dark environments. Why the camera turns canine and feline peepers green instead of red is best left to those who can actually define the term wavelength.

To lessen the dreaded effect, manufacturers have put red-eye reduction flash capability into all but their most basic point-and-shoots. Alas, these red-eye reduction systems can create more problems than they solve. So in this section I explain some ways of circumventing the problems.

Red-eye reduction comes in two varieties:

- ✔ **Preflash type:** This is the most common type of red-eye reduction system, in which the camera emits one or more low-power flash bursts before the final, full-power burst with which it takes the picture.

- ✔ **Prelamp type:** In this type of red-eye reduction system, the camera shines a small white or red lamp at the subject for a second or so before the exposure.

Red-eye is a particular problem in dim light, the light that automatically triggers your camera's flash. In dim light, your subject's pupils dilate, uncovering more retinal surface — and a larger area to reflect the flash.

Whether your camera uses preflashes or a prelamp to reduce red-eye, the idea is the same: Throw light into the subject's eyes, and his, her, or its pupils immediately contract. This effect lessens the retinal area exposed to the final, full flash.

Which type of red-eye reduction system does your camera use? (Have you already lost the manual?) Okay, here's how you tell. Push the flash mode button until your camera's LCD displays the icon for red-eye reduction. With some models red-eye reduction is separate from the flash mode menu, activated by its own button (which is an excellent idea, for reasons I discuss later). Push this button once to make the icon (see Figure 7-16 for some examples of red-eye reduction icons) appear on the LCD panel.

Figure 7-16:
Typical
red-eye
reduction
icons.

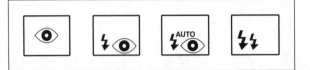

Now point the camera at something dim and press the shutter button halfway, just until the red or orange flash-ready and green focus-OK lamps in the viewfinder eyepiece come on. If nothing happens other than the customary click or zip of the lens focusing, you probably have the preflash type of red-eye reduction. (One sure sign of the preflash type is a double lightning bolt icon.) If a little lamp lights up on the front of the camera or inside the flash tube and stays lit as you keep the shutter button pressed halfway, you probably have prelamp red-eye reduction. Some such lamps may not light up until you push the shutter button all the way, so you may have to waste a picture to find out. Wasting one picture is worth it if you discover that you do, indeed, have prelamp red-eye reduction.

I have a minor grudge against built-in red-eye reduction. So for my own, personal red-eye reduction system, I take a Sharpie — one of those marks-on-anything pens — and carefully blot out any offending red eyes. Afraid of making your kids look like Betazoids, those black-eyed telepaths on Star Trek? Can't bear to darken your daughter's baby blues? Ask your friendly neighborhood photo dealer for a red-eye-retouching pen, which neutralizes the unwanted red instead of simply covering it, preserving a semblance of natural eye color. This type of pen even comes in a green-eye version for kitty.

Digital photographers, you have another option: You can use your computer to eliminate red-eye. Many simple image-editing programs reduce getting the red out to one or two clicks. See Chapter 16 for details.

Why do I have a grudge against red-eye reduction systems? Because they can make you miss important pictures, for a couple of reasons. This is especially true of the preflash variety.

Preflash red-eye reduction systems

Red-eye reduction systems that work by preflash(es) can cause two problems.

- ✔ First, your subject may mistake the preflash(es) for the actual picture, and look or turn away. This ruins the shot, of course.

- ✔ Second, even if you tell your subject to expect the preflash(es), he may not know what to do with himself during the lag between the preflash(es) and the final flash (again, the flash for the picture itself). In

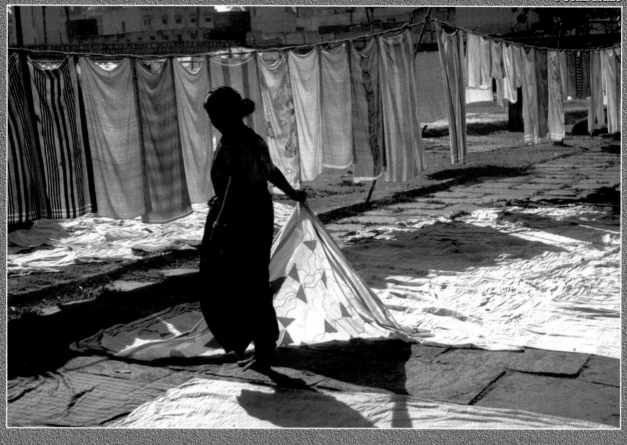

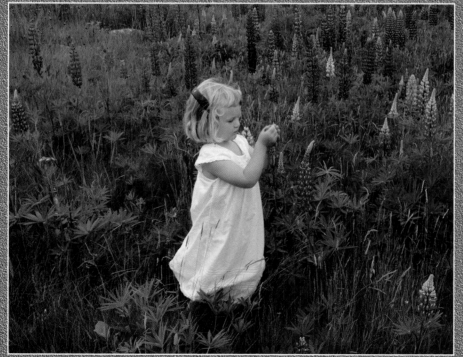

The quality of outdoor light runs the gamut from hard to soft, but either kind of light can produce an effect that suits a particular subject. Hard light (top, from an overhead sun) creates strong shadows that can add drama and hide distracting detail. Soft light (bottom, on a cloudy day) can be shadowless, calling more attention to the subject's tones and colors. The overcast light on the little girl picking flowers in a Maine meadow — light not commonly considered good for photography — gives the image a fitting delicacy it wouldn't otherwise have had, and shows how a cloudy day can actually make colors more vivid. (Chapter 9)

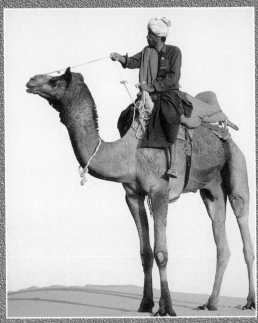

These two very different pictures of a camel and its driver perched on an Indian sand dune were taken just minutes apart. After shooting the camel brightly lit by late-day sun (left), the photographer scrambled to the other side of the dune and took pictures with the sun behind the camel, creating a dramatic silhouette (right). A simple change in camera position can produce a picture with an altogether different feeling — and there's usually more than one good way to photograph a given subject. (Chapter 10)

When the light on your subject has a special quality that you want to preserve in the photo — here, the directional warmth of household lamplight — consider turning off your flash. If you leave the camera in its autoflash mode, the flash may fire and overpower the existing light you want to capture. To shoot this pint-sized poser, the photographer set his digital point-and-shoot to its flash-off mode. (This is usually done by repeatedly pressing a camera's flash mode button until the flash-off icon appears.) He was careful to hold the camera steady so that he wouldn't blur the picture during the longer-than-usual shutter speed needed to gather enough light. (Chapter 7)

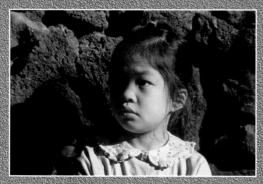

When you want to take pictures of people in direct sunlight, switch your point-and-shoot from its autoflash mode (the mode it sets when you first turn it on) to its fill-flash mode. In autoflash mode, the flash won't fire because the camera detects lots of light, and you'll get dark facial shadows that can ruin the photo (left). Set fill flash and the camera fires the flash every time you take a picture, even in bright light — lightening those unflattering shadows (right). (Chapter 7)

When you take pictures at night or in dim light with your point-and-shoot set to autoflash, you usually get very little background detail (top). Setting slow-sync flash (if your point-and-shoot offers this mode, which also goes by night flash or night portrait) allows more of the existing light to strike the film or image sensor, greatly improving background detail (bottom). But to do this, the camera must use a slower shutter speed, increasing the chance that your hand tremors will blur the background. Hold the camera extra steady for sharp results! (Chapter 7)

Most people use color print film because it provides a realistic representation of the things they ordinarily photograph, including skin tones (left). Some subjects take on a more atmospheric quality, though, when you shoot them in black and white, as in this window-lit portrait (right). Most good photo shops carry black-and-white film that can be developed and printed by the same photofinisher who does your color work. In fact, you can get one-time-use cameras that shoot black-and-white film. And many digital point-and-shoots allow you to take black-and-white pictures — even with a sepia tone, for a distinctly old-fashioned look. Yet some subjects seem to demand color for their success. It's hard to picture this image of a post-9/11 flag display (below) without its red, white, and blue! (Chapter 2)

Many photographers use their camera's viewfinder — or, on a digital point-and-shoot, the viewing screen — as if it were a gunsight, placing the subject dead-center in the frame (left). This usually creates an unattractive static quality. Many pictures can be made more exciting by composing them so that the main subject is off-center in the frame. By placing this game park leopard to the right in the frame (right), the photographer was able to include a nearby thorn bush — its spikey, linear quality providing a visual counterpoint to the animal's rounded spots and shape. When you compose with your main subject off-center, be sure to lock the focus, as explained in Chapter 6. (Chapter 10)

A more daring example of placing the main subject off-center in the frame, this effective portrait of a dress and shawl merchant breaks the scene down into grid-like sections. It proves that there are no set rules for good composition! (Chapter 10)

The great majority of pictures are taken as horizontals. This may be because our world is wider than it is tall, but is also due to a lack of thought: Photographers just seem to forget that they can easily rotate their camera 90 degrees for a vertical if the subject suggests it. Individual portraits are the most obvious case for vertical composition, but there are many times when a scene simply begs to be shot vertically rather than horizontally, as does this corridor in an African mosque. The subject's strong vertical lines make it ideally suited to vertical composition, which also reinforces the receding perspective that gives the picture such great depth. (Chapter 10)

When you look at a scene as you're photographing it, you see it with all the depth that binocular vision provides. But when that scene is translated into the two dimensions of a photographic print, it loses its three-dimensional quality (top). One way to maintain a sense of depth in the print is to include an interesting element of the scene in the foreground. Routinely used by landscape shooters, this technique is often called "near-far" composition. The photographer improved this view (top) of one of the American Southwest's most popular subjects, the "mittens" of Utah's Monument Valley, by composing with a weatherbeaten tree in the foreground (bottom). His composition makes the viewer's eye move between foreground and background, simulating the experience of depth perception. (A wide-angle focal length setting — 28mm on a 35mm point-and-shoot — makes near-far composition easier.) (Chapter 13)

© John Isaac

Reflections are an almost foolproof way to make a photograph more interesting. Watery environments such as this New England estuary are the most obvious place to find them, and here the photographer composed so that the pier's reflection receives as much attention as the pier itself. But you don't need picturesque places to find reflections with which to experiment. They're everywhere: on store windows, wet streets, and puddles of rainwater. (Chapter 10)

A common mistake of adult photographers is shooting children from grown-up eye level. Doing this creates a bird's-eye view of kids — one in which their heads dwarf their bodies, which are small to begin with! Pictures of children are usually better when you squat or kneel down to take them — body language that engages kids more fully too. For this portrait of a young baseball fan, the photographer not only squatted to his eye level but asked him to display his glove and ball. The boy obliged, with a certain shy pride. (Chapter 11)

© John Isaac

Placing the main subject off-center in the frame can make for a very effective composition. But if you shoot an off-center subject without first locking the focus, your point-and-shoot may accidentally focus on the background — causing the main subject to be unsharp in the print (left). To lock the focus, simply place the viewfinder's central focus point on the main subject, which centers it in the frame (middle), press the shutter button halfway down, and hold it there. Compose the way you want, then press the shutter button all the way down to take the picture (right). (Chapter 6)

Snow-covered subjects may cause your camera to think there's more light in a scene than there really is. As a result, the camera underexposes — allowing too little light to reach the film or image sensor. This produces a dark, grayish picture (left). You can anticipate and correct this problem by taking the picture with backlight compensation or adjusting exposure compensation to the plus side (right), if your camera offers these controls. You may have the same problem shooting on a light, sandy beach, and some digital cameras offer "beach scene" and/or "snow scene" modes that will make the needed adjustment for you. (Chapter 9)

Sometimes less is more when it comes to photography. Here, the photographer first shot the overall scene surrounding this Indian elephant (left). Then he moved in close for a detail of the elephant's eye, to emphasize the beautifully painted ceremonial decorations around it (right). The first view certainly provides more information and a fuller context than the detail. But the detail is a more intriguing picture, its abstraction raising questions about the circumstances of its making. (Chapters 10 and 14)

Most photographers take a picture as soon as they see one they want, standing wherever they happen to be at the time and zooming to make the main subject the right size. This strategy (really no strategy at all!) rarely produces the most interesting photos of a subject. After shooting a straightforward, head-on view of this bright green lifeguard station (left), the photographer moved in close and shot from a low angle with a wide-angle zoom setting — framing the subject simply and more dramatically against a clear sky (right). Next time you find an interesting subject, don't just take one picture and quit. Move in close and investigate the subject, shooting from a variety of distances and points of view. (Chapter 10)

A wide-angle focal length setting can help you create a more dramatic feeling of depth in a picture. Here, a 28mm focal length (available on several 35mm point-and-shoot models) let the photographer move close to the subject and create a stretched-out sense of space, emphasizing the brilliant colors of the blanket more than the weaver himself (top). By contrast, for this shot of nonchalant sheep (bottom) the photographer stayed far away from his subject and zoomed his lens to its longest focal length setting. The long focal length combines with shooting from a distance to "stack" the foreground and background — making them seem closer together. If your point-and-shoot camera has a zoom lens, remember that where you set it, together with your distance from the subject, has a strong effect on the aesthetic quality of your picture. (Chapters 10 and 13)

To avoid blur with action subjects, don't shoot them directly from the side. Photographing from an angle — or even from the front, as in this shot of a budding soccer star — keeps the subject from moving as fast across the frame, making the picture sharper (left). You'll also freeze action more successfully if you use a fast film (ISO 800) or set your digital camera to a higher ISO (if it allows this), even in bright light! On the other hand, intentional blur can sometimes be more expressive of subject movement than a tack-sharp image, as in this photo of a Gypsy woman in traditional costume who whirled around for the photographer as he took the picture (right). You can actually get more blur if you use a slower (lower ISO) film — a rare exception to the "use fast film" rule — because it causes a point-and-shoot camera to set a longer shutter speed. But if you use slow film in dim light, turn off the flash and securely brace the camera to prevent blurring everything in the picture. (Chapter 12)

Running water is often best captured with blur, and blurring water usually requires a longer shutter speed than the camera would normally set. If your digital point-and-shoot won't let you choose the shutter speed (and most don't), you can trick it into setting a longer one by going into the camera's shooting menu and selecting the lowest possible ISO, usually ISO 50 or 100. (Just be sure to reset the ISO to "auto" when you're done experimenting!) With a digital camera, you can view the effect of your adjustment right after you take the picture, and try a different ISO if you want to. Here, the photographer made sure to hold his digital camera steady to keep these Indian pilgrims sharp while blurring the sacred waterfall. (Chapter 12)

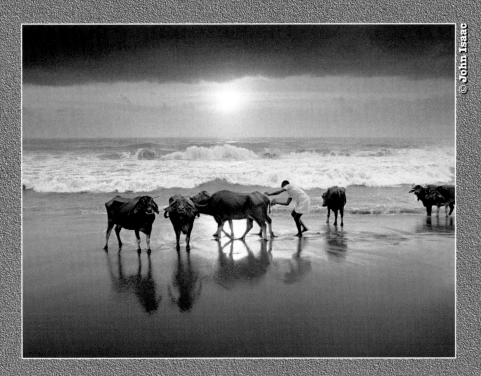

© John Isaac

Shooting in black and white, which in recent years has undergone a renaissance among both professional and amateur photographers, can give subjects a timeless, abstract quality that usually isn't possible in color (top). Though many digital point-and-shoots let you shoot in black-and-white, you can also use digital image editing software to convert your existing color pictures to black and white, and make prints from them. Likewise, a subject with a very narrow color range can make a wonderful picture. The largely blue palette of this African village (bottom), which is made more intensely blue by the open sky of dusk, might have tempted the photographer to shoot it in black-and-white. But the picture gets its visual power from its monochromatic color scheme. (Chapter 2)

© John Isaac

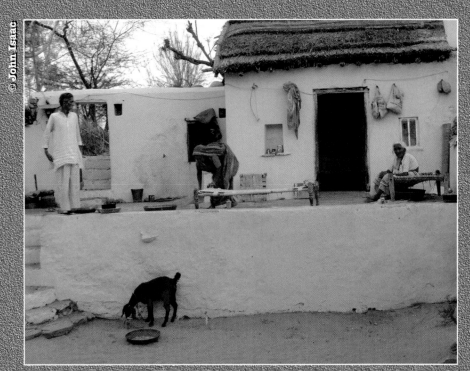

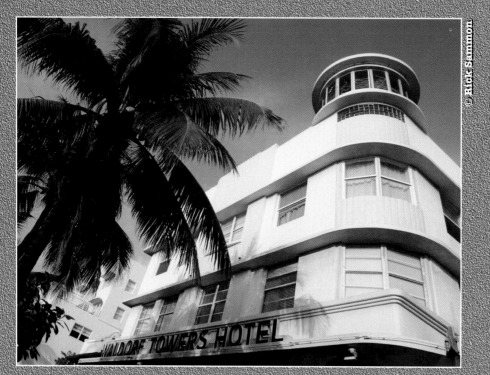

Shooting at night can make a subject more dramatic than shooting it in broad daylight. Here, the photographer took the same picture of an art deco hotel on Miami's South Beach during the day and after dark, with its neon signage in full tilt. To create this kind of shot, you should use ISO 800 or 1600 film or, if you're using a digital camera, turn up its ISO setting as high as it can go (if possible). Also, be sure to turn off the flash — which can overpower the existing light, or may not even reach the subject — before you take the picture, and keep the camera very steady when you press the shutter button. (If you can find some way to brace the camera, all the better!) Shots of night lights are often more effective when taken shortly after the sun goes down, when the sky is still a deep blue rather than black. (Chapter 9)

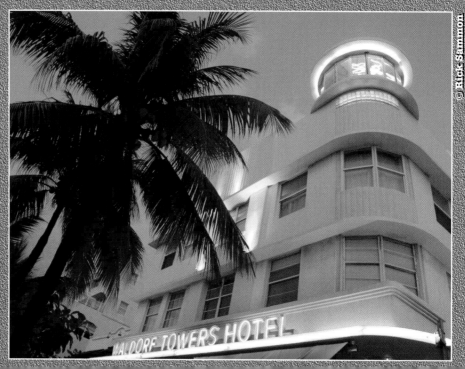

Don't limit your picture-taking to special occasions. Everyday events — here, a Saturday haircut captured filmlessly, with a digital camera — have their own special charm and meaning. Years from now you'll be glad you also have those kinds of pictures to help you remember the way life was. (Chapter 11)

And what photo album would be complete without pictures of pets? Sadly, most pet pictures are terrible — whether a bird's-eye view of kitty blending into the carpet or a doleful old dog with eyes like headlights from the reflection of your flash. To get better pictures of your pets, create opportunities for them to interact with their environment — and wait patiently for the right moment. Here, a well-guarded fishbowl is the perfect foil for a curious cat. To prevent green-eye (the pet version of red-eye), open all the shades, turn on all the lights, and take pictures when your pet isn't looking right at you. (Chapter 11)

If your camera is an autofocus model, don't be afraid to fill the frame with a face. Most autofocus point-and-shoots can focus quite close, keeping the picture sharp enough to show every little detail in the human visage. To maintain flattering proportions in facial features, zoom the lens in to a focal length at least halfway between the shortest and longest settings. And if you're using a digital point-and-shoot, compose with the viewing screen, not the viewfinder. (Chapter 11)

When you're on vacation, ceremonial occasions often get you the most satisfying, meaningful pictures — here, of Cambodian girls practicing for a traditional dance performance. But when you're traveling, local color is just about everywhere you look. (Chapter 14)

that seemingly interminable time, the lively moment you sought to capture when you pressed the shutter button can turn into an awkward, self-conscious stare. Or even worse, a blink.

Watching the perfect picture slip away as your camera puts on a light show is a frustrating experience, to say the least. Some red-eye reduction preflash systems fire a rapid and very distracting series of up to ten or so bursts before they take the picture.

So particularly if your red-eye reduction system is of the preflash sort, I suggest that you don't use it. As if to acknowledge the problem, some manufacturers relegate red-eye reduction to a separate button, so it's not part of the usual flash mode sequence. You can turn it off and on, or combine it with other flash modes, at your discretion. Thank you very much, but I'd rather have a good picture with red-eye (and fix it with my Sharpie, if need be) than a crummy picture without red-eye.

Prelamp red-eye reduction systems

Prelamp red-eye reduction systems are sometimes — and only somewhat — better than the preflash type. The little light may actually serve as an attention-getting birdie, but if it's bright, it may also make your subject squint. The light may delay the picture just as much as a preflash system does, because it needs to stay on for a second or so to have an iris-closing effect — and it doesn't have much of one even then. But at least people won't think that you've taken the picture, and turn away.

To maximize the effect of prelamp red-eye reduction systems, have your subject look directly at the little light until the picture is taken.

If your camera turns on its red-eye reduction light when you press the shutter button halfway, you can minimize any delay this causes simply by maintaining that pressure. (Because this action also locks the focus, just be sure that the viewfinder's or viewing screen's focus point is on the main subject when you do it; see Chapter 6 for details.) Then when you see the expression or moment you want, press the shutter button all the way, and the camera should take the picture without further ado.

By the way, if red-eye reduction is part of your standard flash mode sequence, it is essentially a variation of autoflash. (Certain models may even call red-eye reduction something like *Auto-S.*) The camera can turn the flash on and off as needed, giving you red-eye reduction in the bargain.

However, some models trigger red-eye reduction even in their slow-sync mode (or night flash mode — whatever it's called on your model). The assumption (fair enough) is that, because slow-sync is used in dim light, red-eye is likely. Unfortunately, if the camera relies on preflash(es) for red-eye

reduction, you can't have the pleasure of slow-sync flash without an annoying blitz. I've actually seen cameras with two slow-sync flash modes, one with red-eye reduction preflash and one without. That's a nice touch.

If you're shopping for a new camera and red-eye reduction is important to you, don't let me stop you. Maybe try to find a model with a prelamp system, or a system in which other flash modes aren't saddled with red-eye reduction, so you have more control. And remember that no point-and-shoot red-eye reduction system always eliminates red-eye. That's why they call it *reduction,* silly.

To lessen red-eye without resorting to your camera's red-eye reduction setting, open the curtains, roll up the blinds, and/or turn on more room lights — anything to get your subject's pupils to close. Oh, and take more pictures of people *without having them look at the camera.* Such pictures may be more interesting anyway.

One final note: If you're playing with your flash modes (tsk, tsk), keep in mind that most cameras cancel your selection when you turn them off. They reset themselves to autoflash mode every time you turn them on. (A few expensive models may set the flash mode you were last using, in which case you have to reset them to autoflash yourself.) Some models even reset to autoflash after *each* shot, depending on which other flash mode you choose, *even if you keep the camera turned on.* Shot-by-shot resetting can be a pain, for example, if you're shooting indoors and want to use slow-sync flash for all your pictures. You'd have to set slow-sync flash mode for each and every shot.

Of course, the idea behind having the camera automatically reset itself to autoflash is to rescue folks who forget to change the flash mode when shooting conditions change. But you know better now, right?

Chapter 8

Simplifying the Advanced Photo System

· ·

· ·

A few years ago, when the Advanced Photo System was introduced, photographers asked a fair question: If 35mm ain't broke, why fix it? Why, indeed. The decades-old 35mm film format had been revived by the millions of point-and-shoot cameras expressly designed for it, greatly improving the quality of amateur photography. So why bring out another system — the Advanced Photo System?

In a sense, to pick up where 35mm leaves off. Advanced Photo System (APS) point-and-shoot cameras embrace the same decision-free technology that makes 35mm point-and-shoots such a pleasure, from automatic film advance and rewind to autoexposure, autoflash, and autofocus. Their operational details aren't all that different from those of a 35mm model. Flash modes, for example, include the familiar fill flash, flash-off, and red-eye reduction; on better models, you get slow-sync flash and its variations. Shooting with an APS point-and-shoot feels pretty much the same as shooting with a 35mm model, which is why this book is as pertinent to the Advanced Photo System as it is to 35mm.

But Advanced Photo System point-and-shoots offer several advantages over 35mm models, and these improvements are the focus of this chapter. If you want to find out more about your APS camera's modes, turn to Chapter 4. If you want specifics about APS cameras' lenses, turn to Chapter 5. And if you want to review the way an APS cassette works, turn to Chapter 1.

Advanced Photo System Advantages

For all the automation at their fingertips, users of 35mm point-and-shoots still worry about loading that funny-looking 35mm cassette with its perforated film leader. They worry — or don't worry enough — about handling delicate strips of processed 35mm negatives. They wonder how to safely store those awkward strips. And they struggle to figure out which 35mm negative is the right one for the reprint they want.

The Advanced Photo System is an ingenious solution to those problems. Its sophisticated cassette offers nearly foolproof film loading (see the section "Dropping In: How to Load APS Film" later in this chapter). Its storage and indexing capabilities make keeping track of your pictures easier than with 35mm (see "Finding the right negative — the painless APS way" later in this chapter). And for reasons that this chapter explains, reprinting is simpler, too. Before I get into that, though, I want to tell you about the Advanced Photo System feature that I personally enjoy the most: the choice of *print formats*.

Shape Shifter: APS Print Formats

With 35mm point-and-shoot cameras, your prints come back the same size every time, usually 4 x 6 inches. (You can order the smaller 3½ x 5-inch size, but it has pretty much the same proportions.) The 4 x 6-inch print is a fine shape — a slightly longish rectangle that suits a horizontal landscape or a vertical portrait equally well.

But think, for a moment, about photographers who make their own prints. Most of them don't just use the same shape over and over again. Part of their art is in picking just the right shapes for prints — shapes that are appropriate to what they have photographed. They do this shaping in their darkrooms or computers, of course. But however you go about it, adjusting the shape of a photographic image to complement the subject is called *cropping*.

If you have a 35mm point-and-shoot with a panoramic mode *and* you bother to use it, you're probably familiar with this idea. Set a small, sliding switch to *P,* take a picture, and you get back a print in which the top and bottom of the customary 35mm shape are cropped to create a longer, narrower panoramic image. (See Chapter 3 for more on panoramas.) The problem is that if you forget to tell your photofinisher you've shot panoramas on a roll, those pictures will come back as standard-sized (4 x 6- or 3½ x 5-inch) prints with black bands at the top and bottom. This effect not only causes the image itself to be pointlessly small, but sometimes confuses the photofinishing machinery into making the print too light. You then have to ask that the picture be reprinted as a full-sized panoramic print, usually 4 x 11½ or 4 x 10 inches — and pay accordingly.

The Advanced Photo System gives you direct control over the shape and size of the prints that you get back from your photofinisher. Using a switch or button on the camera itself, you select any of three different print shapes and sizes for every shot you take. Advanced Photo System photofinishing machinery automatically prints each shot in the shape and size you choose.

The system's three print formats are called *Classic, HDTV,* and *Panoramic,* indicated on APS cameras with the letters *C, H,* and *P* (see Figure 8-1). They're essentially regular, wide, and wider. Choose *C,* and your picture comes back in the classic 4 x 6-inch print size to which 35mm users are accustomed. Choose *H,* and your picture comes back in a 4 x 7-inch print size that some manufacturers also call Wide or Group, for its usefulness in shooting bunches of people. (Not coincidentally, the H format has the same proportions as a high-definition television screen.) Choose *P,* and your picture comes back in the size also used for 35mm panoramas, either 4 x 11½ inches or 4 x 10 inches, depending on the photofinisher's equipment.

Figure 8-1: Advanced Photo System point-and-shoots let you choose between three different print sizes — 4 x 6 (upper right), 4 x 7 (right), and 4 x 11½ (left) — simply by adjusting a control on the camera itself.

© Russell Hart (3)

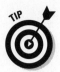

I repeat: You can get a different-sized print for every frame on a roll if you want, or you can use the same format for all the prints on a roll. And you can change your mind afterwards. Curious?

How to select your print format

You usually choose print formats with a sliding or rotating switch near the camera's viewfinder. (The switch may be on the front of the camera with certain models.) Rotating controls are usually located on the camera back to the right of the viewfinder; you move them with your right thumb (see Figure 8-2). Sliding controls may be located either to the left of the view-finder or on the camera top just above it; you move them with your left thumb or left fore-finger. With some models, you toggle through the formats with a pushbutton appearing in one of those places.

Always set your print format *before* you take a picture. The format that's set when you press the shutter button is the one that the photofinisher uses to make the print.

Figure 8-2:
An APS camera's print-format control is usually right beside the viewfinder.

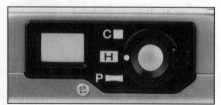 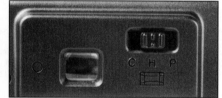

The shape of prints to come

Whenever you take a picture with an Advanced Photo System camera, the print format that you select for the shot is automatically recorded on the film with a special code. After the film is processed, the photofinishing machinery reads the code, sizing and trimming the print accordingly. When you're taking a picture, how do you know what piece of the scene will be printed? By looking through the viewfinder.

Whenever you change formats, an APS camera immediately reshapes or marks its viewfinder frame to show you the proportions of the print you'll get. It narrows the frame at the *sides* for a Classic shot. It narrows the frame at the *top* and *bottom* for a Panoramic shot. And it makes no adjustment for HDTV, because that format uses the whole viewfinder area. After the

viewfinder is correctly proportioned in this way, you can compose to fit the particular print shape that you've chosen.

Advanced Photo System viewfinders take a couple of different approaches to reshaping the viewfinder, also called *masking* it. Some models actually move the viewfinder's opaque black edges in and out. Other models simply impose dark bands along the right and left edges of the frame for a Classic shot, and along the top and bottom edges of the frame for a Panoramic. These dark edges tell you not to put any part of your desired picture in that area of the frame. The darkening is usually translucent; you can still see the scene through it. (See Figure 8-3.)

Figure 8-3:
When you choose an APS print format, the view-finder is automatically masked to show the print shape.

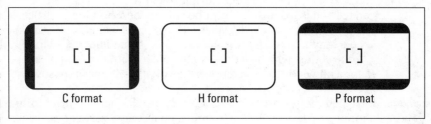

Some less expensive Advanced Photo System cameras use frame lines super-imposed within the viewfinder to show you the three different APS print formats. When you look through the viewfinder, you see three different-shaped boxes, formed by lines. The camera doesn't indicate in any way which one it's using. You must check where you've set the print-format control switch and then compose your shot with the corresponding box. You set the switch to *C* and compose with the squarish box if you want a 4 x 6-inch print; set the switch to *H* and compose with the biggest box if you want a 4 x 7-inch print; and set the switch to *P* and compose with the long, narrow box if you want a 4 x 11½-inch print.

Because these models' viewfinders don't tell you which format is set, you can forget to compose within the correct box. The mistake usually happens when your last picture was taken with the *C* or *P* format and you neglect to set the print format switch back to *H*. You compose with the biggest box, thinking you'll get a 4 x 7-inch print. Instead, you get back a 4 x 6- or 4 x 11½-inch print — and important details are often cut off. If your APS camera works this way, make it a habit to check the print format switch before shooting. Fortunately, you can easily correct such mistakes *after* you take the picture. (See the section "How APS lets you change your mind about print shape," later in this chapter.)

By the way, if your APS model's viewfinder uses dark, translucent bands to indicate different print formats, it probably has a pushbutton for setting them. With this type of control, the formats have no click positions, as do sliding or rotating switches. With a sliding or rotating switch, you can set the format without even looking through the viewfinder. With a pushbutton, you ordinarily have to toggle through the different format shapes as you look through the viewfinder — that is, push the button repeatedly until the shape you want appears. (Some pushbutton models may display your chosen format on their LCD panels.)

Which format is best for the subject?

Which print format you choose for a given shot is entirely up to you. *You're* the creative genius behind your Advanced Photo System camera. The best thing I can tell you is to let the subject be your guide. Shooting a vertical head-and-shoulders portrait? Maybe stick with *C,* the 4 x 6-inch print. An expansive land-scape? Maybe go with *P,* the 4 x 11½-inch (sometimes 4 x 10-inch) print. Taking a group shot in which all the people don't fit into the *C* frame shape? Switch to *H,* for a bit-wider 4 x 7-inch print. (See Chapter 11 for more suggestions.)

Intrigued by the Advanced Photo System's Panoramic print format? Try shooting *verticals* with it. Orienting a panorama vertically doesn't usually occur to people, but it's great for buildings and other city scenes, fun for full-length portraits, and lends itself to setting up interesting relationships between a scene's foreground and background. Even the *H* format's extra length makes it a great choice for verticals that would be cramped with 35mm. (See Figure 8-4.)

In experimenting with Advanced Photo System print formats, don't neglect your camera's zoom lens, if it has one. The combination of changing format and zooming in and out is powerful, giving you a new level of compositional control. With these two capabilities, you can mix and match cropping and composition in creative ways that are otherwise impossible with commercial photofinishing.

Set your print format first and then adjust your zoom. Changing print formats after you zoom may cause abrupt cropping of subject details. You can easily rectify this problem, of course, simply by readjusting the zoom and/or moving closer to or farther from the subject. (See Chapter 5 for more on zooming.)

The Advanced Photo System's *H* print is, in a sense, its standard format. (In a technical sense, *H* is definitely the standard format — see the next section, "Artistic License: APS Printing and Reprinting.") I've always rather liked the shape of 35mm pictures, wider than most other amateur and professional film formats. So for me, the still-wider shape of *H* is just more of a good thing. Which isn't to say that I don't switch to *C* when *H* includes a little too much at the edges, or *P* when I want to make a visual statement about long, wide, or tall subjects. The 4 x 7-inch *H* print is also just a nice-feeling size — more generous than a 4 x 6 yet more hand-friendly than a 5 x 7-inch blowup.

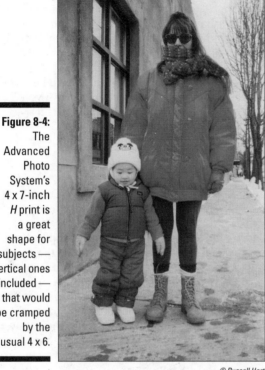

Figure 8-4:
The
Advanced
Photo
System's
4 x 7-inch
H print is
a great
shape for
subjects —
vertical ones
included —
that would
be cramped
by the
usual 4 x 6.

© Russell Hart

But maybe you're more of a strictly snapshooting type and consider changing print formats a bother. If so, just leave your print-format switch set to *H* and get all 4 x 7-inch prints. (For casual shooting, I myself use *H.*) Or, if you prefer the old-fashioned 4 x 6-inch print size, leave the switch set to *C.* Even if the print-format option doesn't jazz you, Advanced Photo System point-and-shoots offer advantages that make them worth having.

Artistic License: APS Printing and Reprinting

Having three on-demand choices of print size is exciting — but what if you change your mind? What if you realize, when you get a picture back, that you were trying too hard to squeeze a subject into the Advanced Photo System's Panoramic *P* format? Or that you lopped off the right half of Uncle Clive's face when you used the Classic *C* format? With APS, you can change your mind long after you've actually taken the picture.

You can have any Advanced Photo System picture reprinted in any one of the three formats. Turn that panorama back into a regular 4 x 6-inch print, perhaps restoring sky to a landscape. Or have the 4 x 6-inch print that cut off your Uncle's face redone as a 4 x 7-inch print, and literally retrieve what was beyond the edge — the missing half of Clive's face.

If you think a 4 x 7-inch print — say a vertical portrait — needs to be a little tighter on the top and bottom, then have it reprinted as a 4 x 6. Or if you think the foreground in a landscape that you shot in *H* or *C* is unattractive, then have it reprinted as a *P* — a big, wide panorama!

How APS lets you change your mind about print shape

Here's what's behind the Advanced Photo System's reprinting flexibility. Unlike a 35mm panorama, with which the image is actually blocked off by the camera on the top and bottom of the negative, no masking goes on in an APS camera. Each time you take a picture, the entire frame of film is exposed — and all the necessary cropping is done in the printing process. If you select the *H* format for a picture, APS photofinishing machinery uses the entire APS negative (which has the wide-screen proportions that I mention earlier in the chapter) to make the requisite 4 x 7-inch print. If you select the *C* format for a picture, APS photofinishing machinery crops off the short ends of the frame, because they aren't needed for the less-elongated 4 x 6-inch print. And if you select the *P* format for a picture, APS photo-finishing machinery crops the top and bottom of the frame to create a long, narrow print.

Finding the right negative — the painless APS way

If you do change your mind about the format you'd like for an Advanced Photo System picture, you could probably just hand the original print and the rest of your processing order to an experienced clerk and say (for instance), "I'd like this redone as a panorama." She would probably be up to the job. But half the point of the Advanced Photo System is that you yourself can figure out your reprint order, painlessly. To do so, you refer to the *index print* that's returned with your processed film (see Figure 8-5).

Made by digital scanning of the negatives, the index print (which is usually 4 x 7 inches) is an easy, quick reference for all the shots on a particular roll. Each shot has its own thumbnail image, which shows the full *H* format image that is exposed each time you take a picture. But if you chose the *C* or *P* format for a shot, a rectangle indicating that shape is overlaid on the thumbnail to

show the way you chose to crop it — the format in which the picture was actually printed.

If you want to reprint a particular shot (or get a blowup of it) with a different print format, here's what you do. Find the picture on the index print; note its number; tell the clerk, "I'd like number 8 reprinted as a panorama," or, "I'd like number 18 reprinted in the *H* format"; and hand over your negatives. You don't have to squint at negatives to figure out which strip the picture's on, the way you do with 35mm. Why? Because the negatives are coiled inside the film cassette that comes back with your Advanced Photo System order — fully processed. All you have to do is give the cassette to the clerk.

Unlike 35mm cassettes, which are discarded after the film is removed and processed, Advanced Photo System cassettes are reused. After APS film is removed and processed, it is respooled, uncut, back into the same cassette. The cassette is then returned to you with your prints.

Inside the APS cassette, your negatives remain safe from the dust, scratches, and fingerprints that often damage loose strips of 35mm film. The APS cassette bears the same code number as the index print of the pictures it contains. Any time you want reprints, whether in your original format or a different one, you just give the photofinisher the right cassette and the number of the picture's thumbnail from the index print.

You should keep the index print and the Advanced Photo System cassette together. You needn't worry if APS prints don't remain with the cassette, because the index print tells you what pictures are on a roll and in what format they were printed. And should index prints and cassettes become separated, you can quickly match them with their code numbers.

Figure 8-5:
The APS index print is a great convenience for reprinting, eliminating the need to look at negative strips to find the correct frame.

Advanced Photo System film comes in different roll lengths than 35mm film. It's available in 15-exposure, 25-exposure, and 40-exposure lengths, with 25-exposure the most popular. The longer the roll, the more thumbnail images must fit on an index print, so usually each thumbnail is smaller. For this reason, some photofinishers can print bigger thumbnails if you shoot shorter rolls.

Dropping In: How to Load APS Film

The Advanced Photo System film cassette is more than just a convenient storage vessel. Much smaller than a 35mm cassette, it makes *loading* film a less intimidating business than it is in 35mm. Its special oval shape fits an APS camera's film compartment only one way, so you can't put it in backward. And it lacks 35mm's perforated leader. Loading with the Advanced Photo System is truly "drop-in."

To load APS film, you simply open the film compartment, slide in the cassette, and close the door. (The cassette may ride up a little in the compartment, so just press it down with the door as you close it.) The camera then pushes out the film and winds it to the first frame. That first frame's number is usually the same as the number of exposures on the roll — 15, 25, or 40. Most APS cameras count backwards, telling you how many exposures remain on the roll rather than how many shots you've taken. (For details, see Chapter 2.)

You must use Advanced Photo System film if you're shooting with an Advanced Photo System camera. (Cassettes of 35mm film simply don't fit in an APS model's film compartment, and lack other features needed for correct camera operation.) The same companies that make 35mm film also offer Advanced Photo System film, but they have different product names for it.

The best way to make sure you're buying and using APS film is to look for the APS logo — a triangular shape with a displaced circular cutout (shown in the margin) and sometimes the words *Advanced Photo System* — on the film packaging and cassette. (The logo also appears on an APS camera's body, usually in front.) Some companies (notably Fuji) even call the film 24mm, which like 35mm refers only to the film's width. Technically, Advanced Photo System film is designated *IX240,* which combines these ideas, and you may see APS film identified *that* way, too. But for simplicity's sake, find the triangular logo.

If you're wearing your photographic thinking cap, a question may occur to you: Because APS film has no leader, how do you know if a roll has been used? With 35mm, you can tell that a roll's been shot if the leader isn't protruding from the cassette; the leader is pulled inside the cassette when 35mm film is rewound. Because the APS cassette lacks a leader, you might think you can get unexposed, exposed and rewound, and even processed cassettes mixed up. You'd be wrong.

First, if you load an exposed and/or processed APS cassette, the camera won't advance the film. If the camera has an LCD panel, it will just stop and blink the letter *E* (for empty), or sometimes a zero, and/or a symbol of the cassette. Some APS models may physically block an exposed and/or processed cassette, preventing you from inserting it all the way. In either case, you can't inadvertently double-expose an APS roll, or shoot a roll that has already been processed.

These protections are important, but you can also visually check whether an APS cassette is unexposed, exposed, or processed. On one end of the cassette, you find four tiny cutout shapes: a circle, a half-circle, an *X,* and a rectangle. A white indicator appears behind one of these shapes to tell you the cassette's status.

If the circle is white, the roll is unexposed and okay to shoot. If the half-circle is white, the film is half-exposed, and only cameras with the Advanced Photo System's mid-roll change feature will allow you to shoot the rest of it. (Otherwise, you should take it in for processing.) If the *X* is white, the film has been exposed, and you should process it soon. If the rectangle is white, the film has already been processed, and should be stored safely with other processed cassettes. (See Chapter 1 for more on the APS cassette.)

Conscious Choice: Types of APS Film

Advanced Photo System films come in ISO 100, 200, 400, and 800 color print films and ISO 400 chromogenic black-and-white film.

ISO 400 film is my top recommendation for an all-purpose film, whether in 35mm or the Advanced Photo System. But if you have an APS camera and you find yourself shooting frequently in the Panoramic print format, you may want to compare prints you get with an ISO 400 film and those you get with an ISO 200 film. Why this possible exception to my "Use ISO 400 film for just about everything" rule? Because APS negatives must be blown up more for Panoramic prints than for *H* or *C* format prints. The enlarging greatly magnifies the film's grain texture.

To compare prints, save the end of an ISO 400 roll that's in your camera and buy a short (15-exposure) ISO 200 roll. Find a suitable subject, set your APS camera on *P,* and shoot the last frame(s) of the ISO 400 roll. Rewind and remove the ISO 400 film, replace it with the ISO 200 film, and shoot the same subject. Shoot off the rest of the ISO 200 film, if you like — may as well check it out in the other print formats too — and have both rolls processed. When you get the prints back, choose the best Panoramic print from each roll and mark which speed film you used for it on the back. Then shuffle the two prints thoroughly, so you really don't know which is which.

Now compare the prints — no looking at the backs. Do you see a difference? More important, do you like one or the other better? If you notice anything, the ISO 200 print may have a slightly smoother quality. If you prefer its quality and plan to shoot lots of Panoramic pictures, then you may want to use ISO 200 rather than ISO 400 APS film.

Information, Please: APS Printing Refinements

Other interesting Advanced Photo System features hinge on the interface between the camera and the printing process that APS film affords. For example, the film's magnetic layer can store the time and date you took the picture, if you have a model capable of recording that information. The time and/or date are automatically printed on the *back* of the print, as opposed to 35mm's image-marring approach, "burning" colored numbers into the front of a print with electrical diodes. Called *backprinting,* this feature is a real plus if you've taken on the job of visual diary-keeper.

Other models even let you specify, with the same pushbuttons used to set the time and date, how many copies you want of a given print — in a sense, allowing you to get reprints in advance for anxious friends and relatives. The APS photofinishing machinery reads your request and makes the extras when it's printing the rest of the roll. You have to set the number of prints you'd like before taking the shot. But if after taking it you decide it wasn't up to par, you can actually cancel your order with the pushbuttons! (You do have to do it right after you take the shot, though.)

Part III
The Art Part

The 5th Wave By Rich Tennant

"Add some interest to the shot by putting the partridge in the foreground."

In this part . . .

Part III is a pushbutton-free zone. In this part, you dis-
cover two valuable but unappreciated pieces of pho-
tographic equipment: your eyes and your legs. And you
find out how to use them, photographically of course.

You find out that for good composition (putting just the
right piece of the subject on film) you must unlock your eye
and let it roam your point-and-shoot's viewfinder frame —
or, with digital models, that cute little viewing screen. (Yes,
I know the screen is small, but I'm going to make you use
it.) You discover that you should let your legs roam too,
moving in and out from the subject, shifting from side to
side, squatting or scrambling up on something — anything
but just standing where you are and zooming.

Equally important, this part asks you to contemplate the
very substance that your eyes were made to perceive, and
without which there'd be no photography: light. It asks
you to notice the way light turns everyday things into
extraordinary things. Are the right light and thoughtful
composition all you need for good pictures? Almost!

Chapter 9

Seeing the Light

· ·

· ·

*E*very year when fall gives way to winter, I notice the light changing in my house. As the surrounding trees shed their shield of leaves and the world tilts away from the sun, light seems to come through windows at different angles, illuminating corners of the house that have been dark for months. The cat stakes out new patches of sun. The light loses the white-hot color of summer, picking up a warmth that belies the cold weather to come.

Light is ever-changing. It changes from minute to minute, hour to hour, month to month. It changes when the weather changes and when the season changes. Experienced photographers take advantage of those changes. They wait until the end of the day to shoot, for example, when the sun colors things red; or for night to pass so that they can shoot by the suffused light of dawn; or for a storm to leave color-enhancing wetness or a blanket of snow in its wake; or for the midwinter days when a clear sky turns the weak sun's shadows blue. If you want great light in your pictures — something more than a good subject — you may have to wait for it, too. But you have to know what you're waiting for — the characteristics of the light you want — and how, if need be, to modify them. That control is what this chapter is about.

How Light Creates Mood and Atmosphere

Realistically speaking, most photographs must be taken when you see them, not one minute later. These pictures — the off-the-cuff shots of friends, family, and events — are of moments, and the light in them is secondary to the subject. When your middle-aged sister attempts a handstand in the living room, you grab your camera as fast as you can and shoot. (At least that's what I hope you do.) You don't stop to worry about the light. In fact, in such situations your flash is probably doing most of the lighting anyway. (Having light *in* your camera is a great thing!)

But some photographs — or should I say photographic possibilities — are as much about light as they are about their subjects. Your husband may occupy the same easy chair every Sunday morning, but one day the light on him may seem different — a beam of warm sunlight from the window raking across the side of his face, making the texture of his skin stand out in a masculine way.

Raking light is light that scrapes across a surface at a steep angle, making its texture stand out. Outdoors, it's especially noticeable at the beginning and end of the day, when the sun is low in the sky.

The light on your husband's face may, indeed, be something new: the effect of a change of season, a felled tree, curtains opened for the first time in weeks. Or maybe you just haven't noticed it before. That's the thing about light: You tend to take it for granted. And if you want to be a good photographer, you can't do that.

To be a good photographer, you should *study* light. Your apartment or house, and your yard or neighborhood, are perfect places to begin. Don't just look at *objects;* look at how the light describes them differently as it changes over the course of a day. The tree across the street may start out looking delicate and ethereal by morning fog; pick up bold, angular contrasts within its branches as the weather clears and the sun gets higher in the sky; and then take on a rosy glow in the setting sun's last rays.

Those changes illustrate what are, really, the three overriding features of light: quality, direction, and color.

The quality of light

Photographers like to describe light's quality in a tactile way: hard or soft. *Hard light* is direct from the source, undiffused. The sun on a clear day produces hard light; a bare lightbulb in your basement produces hard light. If you think of light as being made up of individual rays, hard light's rays head straight for the subject from the light source.

A *light source* is where the light that directly illuminates your subject begins. In the case of the sun or a household bulb, the light source is the actual producer of the light; in the case of a window or a skylight, the light source directs the light.

Soft light, on the other hand, is scattered light. Instead of reaching the subject directly from the light source, its rays pass through things and bounce off surfaces to surround and envelope the subject. The light on an overcast day is soft, scattered by clouds; the light in open shade on a sunny day is soft, bounced in by the clear blue sky; the light from a ceiling full of office fluorescents is soft.

Shadows are your main visual clue to the quality of light. Hard light produces dark, hard-edged shadows. Soft light produces paler, soft-edged shadows, or none at all (see Figure 9-1).

Manipulating hard light (which I tell you how to do in the section "Brilliant Strategies: Coping with Hard Light," later in this chapter) has one main purpose: to make it softer. Hard light is intriguing, but soft light is the ideal, photographically speaking. Indeed, most studio shooters, whether portraitists or product photographers, go to great pains to make the illumination from their studio lights gentle. Soft light is usually more flattering to both people and things. And it's much easier to work with, photographically, than hard light.

Figure 9-1: Hard, direct light produces strong contrasts. Soft, indirect light can be virtually shadowless, creating a delicate quality.

© Russell Hart (2)

Light work: A lesson

To study how light changes, choose an outdoor subject that receives a reasonable amount of light throughout the day. Pick a day that you don't expect to be entirely cloudy and take pictures of the subject every couple of hours throughout the day. Photograph the subject from the same position each time; leave marks on the ground for your feet, if possible. After you get your prints back, line them up and study the changes. You'll have a time-lapse sequence that says more about what light can do than anything I tell you here!

One way to capture changes in light automatically is to use an advanced feature variously called an *intervalometer, interval timer,* or *time sequence mode* (see Chapter 4). This feature is basically a built-in timer that automatically fires the camera at set intervals, without your having to attend it. If your model is so equipped, you can use it for your study of lighting changes. Find a secure, stable place to set up your camera — a table in your backyard or the sill of an open window overlooking the street — and then set your camera to shoot at one-hour intervals over the course of the day.

The direction of light

Within a given scene, some shadows are cast by the subject on adjacent things — Rover's shadow on the grass beneath him, for example. And some are cast by the subject on itself — the shadow of someone's nose on his cheek.

The direction and/or angle of the light determines where those shadows fall. A low sun throws that nose shadow sideways, across the cheek; a high sun throws it down, toward the lips. A high sun throws Rover's shadow down, on the grass beneath him; a low sun throws the shadow sideways, across the grass.

Light striking the subject from the side is called *sidelight*. Light striking the subject from above is called *toplight*.

You're much more aware of light's direction with hard light than with soft, because hard light's shadows are more distinct. In fact, soft light with no shadows visible is often called *nondirectional* light.

Work with the shadows. When a subject casts a long shadow on the ground, for example, consider including the whole thing — making it a part of your composition (see Figure 9-2).

The color of light

If you've ever watched the pale yellows of a spring sunrise or the ruddy reds of a winter sunset, you know that light has a range of color. With natural light,

this variation has to do with weather and other atmospheric conditions. Early and late-day sunlight, because it strikes your patch of earth at a more glancing angle than at high noon, must pass through more atmosphere. And the more atmosphere it passes through, the more airborne particles, dust, water vapor, and even pollution act as a sort of color filter.

But that filtering effect extends to cloudy days, too. A layer of overcast, in addition to greatly softening sunlight, gives it a cool, sometimes bluish quality (more noticeable in prints than when you actually observe it). And the light in open shade on a clear day is bluer still because it's cast by an expanse of open sky. Foggy conditions can actually make a subject almost colorless, for an interesting monochromatic effect in your print.

Indoor light from household fixtures — tungsten bulbs and halogen lamps — is a different story. Most film reproduces indoor light with a usually pleasant yellowish-brown warmth, though digital cameras can be set to compensate for this. (See the section, "Artificial light," later in this chapter.) And fluorescent light usually comes out green, for technical reasons I won't trouble you with.

Indeed, light doesn't just contribute its own color to a scene, but actually picks it up from the environment. My favorite tree, for example, is a sugar maple right outside my daughter's window. Every fall it turns a brilliant yellow, and her room turns with it. When sunlight hits the leaves and bounces back through the window, it's magnificent. I turn off my camera's flash and take pictures of it — not of the youthful clutter of my daughter's room, just of the glorious, palpable yellow light.

Figure 9-2:
If the scene you're shooting contains interesting shadows, make them a part of your composition. Here, the photographer placed the figures to the right so that he could include their shadows.

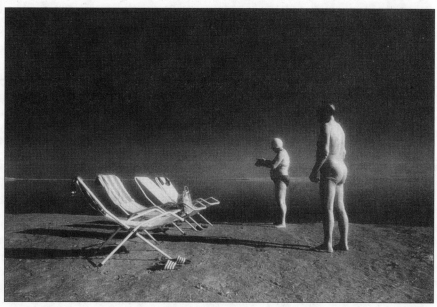

© Russell Hart

Brilliant Strategies: Coping with Hard Light

A long-retired photographic adage held that to take pictures in direct sun, you should keep the sun over your shoulder — in other words, behind you, slightly above you, and to the side. The advice always struck me as ridiculously limiting. It seems to suggest either that you take pictures only in one direction or that you move your subjects around — and that you don't much care what's in the background.

Neither photographic subjects nor the sun are as cooperative as that old adage seems to assume. Usually you can't move the things you want to photograph, and moving people can ruin a picture's spontaneity. Picture possibilities present themselves all the time, not just when the sun is over your shoulder. But that old adage does have a kernel of photographic wisdom in it. Sun hitting a subject from roughly the same angle at which you're taking the picture (over your shoulder) minimizes the size and number of heavy shadows on it. This nearly frontal light is somewhat more flattering to human subjects than overhead sunlight, which creates heavy, unattractive shadows under noses and in eye sockets. In either case, hard sun tends to bleach out color.

Shooting in direct sun

Picture opportunities, of course, rarely wait for ideal lighting conditions. And you don't always have the time to wait for better light either. But several simple, quick techniques can help you tone down harsh daylight: adding fill flash, increasing the exposure, and using reflectors. (See "Shadow play: Preserving detail in hard light" for more on these techniques.)

Avoid letting sunlight or any direct light source (a floodlight, for example) strike the front surface of your lens when you take a picture. This causes stray light to bounce back and forth inside your lens, not only creating streaks and bands but often fogging the entire image — giving it a washed-out appearance (see Figure 9-3). You will see sunlight striking the front of the camera right through your viewfinder or on the viewing screen; the scene will appear washed out, with streaky reflections crossing through it. This ruinous effect is called *flare.*

If you want to shoot toward the sun, position yourself so that a tree, roof, or other object outside the picture area blocks the sun, in effect shading the lens. Or hold the camera with only your right hand as you shoot, using your left hand to shade the lens. (Be careful not to get your hand in the picture.) If you want to include the sun itself in the picture, some flare may be unavoidable, depending on the quality and construction of your lens. But you can minimize the flare by choosing a vantage point from which the sun is partially obscured by a tree branch, telephone pole, road sign, or other picture element. It also helps to use your point-and-shoot's fill-flash mode (see Chapter 7), which adds frontal light to the subject.

Figure 9-3:
Shooting with the sun behind the subject may allow direct light to strike the lens surface — causing picture-fogging flare (left). To prevent this problem, shift your position to block out the sun and set fill-flash mode (right).

Shadow play: Preserving detail in hard light

The patterns created by hard sunlight can be unattractive or confusing. Perhaps the worst thing about hard light, though, is that in extreme cases, photographic film may not be able to record detail — that is, tone and texture — in both the areas that are directly sunlit and those that are in shade. Even when film *can* record detail in both sunny and shady parts of a scene, the print you get from it may contain only one or the other. The image sensors in digital point-and-shoots generally have an even harder time recording detail in both sun and shade than does color print film.

Highlights are the lightest and/or brightest parts of a photographic subject — those sunny areas, for example. *Shadows* are the darkest or most shaded parts of the subject. You can also use these terms to describe the lightest and darkest parts of the print itself, and the difference between them is known as *contrast*. If that difference is great, the subject or print is said to be *contrasty*.

When you actually *look* at a subject with brilliant highlights and deep shadows, you're able to see detail in both areas. When you gaze at the highlights, the lens aperture in your eyes — that is, your pupils — gets smaller. But the instant your gaze shifts to the shadows, your pupils open wider to let in more light. Unlike a point-and-shoot camera, which must choose one and only one aperture for a picture, your pupils change their size continuously as you scan

a scene. What's more, in lower light the "film speed" of your retinas (the light-sensitive back of the eye) is, in effect, increased. Your eyes and brain are a much more flexible system, when dealing with difficult light, than are your point-and-shoot and the film or image sensor inside it. (See Chapter 2 for more on the lens aperture.)

Modern color print film goes a long way toward capturing detail in bright highlights and dark shadows — an ability notoriously lacking in color slide film (see Chapter 2), and in which film point-and-shoots actually surpass their digital cousins. But even if your developed color negative contains both shadow and highlight detail, the print itself may not. The photofinishing machinery may have to choose between one or the other because it can give the paper only one overall blast of light. I can go into my own darkroom, or use digital imaging software on my computer, to give the print a little more light here, a little less light there — and by doing so, keep detail in both highlights and shadows. Your minilab, with its 500-plus prints-per-hour system, cannot stop to do that. As I mention in Chapter 3, up-to-date photofinishers may be using digital printing equipment that tries to balance highlights and shadows — though a human is still better at it!

Don't despair: Here are several ways to trick your color print film (and your prints) into keeping both highlight and shadow detail *when you're taking the picture*. I describe them in order of their effectiveness and convenience. Digital point-and-shoot users, take note: The second technique probably won't work with your cameras. But read on for information about a special adjustment you can make *only* with some digital point-and-shoots.

Use fill flash

Fill flash lightens the subject's shadows without significantly lightening the highlights. (I won't get into the physics of this effect here.) It brings shadows and highlights closer together, so that they're more likely to fall within a range that the film or image sensor can record. But keep in mind that fill flash helps only with subjects that are fairly close. When a subject exceeds the flash's outdoor range — perhaps 10 or 15 feet — fill flash doesn't make much, if any, difference. You can't use fill flash to lighten shadows in a landscape or a big building. (In those cases, you just have to wait for better light!) But you *can* use fill flash to lighten the unflattering shadow on the side of someone's face or the distracting shady spots in your prize bed of roses. To improve the range of fill flash, stick with ISO 400 film. (See Chapter 7 for more on fill flash.)

Increase the exposure

First things first, increasing the exposure may be hard to do with your particular point-and-shoot camera — and fill flash, which you almost certainly *can* do, is generally a better remedy for hard light. But unlike fill flash, increasing the exposure works whether the subject is near or far — and its effect *can* make a difference with that building or landscape. However, unlike the other two techniques that I describe in this section, increasing the exposure works only with color print film. And even if your digital point-and-shoot allows you

to do this, *don't*. If the subject has bright highlights, you risk completely washing them out.

Increasing the exposure simply causes more light to strike the film than the camera would otherwise allow. This effect tends to reduce the negative's overall contrast and, specifically, to lighten shadows in the print.

✔ You can adjust the exposure with the camera's *exposure compensation* control, if your model offers this feature. (This process is usually an easy pushbutton affair; see Chapter 4 for details.) I suggest increasing exposure by at least half an EV (an *EV* is a standard "chunk" that extra exposure is measured in), and in really hard light, one EV.

✔ If your camera doesn't have exposure compensation, it may have *backlight compensation*. You ordinarily use backlight compensation when the light is coming from *behind* a subject, a situation that may otherwise cause underexposure. (See "Backlight," later in this chapter.) But because backlight compensation usually increases the exposure by about 1.5 EV, it can add considerable shadow detail and also lower the negative's contrast. (Unlike exposure compensation, it has only one setting.) That's a lot of extra exposure, so try shooting one picture with backlight compensation and one without so that you can compare them and make mental notes for the next time.

Here's one final note about increasing the exposure to cope with hard light. If the folks at the minilab or other photofinisher make a print that's washed out, ask for a reprint — and don't let them blame it on an overexposed negative. In most cases, the *print* just needs more exposure. (Negatives from one-time-use cameras are often quite overexposed, and they print fine.) Adjusting the print settings just takes extra time on the part of the technicians. (See Chapter 3 for more photofinishing tips.)

Use a reflector

A *reflector* is a white or shiny surface that you use to bounce light into the subject's shadows and thereby lighten them. A big piece of white poster board will do; get it at a good stationer. Foam core is a better idea; it's a white-surfaced, Styrofoam-filled art board that is both lightweight and rigid. You can usually find it at art supply and hobby shops. You can also use a bedsheet or other white cloth, but you may need to attach it to a board for rigidity and control.

To use a reflector, place it on the side of the subject *opposite* the light source (for example, the sun) so that your subject is between the light source and the reflector. For example, if the sun is to the right of your subject, you would place the reflector to the subject's left. Adjust the reflector's distance from the subject and its angle until you see a visible lightening of shadows. Don't move it too close to the subject or you may lose the sense of shadow altogether; remember, shadow is important in defining the light's quality and direction and the subject's shape and textures. Also, be sure to keep the reflector outside the actual picture area. You may need an assistant (a kid looking for something to do?) to hold it in just the right position.

You'll be amazed at the way a reflector lets you control the balance of highlights and shadows. It can even fix overhead sun: Placed underneath a person's face, it immediately fills in those shadowy "holes." And a reflector is great for close-ups, too. I know one nature photographer who habitually tears paper out of his field notebooks and places it around the edges of his close-up subjects, just outside the picture area, to brighten small shadows. Needless to say, this technique doesn't work with large-scale subjects; you can't use a reflector when you're shooting a landscape, unless it's specifically to fill a shadow in the immediate foreground.

You can wrap your reflector in aluminum foil or silver Mylar (available at art supply and hobby shops) to make it bounce light more efficiently. Covering the reflector allows you to use it at a greater distance from the subject. You can even substitute gold Mylar to warm up shadows.

Reflectors are everywhere — and if you're clever, you can take advantage of them. A sandy beach bounces light up into people's faces, softening hard sun's shadows and often making beach pictures better than you expect. (For a stronger fill effect, have people kneel or sit in the sand so they are closer to it.) Snow has the same effect. If you have the ability to move a human subject around, in fact, you can use nearby white or light surfaces — a stucco wall or a sheet hanging out to dry — to fill unwanted shadows quite effectively.

Fancier digital point-and-shoots may offer a setting that allows you to change the actual contrast with which they reproduce a subject. You access this setting through the camera's onscreen menu. (See Chapter 15 for details on how to use the menu.) Generally you're given a choice of three different levels of contrast: low, medium (or normal), and high. If you're planning to take pictures in direct sun or by other hard light sources (stage light, for example), try adjusting the camera's contrast to its low setting. This will give it a better chance of squeezing both highlights and shadows into the range of brightness it records.

Moment by Moment: Waiting for the Right Light

Some pictures that are about light are about *momentary* light — light's more fleeting effects. A familiar landscape can be transformed when the sun breaks through a stormy sky and sends out shafts of dramatic light. Or for a short time in the spring, at a certain time of day, the sun may glint off a window and fill your yard's shadows with an interesting bounced light. Like most pictures of people, pictures of such lighting effects are hard to anticipate — and when you see them, you've got to act fast to capture them.

But for other pictures, you *can* — and should — wait for the right light. Say you're staying at a hotel overlooking the Grand Canal of Venice or (my preference) a tent on Lake Superior. Both spots command a spectacular view, and

you want pictures of them for posterity. You may think that the things in the scene are what make it great: the bobbing gondolas below, or the breathtaking stand of white birch that surrounds your tent. And they do make the scene good, but content alone does not make a photograph great. You have to think about *light* to make the picture as great as its subject.

Midday blues

If you shoot your scene in the middle of the day, you're likely to be disappointed. If the day is sunny, you'll probably get strong shadows, which can give the scene a disjointed, hard-to-read appearance. The direct light also may make colors look less intense than what you remember, when you get the pictures back.

Well, yes, I tend to dump on the poor old midday sun. Don't get me wrong: It *can* be a very interesting light source if handled with care. I've taken pictures of mid-Manhattan buildings with midday sun, for example; it throws ornamental detail into high relief — a sharply defined, three-dimensional appearance. If you wait much later in mid-Manhattan, the great buildings on the city's famed north-south avenues start to block the sun, which travels perpendicular to them. Even with some subjects in nature — valleys and canyons, hillsides and riverbeds — if you shoot too early or too late, you don't get any sunlight in them at all. And high noon is just about the only time, for example, that you can get decent pictures of slot canyons — those narrow, water-sculpted gorges of the American Southwest. The sun can't get inside them any other time!

Generally, though, experienced photographers stay away from midday sun. Needless to say, it can be as bad for portraiture as it is for landscapes, creating harsh, unflattering shadows in eye sockets and under the nose.

Shooting early or late in the day

You're usually better off taking such pictures at the beginning or end of the day — when the light is more angular, less harsh, and warmer.

Outdoor photographers have a special name for the warm-colored, low-angle light that they get early and late on a sunny day: *sweet light.* In fact, many of these photographers take a photographic siesta in the middle of the day, shooting only at its beginning and end!

Your sweet-light photograph needn't be a landscape or a grand view. You can wait for sweet light to do a portrait session in your backyard, or to capture that gnarly detail of your old oak, or to take those close-ups of flowers you've been meaning to shoot.

For sweet-light shooting, use a fast film — preferably ISO 400.

Cloudy is beautiful

A lot of inexperienced photographers avoid cloudy days like the plague. They think the light is drab. They're wrong. By lowering contrast and softening or eliminating shadows, cloudy days bring a special delicacy to subjects. They let subjects' colors and tones speak for themselves, without being drowned out by direct sun.

When I first started taking photography seriously, I would actually *wait* for cloudy days. I preferred their range of close tones — sort of like adding in the minor keys on a piano. Cloudy days also solved some darkroom headaches by keeping contrast under control. Cloudy days can do the same for your commercial prints — provided the printing is a good job. If it's not, cloudy light can make a subject look even worse. Use a reliable photofinisher! (See Chapter 3 for more on choosing a good photofinisher.)

Cloudy days can actually *intensify* colors. Pictures of flowers (see Figure 9-4) or fall foliage are often more vivid in overcast than in direct sun. So if you're on a leaf-peeping trip and the day is cloudy, don't worry, be happy!

When you can't count on clouds to soften hard sun for a portrait, take your subject into open shade. You can find it under a tree, beside a house, under a beach umbrella, and so on.

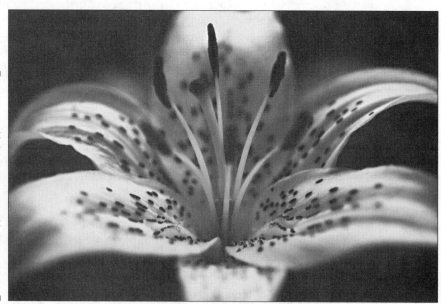

Figure 9-4: Soft overcast is often the best light for photographs of foliage and flowers, avoiding the washed-out highlights direct sunlight can cause.

© Russell Hart

Case by Case: Working with Specific Kinds of Light

People don't spend all their time in the great well-lighted outdoors, of course. (Well, a few hardy souls do.) For most people, light more often comes from various nooks and crannies: windows, open doors, skylights, electric lamps, overhead fluorescent bulbs. And light often comes at odd angles, too — from the side or from the back or even from below your prospective subjects. These specific kinds of light call for different ways of shooting. Here are some common examples.

Window light

Window light can be hard or soft: direct beams of sun or indirect, scattered rays. Either way, it's beautiful. Having to squeeze through the window's rectangle and enter a room from one side gives light a striking directional quality and rich shadows, even when the light outside is shadowless. Studio photographers covet north-facing windows in particular, because they're lighted by an open sky and rarely get direct sun. North light, they call it.

Window light offers a unique photographic lighting opportunity, one worth exploring to avoid the monotony of indoor flash shots. Rather than blast away with flash, try bringing indoor subjects — a newborn or a vase of flowers — over to a window for pictures (see Figure 9-5). Or go ahead and set up a more formal portrait session beside a window. Get your subject fairly close to the window for best results — the light is brighter there. And because moving closer makes the window's area larger relative to the subject, the light is softer overall, helping keep shadows from coming out too dark.

Keep your eye on shadows created by window light. The difference between them and the bright, highlighted parts of the subject can be even more extreme than outdoors because there's so little scattered light indoors, in a dark interior, to fill in shadows. (There's a lot more scattered light outdoors.) This lack of scattered light can make the print have either washed-out highlights or dark, empty shadows.

Here are a few ways to prevent this effect, and you can combine most of them to suit your purposes:

✔ **Turn up the room lights as much as possible and/or move a lamp closer to the subject on the side opposite the window.** This adds light to the shadows, though keep in mind that it appears as a *warm* light in the print because of the way your color print film sees artificial light. (See the section "Artificial light," later in this chapter.)

✔ **Angle your subject slightly *toward* the window, so that the light strikes the subject not directly from the side but a bit more frontally.** With a portrait, this positioning allows more window light to spill into the shadowed side of the subject's face and body. Better yet, simply ask your subject to look toward the window.

✔ **Use a reflector.** Placed on the room side of the subject (the side opposite the window) outside the picture area, the reflector bounces the window's light back into the subject's shadows. (See the section "Use a reflector," earlier in this chapter.)

✔ **Use fill flash to lighten window shadows, but use it only if the light on your subject is direct sun.** Flash usually overpowers indirect window light, destroying the sense of its angle and quality. If the flash fires on its own, set the flash-off mode and take another picture. (See Chapter 7 for more on using fill flash.)

✔ **Use a fast (high ISO) film.** A fast film is especially important if you're shooting by indirect window light. The slower (lower ISO) the film, the longer the shutter speed the camera sets — increasing the risk, already substantial in such low light, that blur will ruin your picture. I suggest an ISO 800 film for this purpose, and even ISO 1600 film, if there are no beams of direct sun in your picture. (See Chapter 2 for more on different types of film.) A high ISO film doesn't excuse you from holding the camera as steady as you can. Brace the camera on something if you want to play it safe. (For tips on steadying your camera, see the sidebar "Going steady: How to brace your camera.")

✔ **Manipulate the window's treatments.** Sometimes you can change the quality of window light just by doing this. If the window has translucent curtains or translucent blinds, you can use them to soften direct sun. If it has horizontal or vertical blinds, you can adjust them to create interesting slitted patterns of sunlight or to control where the light falls. If your window is bare, you can cover it with layers of wax paper or tracing paper to diffuse sunlight. Even a dirty window can add interesting texture and pattern to the light!

Artificial light

Indoor light — the illumination from household lamps and ceiling fixtures — may seem to be a light of mere convenience, but it has a photographic quality all its own. Because your color print film is actually designed to produce the most accurate color in daylight or with flash, it sees the light from tungsten and halogen bulbs as very warm in color. Pictures taken by such artificial light end up with a yellowish or brownish-yellow cast — an effect that can be quite rich.

The strength of that effect depends heavily on photofinishing because automated printers can partially correct the yellowish cast. Some correction is good; otherwise, the effect may be so brown that the print lacks a sense of color. If this happens, ask for a reprint. (See Chapter 3 for more photo-finishing tips.)

Figure 9-5:
For flattering window-light portraits, bring your subject close to the window, use fast film (ISO 800), and turn off your flash to preserve rich shadows.

© Russell Hart

To shoot exclusively by household light, you may have to turn off your flash by setting the camera's flash-off mode. Otherwise, your flash may fire automatically and overpower the light. (See Chapter 7 for details.) Use an ISO 800 or even faster film (ISO 1600 or 3200) so that the camera sets shutter speeds high enough to counteract blur due to hand shake. In fact, with an ISO 800 or faster film the camera may not fire the flash anyway because the film has enough light sensitivity for a good exposure. (See Chapter 2 for more on film speeds.)

Backlight

Backlight is just what it sounds like: light coming from behind a subject. Sometimes it's the main light source; in this case, a subject is said to be backlit. Backlight can be beautiful, defining a subject by glancing off its sides and/or throwing it into shadow (see Figure 9-6). It's the classic light for silhouettes. But backlight is also one of the most difficult kinds of light for a point-and-shoot camera to deal with.

The problem, usually, is that the camera sees lots of light in a backlit scene even though the main subject is shadowy. So it chooses an exposure that may not get enough light from the main subject to the film. The result is a print in which the main subject is too dark — unless you do, indeed, want a silhouette. If you don't, here are a couple of ways to prevent or minimize the effect.

- **Move closer to the subject, or if you have a zoom lens, zoom in tighter so that the subject fills more of the picture area.** By cutting out more of the surrounding area, you lessen the peripheral light that can throw off the exposure. The problem with this approach is that it may cramp your compositional style — forcing you to compose more tightly than you'd like.

- **Set your camera's fill-flash mode.** (See Chapter 7 for details.) By brightening the main subject, the added flash helps balance it with the brighter background. A few more sophisticated point-and-shoot models may actually fire the flash on their own when they detect that the middle of the scene (the main subject) is significantly darker than the surrounding areas. Fill flash works only if a backlit subject is within the flash's range.

- **Set backlight compensation, if your camera offers it.** Backlight compensation does its job regardless of the subject's distance. Many cameras have this feature (see Chapter 4); it forces the camera to increase the exposure, improving the sense of detail in the main subject. (The increase is about 1.5 EV — photospeak for about 150 percent extra exposure.) A few more advanced models provide automatic backlight compensation when they detect that the center of the picture area is substantially darker than the surrounding areas.

The problem with backlight compensation is that it gives as much extra exposure to the background as the foreground. The resulting print may in turn lack background tone or detail — a penalty you don't suffer when you use fill flash to fix backlight. Depending on the properties of the light, backlight compensation may also cause light to spill over and around the edges of the main subject, making it appear somewhat flat or foggy. Fogginess is a special risk with backlit subjects because you are often shooting *into* a light source such as the sun, which can result in picture-wrecking flare.

Almost human: How digital point-and-shoots see light

One of the advantages of digital cameras over cameras that use film is almost human: They automatically adjust the way they "see" the color of light, lessening the chance you'll get unwanted color casts in your pictures. For this reason, when you take nonflash pictures by household light with a digital point-and-shoot, they usually don't look as warm (yellowish or brownish-yellow) as pictures made in the same light with a 35mm or APS camera.

Though your digital point-and-shoot does its automatic best to match the color of the light you're shooting in, you can also use the menu to set it for a specific kind of light. This adjustment is called the *white balance.*

Once you've accessed the white-balance setting in the camera's menu it will present you with a range of choices, usually indicated with icons that

represent different lighting conditions. Sometimes the type of light is spelled out, too. A sun icon typically indicates the setting for direct outdoor sunlight, sometimes with the word "daylight"; a cloud, for overcast light, sometimes with the word "cloudy"; a lightning bolt, for flash illumination, sometimes with the word "flash"; a tube-like icon, for fluorescent light, sometimes with the abbreviation fl or fluor; and a lightbulb, for household light, sometimes with the word "tungsten". (Check your camera's manual to be sure of the meaning of these white-balance icons.)

"Auto" is the camera's white-balance default setting — the setting it maintains unless you choose one of the other settings. (If you think default is a tennis term, see Chapter 4.) Again, most digital point-and-shoots do a pretty good job of setting the white balance automatically, a talent they've inherited from video camcorders. When you go into the menu to adjust the camera's white balance for the first time, auto is where you'll find it set. But if, for example, you want to do some shooting by household light, without flash, it's worth changing the white balance to the household light (lightbulb) setting and taking some pictures to see if the results are more to your liking. (If the camera's flash fires on its own, turn it off unless you want blue pictures.) These pictures will probably be less warm (yellowish) than what you get from the camera when it does the adjusting itself. If you prefer that warmth, go back into the menu and reset the white balance to its auto position.

Figure 9-6:
Backlight can add tremendous drama to a photograph (left). Minutes after the first shot, the sun had dropped behind the mountain (right), making the subject flat and much less interesting.

© Pat O'Hara (2)

TIP

Going steady: How to brace your camera

When you're shooting in fairly low light — whether by a window, by artificial indoor light, or at dusk outdoors — your point-and-shoot may have to set a fairly slow shutter speed to get enough light to the film for a good exposure. In fact, some point-and-shoot cameras are able to set shutter speeds as slow as a quarter or a half a second, or even longer. A slow shutter speed means that if you don't hold the camera steady, your pictures may be ruined either by a visible blur or (almost worse) just an annoying lack of sharpness — an effect called *shake*.

In low-light situations, advanced photographers sometimes resort to *tripods* — three-legged collapsible supports that not only keep the camera steady but allow you to control composition and your point of view more precisely. You can even use tabletop tripods — miniature versions that must be used on elevated surfaces and that let you angle the camera in any direction. But other (free) steadying strategies exist as well.

One is simply to steady your arms against your body, specifically, pushing your upper arms into your chest as you shoot. At the same time, you can spread your legs widely, turning yourself into a "bipod" — a human tripod. Or, if a vertical surface is near your shooting position — for example, a wall or door frame — you can lean against it as you shoot. While you're at it, take a deep breath and push the shutter button as you slowly exhale.

Finally, if you can find a table, chair, ledge, or shelf that suits your point of view, you can rest the camera on it as you take the picture. However you brace the camera, be sure to press the shutter button smoothly — no stabbing motion allowed. You can also set the camera to self-timer, take your hands off, and have the camera fire by itself, as I describe in Chapter 4.

Many if not most digital point-and-shoots will reset the white balance to auto every time you start them up again. So if you've fiddled with the white balance, you can reset it to auto simply turning the camera off and on again — as long as this won't undo any other special settings you've made. With other models, you may have to go in and reset the white balance yourself. If you don't, your outdoor pictures may turn out blue!

On the other hand, you may *want* to mix warm tungsten light with flash illumination, as I describe in Chapter 7. Set your camera to its slow-sync flash mode, or if it doesn't offer slow-sync, to fill-flash mode. Set these modes even if the flash is firing on its own (that is, in its autoflash mode) because it will otherwise overpower the existing light. (Again, stick with ISO 800 film.) Mixing flash with tungsten light creates an interesting two-toned effect in which the foreground (the main subject) is mostly lighted by flash, and the background (where the flash doesn't reach) is mostly lighted by existing light. Even when you're mixing flash with room light, make an effort to hold the camera steady; it sets slower shutter speeds indoors than it would set outdoors.

Finally, if your room is lighted with fluorescent lamps, you take your chances if you shoot by room light alone. Fluorescent light usually ends up green in pictures, though the photofinisher may be able to correct this cast a bit in printing. If I really want background detail in interior shots and the light is fluorescent, I set my camera to its slow-sync flash mode; this setting tends to limit the effect to a greenish tinge in the background. If your flash isn't firing on its own — a good possibility, given how bright fluorescent light can be — you should force it to, either with slow-sync or fill-flash mode. These settings lessen or eliminate the green cast.

An increasing number of color negative films, particularly those made by Fuji, use an ingenious photochemical trick to get the green out. Fuji describes these films as having a "4th color layer," and sometimes even touts this feature on the box. (When in doubt, ask your photo dealer.) And again, if you're using a digital point-and-shoot it should *automatically* set its white balance to fluorescent if it detects fluorescent light. But if you're unhappy with the results, you can set it manually, as described earlier in this chapter.

Chapter 10

Suitable for Framing: How to Compose a Good Photograph

*1*f you've ever visited an art museum, you know that a painting is rarely shown without a frame. Yet even if it's full of gilded frills, a frame is more than just decoration for the painting it contains. It makes a statement. A frame says that the image within it (unless the image is totally abstract) is a slice of life carefully cut by the artist. A frame also declares that inside its boundaries, your eye is under the artist's control.

Whether or not you put it in a fancy frame, a photograph really comes with its own built-in frame — the picture's edges. Your camera's viewfinder — or, with a digital point-and-shoot, its viewing screen — tells you where those edges fall within the scene you want to capture. You adjust the edges' placement simply by moving the camera around (aiming it up, down, or sideways); by moving yourself around (getting closer or farther away, or moving to the right or left); and/or by zooming (if your camera has a zoom lens). (For more on using the viewfinder, see Chapter 5.)

Framing the subject is an important part of *composition* — the way you squeeze, shape, and cajole reality into that little rectangle, which of course eventually becomes your print. But framing isn't the *only* part of composition. Other simple and effective techniques can improve your composition, from shooting the subject at an unusual angle to setting up depth-enhancing

relationships between the scene's foreground and its background. I explain these techniques in this chapter.

Composition Rules!

Composition is the sum of all the visual tricks a photographer uses to make a picture pleasing and/or challenging to the eye. It starts with where you place the edges of the frame — basically, what section of a scene you choose to put on film. But composition also includes how you lead the viewer's eye around the picture; how you control interrelationships between elements of the scene; and the ways in which you emphasize one part of the scene over another.

Composition is especially important in photography because, unlike painting, you can't invent or rearrange reality. (Well, unless you're very good at digital manipulation; see Chapter 16 for details.) As a photographer, you have to work with what's out there — with the physical facts of the scene in front of you. But those facts can be interpreted and presented in different ways.

If you've come to this chapter in search of cut-and-dried formulas for good photographic composition, though, you may be disappointed. Composition is an endeavor in which anything goes — if it works. It amazes me how regularly and effectively good photographers violate all the visual conventions handed down from painting and other graphic arts. One is the *Rule of Thirds,* which dictates that the most satisfying compositions are those in which important elements (especially the main subject) fall along a grid of lines that divides the scene you're shooting into vertical and horizontal thirds. I don't believe this rule is worth the paper it's often written on, so you don't find it in this book. Besides, the great thing about photography is that experimenting with composition is cheap. For the cost of a few frames of film and a handful of 4 x 6-inch prints, you can compose your subject in various ways — and then decide which of them works best when you get your pictures back.

So in this chapter I suggest several experiments to get you thinking about composition. Composition is worth thinking about, because when it's good, it can make a huge contribution to the quality of your photographs. And I mean good, not great. Every shot can't be a compositional masterpiece, nor does every subject warrant a lot of thought. But you can train yourself — your eye, really — to put that frame around your subject in an interesting and appropriate way, and to apply ideas that help you present the subject in a visually satisfying form.

Aiming versus Framing

Most photographers use a camera's viewfinder like a gun site. Basically, they center whatever they're shooting. (Shooting is the right word: The viewfinder

might as well have crosshairs in it.) This mistake is understandable. Photographers get so caught up in the moment they're trying to capture that they forget they're also putting a frame around it.

The classic example of this compositional no-no is in people pictures. When most photographers look through the viewfinder or at the viewing screen, their eye is immediately drawn to the subject's face, and locks there. The face ends up dead center in the frame, with empty space above the subject's head.

For better composition when you're photographing people, place heads near the top edge of the viewfinder or viewing screen, not in its center. To do so, you must aim the camera slightly down. (For more on photographing people, refer to Chapter 11.)

But whether you're shooting people or things, to compose effectively you need to see and use the entire viewfinder or viewing screen area — to unlock your eye from what first caught your attention, whether it's a face or a big red barn. Every time you look through the viewfinder or at the viewing screen, scan its edges. (If you have an autofocus point-and-shoot, remember that the little marks in the middle of the frame are for focusing, so don't let your eye settle there.) Notice the distance between things in the scene and the edges of the frame — whether those things are far away from the edges, just touching them, or cut off by them.

Composition is much easier if you think of it in terms of creating relationships between the edges of the viewfinder or viewing screen frame and things in the scene. You can point the camera up to place a landscape's horizon line near the bottom edge of the frame, for example, so that the horizon will be low in the picture. You can swing the camera to the side to place a person closer to the right- or left-hand edge of the frame, so that the person will be off-center in the picture. Or you can point the camera down to place a face closer to the top of the frame — a simple adjustment that includes more of the subject's body in the picture.

Keep your eye close enough to the viewfinder eyepiece so that you can see the entire frame. If you don't, you may end up with composition that is unexpectedly off-center, that includes things in the picture that you don't want, or that leaves too much space and extraneous detail around your subject.

If, when you scan the frame, you see a lot of space between your main subject and its edges, then you can probably make this conclusion: The subject is too *small* in the frame. Which brings me to one of the most important things you can do to improve your composition and your photographs as a whole: filling the frame.

Screening it: Composition with a digital point-and-shoot

If you're a digital point-and-shoot user, you have an interesting choice when it comes to composition. On the back of most such models you find both the usual viewfinder (a little window) and a miniature, TV-like viewing screen. (See Chapter 5 for details about the viewing screen.) You can use either one to compose a picture, and there are good arguments for both.

Call me old-fashioned, but I think there are a couple of *practical* advantages to using the regular viewfinder. One is that it allows you to turn off the viewing screen when you're shooting. (You usually do this with a little button beside the screen; it's usually marked with the outline of a rounded screen.) Because the viewing screen is the single most power-hungry feature on a digital point-and-shoot, turning it off and using the viewfinder instead greatly prolongs your battery life. Another viewfinder advantage is that by making you press the camera against your eye and face, it keeps the camera steadier than when you use the viewing screen, which requires that you hold the camera a foot or two away from your face. That position can transmit more of your hand tremors to the camera, causing anything from a slight lack of sharpness to an outright blur. The gain in steadiness you get by using the regular viewfinder can actually make your pictures sharper.

When it comes to the *aesthetics* of composition, though, there are arguments for both the viewing screen and the viewfinder. Because the viewing screen is electronically connected to the camera's image sensor (which is, in effect, its "film"), it shows you with considerable accuracy what part of the scene will be "framed" by the camera when you take a picture. A regular, window-type viewfinder, because it is separate from and usually to the side of the lens, may not

show you as precise a representation of what will end up in the final shot.

This is particularly true when you're taking a picture close to the subject — a head-and-shoulders shot of a couple of friends, for example. The closer you get, the bigger the discrepancy between what the lens sees and what you see through the viewfinder window, and the less accurate your composition may be.

When you take close pictures with a digital point-and-shoot — say, closer than three or four feet — always compose with the viewing screen, not the regular viewfinder. This ensures accurate composition. One sensible strategy, in fact, is to use the regular viewfinder for subjects at middle to far distances (where its accuracy is not an issue) and the viewing screen for close subjects. This will extend battery life *and* prevent you from shooting inaccurately framed closeups.

There is, I have to admit, something fun about composing with a digital point-and-shoot's viewing screen. In reducing the scene to two dimensions, the screen can even give you a better sense of how a subject will look in the print, which is two-dimensional itself. But one of my gripes about viewing screens is that they're small, especially compared to similar screens on video camcorders. If your eyes aren't as good as they used to be, and mine aren't, it can be hard to see clearly — and who wants to put on reading glasses to take a picture? More important aesthetically is that even with 20-20 vision, it can be hard to see a scene's *details* clearly on such a small screen, and being aware of such details is one of the hallmarks of a good photographer. Details may not matter much if all you want is a picture of a

pretty face. But if you're photographing a large group of people, it's hard to see their expressions on a viewing screen, and therefore tougher to know which moment is the best one to press the shutter button.

If you're using a digital point-and-shoot's viewing screen to take pictures of a group of people, look over the camera directly at your subjects' faces, then when you're ready to take the shot, quickly look back at the screen to make sure that the framing is okay and that you're not cutting off people or body parts.

Even if you're not taking people pictures, a viewing screen can make it difficult to scrutinize the scene, especially if it's big — a landscape or city view. When you're looking through a regular viewfinder, on the other hand, things in the scene are fairly close in size to what they'd be if you were looking at them with the naked eye.

Big and Bigger: Filling the Frame

A famous photojournalist, Robert Capa, once said, "If your pictures aren't good enough, you're not close enough." (Alas, he got a little too close to his subject, war.) Getting closer to your subject — and in doing so, making it bigger in the frame — is often the simplest, most powerful way to add drama to a picture. Getting closer lessens or eliminates extraneous detail, gives more emphasis to your main subject, and even improves a picture's sense of depth.

If you have a nonzooming point-and-shoot, getting closer is the only way to make the subject bigger in the frame (see Figure 10-1). If you have a zoom model, though, you can zoom in to make the subject bigger. And with some situations, zooming in is the *only* way to make the subject bigger. One is when you physically can't get any closer to your subject — for example, because a fence blocks you or you'd fall down a cliff. With other situations, zooming in is just the *best* way to make the subject bigger. One example is when moving closer would call too much attention to your picture-taking, causing you to lose a spontaneous moment or to scare off a skittish subject (like deer in the backyard). But most of the time, moving in to make a subject fill the frame produces a more interesting picture than zooming in. (See Chapter 5 for more on filling the frame.)

Zooming versus Moving

Zooming is fun. Unfortunately, the fun of it (and the ease of just standing there and looking through the viewfinder or at the viewing screen as you rock the zoom switch or push the zoom buttons) seems to have convinced point-and-shoot photographers that zooming is the main way to control composition. It absolutely, positively is not! Zooming in and out is no substitute for composition. Real composition requires two legs. In my opinion, legs are the most important compositional tool you have. They let you squat or kneel for a low-angle shot, stand on your tiptoes for a little extra height on the subject, inch to the side, or — most important — walk toward or away from the subject.

Figure 10-1:
One easy and important way to make your pictures more exciting is by filling the frame — and usually the best way to do this is to move closer to the subject.

© Russell Hart

The worst thing you can do, compositionally speaking, is to stand where you are when a subject catches your eye and zoom to compose. It's very unlikely that the position you happen to be in is the best one for the picture.

If your point-and-shoot has a zoom lens, recruit a cooperative friend or family member — someone who'll stay put while you take a few pictures of him or her. Place your subject against an interesting background so that you can include a fair amount of detail along the edges of the frame. Zoom your lens to a focal length around 70mm. (If you've got a 35–70mm or comparable 2X zoom model, just zoom it to its longest setting; if your model zooms longer that, any middle setting or a bit beyond is fine.) Compose so that your willing subject fills a pretty big part of the frame. Then take a picture.

Next, zoom your lens to its shortest focal length; on most 35mm point-and-shoots, this will be 35mm or 38mm, their equivalents on APS and digital models. Setting a shorter focal length gives the lens a wider angle of view, so you get more of the scene in the picture — and as a result, the person will be smaller. Look through the viewfinder and move closer until he or she is *the same size in the frame* as in the first, farther shot. Now take another picture.

When you get your prints back, compare them. You'll be surprised: The closer shot (the one taken at the shortest focal length) will actually show *more* of the background than the shot taken from farther away (the longer focal-length version). Oddly enough, the farther you get from the main subject, provided you keep zooming in to keep it the same size, the less and less background detail will be included in the picture (see Figure 10-2).

Figure 10-2: For this pool portrait, the photographer first shot at 70mm (top) and then 35mm (bottom), moving closer to keep the little girl the same size in the frame. The 35mm setting shows much more of the surroundings — without making the main subject any smaller.

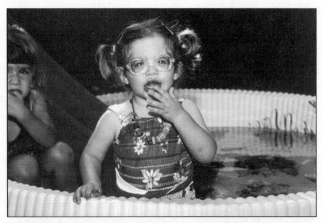

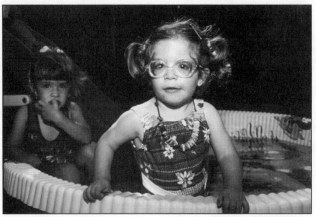

© Russell Hart (2)

 If your background is cluttered, showing less of it may actually be a good thing. In that case, zoom in tight to your subject. But in my opinion, photos that show the subject's context (its surroundings and background) are usually more interesting and valuable than photos that don't. This is especially true if you're taking pictures more for memory's sake than for art's sake. So when I'm shooting with a zoom camera, I tend to stick with shorter focal length settings and I get as close to the subject as I can.

Again, you can't always get physically closer to a subject. In that case, go ahead and zoom in. Better to have your subject fill the frame, even if you have to zoom to do it, than to have it be too small.

 If you're shooting with a digital point-and-shoot, avoid using its *digital zoom* capability unless absolutely necessary. Digital zooming has nothing to do with the lens; instead, the more you "zoom," the more the camera "crops" the image sensor — enlarging a progressively smaller piece of it. This can greatly reduce the sharpness of your pictures. See Chapter 15 for details.

If you do the experiment I describe earlier in this section, you'll notice something else. The closer, wide-angle shot — the one that shows more of the background — also makes the objects in the background look smaller, relative to the subject, than they do in the zoomed-in shot. Technically, this is because the lens has less magnifying power at a wide-angle setting (35mm or 38mm) than it does zoomed in (at 70mm). But you can think of it this way: The lens has to make things in the background smaller to squeeze more of them into the shot!

You may also notice a flip side to this effect. Zooming in for a shot does more than just show less of the background. If you zoom to a longer focal length in combination with physically moving — in this case, moving *back* to keep the subject the same size in the frame — you change the size relationships between the main subject and things in the background. You make the individual elements in the background seem larger than they would have been if you'd shot from a closer distance with a wider-angle focal length.

If you want to emphasize a specific object in the background — especially something that is pretty far away and might end up very small compared to the main subject — backing up and zooming in is the way to do it. The extra magnifying power you get when you zoom to a longer focal length makes background objects appear bigger (see Figure 10-3).

Figure 10-3: The photographer first shot at 70mm (left) and then 105mm (right), backing up to keep the man the same size in the frame. This reduced the visible background but increased the apparent size of the distant building.

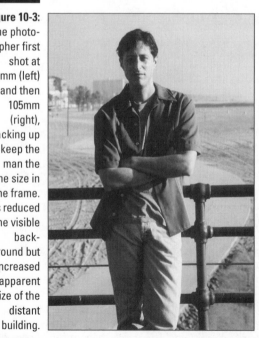

© Mark Harris (2)

By combining changes in focal length (zooming to different settings) with changes in your physical position, you exert tremendous control over the size relationships between foreground and background. But again, you have to *move* to do this. Simply zooming in and out produces no changes in that relationship.

Near and Far: Balancing Foreground and Background

As you compose a photograph, always keep in mind that a print reduces a three-dimensional subject to a flat plane, lessening the sense of depth your eyes and brain provide. But one way to restore that sense of depth is by choosing a shooting position from which you can include interesting foreground elements — objects in the near distance (see Figure 10-4).

Including interesting foreground elements is especially important when you're photographing scenes without people close by. If you're photographing a landscape, for example, try to compose so that natural or manmade things — a tree branch, plants, rocks, or a portion of an architectural structure — occupy part of the foreground. Photographers sometimes call this approach *near-far composition*.

Figure 10-4:
Plants in the foreground of this Montana landscape add depth to the scene, creating a more interesting shot than if the photographer had concentrated only on the butte.

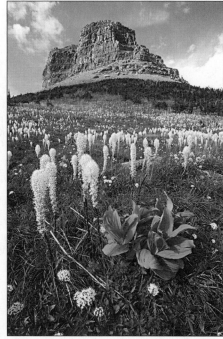

© Rick Sammon

If you want to include foreground objects to enhance the sense of depth in your pictures, use as short a focal length setting as possible. Shorter focal lengths provide the wider angle of view needed to take in both foreground and background. On 35mm zoom point-and-shoots, the best setting is usually 38mm or 35mm; some models may offer a 28mm setting, which is even better. On Advanced Photo System zoom models, the shortest setting is usually 30mm, 26mm, or somewhere in between; a few models may offer a 24mm or 21mm setting.

The focal-length numbers on digital point-and-shoots are much lower than on film cameras, and aren't generally used for reference. (See "Film format: The long and short of it" in Chapter 5.) But very few digital point-and-shoots offer true wide-angle focal lengths. On such models, simply adjust the lens to the setting that takes in as much of the scene as possible.

If you're having trouble fitting both a near object and a distant one (or the horizon line) in the frame, here's a suggestion. Try shooting from a lower angle — even a squatting position — to bring them visually "closer."

Single-focal-length (nonzooming) point-and-shoots are often especially well-suited to creating strong near-far relationships. This is because their one focal length is often shorter than the shortest focal length on a zoom point-and-shoot — as short as 30mm (and occasionally 28mm) on 35mm models, and as short as 24mm (and occasionally 21mm) on Advanced Photo System models. Also keep in mind that vertical composition (see the section "Rotating the Frame: Horizontals versus Verticals") can make it easier to create near-far relationships, especially if the close object is sitting on the ground — a rock, tree stump, or a cluster of flowers, for example.

One visually pleasing variation on the idea of near-far relationships is to frame a more distant subject with something in the foreground — to create a sort of frame *within* the photograph (see Figure 10-5). You can do this with window frames, doorways, arches, or natural elements. Scout around for these prospects before you shoot a subject.

If your frame-within-a-frame is very dark, which is often the case when you're shooting an outdoor scene from inside, through a window or door, you can brighten it by setting your point-and-shoot to its fill-flash mode. (See Chapter 7 for details.) If you choose to leave your frame-within-a-frame dark, keep in mind that if it occupies a large area of the picture, photofinishing machinery may make the print too light. In this case, you should ask for a darker reprint. (See Chapter 3.)

Figure 10-5:
Composition can often be improved by framing a more distant subject with foreground elements, either manmade (left, an archway) or natural (right, a tortured tree).

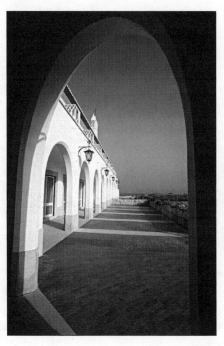

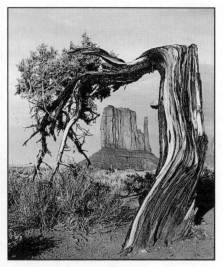

© Amos Chan
© Rick Sammon

Dynamic Imbalance: Composing Off-Center

One tried-and-true compositional technique that works with nearly any kind of subject, from people to landscapes, is to place the main subject off-center in the frame rather than centering it (see Figure 10-6). Set up your shot so that a person standing in front of the scene is off to one side in the picture, for example, and the other side can be entirely devoted to the background — allowing you to show a bigger swath of it, or to give the background more visual weight. The visual imbalance created by this type of composition also gives the photograph a more energetic quality than does a centered composition, which tends to create a static feeling.

If your point-and-shoot is an autofocus model and you use off-center composition, be sure to lock the focus on the main subject before shooting. (See Chapter 6 for details on locking the focus.) Locking the focus before establishing your final composition prevents the camera from focusing on the background and keeps the main subject sharp.

Figure 10-6: Instead of centering this passing amusement park gondola, the photographer composed so that it was on the right side of the frame. This off-center position lends the background more importance.

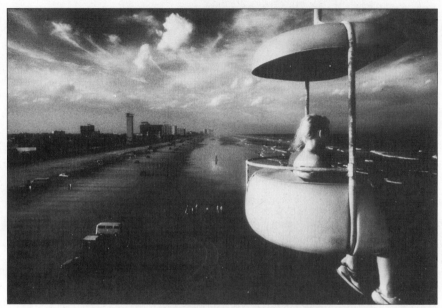

© Russell Hart

Low and High: Changing Your Angle

Moving sideways one way or the other before you take a picture is something you may do instinctively, if only to be able to photograph your subject from the front. But chances are you don't give much thought to moving up and down — to changing the *height* from which you shoot. You probably take nearly all your pictures from your own standing eye level, whether it's 5'2" or 6'2".

But no photographic rule commands that eye level is the best height from which to shoot a subject. In fact, it often isn't. For example, pictures of kids are usually much better when they're shot at a kid's eye level (see Chapter 11). And many other subjects benefit from being shot from a position lower or higher than eye level (see Figure 10-7).

A low angle can make an ordinary-sized subject look monumental, sometimes comically so. It also tends to minimize receding planes — a field, a floor, a basketball court. And a low angle radically changes the relationship between the main subject and its background. Photograph your kids from your own eye level in the backyard, and you'll probably get mostly grass, and all the junk in your yard, behind them. Lie down on the ground and aim the camera up at them, though, and the background will probably be trees, sky, or (if you're not so lucky) the upper half of the neighbor's house. In fact, shooting

from a low angle can actually simplify a subject by putting sky or trees behind it instead of the usual ground-level clutter.

But a high angle can simplify a subject, too. In particular, it lessens the overlap of objects at different distances; it literally helps you see over one object to the next. Even a little extra height — standing on a rock or a chair — can accomplish this, and with indoor shots produces a much different look than you're accustomed to getting. For outdoor shots, you may even want to shoot from a second-floor window, stand on a car, or (if you're limber enough) climb up a tree. This extra height gives you a clear shot of a large group of people, for example, because you can literally see behind the people in front. A good wedding and party trick! (See Chapter 13 for more on using high or low angles to control the position of the horizon line.)

Figure 10-7: Pictures don't have to be taken from your standing eye level. To show all the faces in this preschool class (top), the photographer stood on a chair; to place this blowing laundry (bottom) against a dark sky, he shot while lying on the ground.

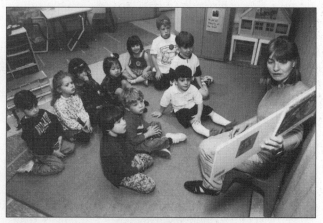

© Russell Hart (2)

Creative Shuffle: Shifting Sideways for Clarity

Shifting sideways to take a picture does much more than simply let you shoot a subject from a more head-on position. If you've ever gotten back a picture in which the subject's head seems to be sprouting a tree or impaled by a telephone pole, a sideways move would have been the preventive medicine for that photographic affliction.

Small shifts in your lateral position — a mere few inches — can prevent objects at different distances from overlapping in confusing and unattractive ways. Bigger moves — a couple of feet — can entirely change a subject's background. A quick shift to the side can replace a cluttered or drab background with one that's simpler and more colorful.

As with all such movements, it's imperative that you carefully study the subject through the viewfinder, or on the viewing screen, as you change your position. The viewfinder or viewing screen is your canvas.

Rotating the Frame: Horizontals versus Verticals

There are a few reasons why photographers shoot many more horizontal pictures than vertical ones. One reason is lack of thought — reinforced by the fact that a camera is usually easier to hold and operate horizontally than vertically. Another reason is that most of the things you photograph are themselves more horizontal than vertical, from landscapes to groups of people. I say *most,* because lots of subjects can benefit from vertical composition. In fact, photographers shoot way too few vertical pictures.

Pictures of individual people are usually better as verticals than horizontals. So if you're photographing an individual, unless there's a compelling reason for horizontal composition, turn the camera on its side and shoot a vertical. (Read on for reasons to shoot horizontals.) For a head-and-shoulders shot, composing vertically rather than horizontally eliminates unnecessary background on either side of the subject and also lets you fill the frame more fully with the subject.

When you shoot vertical pictures of people with flash, try to hold the camera so that the flash is at the top. Because most built-in flash units are to the left of the lens (from the photographer's behind-the-camera perspective, of course!), this usually requires that the shutter button, and your right hand, be at the *bottom* of a vertically held camera.

Orienting the camera this way causes light from the flash to strike the subject from slightly above the lens angle, rather than below. This effect is usually more flattering to people, especially when you're shooting from a fairly close distance. (See Chapter 1 for specific suggestions about holding the camera.)

Vertical composition is also useful when you're trying to set up a near-far relationship in a photograph. (See the section "Near and Far: Balancing Foreground and Background," earlier in this chapter.) Why? Because the camera "sees" a wider swath of the scene in its long dimension than its short. But beyond that, vertical composition can also lend a certain abstract quality to your pictures, simply by showing a piece rather than the whole of a subject. It's more unexpected, and more surprising, than horizontal composition, given that the overwhelming majority of pictures taken are horizontals.

So even when your first inclination is to shoot a horizontal picture, consider vertical composition. (All it takes is a quick turn of the camera!) Instead of backing up for a horizontal shot that includes the whole subject — a building, a landscape, and so on — try shooting a vertical section that crops the subject at either side of the frame.

If you have an Advanced Photo System point-and-shoot, try taking verticals in the 4 x 7-inch *H* print format. The extra inch of height over the usual 4 x 6-inch size makes *H* verticals fun both to shoot and to look at. But with a little thought, you can even shoot vertical panoramas.

And what about horizontal composition? I certainly don't have to convince you to use it; it is composition's default orientation. It can be more effective, however, if you place the main subject off-center — that is, on one side or the other of the frame. As I explain in the section "Dynamic Imbalance: Composing Off-Center," earlier in this chapter, this not only makes your composition more dynamic, but allows you to set up more interesting relationships between foreground and background.

Working the Subject

Sometimes you have just one shot at a subject — literally. Whether it's the expression you've been waiting for in a portrait, a telling gesture in a candid, or an instant of spectacular light in a landscape, the moment you capture is the picture you want, even if right after you shoot it, a better way of composing it occurs to you. My advice: Don't lose the moment because you're fiddling with composition.

On the other hand, the more attention you pay to composition, the more good composition becomes second nature. And when composition becomes second nature, you can have things both ways — capturing the moment *and* composing it in a visually appealing and meaningful way.

Fortunately, not all subjects are so transitory that they limit you to one picture. Now, there are subjects (even those static enough to allow more than one shot) with which only one way of composing clearly seems best: where only one combination of distance, shooting height, zoom setting, and, of course, framing seems to bring all their elements together in the most effective way. Other times, the right composition isn't always immediately apparent. So when the time is available and the subject isn't going anywhere, try to shoot it in as many different ways as possible. You won't know what's best until you get your prints back!

Choose a favorite subject — no, not your spouse or children, but an inanimate one that won't protest, or blink, or get bored. An old gazebo in the local park? A favorite tree? Even your new sports car. Get a short roll of film and devote it to this experiment. Now shoot the entire roll on your chosen subject.

First, shoot the *whole* subject. Shoot it from up close with a wide-angle focal length setting and from farther away with a longer, zoomed-in setting. Shoot it from different horizontal positions, and from low and high angles, if possible. Shoot it horizontally and vertically, centered and off-center. Then move in or zoom in for details, and shoot a bunch.

When you get your prints back, compare them. Does one composition stand out? Do a couple? Did you have a sense when you were taking them that those shots would be the best ones? If so, then maybe next time you can trust your visual instincts and shoot fewer pictures. But I bet there are some surprises — that some of the prints you like are of variations you didn't have much hope for. The point is that those subjects for which one shot is the perfect shot are rare. If you want the best results, shoot more pictures!

Part IV
Shoot to Thrill

The 5th Wave By Rich Tennant

"And how many times has this happened to you? You land in a nice secluded spot, get out to take a picture, and a couple of yahoos in a pick-up truck wander into frame?"

In this part . . .

This part is the part of particulars — particular subjects, that is. Whether you prefer people, landscapes, sports, architecture, or nature, Part IV is where you discover how best to capture the subjects you love to shoot. But this part is also where I nag you to take pictures of things that you may not ordinarily photograph — the everyday scenes around you.

People get the lion's share of attention here. But if sports subjects are your game, you find out that keeping a ball in the air isn't that hard, with a little timing and a fast film. (I also tell digital point-and-shooters how to pull a fast one with action subjects, and why their cameras are surprisingly good at freezing a moving subject.) If landscape is more your speed, here's where you discover that a little deliberation (of the visual sort) goes a long way. And because I hope photography gives you a new reason to get away, travel gets its own chapter. Travel is the ultimate photo op, a Whitman's Sampler of visual delights.

Chapter 11

Capturing Your Life: How to Keep a Photographic Diary

Want to get a sense of the importance of photography to ordinary people? Hang out at your local photo shop. You find customers standing by the sales counter, or sitting in their parked cars, as they pore over the package of prints they just picked up. You may have beeped at some of them on the street — they're the ones whose cars don't move when the traffic light turns green. They're trying to sneak another look at their pictures before the light changes, too excited to wait until they get home.

Don't be too hard on them. They're you.

That package of prints is a gift, and the photographer who shot them is like a child tearing at ribbons and wrapping paper. Why? Because photographs give you your life back — returning you again and again to its best moments and feelings. By letting you go back, photographs make your memories much more vivid. And when photographs are really good, they surprise you by showing familiar things in a new way.

In this chapter, I first look at the whys, whens, and wheres of capturing your life on film, mostly around your home and in your neighborhood. Then I talk about simple, but effective, techniques to get better people pictures — whether pushing the right mode button or just knowing the best way to capture a fleeting expression.

Why Take Pictures?

For most people, the obvious answer to the question "Why take pictures?" is "to preserve a moment in time," and photographs are momentary by nature. But why, in an era of moving video and 3-D computer effects, do still photos — flat, frozen images — remain so deeply satisfying? Perhaps because they leave something to your imagination, allowing your mind to animate the image from its own rich databank. In this sense, photographs are genuinely interactive, to use that big buzzword — more real than the multimedia, multisensory representation of video or computer screen.

That view sounds a little highfalutin, so I'll come back down to earth: Most of all, photography is just plain fun. The act of taking a picture, because it recognizes the importance, charm, or joy of a moment, adds energy to an event or experience (see Figure 11-1). Picture-taking makes people pay attention, and this is especially true of people pictures. People rally for the camera. If your subjects don't willingly pose, they often pretend they don't know you're there, playing along with your attempt to get candid photos. They understand the importance of their participation. Taking candids — purportedly unposed pictures of people — is, in truth, a team sport.

Candid shots, by definition, are pictures taken when people are unaware of the camera, or at least indifferent to its presence. But how do you keep pictures "candid" at events like parties or formal gatherings, where people are very much aware of the photographers all around them? Here are some tricks to try:

- **Take pictures of people when they're posing for someone *else's* camera.** You'll probably shoot a little to the side of the "official" photographer; this position actually can give you a more interesting angle on faces than the usual eye-contact pictures. If you shoot from way to the side, you can "stack" faces and figures in an uncommon way.

- **Take pictures before people have a chance to pose.** When you photograph a group of people, snap away before the group has a chance to organize itself; people look more animated and relaxed. Then, for the same reason, keep shooting *after* the official picture.

- **If your subjects start posing for you or looking at the camera, tell them to ignore you.** They usually do. If they don't, go away and come back in a few minutes.

Figure 11-1:
The very act of taking a picture adds energy to an event or experience.

© *Russell Hart*

Sharing Pictures Is Half the Fun

While photographs indeed help you preserve and energize your life, there are other, more practical reasons to continue shooting in this video-crazed world. First is that photographs let you share your life conveniently with others who aren't a daily part of it. Even if you could fit a DVD into your wallet, you'd need a DVD player to show off pictures of your kids, your spouse, or your significant other. A photograph is compact, and you can show it off immediately. You don't have to play it, except in your mind!

Sharing photographs takes many forms. If your audience isn't within viewing distance, you can mail prints, though these days many computer-savvy people prefer to e-mail them. Or you can send them to a picture-sharing Web site, where others can view them onscreen and order prints, if they wish. There are even electronic picture "frames" to which pictures can be automatically transmitted. (See Chapters 15 and 16 for more about electronic picture-sharing.)

Most often, though, you share pictures in person, with friends, relatives, or coworkers. Contrary to the old canard that snapshots are inflicted on unwilling victims, people love to see pictures. So don't leave home without them. Carry pictures of your kids, wife, dog, your last vacation, your new car, or your son's baptism.

> ## Please do not bend: Mailing pictures safely
>
> Protect your prints when you mail them. Never put them unstiffened in a regular envelope, because they may get creased, dog-eared, or otherwise distressed in transit. Save thin cardboard from the backs of paper pads, new shirts, and packaging from toys and appliances. Cut the cardboard to size and place it on either side of prints you mail. With bigger prints, use corrugated cardboard. And be sure to mark your envelope "Photographs: Please do not bend!" This way, if recipients want to frame your pictures, they don't have to ask you for a dreaded reprint!

Get double prints when you have your film processed, especially if you have important pictures on the roll. Sometimes you can get double prints as part of a free promotion; at most they add a couple of dollars to the cost of a roll. And they make sharing pictures much easier: You just give the duplicates away. You end up with two prints of some less good pictures, but it's still cheaper than getting reprints, and less trouble, too! Even if you're shooting with a digital point-and-shoot, take advantage of multiple-print discounts if you use commercial photofinishing.

Just remember that *you* bring the actual memory to that hilarious but fuzzy picture of your toddler with a bowl of spaghetti on his face. You can sharpen it in your mind, and add the details and context. But the person you show it to has only photographic information to go on, despite your best efforts to fill in the details verbally. Your job is to make the *picture* good enough to convey the meaning or joy of the moment. Of course, you have even more incentive to make your pictures good if you actually give them away. If they're good, people will ask to keep them.

Film Is Cheap, and Digital Photos Are Cheaper

Snapshooters are, to put it charitably, a bit parsimonious when it comes to film. This stinginess is one of the biggest factors working against their photographic success and satisfaction. The habit persists, I've noticed, if and when snapshooters make the transition to digital photography — which makes no sense given that pictures cost them nothing to shoot once they've made their initial investment in memory cards. (See Chapter 15, where I encourage you to get a big enough memory card to hold lots of pictures!)

As any professional photographer can tell you, the first rule of photography is to take lots of pictures.

I'm not suggesting that photographic success depends on the law of averages. But especially with active, changing subjects, the more you shoot, the more likely you are to get that one-in-a-thousand frame (see Figure 11-2). And most subjects are active and changing — kids in motion or facial expressions in a portrait subject. Even a landscape changes in different light. Nobody has perfect photographic timing — the ability to snatch just the right moment every time. There's a good chance that the moment *after* the one you choose to shoot may turn out better — whether due to a subtle change in facial expression or a dramatic shift in a landscape's shadows.

Taking lots of pictures is particularly important when traveling or at special occasions. Why try to save a few rolls on an expensive and long-awaited trip — small change, after all? Why get cheap with film and take the chance that you won't get the most expressive images at a family wedding? Why be penny wise and pound foolish?

Photography is no different than playing tennis or acquiring computer skills: The more you do it, the better you get. But you need the feedback of prints to understand what you've done, artistically and technically, and to improve on it. And to get prints, you need to shoot pictures. Film is cheap, and pixels are free. (Still not sure what pixels are? See Chapter 15.)

A Time and Place: When to Shoot

When should you take pictures? The simple answer: Anytime and all the time. Many people have the idea that they should save picture-taking for special occasions — unfortunate thinking that goes hand-in-hand with film frugality. Don't just take pictures at your kid's recital, or on trips, or at birthday parties and graduations and weddings. Photography is a visual diary. If you've ever kept a diary, you know that you have to do it every day to keep up. Well, maybe not *every* day — but diary-keepers will tell you that if you miss a week or two, you're in trouble. Memory can fail you.

Life has a rhythm to it. If you only photograph the big events in your life, then your photographic diary won't capture this rhythm. So photograph the seemingly ordinary times, too: a child's lazy summer afternoon in the sandbox, an early morning walk in the fall, a potluck supper with the neighbors, a loved one reading a murder mystery, or — one of the greatest of all family photo ops — the bathing of the dog. These pictures of ordinary times needn't show their human occupants. They might show the day's laundry drying in the wind, the heap of just-raked leaves, or the bowl of particularly luscious fruit on the kitchen table (see Figure 11-3).

Figure 11-2: When you're photo-graphing people — especially more than one person — always take more than one picture. Here, the third shot of three captured the best expressions on both husband and wife.

© Russell Hart (3)

Figure 11-3:
Shoot the ordinary. Light can transform familiar things — a tomato sitting on the kitchen counter — into extra-ordinary ones.

© Russell Hart

Either way, these everyday occasions, places, and things are the ones you might not otherwise remember, because we tend to mark time with "important" events, celebrations, and holidays. I don't have to tell you that, in the rush and clutter of a fully lived life, the quiet times are often the most satisfying. But rest assured: Photographs of quiet times and ordinary subjects don't have to be boring, if you go about taking the pictures the right way.

What You Need for Great People Photos

First, a word about equipment. Believe it or not, your point-and-shoot camera is capable of making people pictures that are every bit as excellent as those taken with fancy "system" SLR cameras, even when professionals are behind them. This is because people pictures — especially candid ones — are more about timing than costly lenses or a clicking-and-whirring motor drive. But you'll find two extremely valuable features in any point-and-shoot you plan to use for people photography:

✔ **A built-in flash:** Almost all point-and-shoots have built-in flash units, except for the flashless one-time-use models and a few digitals. A flash with a few modes — such as fill flash and flash-off, which allow you to

enhance and control the light for more flattering results — is even better. (See Chapter 7 for more on flash modes.)

✔ **A modest zoom lens:** For the best people pictures, a 35mm zoom model's lens should go at least to 70mm, and, for more versatility with candids, to 90mm or 105mm. Comparable focal lengths for APS models should go at least to 55mm; with digital models, the closest thing is a 2X or 3X zoom (zoomed all or most of the way in). These longer focal lengths can be particularly useful for tight shots of individuals — again, in order to make pictures of them more flattering. (See Chapter 5 for more on zooming.)

What about special "portrait" modes, or those very common red-eye reduction flash modes? Not necessary at all. In fact — believe me — they can actually get in the way of good people pictures. In many situations, you should avoid these settings, and you may even want to turn them off if the camera selects them automatically. (See Chapter 7 for more on red-eye reduction.)

What film is best for people pictures? If you read any other part of this book, you already know my answer: ISO 400 color print film. And if you shoot by low light — often the most atmospheric and flattering light for people pictures — you may be better off with ISO 800 film. (See Chapters 12 and 15 for more about "equivalent" ISO settings on a digital point-and-shoot, and how to select them.) These fast films (or ISO settings) offer a number of benefits (see Chapter 2). Use them, and you can make sharper *and* more flattering people pictures. Fast films (or ISO settings) also add background detail to your flash pictures, avoiding the usual dark, empty surroundings. And you get much better pictures of large groups because your camera's increased light sensitivity lets your flash illuminate subjects at greater distances.

From Candid to Formal: Expression and Gesture

Pictures of people certainly benefit from the same properties that make for any good picture: thoughtful and interesting composition, fetching light, and an uncluttered background, for starters. But at the heart of people photography is *expression.* Any photographer who takes pictures of brides or babies for a living can tell you about the importance of expression. For professional portraitists, the difference between an engaging expression and a blank stare is the difference between feast (lots of reprint orders) and famine (*no* reprints!).

Whether you pose your subjects or just snapshoot them, the expression on a subject's face is key. The photograph's viewer looks first at the expression, and only then (you hope) checks out everything else in the picture.

Second only to expression is *gesture:* the way someone uses or places her hands and arms, the way she carries herself, posture, a characteristic slouch.

TECHNICAL STUFF

A supporting role: The tripod

A zoom lens and a flash may come built into your point-and-shoot, and may be all you need for satisfying people pictures. But a *tripod* can make a big difference in the quality of your portraits — especially if you like to photograph people in a more posed way by natural light.

A tripod is a collapsible, telescoping, three-legged support for your camera. It has a small bolt on the top; you simply screw the bolt into the small, threaded opening on the bottom of your camera. (Most point-and-shoots have this opening, called a *tripod socket* — but don't buy a tripod if yours doesn't!) You can get a light-weight tripod for $50, and light weight is all you need for a point-and-shoot camera. (Light weight also makes you more inclined to get out the tripod and use it.) If you're shooting with a digital point-and-shoot, by the way, you don't *have* to buy a "digital" tripod, though many are being marketed that way these days.

Tripods are especially good if you like to shoot by window light, a magical kind of illumination for people pictures. But in addition to keeping the camera steady, which offsets the increased chance of blur in such light, tripods offer a less tangible benefit: By keeping your camera in a fixed position — which eliminates the need for you to hold and constantly look through it — a

tripod actually enables you to interact *more,* not less, with your subject. (Surprised?)

People often feel more comfortable if you look at them *over* the camera, rather than with the camera obscuring your face. In fact, a tripod actually enables you to take pictures without looking through the camera, provided the subject stays in more or less the same place. And a tripod lets you take a series of photos with exactly the same composition. Check with your photo dealer to find out about the available models.

If expression is facial language, gesture is body language. Whether posed or spontaneous, gesture can say as much about a person as expression. And it can say a lot about you as a photographer. A stiff, awkward pose is probably a sure sign you waited too long to take the picture (or, sometimes, not long enough) or that you somehow made the subject feel uncomfortable.

Expression and gesture are fundamental to what are, basically, the two types of people pictures: candids and formals.

A *candid* photograph is an unposed photograph of friends, family members, or others. It shows the subject(s) in the course of spontaneous events, moments, or interactions. A candid may or may not feature eye contact. It

can be a picture of someone looking at the camera as he's engaged in an activity or interacts with other people, but before he has a chance to clam up. In a candid, the photographer exerts little or no influence on the subject. Some candids are indeed a slice of life: pictures in which the subject is totally unaware of your presence, until, of course, you give it away with a burst of flash or a click of the shutter. But in any event, you can control the picture by the angle at which you shoot and, of course, the instant at which you choose to take it.

A *formal,* on the other hand, is a portrait made by mutual agreement between the subject and photographer. It often involves carefully positioning the subject relative to a background and light source (see Figure 11-4). You certainly can do formals with your point-and-shoot, as I explain in the section "Getting formal," later in this chapter. But your point-and-shoot camera's ease of use makes it ideal for candids (see Figure 11-5).

Getting your subject to relax

Whatever kind of people picture you shoot, the best way to get natural, unforced expressions from your subjects is to be natural and unforced with them. Engage them in real conversation. You may need a little practice at operating the camera and talking at the same time, but remember that your point-and-shoot does most of the technical thinking for you. So as you photograph your subject, be calm, confident, and upbeat. If you seem too preoccupied with the camera or nervous that something might go wrong, the subject will pick up on your jitters — and you can kiss good expressions goodbye!

 Start conversing with your subject by holding the camera down, away from your face, making eye contact as you speak. When your subject replies, lift the camera to your eye and take the picture. (Be sure to have the camera turned on and, if needed, the correct modes set, so you don't have a delay while you stop to fiddle with it.) If you're using a digital point-and-shoot, composing with the viewing screen may make this easier, since you can look back and forth from screen to subject — and take the picture — with little if any change in camera position.

Don't be too bossy with the subject, especially if you shoot candids. Be funny, or if you're not a natural comedian, at least lighthearted. (This makes your sitter more relaxed.)

Nor should you appear to be "sneaking" your shots. Photographing people is, again, a cooperative venture between you and the person you want to shoot. If you loosen up and have fun, your subject usually loosens up and has fun, too. This helps you get better expressions — but you should still take lots of pictures. The best expression could come on the 14th frame of a 24-exposure roll devoted to a single person.

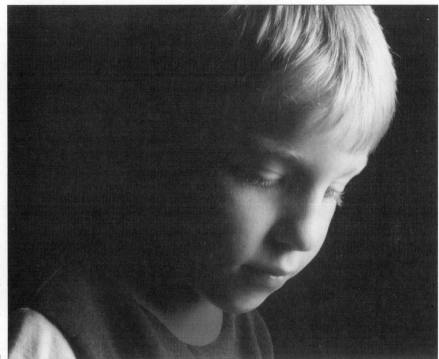

Figure 11-4:
A formal portrait made by agreement with the subject, and often involves a controlled environment — here, placing the boy near a window for a light source and using a dark cloth as a background.

© Peter Kolonia

Figure 11-5:
A candid photo is an unposed shot of people — here, toddlers drawing. Contrary to what you might think, a candid is often better with eye contact.

© Russell Hart

Nuptial niceties: Shooting at weddings

For people who like people pictures, weddings are made in heaven. All the generations of a family are in one place; everybody looks their finest; one and all are in an upbeat mood: No wonder so many guests show up with camera in hand. You've probably been one of them. Because the opportunities for pleasing people pictures are so great at weddings, consider making your own mini-album to present to the bride and groom after the happy day.

Please don't get in the way of professional photographers who've been hired to produce albums, though. Don't ask them technical questions while they work; don't steal their angle. While the pro may be a better photographer than you, *you* have an inside track: You probably know many of the guests. You know who you should photograph with whom, who's the cutest, the funniest, and so forth. You can use this knowledge to produce an album that may not be as elegant as the one made by the pro, but that has a personal touch the official album lacks. Whether you create an album or not, consider the following:

- Use ISO 400 or 800 color print film, if you're shooting film.

- Look for reaction shots. When the bride and groom kiss at the altar, turn around and shoot Great Aunt Gretyl crying. Leave the kiss to the professional.

- Yes, take lots of pictures of giggling kids.

- Photograph objects as well as people: the church, the wedding cake, flower arrangements, table favors, and so forth.

- When you photograph objects, move or zoom in for details. Try a close shot of the cake — or the cans tied to the bumper.

- If you make an album, consider including objects as well as photos. These might include dried flowers, cocktail napkins, or a wedding invitation. Also, art and craft supply shops often have a nicer selection of albums than photo shops.

© Russell Hart

Want proof that your life is full of unexploited photo opportunities? Think about the last few weeks and count the number of situations that involved interesting or funny interactions with or between people. Did you have your camera with you?

Getting formal

What's the difference between candids and formal portraits? The formal is consciously, carefully posed. Formal portraits try much harder than candids to flatter the subject — or at least to make the subject look as interesting as the photographer knows him to be. Formals require the photographer to think more about light, pose, and composition. Done well, a formal can have a classical, painterly feeling.

If you're interested in formal photo portraiture, plan a trip to an art museum. Study portraits by old and modern masters, from Rembrandt to Andrew Wyeth. Note poses — a certain turn of the head, the position of hands — and the way light defines features and contours. (If you don't live near a museum, borrow some art books from your local library.) Try some of these posing ideas in your formal portraits.

The most important prerequisite for formals is patience — with yourself, not your subject. Don't be surprised if your first few attempts are disappointing. That's normal. A formal portrait isn't brain surgery, but it takes a while to develop an eye for what works and what doesn't. Your technique may improve sitting by sitting, but you may want to start by practicing on a (patient!) loved one who doesn't mind being used as a guinea pig. (Forget children. They have enough trouble sitting still for a candid shot, let alone a formal!) Here are some ideas:

- **Background:** Set up a backdrop perpendicular to an interior window — that is, extending into the room at a right angle from one side of the window's frame. A dark sheet, blanket, or tablecloth works well; just avoid patterns. (You have to figure out a way to support the backdrop, perhaps tacking it to the window frame and hanging the other side over a lamp.)

- **Lighting:** The light from the window should be soft and indirect. (Direct sun is usually too harsh, though if you set your camera's fill-flash mode you can soften it considerably.) If the light causes features to cast objectionable shadows across the face, reposition the subject if possible, angling the subject's face more toward the window. Consider lightening shadows with a *reflector,* a big sheet of white paper or cardboard (or just a big sheet). Place the reflector outside the picture area and angle it so that light bounces back into the subject's shadows. A good trick: Have your subject tilt her head up, so light strikes the face more completely. (And another: Shoot outdoors on a cloudy day, with something dark behind your subject.)

- **Camera angle and orientation:** Choose your camera angle with care. For tighter portraits (faces or heads and shoulders), place the camera

at your subject's eye level, or even slightly lower. A portrait subject is usually, though not necessarily, best suited to vertical composition.

✔ **Posing:** Coax your subject into a comfortable but typical pose, maybe even modeled after a portrait painting you admire. In group portraits, individuals shouldn't cluster so tightly together that they can't move, nor should they spread out so loosely that they don't seem to form a group. Try to set up a structure that leads the viewer's eye from one member of the group to the next. If this setup seems too difficult, try arranging the group in order by height, with the tallest people in the center and smaller people flanking them on the sides. Mix sexes, too. The idea is to create a uniform composition and to keep your subjects' faces relatively close together, not all over the picture area (see Figure 11-6).

✔ **Clothing:** If possible, dress your subject in neutral tones that complement, but don't blend into, the background. Avoid patterns, bright colors, and pure white or black. Choose textured fabrics like velvet or corduroy, if possible. If you're shooting a group and you have any say in the matter, dress everyone in colors of the same family (that is, all bluish or all warm-tone colors).

✔ **Film:** Along with your usual color print film, consider shooting with black-and-white chromogenic film (see Chapter 2). Black and white brings a timeless, classic look to formal portraiture.

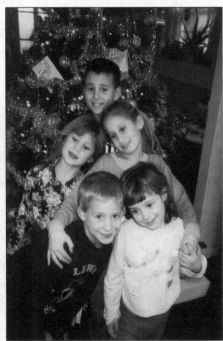

Figure 11-6: For this Christmas portrait, the photographer arranged his subjects to create a close group — you guessed it, in the shape of a Christmas tree.

© Peter Kolonia

Acting class: Shooting staged events

You may get some of your best people pictures during staged or semi-staged events — school plays, ballet class performances, or wedding ceremonies, for example. But at these occasions, people often consider a flash intrusive. It can ruin the mood, distract the performers, and drain your camera's batteries — all for no photographic purpose.

Why? Because the people onstage may be out of flash range. Few point-and-shoots can light anything beyond about 20 feet with their built-in flash units. What's more, the stage (or altar) may be pretty well lit, and flash may be unnecessary to get the shot.

However, your camera may *think* that flash is needed because the area around the performers in a staged event is often quite dark. So you should set its flash-off mode. Just be sure to use a fast film; I suggest at *least* ISO 800 film in these situations, especially if you're zooming in, which is likely. The faster film lets the camera set a higher shutter speed, reducing the chance that hand shake will blur the picture — and making it better able to freeze moving figures (your little ballerina). The faster the film, the smaller the chance of blur, so you may want to try an ISO 1600 color print film if you can find it at your photo dealer.

When you take the shot, though, you should still place your camera on something secure like a tripod (or an empty seat) and gently press its shutter button so that you don't jiggle the camera. One way to avoid blur in the subject: Resist shooting until the on-stage action comes to a standstill. If you shoot while the performers move, there is always the chance they'll appear as blurs in your picture.

Many digital point-and-shoots have a "black-and-white" mode that you choose in the menu; some models can even give their black and white pictures an old-fashioned sepia-brown color. And if you know how to use digital imaging software (these days, such programs make it very easy) you can shoot in color and change to black and white in the computer.

Possibly the easiest way to create a formal portrait is turn the subject into a *silhouette* — a dark shape with a much lighter background. Shoot the subject directly against a window or open door with cloudy sky behind him; avoid including prominent latticework or sashes. You have to make up for not seeing the subject's expression by shooting in profile or at an angle that creates a recognizable shape. You may also want to have the subject hold something that's associated with her and easily readable in silhouette — a pipe or hat, for example (see Figure 11-7). Now here's the weird part: Set your camera to its fill-flash mode, but cover the flash with your finger as you fire. This causes the needed underexposure of the figure. Then ask your minilab to make the prints extra dark.

Planning your candids

Candid photography may bring to mind totally spontaneous pictures — basically, shooting from the hip. You see a scene or expression worth

capturing, so you pull out your camera, aim, and fire. While this approach to candids can sometimes yield good results — and point-and-shoot cameras are certainly meant for such spur-of-the-moment photography — seemingly spontaneous people pictures are usually best made with planning and forethought.

First, you need to identify the times of your life that lend themselves to great pictures and make sure that you have a camera on hand for them. Any time family, friends, and acquaintances gather, seize the opportunity. You don't need to wait for a big holiday or a milestone event like a wedding, christening, or bar mitzvah. You'd be surprised at how many great people pictures you can make during a card game, both of the group and of individuals. Then you have the traditional gatherings for sports and games — participatory or spectator, live or televised. When people come together, photography is fair game. Depending on how your family and friends feel about it, even more somber occasions may be appropriate for photography. They are, after all, a part of your personal history.

The best unposed candids, ironically, take planning. Following are some strategies that can help you capture better candids:

- **Before family and friends converge, plan your tactics.** If the pretext is a game of cards, set up the table next to the window or some bright lamps, in case you want to shoot without flash for more natural-looking light. You may never lift the camera to your eye — that's okay, too — but you're ready for a shot if you get the urge.

- **When people arrive and get settled, analyze the scene and its players.** Who's the most expressive and gestural? Who's in the best light? Who's against the nicest background? If you want to photograph anyone in particular, seat or rearrange people so that person has the best light or the best background.

- **Once you determine the most likely candidates, find a shooting position that gives you unobstructed views of them.** When you're in position, sit or stand back and observe your subject — and keep in mind that it's best to start shooting slowly. Don't startle or annoy people with your camera. Fire off a few frames just to get everyone accustomed to the camera. Take your first pictures as "jokes."

Organize a game that requires some physical involvement (basketball or Twister) with the purpose of photographing it. Shoot both when the action is in high gear and during the quieter moments. You may be surprised at the number of keepers you get!

Successful candids require good observational skills. To get good unposed shots, you must wait for them to happen, anticipate them, and seize them when they present themselves. Lying in wait requires some discipline, but once you start, it's fun. In fact, you may be surprised at what you learn about the people you think you know — family, friends, and acquaintances — by watching them in the hope of nabbing a good candid photo. You can get so wrapped up in watching people, in fact, that you forget to photograph them!

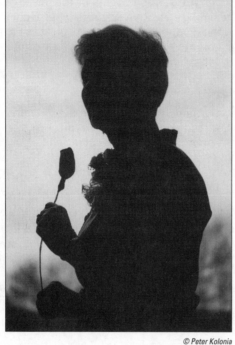

Figure 11-7:
Shot against a bright, cloudy sky, this silhouette is especially effective because the woman is holding an easily identifiable rose.

© Peter Kolonia

All that said, nobody has perfect photographic timing. The expression or gesture or interaction that caught your eye may not be the exact one that ends up on film. What's more, while you concentrate on rather unexpressive Uncle Clive, Great Aunt Gretyl may have one elderberry cordial too many and start doing her famous impressions of long-gone family members — and you're missing them! Good candids sneak up on you. And because taking a candid is often such a delicate matter, you really don't know what you've got until you get the prints back. Moral? Don't wait for the perfect shot. Shoot a lot of pictures and have fun.

Make candids tell a story

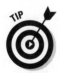

One good way to go about taking candid photos is to make your pictures tell a story. The obligatory, for-the-record shot of family gathered around the Thanksgiving table or Christmas tree serves perfectly well as a historical document, but not much else. More satisfying are groups of pictures that illustrate how the family lives and interacts. Photographic storytelling can reveal much about the character of a family and its individual members.

What do I mean by storytelling? Imagine going on a family vacation to a beach resort. Naturally, you get pictures of Johnny buried in the sand and Ginny shrieking her way through amusement park rides. But there was more to the vacation than that. There was the planning stage, when Mom and Dad sat around the kitchen table picking through brochures. Then the drive to the

resort, with its spats and diner stops. And how about the misadventure you had when you pulled off the wrong exit? And, of course, the accommodations, grand or grimy. If you have the composure to photograph these sometimes less-than-splendid experiences, the pictures will make your photo albums that much richer over the years.

Candids and backgrounds

It may be the last thing on your mind when you're trying to capture Great Aunt Gretyl's best impression, but you need to pay some attention to the backgrounds of your candid photos. Try to keep them simple. You generally don't want too much activity going on behind your subject; the classic error is to have something "growing" out of someone's head — a backyard tree, a telephone pole, the flowers on the mantel.

Remember that even though your eye and selective attention filter out such visual intersections, a photographic print only reinforces them by squashing them together on a flat plane. So when you frame your candids, scan the area behind the subject for any such conjunctions. If you spy any, all you usually need to do is shift yourself a little to the side. If you're composing with a digital point-and-shoot's viewing screen, you may want to eyeball the background first, since distracting background details may be difficult to see onscreen. If you're concerned, use the camera's regular viewfinder.

Another thing to watch out for is your candid subject's distance from the background. With indoor flash photographs, a background that's fairly far from the subject can end up completely dark in the print, and even worse, may trip up the photofinishing machinery into making the person's face too light — a ghostly visage in a black void (see Chapter 3).

Here are some ways to prevent both the visual clutter and the dark backgrounds that can mar your candids:

- **Fill the frame more fully with your candid subject.** Physically move in closer or zoom in to a longer focal length that makes the subject appear bigger. Getting closer reduces the amount and importance of the background and focuses attention on the person. Important: If you're shooting a single person, use vertical composition to cut down the amount of "empty" space on the sides of the frame.

- **Make your background closer.** Shift your position to the side so that a nearby wall or other element falls behind the person. (Shoot at a bit of an angle to the wall to avoid casting unattractive flash shadows on it.) Of course, by moving, you may not end up with the direct angle on the person that you initially wanted — so call out to get her to look your way!

- **Ask the subject to move.** Move the person to a position in which the background will be closer or more interesting. If you make this request, though, you probably should wait to shoot again until he forgets about you.

- **Use your point-and-shoot's slow-sync mode for flash pictures in which the background is unavoidably far away.** This mode (see Chapter 7)

causes the camera to set a slower shutter speed — that is, to keep the window in the lens open for a longer time — so that the film records more of the existing light, most visibly in the background. But this effect really works only if you use fast (ISO 400 or 800) film or are able to raise your digital camera's ISO setting, and if the light level (from either household bulbs or windows) is reasonably bright to begin with. Turn on some extra room lights to be safe.

If light levels are bright enough to let you shoot by existing light, your strategies may change. In fairly bright interiors, the background is often bright enough for the film to record, with no black void effect. So the background can be as far away as you like — sometimes, the farther the better. Having the background far away makes it more out of focus — more blurred. And a blurred background has the wonderful effect of placing emphasis where you want it, on your sharp subjects (see Figure 11-8).

Dramatically out-of-focus backgrounds are easier to get when you zoom your lens to its longer focal length settings (see Chapter 5). But just remember that the longer the focal length, the greater the chance that camera shake (caused by your hand tremors) will blur the whole image. And the longer the focal length, the greater the chance the flash will fire, if your camera is set to autoflash mode. If this is the case, you may want to turn the flash off, or zoom to a wider-angle setting and move closer to your subject.

Figure 11-8: When light is bright enough to shoot without flash, a distant background can actually be a plus. At longer focal length settings (here, 135mm), the lens throws it out of focus, emphasizing the main subject.

© Peter Kolonia

Instant Light: Using Flash for People Pictures

Of all the features on a point-and-shoot camera, the built-in flash may be the single most important for making better people pictures. Each flash mode, including flash-off, delivers excellent results in the right circumstances. Your flash can create light where none exists, making portraits possible when you otherwise wouldn't have been able to make them. It can soften harsh light on the faces of your portrait subjects by filling in shadows in eye sockets and under the nose or chin. It can also offset the image-marring effects of strong backlighting. For details on using flash for people pictures, see Chapter 7.

Pretty as a Picture: Zoom Settings for Portraits

If your 35mm point-and-shoot has a zoom lens, it probably starts out at wide-angle focal length settings such as 35mm or 38mm, and ranges out to longer focal length settings of 70mm, 90mm, 105mm, and beyond. Professional photographers who use 35mm cameras sometimes call lenses having focal lengths around 90mm or 105mm *portrait lenses*. But that doesn't mean you can't take good people pictures with virtually any focal length setting your zoom offers; you just have to know when to use which! Nor does it mean that you can't get good results from a nonzooming model. (See Chapter 5.)

Long focal length portraits

The fastest way to a flattering portrait — especially if it's a close-cropped face or a head-and-shoulders shot — is with a zoom setting between 70mm and 105mm (see Figure 11-9). With Advanced Photo System cameras, a portrait zoom setting works out to about 55mm to 85mm. A digital point-and-shoot has no useful focal length markings or displays; if yours is a typical 2X or 3X zoom model, just zoom in all the way, or close to it.

Longer focal lengths let you move back from your subject but still fill the frame with her. Physically moving back from the face creates more natural-looking — that is, flattering — size relationships among facial features. No one element (like the nose) appears much larger than any other. Long focal lengths are also useful because they let you exclude background details that might distract from your subject. And because they allow you to shoot from a distance, they're ideal for subjects who might not want a camera shoved in their faces.

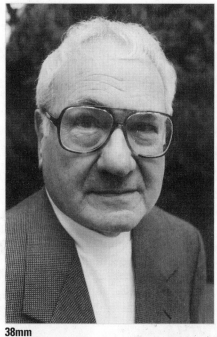

38mm

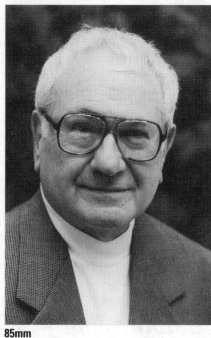

85mm

55mm

105mm

Figure 11-9: For the most flattering results with tight portraits — a face or head and shoulders — zoom to focal length settings of 70mm or longer. Notice how the proportions of this man's facial features change with different settings — and the unattractive "big-nose" effect at 38mm!

© Mark Harris (4)

Trimming down: How to fake long zoom settings

If your camera doesn't have long zoom settings (only going to 50mm, for example), or if it's a nonzoom model, you can mimic the more natural facial proportions you get with longer focal length settings by stepping back to make your subject smaller in the frame. After you have the film processed, have the negative (or, in the case of a digital point-and-shoot, the image file) reprinted at a larger size — 5 x 7 or 8 x 10. Then just trim the print down to the area immediately surrounding the subject.

If you have to photograph someone up close with a relatively wide-angle focal length — your only option if you have a nonzoom point-and-shoot — try shooting him in profile. Because this places all the facial features at about the same distance from the lens, less distortion occurs. Keep in mind, though, that portraits shot in profile don't give you the subject's full expression.

Wide-angle portraits

If long zoom settings are good for people pictures, does that mean you should avoid your camera's wider-angle zoom settings when taking people pictures? No. The bigger swath taken in by wider-angle settings makes them useful when you're shooting big groups or in tight quarters — those holiday pictures in which you try to pack everybody into your dining room. But you can also use wider-angle focal lengths very effectively for portraits of individuals.

You do so simply by keeping your distance from the subject — and using the extra surroundings to create what photographers call an *environmental portrait*. A good environmental portrait makes meaningful use of the subject's familiar context — bedroom, backyard, kitchen, or workplace. This kind of portrait reveals something about how a person lives, works, plays, or even feels. The stuff that collects around a person often reflects that person's character. Such pictures are especially fun if the location is exciting, colorful, eccentric, or busy. This approach to people pictures may be your only option when photographing folks who don't want to be reminded of their wrinkles — something a more close-cropped portrait shot at a longer focal length setting makes all too apparent. (See Chapter 5 for more on wide-angle zoom settings.)

Love at First Shot: Photographing Children

Parents just can't help themselves. Their kids are the natural targets of their photographic affections. Even childless aunts and uncles — seemingly more

sensible people — are party to the obsession. Why do people feel so compelled to photograph children? The answer seems obvious: We find them cute and irresistible. Well, most of the time.

Take pictures of kids not just when they're most charming, but also when they pout or act up (see Figure 11-10). If the face you get is glum or angry, shoot anyway. Your pictures should reflect the emotional variety of your life.

Make an effort, in fact, to photograph kids when they do their utmost to be uncute and utterly resistible. Again, think of photography as the visual diary of your life. Episodes that may not seem to warrant picture-taking, or that you may be disinclined to photograph, take on new meaning and value as each childhood phase passes. Don't censor your photographs before the fact. You will look back at even the greatest annoyances — the artwork on the new wallpaper, the car happily washed with the windows wide open — with amusement and nostalgia, not anger. You'll be glad to have the pictures.

Of course, I don't mean to tell you how to discipline your kids. But sometimes, instead of getting mad, you might try just getting out your camera. You don't want to reinforce bad behavior, but a picture can defuse a situation that may be due more to childish misunderstanding than any challenge to your authority.

People take more photographs of children than of any other single subject. This is ironic, because children are among the most difficult subjects to photograph. They move too fast — from one activity to the next, from one mood to the next, from one endearing moment to the next. To keep up with them photographically, you need good reflexes — to get out your camera and shoot quickly. Those reflexes come naturally as you take more and more pictures.

And don't just take pictures of your own children. Practice your skills on other kids, the children of friends or family members. Parents will be grateful for the prints you give them. And when you get good, if you want the challenge, you can offer to take pictures at school events and functions.

Know your child — and be ready

Well, of course, you know your child. But you should use that knowledge to plan your photographic strategy. Otherwise, you may curse yourself that in the time it takes to find your camera and make sure that it has film — and put some in it if not — the moment that captivated you has vanished.

Figure 11-10:
Most kids
are moody.
So if you live
with kids
and take the
job of photo-
graphing
your family
seriously,
don't just
shoot them
when
they're all
smiles.
Pouting is
part of
childhood.

© Russell Hart

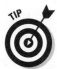

You may find certain times of day or certain activities during which you always want to shoot pictures of your children — and regret not acting on that impulse more often (see Figure 11-11). Maybe your little one likes to play catch before dinner, or stage a command ballet performance afterward. Maybe your kids always stop to giggle at a window display, or study a bird's nest, on the walk to school. Be ready to take pictures at these times.

Study reactions and expressions, too. Maybe you've noticed the look of intense engagement when your child reads a book, clicks through a favorite CD-ROM, paints a picture, or practices an instrument. Or maybe the presence of a particular playmate brings out the *joie de vivre* in your child. Look for the photographic possibilities in your daily or weekly routine. (Doing so may well change and enrich the way you see that routine!) And once you identify these times, have your camera nearby — in your pocket, around your neck, or in your hand.

When you plan your session, check to see whether you're near the end of the roll, or, if you're using a digital point-and-shoot, are close to filling up the memory card. If you are, have a new roll — or an extra memory card — handy in case you run out of film or space. (If you only have one memory card, download its pictures to your computer and erase it.) If you *are* at the end of a roll — say on the 22nd frame of a 24-exposure roll, or the 33rd frame of a 36-exposure roll — just rewind the film and load a new roll (see Chapter 1). That way — and this bears endless repeating — you won't be stuck reloading film when that perfect photo opportunity appears.

Figure 11-11:
Identify the activities, rituals, or times of day when you find your kids most appealing. Then have your camera ready and waiting, making sure it has enough film for at least a few good shots.

© Mary G. Cobb/courtesy Kodak/KINSA

You shouldn't take just one picture; you should take two, three, or more so that you're more likely to get the look or gesture you love. And you may be surprised to see a look or gesture you hadn't even noticed! A camera sometimes sees what you miss. When you get your prints back, pick the one you like best — the one that does the most justice to your own experience. That's the one for the frame, or the album, or to send to friends and relatives.

Now listen to this advice: You shouldn't just wait for the right moment to occur, and then raise the camera to your eye. By then you're usually too late. Put the camera to your eye (or up where you can watch its viewing screen) frequently as your child goes about her business and be ready to press the shutter button at any time.

This idea seems simple enough, but most photographers don't do it. You have to learn to *see* through the viewfinder (or the viewing screen): to study the subject through it or on it. Only if you see the right expression, gesture, or moment *through the viewfinder* (or on the viewing screen) are you likely to capture it.

If you're using a digital point-and-shoot, its viewing screen *may* give you an advantage in this endeavor. Because the viewing screen makes you hold the camera away from your face to compose and shoot the picture, you can move your glance back and forth between the viewing screen and the subject — no need to put the camera to your eye to shoot. Models with adjustable viewing screens even let you comfortably hold the camera at a

low position, closer to a child's-eye level; just tilt the screen up to see it. But as I said before, you may find it hard to identify the right moment on such a tiny screen. Solution: Turn off the viewing screen and use the regular viewfinder, if the camera has one.

And as you look through the viewfinder or at the viewing screen, keep your finger on the shutter button, periodically pressing it halfway down without actually taking a picture. This pressure keeps the flash charged up and prevents the camera from shutting itself down just before a good photo op. (Most models turn themselves off automatically if left unattended for a couple of minutes.)

Nonetheless, your camera may sometimes thwart a fast reaction on your part. The time lag between when you push the button and when your camera actually trips the shutter often seems interminable. Flash charging in particular can hang you up. You can find out more ways to minimize such problems in Chapter 7.

Why not just set the flash-off mode and eliminate the problem altogether? Because if your point-and-shoot fires the flash on its own — something it's likely to do indoors or in dim existing light — chances are you should be using it anyway. Without the flash, you'd have insufficient light for good results.

In fact, if the flash doesn't fire on its own, you might even want to force it to (see Chapter 7). Why? Because the flash helps in other ways, too, when you take pictures of your kids. The flash burst's very brief duration — it can be $\frac{1}{5000}$ second or even shorter — helps freeze a fast-moving subject. And kids are nothing if not fast-moving.

But if you don't want to use flash, you can get the camera to set a more kid-stopping shutter speed by using a faster film (see Chapter 2). You should use a film of at least ISO 400 speed anyway; to minimize kid blur, use an ISO 800 or ISO 1600 film. And with a digital point-and-shoot, you can trick the camera into setting a more blur-stopping shutter speed by increasing its ISO setting, as explained in Chapter 12.

Should kids look at the camera?

You've probably heard self-styled photo experts expound mightily on the matter of kids looking at the camera. Most such experts think that having your subjects even look at the camera, let alone pose, is a bad idea — that it makes for stiff, unnatural pictures. I beg to differ. Pictures in which a child is absorbed in an activity are great. But nothing is better than a spontaneous shot with direct eye contact. Eye contact animates the face. It engages the picture's viewer.

Spontaneity is the key. If you line kids up, of course, they'll start mugging and squirming in no time. In fact, don't try to pose them at all; don't disrupt their

activity. Start by taking a few unposed pictures. Then, after the kids get used to you, call out to them to look at you. Shoot as soon as they do. Give them as little time as possible to object or make faces. If they oblige with a good smile, shoot another picture. If they start to act up, and you don't want them mugging, wait to shoot until they're bored by their antics. (Mugging's fun, too.) But either way, keep shooting. The second or third shot, or the fourth or fifth, is often the gem. I've been known to shoot a whole roll (36 exposures) of one situation (and not special occasions, when I'm likely to shoot many rolls). I can't tell you how many times the 36th frame has been the winner.

Even if kids don't get unruly about having their picture taken, they sometimes get hammy. For a while, my daughter offered up the same silly grin and squinty eyes each time I tried to take her picture. Every shot looked the same — the same face pasted onto a different background. She outgrew the habit, and in the interim I stuck with more surreptitious shots. (After that she started to stick out her tongue for the camera.)

Just one cautionary note about eye-contact photographs: If you set your point-and-shoot's flash system to *red-eye reduction,* which is designed to lessen the devilish-looking red eyes you sometimes get in flash pictures, you may get an agonizingly long delay between when you push the shutter button and when the picture is actually taken. This long delay is particularly true of red-eye reduction systems that use a *preflash* approach, but some *prelamp* systems can also take seemingly forever. If the delay is so long that you're likely to lose the moment, expression, or gesture you want to capture, you're better off shutting the red-eye reduction system off. See Chapter 7 to find out how.

And if your subjects are too young to explain their reactions, don't assume that crying means they don't like being photographed. It may be that they're upset by the bright burst of flash, though if they're like most kids they'll get used to it. In the meantime, use a fast film, shoot in good light — and turn off the flash.

Shoot from eye level — theirs

Perhaps the most common mistake in photographing children is to shoot them from your own eye level. An adult's-eye view turns kids into big faces with foreshortened little bodies. Get down on their level to take your pictures (see Figure 11-12). I repeat: Legs are your most important photographic tool. The pictures you shoot this way not only have less distortion, but also make the viewer feel more involved with the subject.

As I mention earlier in this chapter, some digital point-and-shoots have viewing screens that tilt, so you can compose from a lower angle by tilting the screen up rather than scrunching yourself down.

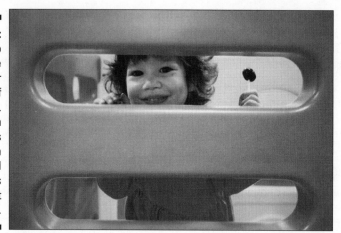

Figure 11-12: Stoop to kid's-eye level for pictures of children. This both prevents distortion and engages your subject more fully.

Photo fashions for photogenic kids

A couple of styling suggestions about photographing kids: If you have the chance, dress the kids in clothes that aren't distracting. Don't let a baby-clothes maker's oversized logo take the attention off your child (unless, of course, you plan to enter that company's photo contest!). Keep clothes simple, not too brightly colored or heavily patterned, so that they don't compete with delicate skin tones. Soft, textured clothing is often a good choice because it gives a feeling of substance to clothes without being distracting.

Also, consider having toys around, both to hold the child's interest and as props. Choose them with care, though. They shouldn't be big, brightly colored, or plastic. Wooden blocks are a classic choice.

And one final note about photographing your kids: As they get older — as the infatuation with a newborn and the fascination with a toddler mellow into familiar love — you may find yourself taking fewer and fewer pictures of them. Don't let this happen, if only for your kids' sake. Your pictures will become a big part of their family history. As they grow up and their heads get filled with the minutiae of adult responsibility, your pictures will serve as the main catalyst for their memory. So make that record as complete as you possibly can. Your kids will thank you.

The Cat in the Hat: Photographing Pets

Pets are more stalwart photographic subjects than kids, or grownups for that matter. They don't groan "Oh, no, not again!" when you raise the camera to your eye. They don't make funny faces or deliberately stick their tongues out

to thwart your photographic endeavors. (Dogs pant, of course.) While they can be just as active as kids — and as much of a photographic challenge when they speed around — they also actually *like* to take naps. Nap time is a good time to get pet pictures.

Otherwise, though, many of the same photographic techniques that apply to taking photos of kids work with pets, too. (See "Love at First Shot: Photographing Children," earlier in this chapter.) Be sure to get down to their eye level. Unless you have a pet llama or a horse, pets are even lower to the ground than kids.

With cats and dogs, you can get easier eye-level pictures by snapping them when they perch on a window sill or, if allowed, a favorite chair.

Your pet no doubt has some distinctive behavior, often comical (see Figure 11-13). My old family dog used to study ants, nose inches from the ground, head cocked to one side for a one-eyed microscopic view. (It was a perfect opportunity for a ground-level shot.) Our nutty new cat likes to lie flat on her back on our bedroom carpet with her legs straight up in the air, staring at us upside down. Photographing interesting and amusing pet behaviors is a kind of substitute for the fact that animals don't have a child's range of facial expression, at least to human eyes. Pet pictures may otherwise have a certain sameness to them. Their context — environments, behaviors, settings, and so on — becomes especially important.

Figure 11-13: Pets are great photographic performers. Knowing her dog's fondness for chocolate chip cookies, this photographer set the stage (milk and all) and lay in wait with her camera.

© Annette Feutz/courtesy Kodak/KINSA

For the same reason, you should show pets interacting with family members. They are, after all, a part of the family. These pictures can, of course, be candid: playing fetch, chasing a string, getting a tummy rub. Or they can be more posed — a pet in your arms or on your lap.

I think that making eye contact with pets is just as important as with kids. (See the section "Should kids look at the camera?" earlier in this chapter.) Call out to them when you're ready to take the shot. With pets, expression is almost entirely in the eyes. Indeed, a true dog or cat person will tell you that the eyes are the window to a pet's soul.

Unfortunately, that soul may seem to come from the dark side when flash turns those eyes red — or green, as often happens with pets. Red-eye and green-eye are a special problem with pets (see Chapter 7). With cats in particular, the large area of their eyes relative to their faces compounds the problem. You can use your camera's red-eye reduction system to lessen the effect. But depending on your particular system, there's a long delay between when you press the shutter button and when the picture is actually taken. This delay can cause you to lose the moment you wanted to capture. And pets aren't in the habit of waiting around. You find better remedies for this problem in Chapter 7.

Visual Heirlooms: Photos as Family History

Photographs have become icons of human events and achievements: a space-suited Neil Armstrong on the moon; John-John Kennedy saluting his slain father; a World War II sailor planting a kiss on a female celebrant in Times Square; a craggy Abraham Lincoln just days before his assassination. Indeed, our sense of recent human history revolves around photographic images.

The same is true on a personal level, the level of *family* history. Photographs passed on from one generation to the next — of ancestors in their Sunday best, the grandparents' homestead, mother as a young bride, yourself as a pinkish newborn — are imprinted as much in your head as on the paper that backs them. With such images, in fact, separating what's in the mind from what's in the photograph itself is hard. Memory and photograph become inextricably linked.

So when you feel too lazy to get out your camera, motivate yourself with the reminder that any picture you take could end up becoming a family icon — an important piece of family history. Your photos are more likely to become icons, however, if they capture the essence of a family member, a family tradition, a family place, or a family experience. And *you're* more likely to capture that essence if you work harder at being a photographer.

People — family and friends, children and parents — probably get most of your photographic attention. And your people pictures will usually have

more visual impact if you fill the frame — that is, move close or zoom in to make the subject occupy a large part of the picture area. But sometimes, for the sake of history, stepping back is important — both literally and figuratively. By stepping back, you show your subject in *context*.

When you photograph the kids romping with the dog in the backyard, for example, take a few pictures that show the *whole* backyard, with its occupants smaller in the frame. When you photograph Fido in his favorite chair, take a few pictures that show the whole living room. And after you shoot that tight photo of your five-year-old on the first day of school, back up and take another that shows as much of the school as possible.

For that matter, you don't always need to include people in these pictures of important places. The backyard, the living room, or the school is a fine subject in itself, especially if you take care to compose the photo in an interesting and meaningful way, in interesting, even beautiful, light.

Consider your house, if you own or rent one. If you take pictures of its exterior over the months and years, you have an incremental record of its changes — seasonal patterns of light and foliage, the growth of trees and plantings, new paint. In fact, try shooting at least one picture from the same position each time, for a sort of time-lapse effect.

Your home's interior — whether apartment or house — goes through similar changes over the months and years. As you rearrange the furniture, acquire new things, repaint and remodel, you alter the feeling of the rooms. Document each phase, especially if you plan to make changes. Think about how an old photograph of a room in a former house can evoke powerful memories and feelings from its time. Think about how kids' rooms change with the growth and youthful fascinations of their occupants.

Take stock: Shooting your possessions

Sharing your life and preserving your memories may be the most compelling reasons to take photographs. But there are practical reasons, too — uses that may not even occur to you. Looking for a shower head to match your bathroom faucets? You can't bring the faucets to the store, so bring pictures of them with you instead. A tree fall on your garage, heaven forbid? Take pictures of the damage from every angle, *right away,* in case your insurance company has any questions about it after the debris has been cleared.

In fact, photographing all your most important or valuable earthly belongings is a good idea. If your home or apartment burns or is burglarized, the pictures are the proof of possession you present to the insurance agent — more convincing evidence than your mere verbal vouching. (Oh, and keep those pictures of your possessions in a safe, fireproof place; see Chapter 3 for more on storing negatives, prints, and digital image files.)

Get down: Shooting party pix

It goes without saying that some of the best opportunities for people photography happen at parties. Whether a wedding reception, birthday bash, or New Year's Eve celebration, party time is a perfect time to get out your camera and fire at will. Here are some important pointers for party pictures.

✔ Photograph party preparation and cleanup. Get shots of the nicest food spreads before guests gobble them up, and the decorations before they're trashed. Afterward, present the pictures as gifts to the hosts.

✔ Concentrate on the most animated groups but make portraits of individuals, too.

✔ Look for groups that seem to hold together visually. Avoid groups with individuals whose backs are to the camera or who block the camera's view of others in the group.

✔ If the gathering is a rare or once-in-a-lifetime event — a family reunion, for example — try to photograph everyone there. If you leave someone out, you may regret it later.

✔ Bring appropriate family and friends together for loosely posed group portraits.

✔ Suggest making a group shot of everyone there.

✔ For better background detail with indoor party shots, set your point-and-shoot to its slow-sync mode, if possible, or if it doesn't offer this, fill-flash mode.

✔ Always have double sets of prints made. This gives you one set to give away to the people you photograph, and a second set to keep.

Neighborhoods change likewise. Whether you live in the city, the suburbs, or the country, make regular pictures of familiar street corners, back alleys, storefronts, shortcuts, the view of neighbors' yards. These pictures become especially meaningful if and when you move to a new home, a new neighborhood, or a new city or state.

At first, such photographs may not seem as interesting as pictures of people, and taking them might seem a bore. But if you have the right attitude, you won't find the task boring at all — nor are the pictures strictly for the historical record. A carefully considered, well-made photograph of a seemingly ordinary object or place can transform it, letting you see it in a new light, sometimes literally. Light is particularly transforming: In the right light, even the most mundane subject can look astonishingly beautiful. (For more on lighting, see Chapter 8.) In this and other ways, photographs give you a better appreciation of the world that surrounds you — and might just be history in the making.

Ten Lame Excuses for Not Taking Along Your Camera (And Why They're Lame)

You may find lots of photo ops around your home and neighborhood, but you'll also want to shoot special occasions and your travels, too. This chapter and Chapter 13 are full of advice about taking those kinds of pictures. Here's a little motivational roster — a few of the many ways you can talk yourself out of taking your camera along, and my rebuttals of each!

1. **The camera's too heavy.** Then buy a lightweight point-and-shoot camera. Or get a padded shoulder strap.

2. **The camera's too big.** Get a pocket-sized point-and-shoot — or buy a one-time-use camera when you get where you're going.

3. **Taking pictures interferes with the experience.** Yes, you have to pause to shoot in the middle of whatever you're doing or wherever you are. This routine becomes second nature. If you don't do it, you'll regret it later, when you have no pictures with which to remember.

4. **The friends I'm with will think I'm obnoxious.** It's your life — and photography is your passion. Send them some flattering pictures of themselves, and you'll soon become their official photographer.

5. **Nothing important is going to happen.** You never know. The best photographic opportunities are unexpected.

6. **I forgot to buy film.** Unacceptable. You can buy film almost anywhere. And you should have a few extra rolls in reserve.

7. **My battery is dead.** Sorry. You should always keep an extra battery handy, especially if your camera uses lithium batteries. These batteries may be hard to find, or very expensive, in faraway places. (See Chapter 1 for more on batteries.) And if you have a digital point-and-shoot with a proprietary rechargeable battery, consider buying an extra, accessory battery — and keeping it charged — for backup.

8. **My camera is broken.** It may not be. See Chapter 20 for some troubleshooting tips. If trying those things doesn't make it work, buy a one-time-use camera for now. Then replace the camera with an inexpensive point-and-shoot.

9. **Photography is too hard.** Nonsense. The automation in today's point-and-shoot cameras nearly eliminates the technical decisions that used to make snapshot photography such a bother.

10. **I'm not artistic.** Let me raise your self-esteem: A few simple tips and techniques can make you a much better photographer than you ever thought possible. That's why you bought this book!

Chapter 12

Capture the Action

- -

In This Chapter

▶ Showing action with still photos

▶ Why digital point-and-shoots are great for action shots

▶ Prefocusing ahead of the action

▶ Freezing versus blurring

▶ Using fast film to freeze action

▶ Changing a digital point-and-shoot's ISO to freeze action better

▶ Panning to follow action

▶ Freezing action with flash

▶ Showing action with blur

- -

A ction photography might just be the most popular and admired form of picture-taking, especially in our sports- and fitness-happy society. But when you think about it, it's really a remarkable contradiction.

Action photography captures *movement* — in *still* photographs! And that's precisely what makes photographs of action subjects so compelling. The still photo, by taking one brief moment of a continuing action — be it a pro football play or your budding gymnast somersaulting in the backyard — lets you look at the action again and again. A great action shot is an instant captured for an eternity. In this chapter, I tell you all you need to know to capture action with your point-and-shoot.

You Don't Need Fancy Equipment to Shoot Action

With all due respect to video, I don't think a moving picture crystallizes movement quite the way a good action shot does. Ever notice, in TV sports, what video directors do in instant replays of close plays — like a late throw to first base or a pass caught right on the sideline? They slow down the tape

and then stop it outright at the critical moment: the runner's foot touching first base or the receiver's toes staying just inbounds. In other words, they show you exactly the sort of frozen action that a good sports photographer nails for the front page of the sports section.

"Yes," you're muttering, "exactly the sort of picture I don't have a prayer of getting with my Zippymatic Zoom." Wrong. I'm not going to snow you and say that you can get the same results as pros who use high-speed camera equipment. But the most important component of action photography has nothing to do with equipment. It has to do with timing — with anticipating the critical moment and honing your reflexes to hit the shutter button when it arrives! (See Figure 12-1.)

Figure 12-1:
You don't need special high-speed photo gear to capture action. This rafting shot was made with a Kodak Fun Saver Weekend 35 camera — a waterproof one-time-use model.

© Don Chochran/courtesy Kodak

Your Dawdling Point-and-Shoot

Point-and-shoot cameras, though, can have their quirks when you're trying to shoot fast action. You've probably noticed that your point-and-shoot doesn't necessarily fire right away when you press the shutter button, perhaps because the flash needs to recharge some more or because the camera takes a moment or two to focus. But the other problem is that the lens aperture — the window in the lens — isn't very big on most point-and-shoots. So the window has to stay open longer to gather light from the subject, making it hard to stop the action cold.

Here's where a digital point-and-shoot differs from its film counterparts. It may well open and close the little window in its lens so that light can pass through to the image sensor, but it doesn't do so with particular precision. Instead, it controls the exact interval of time that light from the lens is recorded by the image sensor *simply by turning the sensor on and off.* Technically, the approach is electronic rather than mechanical. But in terms of freezing action, the effect is the same as with a 35mm or APS point-and-shoot.

Digital point-and-shoots actually have an advantage over 35mm and APS models in their ability to freeze action. This is because manufacturers can make the window in the lens bigger, relative to the image sensor, than they can the windows in 35mm or APS models' lenses (again, relative to the film). And they can *keep* it bigger when you zoom the lens in. Because a bigger window lets in more light, the length of time the light must strike the image sensor can be shorter than with film. If that time is shorter, the camera can do a better job of freezing action.

Whatever kind of camera you're using, though, you can often overcome its sluggishness with special action-oriented techniques. Some techniques require a bit of practice. So get ready to take lots of pictures!

If you want to practice shooting the same action over and over again, and are using a digital point-and-shoot, fire at will: It will only cost you battery power. But if you want to practice with a film-using camera, you can save a considerable amount of money on processing by getting the film developed (made into negatives) but not printed. Tell your photofinisher that you don't want prints, just an index print. (An index print comes automatically with an APS order). Later, you can look at the index print, or the negatives themselves, and get the best takes printed. With 35mm, an index print costs a couple more dollars, if your photofinisher offers this service. (See Chapter 3 for more on index prints.)

Anticipating Action: The Art of Prefocusing

To be a good action shooter, you have to keep your point-and-shoot from dawdling when you press the shutter button. The only way to do so reliably is by mastering a technique that may sound weird at first: Set up a photograph completely and be ready to shoot *without* your subject in the frame. Yes, you read that right. And now for the details.

For good action shots, *prefocus* your subject — that is, make the camera focus *before* the subject enters the picture. You could call this technique *surrogate focusing* because you prefocus on something that's at about the same distance, and in about the same light, as your action subject.

Prefocusing is basically the same thing as locking your focus. (See Chapter 6 for more on this.) The difference is that you lock the focus a little ahead of time — before your subject has entered the viewfinder frame or viewing screen. Here's how to prefocus your action subject:

1. **Choose a stationary object that your moving subject will pass by at a close distance.**

 Some possibilities: a tree, a fence, third base, the goalpost, a parked car, even a friend or bystander.

2. **Lock the focus on the object.**

 Center the viewfinder's or viewing screen's focus point on the object and press the shutter button halfway down to lock your focus.

3. **While holding the shutter button halfway down, re-aim the camera to establish your desired composition.**

 Compose so that your action subject — skateboarder, runner, and so on — will be entirely within the frame when you shoot.

4. **Hold that focus until your subject enters the frame.**

5. **Push the shutter button all the way down to take the picture.**

Prefocusing is a crucial skill in action photography, and every action technique I describe in this chapter requires it. So I can't overstate the importance of prefocusing. But if you haven't fully mastered the basic procedure needed to lock your point-and-shoot's focus, you might have a little trouble with this technique. Now's the time to practice until you have it down pat. For action prefocusing, you should be able to lock the focus and hold it for a good bit of time, maybe as long as 30 seconds. Practice until you have a shooting finger of steel — and, if you're shooting film, with an unloaded camera!

Those of you with *focus-free cameras* — that is, models with no autofocus capability — don't need to prefocus. But focus-free cameras usually have some firing delay, for other reasons. So most techniques I describe in this chapter apply to these models as well.

You may ask yourself: If I prefocus on some other object, won't my main subject be a little out of focus? Possibly. But if it is, that's a very worthwhile tradeoff. Capturing the action at just the right moment is far more important to the success of an action photo than getting a flawlessly focused picture. If you choose your prefocusing spot carefully, the little difference in focusing distances won't seriously mar your picture. And even in *stop-action* point-and-shoot pictures, you're likely to get a little image blur anyway — though I tell you how to minimize that later in this chapter in "Tips for Better Action-Freezing."

How prefocusing speeds up your camera

Chapter 4 explains that pressing the shutter button halfway down gives your camera a rather complex set of electronic instructions. Under the best conditions, these instructions take maybe half a second to get your camera into what you might call "standby" status. (If the flash needs to recharge, or you're using a digital point-and-shoot, this time can stretch out to four or five seconds or more. If the camera can't focus correctly, it won't fire at all.)

A half-second delay doesn't make much difference when photographing your toddler's early steps. He's not going anywhere very fast, so you can lock the focus and snap away pretty comfortably. When the toddler graduates to a tricycle, it's still no problem — you usually have enough time to lock focus as the child wheels by at all of two miles per hour. But when that former toddler gets a two-wheeler, you'll have to set up to take an action shot. Otherwise, you'll

end up pressing the shutter button frantically as he comes speeding by, only to get . . . a fine picture of shrubbery.

As action speeds up, that little prefocusing delay becomes impossibly long. I'm not talking 200mph race cars here. Even people walking at a brisk pace can beat the time delay of a typical point-and-shoot.

So here's the way to snap your budding cyclist: Find a spot along his path that he'll pass close to. For example, if he's pedaling along a dirt trail that goes right in front of your backyard fence, then set up to take a picture *exactly* as you would if he stood in front of the fence. Adjust your framing (with your feet or zoom lens) and then lock the focus *on the fence* (again, by pressing the shutter button halfway) and hold it there. When your bicyclist rides into the frame, press the shutter button all the way down.

Your actual subject doesn't have to be out of the frame while you prefocus, by the way. Think of a fast-moving gymnast working on a balance beam or pommel horse. If you try to focus on the gymnast, the camera may get fooled — focusing right past the athlete on the opposite wall, for example. Even if the camera focuses properly on the gymnast, you may miss some good action because of the extra time the camera needs to get ready and set. But prefocusing on the balance beam or the pommel horse is a simple matter. Then just hold that focus by keeping the shutter button halfway down, and wait for an interesting move.

Don't get the action shakes! You may be so intent on hitting the shutter button fast that you jerk the camera when you take the picture. This can lead to even more blur in your pictures than a fast-moving athlete creates. Get a firm grip on your camera, tuck your elbows in tight against your body — and now *relax*. Concentrate on *squeezing* the shutter button — clench your fist as you fire the camera — rather than *pushing down* on the shutter button. And make sure that your finger never leaves the shutter button, before, during, or after the shot.

Different Strokes: Frozen or Blurred Action?

A camera gives you two main ways to convey a sense of action in a still photo-graph. One is by *freezing* the action — that is, taking a picture within such a short time interval that the subject seems to stop cold. (Indeed, such photos are sometimes called *stop-action* shots.) The other way to convey a sense of action is by capturing the subject's movement across space — in plain terms, *blurring* its motion. These two methods, freezing and blurring, can even be combined in a *single* picture to create what is often the most effective photo-graphic rendition of action of all. I tell you how to do that in "Moving target: How to capture action with panning" and "It's the motion: Showing action with blur" later in this chapter.

Freezing and blurring are really just variations on each other. You can think of the stop-action shot as a thin slice of time: the tennis racquet frozen in midswing with the ball suspended in midair. Blurring, on the other hand, is a thicker slice of time: the tennis racquet and player's arm forming a wide, blurry arc across the picture frame, with the streak of the tennis ball ahead of it.

Freezing action with a fast shutter speed

To freeze action effectively, you need to take as thin a slice of time as possi-ble. One way to do this is with a fast shutter speed. (See Chapter 2.)

The other method of stopping action is to use electronic flash, which illumi-nates your subject with an extremely short burst of light. Though you can sometimes use flash outdoors for action, the best way to stop action in bright light is with a fast shutter speed.

Different point-and-shoots have different top shutter speeds — that is, the shortest (or, more correctly, the *highest*) shutter speed they can set. Some models can set only wimpy top speeds of $\frac{1}{250}$ second or even $\frac{1}{200}$ second. Others can go as high as $\frac{1}{700}$ or $\frac{1}{1000}$ second. Most current 35mm and APS point-and-shoot cameras above the $100 mark have a top shutter speed of about $\frac{1}{500}$ second — not too shabby. This speed is usually high enough to freeze a runner, making his arms and legs motionless in midstride. If the camera can only go as high as $\frac{1}{250}$ second, the runner's arms and legs may show signs of blur.

Digital point-and-shoots can claim an advantage here. Even inexpensive two-megapixel models usually have shutter speeds up to $\frac{1}{1000}$ second, and midrange models may go as high as $\frac{1}{2000}$ second. As I explain earlier in this chapter, that makes them better able to freeze fast action, depending on the circumstances.

Manuals ordinarily list a camera's highest possible shutter speed in their specifications section. If you have a camera with a shutter speed no higher than ½₅₀ second, you can still use all the techniques I describe in this chapter. Just keep in mind that you may not get *fully frozen* stop-action shots — you may have a bit more blur in them.

You've probably noticed, though, that you can't set the shutter speed on your point-and-shoot. *The camera sets the shutter speed for you.* After all, you bought a point-and-shoot camera so that you wouldn't have to worry about stuff like that, right? So, when you want to shoot action subjects, how do you make sure your camera sets as high a shutter speed as it can? If you're using a 35mm or APS point-and-shoot, by following the same advice I give throughout this book: Use fast film.

Fast action requires fast film! If you want to stop action, use as fast a film as possible in your camera (see Figure 12-2). Even outdoors, use ISO 800 film. In lower light, or for indoor action, you may want to go with an ISO 1600 color print film, or even an ISO 3200 color print film, though the latter is tough to find. Not sure that your camera accepts fast film? Take another look at your camera manual's specifications page to find out. If you don't have a manual, open up the back of your unloaded camera and look in the chamber where the film cassette goes. Do you see four metallic contacts in a row? Then your camera most likely can use films up to ISO 3200 in speed. Only two or three contacts? Then your camera is limited to ISO 400 or 800 films. (For more information on film speeds, see Chapter 2.)

Because fast film needs less light than slow film to make a good picture, using it means the window in the lens need not stay open for as long a time. In other words, your camera sets a higher shutter speed, provided the light is reasonably bright to begin with. And this higher shutter speed freezes the subject better.

I can hear you digital photographers saying, "What about me? I can't switch film." You're right, but to some extent your camera does the "switching" for you. It doesn't really switch film, of course, because it doesn't shoot film. But it can actually *change* the image sensor's sensitivity to light — a sensitivity that's described in ISO numbers, just as with film. In fact, the *default* (remember that term from Chapter 4?) ISO setting on digital point-and-shoots is *auto*, meaning that the camera automatically adjusts the sensitivity of the image sensor to suit the lighting conditions, firing the flash if the light is too low just like a film camera. But if you have a fairly advanced digital point-and-shoot, you can actually go into the camera's shooting menu and change the ISO setting from auto to a specific, fixed ISO.

If your digital point-and-shoot adjusts its ISO setting automatically, why would you want to go and override it? Because the camera doesn't know what kind of subject you're shooting. Yes, if the light is dim it may set a higher ISO to capture more of it, but it might just as easily set a slower shutter speed, or

fire the flash. It can't know that your subject is moving — and that a higher ISO setting would be helpful in freezing that motion. By selecting a higher ISO, you trick the camera into setting a higher shutter speed.

Just press the menu button, go to the shooting menu, scroll to the ISO setting, select it, and adjust the ISO as high as it will go. Most cameras only go up to ISO 400, but even this will help — more than you think, given that zooming digital point-and-shoot models don't have to shrink their aperture windows at long focal lengths as much as do film models. (For more about these adjustments, see Chapter 15.)

Figure 12-2: The faster the film you use, the better your point-and-shoot will be able to freeze action. With ISO 100 film, this sliding boy is a total blur; only with ISO 800 film is he totally sharp. The moral: Use ISO 800 film (at least) whenever you shoot fast-moving subjects.

ISO 100 film

ISO 200 film

ISO 400 film

ISO 800 film

© Russell Hart (4)

Using a fast film — or a higher ISO setting, if your digital point-and-shoot allows it — is even more crucial with action subjects if you like to zoom in with your lens to make the subject bigger in the frame. Why? Because as you zoom in more, the little window in the lens (the lens aperture) gets even smaller. And the smaller the window, the longer it must stay open to get the correct amount of light to the film — that is, the slower the shutter speed must be. (Remember, a digital point-and-shoot controls its shutter speed by turning the image sensor on and off for longer or shorter intervals.) The slower the shutter speed, the less well the camera can freeze movement. So if you like to zoom in close to the action, use at least an ISO 800 film for action subjects — even outdoors in bright light.

Stash the flash! In some bright-light situations, your point-and-shoot camera may automatically fire its flash — even if you've got fast film loaded. The reason? Quite a few models have light meters that are sensitive to backlight or to other kinds of lighting that create prominent shadows in the subject. (See Chapter 9 for more on backlight.) If these light meters detect backlight, they tell the camera to fire the flash to compensate. And as mentioned, this can slow down your shooting, the last thing you want with an action subject. To avoid the problem, just set the flash-off mode.

Once you load up with fast film and get used to the prefocus technique (see the section "Anticipating Action: The Art of Prefocusing," earlier in this chapter), you're ready for all kinds of daylight action:

- **The Little Leaguer charging first base:** From a position off the first-base side of the field, prefocus on the base or the ground around it, and the instant the little slugger runs into the frame, fire.

- **Your daughter on the backyard swing:** Prefocus on the part of the swing frame closest to her. When she reaches the apex of her swing — its slowest and most easily frozen point — shoot!

- **The swimming pool belly flop:** Prefocus on the deck at the edge of the pool (or the diver herself, if she stops to look before she leaps). When she takes the plunge, fire.

Improving your photographic reflexes

If you've already taken pictures of fast action like base running or diving, though, you may have noticed a pattern. Your little slugger is already past the bag. Or the belly flop is just a splash — because the diver's already underwater. Even if you prefocus the shot, you *still* have a short delay between when you press the shutter button and when the shutter actually opens for the shot. And that delay can combine with your delay in reacting to the subject's action to make you miss the slice of time you meant to cut.

A slight time delay when taking pictures of your toddler toddling across the backyard probably amounts to half a baby step — not so critical. But with a

speeding two-wheeler, it's another story. Say that you prefocused on your backyard fence in anticipation of your cyclist's arrival; if you wait to push the shutter button until the bike is *centered* in the frame, it may be partially *out* of the frame by the time the shutter actually clicks.

So the trick is not only to anticipate the moment when your subject will reach the correct position, but to fire *slightly in advance* of it. To get that two-wheeler in the right position, for example, you may have to press the shutter button when it's just halfway into the viewfinder frame or viewing screen. You might try keeping both eyes open as you're looking through your camera — don't squint your other eye closed — so that you can see your action subject approaching out of the corner of your nonshooting eye. You can also prefocus, hold the shutter button halfway down, and look *over* the camera to see when your action subject is approaching. (This is actually easier when you're shooting with a digital camera's viewing screen.) Then, at the last second, look back through the viewfinder or at the viewing screen to snap the picture.

Different cameras have different time delays, so you need to listen for the click of the shutter firing. When you hear the whirr of the motor advancing the film to the next frame, you know the shot is over; it's harder to tell with a digital point-and-shoot, though if yours can fake a shutter sound, be sure to turn on that capability in the menu. After a while, you get to know the delay of your camera pretty well and know instinctively how much in advance you have to press the button. Remember that your response should speed up with the speed of your subject. You don't need to fire as much in advance for a tentative tricyclist as for that speeding two-wheeler. It takes practice — and you can't really gauge your success with an unloaded camera. You need the feedback of processed negatives or prints. Digital photographers have an advantage here, because practicing is free!

Tips for Better Action-Freezing

If you use an ISO 800 film for your action shots (or are able to increase your digital point-and-shoot to a setting of at least ISO 400) yet get blur even in bright light, you can probably assume that your point-and-shoot just can't set a shutter speed high enough to freeze really fast action. So here are a few special techniques that should help you get the sharpest possible shot — techniques used even by professional sports photographers with their super-high shutter speeds.

> ✔ **Catch the peak of the action:** When a basketball player jumps up for a rebound, she's moving pretty fast. And when she comes down with the ball, she's moving pretty fast, too. But when she reaches the highest point of her jump, there is a brief moment when she moves neither up nor down — when she's nearly suspended in space. In fact, when films were less sensitive to light and arena lights were less bright, sports

photographers waited for such moments because they knew they could get away with the pretty slow shutter speed that they had to use.

For indoor basketball shots, flash is usually a better approach to freezing the action. (I cover flash techniques in the section "Freeze frame: Stopping action with flash.") But if you can't use flash, or you want to shoot only by the existing light, you can get pretty good stop action by timing the shot for the top of the jump. (Just be sure to prefocus on the basket.) See the section "Anticipating Action: The Art of Prefocusing," earlier in this chapter, for more on prefocusing.

What's more, the peak of any action is often the best moment photographically (see Figure 12-3). The moment a high jumper goes over the bar is also the slowest he moves at any point from run-up to landing. (Prefocus on the high-jump bar.) The high point of a springboard diver's trajectory is also the slowest. (Prefocus on the diving board.)

✔ **Shoot action as head-on as possible:** The angle at which an action subject is moving relative to your camera position has a big effect on how blurred it appears in your picture. If you photograph something moving at a right angle to your line of fire, the chance of blur is greatest: Think of how quickly a toddler on a two-wheeler passes from one side of the viewfinder frame to the other. But if you photograph the cyclist coming at you from an angle, her position changes less quickly and the chance of blur is reduced. If you photograph the cyclist coming at you head-on, her position stays more or less the same — she gets bigger in the frame, of course, so mind your distance — and the chance of blur is far less.

Figure 12-3:
If you time your shot so that the action is at its peak — in this case, at a leap's high point, before the subject begins to descend — you have a better shot at freezing it. Prefocus so that the camera won't delay.

© Janalee Stock/courtesy Kodak/KINSA

Shooting head-on is clearly not the ticket for speeding trains, but it has many safe applications — shooting a little one coming down a playground slide, for example. If you take the picture as he comes down straight at you, you're likely to see less blur than if you take the shot from the side (see Figure 12-4). And you just might get a livelier picture!

✔ **Shoot action from a distance:** When you stand beside a road, cars seem to whiz by faster than you can turn your head. But when you look at cars as they approach from a distance, you can follow them more easily. The farther away an action subject is, the less quickly its position changes as it moves. Now, I'm not suggesting that you photograph a track meet from a quarter mile away. But you might keep in mind that photographing runners on the far turn gives you better stop action than if you photograph them right from the edge of the track as they run by you.

Figure 12-4:
To reduce the chance of blur with a fast-passing subject (left), shoot it from an angle (center) or even head-on (right).

© Mark Harris (3)

✔ **Pan the action:** *Panning* is an action-shooting technique that requires violating one of the sacred rules of still photography: holding your camera steady. Instead, you move your camera along with the subject, actually taking the picture as you do (see Figure 12-5). The idea is to keep the subject in about the same place in the frame, instead of allowing it to move across the frame. If the subject doesn't move across the frame when you take the picture — that is, quickly changing its position — the chance of blur is less.

Moving target: How to capture action with panning

To envision how panning works, think of riding on a merry-go-round. If you look off to the side and keep your eyes dead ahead, everything goes by in a

blur. But if you turn your head rapidly, you can fix on a person or thing and keep it sharp as you speed by. Panning is simply following a moving subject in much the same way, with your camera rather than your eyes.

One visually interesting side-effect of panning is that you often get a little selective blur in the picture, and this can strongly evoke movement. A runner's torso may freeze, for example, but his faster-moving arms and legs may be blurred, suggesting his fast pace. A bicyclist might be quite sharp, but her faster moving spokes, pedals, and feet blur, suggesting speed. And, finally, panning also blurs the background. Background blur creates a dynamic feeling in an action shot, as if you're pedaling right beside that bicyclist. Blur also softens distracting backgrounds, placing more emphasis on the action subject itself.

Here's how you get a panned shot of a moving subject:

1. **Prefocus on an object that your subject will pass in front of and continue to hold down the shutter button halfway.**

 For more on prefocusing, see the section "Anticipating Action: The Art of Prefocusing," earlier in this chapter.

2. **As your subject approaches, instead of keeping your camera pointed at the original object and waiting for him to pass by, point the camera at him.**

Figure 12-5: Successful panning — moving the camera as you take the picture to keep an action subject in the same place in the frame — keeps the subject acceptably sharp, but causes interesting streaks in the background.

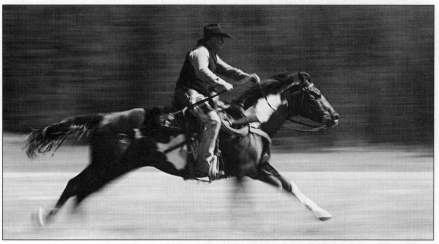

© Rick Sammon

Now swing your camera to keep the viewfinder glued to him as he moves along, trying hard to keep him in the same part of the frame.

3. **When your subject is right in front of the object you prefocused in Step 1, press the shutter button as you continue to pan.**

Keep following your subject with the camera even after you take the picture, because this gives you a smooth panning action (sort of like following through on a golf swing).

Expect to blow a few pictures at first. Practice by panning your camera without film. (Again, digital point-and-shooters can practice with real pictures, free.) Find a busy road and pan cars as they go by. Don't press the shutter button at first; concentrate on smoothness. Then work on prefocusing and firing the shutter.

One more thing. When you really get the hang of following a moving subject smoothly, you discover that you can actually focus on it *while* you're panning, provided it stays about the same distance away and you keep it in the center of the frame. (Centering the subject keeps the focus point on it, where it needs to be for such on-the-fly autofocus.) So you don't necessarily *have* to prefocus on something else at the same distance. Just follow through with one smooth button press, locking the focus and taking the picture all at once.

Freeze frame: Stopping action with flash

Your point-and-shoot camera has a not-so-secret weapon for taking stop-action photos: its built-in electronic flash. Using flash should be your technique of choice for action shots indoors, as well as outdoors in low light or at modest distances.

Electronic flash freezes action very effectively because it is, oddly enough, a slice of time within a slice of time. When you take an ordinary flash shot with your camera set to autoflash — the default setting — the shutter opens up (or the image sensor is turned on) for a brief period that is usually too short to expose the film properly by the existing light. But within that brief time the shutter opens, the flash fires. Electronic flash is basically a very bright spark with a very short duration — $\frac{1}{1000}$ of a second or $\frac{1}{2000}$ of a second on most point-and-shoot cameras. Because the flash lights your subject only for that short spark, it nicely freezes your subject in the picture.

However, you have to worry about three things when using flash for action shots: Distance, distance, and distance. If you're too far away from the subject for your flash to light it properly, you get a weak, muddy picture (see Chapters 3 and 7). And a picture in which you can barely make out your subject doesn't make for much of an action shot. So always use at least ISO 400 speed film, and preferably ISO 800, for indoor flash action. And if you're using a digital point-and-shoot that lets you adjust its ISO, go into the menu and set it as high as it will go, usually ISO 400.

Panning with a one-time-use camera

Those ubiquitous one-time-use point-and-shoots are, as you might have guessed, really not the best kind of camera for action photography. They have only one shutter speed, in fact, and it's a fairly slow one — not what you need for freezing a subject. But that's exactly why you should try panning action with them instead!

Any moderately fast-moving subject in daylight — kids running, for example — works well. Just follow the panning techniques I describe in this section and get in pretty tight on your subject. (You won't need to prefocus, of course, because one-time-use cameras have fixed-focus lenses.)

Also, move in as close as possible to the action, which makes your pictures better anyway. And zoom out to wider-angle focal lengths, which happen to make your lens's window bigger so that it admits more light and gives your flash range a boost.

Other than that, using flash to stop action involves pretty much the same techniques as shooting stop-action pictures in existing light, as described in "Anticipating Action: The Art of Prefocusing," earlier in this chapter. Prefocusing is particularly important with flash action shots. For one thing, pressing the shutter button halfway keeps the flash charged up. For another, your autofocus camera has to know the distance to the subject to determine the proper flash exposure.

Flash action shots suck batteries! You may have a frustrating time trying to take a series of flash shots with weak batteries, because your camera will take a long time to recycle the flash between shots — preventing you from taking the picture until it does. This delay gets longer the more you shoot. So start out with fresh or freshly-charged batteries and bring spares.

Indoor basketball is a good opportunity for flash action. Suppose you want to get a picture of a layup shot or a rebound. You should position yourself off the sideline in such a way that you have a reasonably clear shot of the basket, within the flash range of your camera. As the player moves the ball toward the basket, prefocus on the rim of the basket or the bottom of the backboard. As long as you can hold focus steadily, you can look away from your viewfinder to monitor the action of the game. And be prepared to fire a little ahead of the action. Just remember that you won't be able to shoot at the same pace you do outdoors, because the flash has to recharge. Recharging takes at least three or four seconds between shots.

Don't be a flashing nuisance! School and local league indoor athletics provide good opportunities for action photography, but officials may restrict flash shooting close to the sidelines. Check with the leagues to see whether you need permission. (They might even authorize you to stand in a good shooting spot, if you ask.)

Autoflash is the best flash mode for indoor action shooting. It keeps the shutter open a fairly short time, with the flash providing most or all of the light for the picture. But you might find, if you loaded up with very fast film and are shooting in a well-lit area, that your camera suppresses the flash. In this case, you have to change the camera from autoflash to fill-flash mode.

It's the motion: Showing action with blur

Freezing action is fun, but blur isn't necessarily a bad thing in action shots. A trace of blur in the subject often says *action!* more than a completely frozen effect. And, depending on your point-and-shoot model, you may get some degree of blur whenever you shoot an action subject, even with an ISO 800 film.

If you want even more blur, moving the camera is one easy way to get it — and it doesn't have to be panning movement. You can move your camera against the direction of the action, or at angles to it. You can even jiggle the camera or move it up and down. In other words, *you* can add the blur. If you do it right, the blur will look as if it's somehow the consequence of the subject's movement, not what you did with the camera. Regardless, you get interesting streaky, smeary effects — instant abstraction.

Another simple way to up the amount of blur is switching to a slower film, though this option is a bit of heresy in this book. A slower film makes the camera set a slower shutter speed. If you get good stop-action shots with ISO 400 film, for example, try shooting with an ISO 200 film. Want still more blur? Try an ISO 100 film. With a digital point-and-shoot, try setting a lower ISO, if possible. And while you're at it, try panning with these slower films or ISO settings.

You can also increase your blur potential *without* switching film, simply by shooting in different light. If you get sharp stop-action shots in midday light, shoot in late afternoon or on an overcast day. Shooting in less bright light usually causes the camera to set a lower shutter speed and ups the chance of blur.

Double strength: Combining stop action and blur

Can a picture be sharp and blurry at the same time? Actually, yes. And the effect is often more powerfully suggestive of action than either stop-action or blur effects. Better still, most point-and-shoot cameras make it pretty easy to accomplish.

Remember that your camera gives you two basic ways of making an exposure — that is, getting light from the subject to the film. One is to shoot in daylight, or good indoor light, without flash. In this case, you make the picture

In the mode for action

Many point-and-shoots have specialized modes that make action shooting a little easier — though they're no guarantee of good results. I describe these modes in some detail in Chapter 4. But here's a specific look at how you can use these modes for action shooting.

✔ **Sports or action mode:** On most point-and-shoot models, this mode simply turns off the flash and sets the motor to continuous film advance mode. Basically, it lets you fire off shots for as long as you hold down the shutter button. But you should know by now when to turn off — or turn on — your flash. And with a well-trained index finger, you can take pictures as fast as in the continuous film-advance mode.

A few point-and-shoots employ *continuous autofocusing* when set to action mode. They automatically adjust the focus to follow a moving subject right up to the moment they take the picture, rather than locking the focus at one distance. This feature can help especially in sports with unpredictable action, such as soccer.

✔ **Multiple exposure (or multiexposure):** This mode prevents the film from automatically advancing to the next frame, so that you can layer several pictures on the same piece of film. It gives you interesting results indoors if you shoot events like gymnastics floor exercises in autoflash mode. Set the camera to multiple exposure and take a shot with the gymnast on one side of the picture frame. Now take another shot with the gymnast on the other side of the frame. (Try not to move the camera between shots.) The result shows the two moments in the same print.

✔ **Snap mode:** Snap mode is a fast-firing mode that simply turns off the camera's auto-focus, prefocusing the lens at snapshot range — usually six feet or so. You can use this mode for shots of rambunctious kids because you don't have to prefocus at all, but it may limit your ability to set other modes at the same time.

by the existing light. The other way of making an exposure is to add light — to shoot by flash.

Suppose that you're shooting action pictures in existing light that's okay but not great. You're likely to get at least a little blur. Now suppose that you decide to use flash. The flash's spark freezes the action at that split second, of course. But the film or image sensor also takes in some of the existing light, recording it as a streaky blur. Voilà — a picture in which one moment of the action is frozen, in the midst of a blur. You can think of it as two pictures taken simultaneously on one piece of film.

When you use flash and get a sharp moving subject with blurry streaks around it, the effect is called *flash ghosting*. I like the effect of flash ghosting — call it blurred sharpness. Flash ghosting adds to the sense of action and can also improve a shot by filling in dark shadows.

Here's how to get flash ghosting in action shots. (For more on specific flash techniques, see Chapter 7.)

✔ **Ghosting with fill flash (flash-on):** Switching your camera to its fill-flash mode (rather than autoflash or flash-off modes) when taking stop-action shots in bright light almost always adds at least a slight ghost. Try the fill-flash mode with runners, or cyclists, or just the kids scooting around the backyard (see Figure 12-6). In fact, try these shots with and without fill flash and compare the results. Remember that you must be close enough to your subject to be within the range of your flash; otherwise, the flash has no effect in the picture.

The slower the film, or the lower the light, the more flash ghosting you see. The camera lowers the shutter speed in these cases to get enough light to the film, making the blurred stuff blurrier still. And if you have a digital point-and-shoot that allows you to adjust its ISO, you can lower it as described earlier in this chapter to make the camera set slower, more ghost-inducing shutter speeds.

✔ **Ghosting with slow-sync flash (night flash):** This mode, which allows the shutter to stay open for a longer time than with fill-flash mode, produces an effect similar to that of fill flash, but with more pronounced blur. Again, the blur is more exaggerated with lower light or slower film; after a certain point, the blurry part of the picture looks more like an abstract painting than a photo. Indoors, you can get heavy-duty art effects with moving subjects, such as people dancing.

Figure 12-6:
Fill flash froze this runner in his tracks, but the film also recorded existing daylight — creating both a blurry fringe around the figure and a sharp background.

© Russell Hart

✔ **Panning with flash:** You can add flash to any panning picture as long as your subject is within flash range. Just follow the subject with your camera. (See the section "Moving target: How to capture action with panning," earlier in this chapter.) With fill flash, panning may actually slightly lessen the blur if you do it right. And if you're good at it, you can use panning with your camera's slow-sync (night flash) mode, for very cool effects with subjects like cyclists and rollerbladers.

Beyond Sports: Be a Clutch Photographer

While your local sandlot softball league or high school track team can provide you with great action photo ops, I hope I haven't given you the impression that action subjects need be limited to sports. The world around you is full of action ready for the shooting. A trip to your local zoo, for example, might net you a leaping monkey or a diving polar bear. Going to a wedding? Take your pocket point-and-shoot with you onto the dance floor, set it to slow-sync flash, and snap away; you'll get some wild and crazy shots, guaranteed. And speaking of formal events, don't forget graduation action shots. No kidding! Almost every graduation has some kind of post-ceremony horseplay, and you can always snap the graduate leaping in the air. Oh, and be sure to bring your weatherproof point-and-shoot along when you take the kids sledding.

Finally, remember that some of the best action pictures are of the human drama after an event: an exhausted marathoner pouring water over his head, Little Leaguers mobbing the pitcher after the game-winning strikeout (see Figure 12-7). So don't put your camera down after the action has officially stopped.

Figure 12-7:
Sports events are full of great moments that aren't about action itself. Here, a racetrack jockey excuses his poor performance to his horse's disgusted owners.

© Henry Horenstein

Wet and wild: A splash of action

Action photography can sometimes get you pretty wet. Whether you're shooting from a white-water raft or just snapping the kids running through the sprinkler, your camera may get wet, too. The problem is that water and most point-and-shoots don't mix. Camera electronics in particular can get zapped by moisture, and the all-electronic nature of digital point-and-shoots makes these models even more vulnerable. If water sports, boating, and singin' in the rain are your ideas of a good time, consider buying a weatherproof camera, or even a true waterproof camera.

✔ *Weatherproof* (also known as *splashproof*) means the camera has moisture seals that enable it to get wet, but not submerged. You can use a weatherproof camera in the rain (though not a torrential downpour) and in situations in which you might get splashed — poolside or aboard a cruising boat. A good number of current point-and-shoot models (more 35mm and APS models than digital models) are weatherproof, usually designated with a "drops" sticker on the camera body.

✔ *Waterproof* (also known as *underwater*) means you can fully submerge the camera, usually to at least 10 or 15 feet, and sometimes to serious scuba-diving depths. Take these models kayaking and white-water rafting, use them in sloppy rain or snow, and shoot at the pool — or should I say, *in* it. (Try the bathtub, too!) Only a few true underwater point-and-shoots are available, but you can also get special waterproof camera "baggies" designed for underwater operation of nonwaterproof point-and-shoots. Underwater housings are available for an increasing number of digital point-and-shoots, but be warned: They can cost half the price of the camera itself!

And you can always shoot with one-time-use models. A standard one-time-use camera can take a modest splashing; you only use the camera for one roll of film, after all. "Sports" models are even more water-resistant. And underwater models can go to depths of 10 or 15 feet, sometimes more. These models are a good choice when your wet-and-wild shooting is only occasional.

Chapter 13

Scene Stealing: Making Effective Landscape Photos

*I*n *my* photographic vocabulary, a *landscape* isn't just a picture of land — of scenery at a distance. It's any image that seems to invite the viewer into an environment. That environment may be full of buildings rather than mountains (a cityscape), or it may be mainly water rather than earth (a seascape). It may even have people in it. (Human figures can do wonders for photographic landscapes, contributing a valuable sense of scale.) But in landscape photography, the place, not its occupants, is the most important thing about the picture.

I have a special fondness for landscape as a photographic genre, because it is, in some ways, a pure visual challenge. You need practice and even skill to get a good portrait, of course, but the picture's success often depends on a subject's willingness to participate in the photographic process. A landscape's success is almost entirely up to you, the photographer: to the way you "frame" the scene, to the physical position you choose, to your sensitivity to light — and even to your patience.

Which isn't to say that a landscape photo's success doesn't depend on the landscape itself. Naturally, a spectacular scene is a great starting point — but the spectacle doesn't guarantee a great picture. And you can make a seemingly ordinary landscape look special simply with your photographic skills and eye. So this chapter offers suggestions not only about how to capitalize, photographically, on gorgeous scenery, but also how to find and shoot interesting landscapes in the familiar world around you.

A landscape photograph is often called a *scenic*. But I think scenic is a less interesting word than landscape; it suggests a picture that is just superficially pleasant. I think a photograph of a scene can be better than this, so I stick with *landscape*.

Finding Landscapes Close to Home

Photographers who live in the middle of the Rocky Mountains or in the wide-open spaces of the Great Plains may seem to have an advantage in creating landscape photographs. And fair enough, landscape-shooting opportunities definitely increase when you travel or go on vacation (see Chapter 14 for more details). But these opportunities are probably a lot closer than you think — maybe even in your own neighborhood.

The key to finding landscapes close to home — whether you live in the city, the suburbs, or the country — is often a simple combination of finding the right vantage point and waiting for the right light. If you live in a tight little neighborhood, finding the right vantage point involves getting a reasonably clear view of, and a little elevation on, the subject. This could mean just shooting from your window. Or it could mean a little scrambling.

Even just a little height on the scene gives it a new, less familiar look. Try parking your car in a good spot for a landscape shot — city or country. Then stand on its hood or roof to take the picture. (Be careful!) Getting that height helps to vertically separate the elements of the scene (especially valuable if you shoot in the confines of a neighborhood or city street). By vertical separation, I mean spreading things out more from the top to the bottom of the picture, so that they don't overlap confusingly in the print.

As for light, if you want to shoot in a city or suburban neighborhood, you should study the way shadows change over the course of a day. Avoid shooting at times when large parts of the scene are cast in shadow. Late daylight is nice for the color it contributes, and it creates interesting long shadows. But late daylight may also elevate the scene's *contrast* — the difference between light and dark parts — which can give your photographs a disjointed appearance. Consider shooting on cloudy days if this seems to be a problem. (See Chapter 9 for more details.)

And then, of course, you have to consider *composition*. The way you frame a landscape subject — which includes not just your vantage point but the focal length you choose — has a powerful effect on how the viewer perceives it. For tips, see the section "Mastering the View: Landscapes and Composition," later in this chapter, as well as Chapter 10.

Taking in the View: The Lens and Landscapes

Photographers tend to have pretty set ideas about how to shoot landscapes. One idea is that you need a wide-angle lens — the better to take in a landscape's big sweep. You don't. While a wide-angle focal length can play an important role in landscape shooting, other techniques, such as sectional panoramas and telephoto perspective, can produce dramatic landscapes. (See Chapter 5 for more on the lens.)

Some landscape subjects — the big spaces of the American West are a classic example — nearly beg for a wide-angle focal length, which takes in more of the scene when you can't get any farther away (or when doing so would risk a tumble off the cliff behind you!). If you have a zoom point-and-shoot, though, its most wide-angle focal length is probably just moderately wide — about the equivalent of 35mm or 38mm on a 35mm point-and-shoot. While this setting works fine for many scenes, it can't do much justice to the Grand Canyon's scale. In fact, if you're trying to photograph an expansive scene you may want to shoot a series of side-by-side views to create a sectional panorama of the scene. (See the sidebar "Lens not wide enough for a big view? Then point and pan.")

If you're shopping for a new point-and-shoot and you have a penchant for landscape photos, buy a 35mm model with a lens that starts zooming at a true wide-angle focal length of 28mm rather than the more typical 38mm. (There are a number of models now available with this capability.) With the Advanced Photo System, the closest thing to true wide-angle would be a compact model that starts zooming at 24mm or 26mm, rather than the more customary 30mm (see Figure 13-1).

As of this writing it's hard to find digital point-and-shoots with true wide-angle capability, but it's probably just a matter of time before they start to appear. In the meantime, depending on your particular model, you may be able to buy a wide-angle adapter lens that mounts directly on the camera's built-in lens, greatly increasing its angle of view. (See Chapter 5 for more on angle of view.)

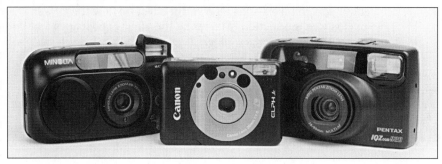

Figure 13-1: For landscapes, buy a 35mm model that zooms from 28mm (left and right) or an APS model of 26mm or shorter (center).

Actually, many single-focal-length (that is, nonzoom) 35mm point-and-shoots offer shorter (that is, wider-angle) focal length settings than 38mm, or in the case of APS models, shorter than 30mm. Even the relatively few digital models that don't zoom tend to have lenses on the short side by filmless standards. Because the shorter focal length lets these models take in a bigger swath of the scene, nonzoom point-and-shoots are often better suited to landscape photographs than zoom models. (See the section "Shooting wide-open spaces — with a long focal length!" later in this chapter.) For example, some 35mm models have 34mm focal length lenses; some have 32mm lenses; some have 30mm lenses. Some even have 28mm lenses, though these tend to be the more expensive "designer" models. In the Advanced Photo System, some single-focal-length models have lenses around 24mm or 26mm, rather than the 30mm at which APS zoom models generally start zooming.

The secret to a wide-angle setting

A wide-angle focal length does something more interesting than just putting more of the scene on film: It lets you move closer to something to make it bigger in the picture, yet still show lots of background. Basically, a wide-angle focal length lets you change the size relationship between foreground and background, making foreground objects seem larger relative to the background. This effect is useful if you like to photograph people in front of landscapes, but it's even more valuable in confined situations. It not only lets you place more importance on certain parts of the scene, but it also creates the sense of a deeper space.

Lens not wide enough for a big view? Then point and pan

If you can't fit a whole landscape into a single picture, take two — or more. Shoot several side-by-side sections of the scene and then piece the prints together to form a panoramic image.

To create this kind of sectional panorama, first decide how many shots you need to take to span the view you want. Then do a dry run, pivoting the camera from one section to the next as you identify visual cues that can help you match up your shots. A bush or tree can mark where one shot ends and the next begins, but avoid placing important features of the landscape at the edges of a frame. In fact, it's a good idea to slightly overlap the edges of each shot so that you don't have gaps in the final panorama. Then you can simply overlap the finished prints.

Once you figure out the sequence, start on the left side and shoot each consecutive frame as planned. Keep the camera level and rotate your body at the hips so that your point of view stays more or less the same from shot to shot. A tripod can add precision to this process, allowing smooth rotation from one section to the next, but if you use one be sure to "level" the head and do a dry run before you start shooting.

This technique gives you a much wider total view than the panorama mode on your camera, if it has one. (A point-and-shoot's panorama mode has a horizontal span no wider than a regular frame; its top and bottom are just cut off!) In fact, if you use a slightly longer focal length setting — say 50mm or 60mm rather than 38mm — the result is more natural looking in its size relationships. You can even shoot a *vertical* for each section (try four or five), for a taller image that includes more sky or foreground. Put enough sections together, and you can create a 180- or 360-degree view!

The effect of this technique isn't seamless, and the slight mismatch where the prints' edges meet can actually make your panorama more interesting. But if you want a seamless effect you can turn to digital technology. Special software programs, often provided with digital cameras, allow you to "stitch" a series of side-by-side sections together. Such stitching programs do such a good job of matching each section's details, then reshaping and smoothing them, that you usually aren't even aware of the line at which two frames meet in the final image. While you can use this software with photographs you've taken on film and scanned to produce picture files, some digital point-and-shoots incorporate built-in, on-camera stitching guidance, helping you compose for more effective panoramas using markings on the viewing screen. (See Chapter 16.)

Setting up "near-far" relationships between the foreground and background of a landscape scene can also reinforce that sense of space. When composing a landscape shot, try to include interesting objects in the fairly near distance — a tree, a rock, an animal. You may want to place these elements to one side of the frame so that they don't detract from the overall scene. (See Chapter 10 for details about this kind of composition.) If you do this, just be sure to lock the focus on a closer part of the scene.

Shooting wide-open spaces — with a long focal length!

You don't absolutely need a wide-angle focal length to shoot an effective landscape. Many professional photographers even favor longer focal lengths — telephoto settings — for landscape shots. Why? Because longer focal lengths let them *stack* (in a visual sense) elements of the scene that are actually at different distances from one another. That is, longer focal lengths help create the illusion that these parts are closer together than they really are. This effect can give a landscape an interestingly flat, graphic quality.

Stacking, also called *compression,* isn't a direct consequence of a longer focal length. It's actually due to the change in perspective you get when you shoot a subject from a greater distance. The longer focal length simply gives you the greater magnifying power (the narrower slice of the scene) needed for this "long distance" shooting. In fact, stacking isn't even an option unless you're pretty far away from the scene to begin with.

If you're shooting in fairly wide-open spaces, you may want to experiment with stacked perspective. Zoom your lens in on a subject as far as it can go — the longer the focal length, the more it enhances the stacking effect — and choose shooting positions from which near and far elements sit side by side. (Be sure to lock the focus on the near element; see Chapter 6 for details.) Keep in mind that you may not see the effect as readily in the viewfinder as in the print, because the print further flattens the subject by reducing it to two dimensions.

When you zoom your point-and-shoot's lens to a longer focal length for a stacked landscape, you increase the risk of blur due to camera shake. (Camera shake is due to the lens's higher magnification; think of looking through shaky binoculars.) Shake is a particular concern in low, late daylight because the camera sets a slower shutter speed, but it can also have an ill effect even in bright conditions. Use a fast (ISO 400 or 800) film to prevent or minimize the problem. (See Chapter 2 for more on film speed and shake.)

Mastering the View: Landscapes and Composition

Choosing a focal length is an important part of composition (see Chapter 10). And composition tends to play a bigger role in landscape photography than in people pictures, perhaps because the subject is inherently more abstract — that is, all about shapes, textures, and their physical interrelationships. For similar reasons, creating a feeling of depth is also more important. Placing

objects in the foreground is one way to create depth. Another is to look for, and exploit, receding lines in the scene (if they're available). A fence, a stone wall, or a row of trees may cross the scene at an angle, for example, from a close distance to a far one. Such tricks also lead the viewer's eye into the scene (see Figure 13-2).

Figure 13-2:
A 28mm focal length helped reinforce the sense of depth created by this sunlit sea wall. To enhance depth, look for receding elements and choose vantage points from which they cut across.

© Russell Hart

The horizon line: high, low, or in-between?

If you use a wide-angle focal length setting for a landscape shot, its bigger view demands more attention to the position of the *horizon line* — the line in the far distance where the earth meets the sky, or the water meets the sky.

To put more emphasis on a scene's land (or sea) area, point your camera down to place the horizon line high in the frame. To put more emphasis on the sky, point your camera up to place the horizon line low in the frame.

Most photographers avoid placing the horizon line in the exact horizontal middle of the picture. Doing this leads to a static feeling in a landscape photograph. But you may find, in some cases, that a centered horizon line is the right choice for a subject. A photograph of a mirror image in water, for example, is often more powerful when the line between the real scene and the reflection bisects the image. Photography's rules, as helpful as they may be, are meant to be broken — and broken often!

Move yourself around for a better view

Just as important as moving the camera around to adjust the horizon line is moving your body — experimenting with different physical positions. This movement can mean squatting for a low point of view, climbing onto a rock for a high point of view, or moving from side to side.

Using your body as a camera-positioning tool helps accomplish a very important purpose: keeping parts of the scene from intersecting one another in confusing ways. A higher vantage point lets you see over and beyond things in the foreground; a small step to the side can separate two overlapping elements. Remember that the scene is reduced to two dimensions in the print, and overlapping items may look more confusing.

Should you shoot a horizontal or vertical?

Most photographers instinctively hold a camera in the horizontal position. This may be because the camera is simpler to operate that way, but also because people's natural field of vision seems to spread sideways rather than up and down. Shooting a landscape reinforces the inclination to make horizontal pictures, because the landscape seems such a horizontal place to begin with. But some of the best landscape photographs are vertical compositions.

Make yourself shoot vertical landscape photographs. Vertical composition can be especially useful if you don't have a very wide-angle focal length on your point-and-shoot. A vertical shot often allows you to set up more interesting relationships between foreground objects and the background.

When to shoot verticals? First, look for vertical elements in the scene (see Figure 13-3). A subject with strong vertical lines often wants to be within a vertical composition (though not necessarily). Vertical composition is also a way to get more foreground or sky into a picture, simply because your camera takes in a bigger swath in the frame's long dimension than in its short. All that said, sometimes a scene with strong *horizontal* lines can make an interesting *vertical* composition — by virtue of the way the edges of the frame abruptly chop off the lines.

Figure 13-3:
Your subject often tells you whether it should be photographed as a horizontal or a vertical. Some good candidates for vertical composition are obvious, such as this pair of giraffes. Other subjects take a moment of thought — and if in doubt, you may want to shoot both vertical and horizontal versions so you can decide which is best later.

© Rick Sammon

Shaping Your Print to the Landscape

With some landscape scenes, the familiar 35mm frame shape and Advanced Photo System "Classic" format just seem to leave too much stuff on the top or the bottom. In such cases, you may want to try a more elongated print format — changing the actual shape of the final print. Digital point-and-shoots have an even squarer "frame" than 35mm and APS models (see Chapter 15), but to change it in the final print you'll have to use imaging software and your computer (see Chapter 16).

Wide-screen photography: The bigger picture

One way to get a different sized print is with the *H print format* offered by Advanced Photo System point-and-shoots. To get an *H* print, you simply set the camera's print-format switch or toggle its print-format button from *C* to *H,* and the viewfinder automatically marks the more elongated frame shape. You compose the shot within this shape, and when you take the picture, the camera automatically records your choice on the film. When the prints are made, the photofinishing machine automatically spits out a 4 x 7-inch print, rather than a 4 x 6-inch print.

When you switch to an *H* print, you don't just get a different shape to work with; you also get a little more of the scene on the right and left of the frame. The extra is helpful when you want more on the sides and less on the top (the opposite of a haircut, unless you're getting a mullet).

Stretching things: The panoramic format

You can also choose the *panoramic format,* which is available on some 35mm point-and-shoots and nearly all Advanced Photo System cameras except for one-time-use models. (A few specialized 35mm models shoot only panoramas.)

A *panorama* is a photographic image that is usually at least twice as long (wide) as it is tall. The stretched-out shape can create a sense of expansiveness in a landscape photograph (see Figure 13-4).

The standard panoramic print size, whether in 35mm or the Advanced Photo System, is 4 x 11½ inches. Some photofinishers print APS panoramas in 4 x 10-inch size. When you set an APS point-and-shoot's print format switch to *P,* or a 35mm camera's panorama switch to *P,* the viewfinder usually automatically shows the new shape for your composition, narrowing the frame at the top and bottom.

As with the *H* format, Advanced Photo System cameras record your choice of the Panoramic format on the film, and the print is made to the correct size automatically. (See Chapter 3 for more on printing panoramas.)

Also keep in mind that with the Advanced Photo System, you can have any shot reprinted in any other format — restoring a panoramic picture to the *H* format, for example. All the information is stored in the film. But 35mm cameras crop the image on the top and bottom inside the camera, so you can't go back once you shoot a picture as a panorama.

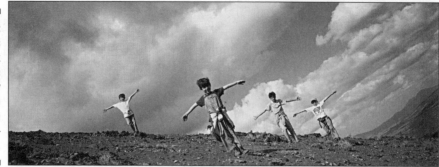

Figure 13-4: Panoramas usually work better if you use a fairly wide-angle focal length setting — here, 28mm.

© Fernando S. Islas/courtesy Kodak/KINSA

If you have an autofocus model, your point-and-shoot may have a landscape mode that you can use in combination with the panorama setting. For tips on using this mode, see Chapter 4.

People Power: Adding a Sense of Scale

Landscapes don't have to be devoid of people. In fact, human figures — friends or passers-by — can add an important sense of scale to your landscape photographs. Usually, the scene's much larger elements dwarf the figures (see Figure 13-5).

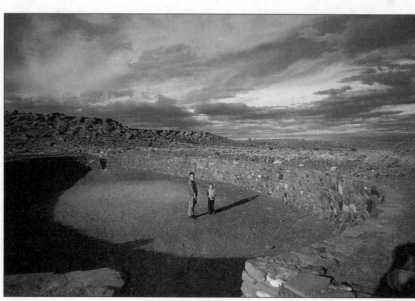

Figure 13-5: Including figures in a landscape photo can add a powerful feeling of scale. Here, figures tell the viewer about the dimensions of a Southwestern Indian ruin.

© Jody Dole

Including a human figure in a scene is also a way of commenting on it, as if to say "look at this spectacle." Sometimes you have to take figures where you find them — visitors to a national park, for example. With friends or family, you can pretty much direct them to stand where you want (if you don't have an uncooperative toddler). Be careful to choose a position that won't detract from the scene (perhaps on the side), and that isn't so close that it puts too much emphasis on the people.

Finding the Right Light

Light is the defining ingredient of landscape photography. Because a landscape's forms are so often reduced to curves, lines, patterns, and textures, you're more aware of what light does to it. Landscape photographers favor both early and late daylight because the sun's low angle describes shapes and textures more dramatically, and its reddish-yellow color adds warmth. In fact, photographers often call this kind of light *sweet light.* For more about the qualities of light, see Chapter 9.

By the same token, landscape photographers usually avoid shooting in the middle of the day. Midday sun creates deep shadows and harsh contrasts that make a landscape hard to "read," in a photographic sense. But there's an unexpected solution to this problem: overcast. Cloudy skies can make for beautiful landscapes. The clouds create delicate tones and softer contrasts. Of course, to reap those benefits you have to wait for the clouds to roll in. But once they do, you can shoot at just about any time of day!

Exploring Seasonal Changes

A landscape's look changes from hour to hour and day to day, mainly due to changes in weather and light. But landscapes are also profoundly altered by the seasons. Such changes are due in part to changes in growth patterns, from spring lushness to winter barrenness. But even the *quality* of light changes from season to season, as the sun's angle and intensity changes. These differences are worth exploring photographically.

Find a landscape close to home. Choose the best camera position and make mental notes about the exact spot. Shoot the scene when the light is right. Then wait.

How long should you wait? A few months. Wait for the season to change the landscape. Then, when the light is good again, return to the same spot — and take another picture. Wait a few more months, then do it again. Each time, try to frame the subject in the same way. You end up with a time-lapse landscape!

Depending on where you live, one of the most visually remarkable seasonal changes comes in winter: snow. Nothing spruces up a landscape like a fresh blanket of snow (see Figure 13-6). It smoothes contours and enhances textures. It simplifies ordinarily complex scenes by canceling out colors and tones.

Figure 13-6:
Snow can turn a familiar landscape into a fantastic one — here, sculpted by the wind. To prevent underexposure, set backlight compensation or exposure compensation, if your camera offers these modes.

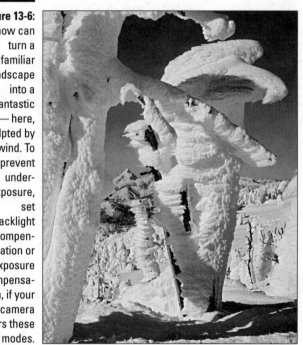

© Pat O'Hara

But snow can also wreak havoc with your point-and-shoot's exposure system. The system sees all that highly reflective white stuff and is fooled into thinking that the landscape is more well-lighted than it actually is. The camera ends up underexposing — turning all the white stuff gray in the picture. (See Chapter 3.)

You can prevent underexposure in several ways:

✔ **If your camera has a backlight compensation mode, set it anytime you shoot a scene with a lot of snow in it.** This mode gets extra exposure to the film (see Chapter 9).

✔ **If your camera has an exposure compensation mode, set it to +1 EV or +1.5 EV.** (See Chapter 4.) This mode also adds exposure.

✔ **If your camera has no provision for backlight or exposure compensation mode, try this.** Point the camera at a dark area at middle distance: the shadow of a thick tree trunk, or a dense evergreen bush, or the shaded side of a house or other structure. Press the shutter button halfway and then recompose to include all the snow you want in the picture. This technique will lock in extra exposure. But make sure that the object that you lock focus on is about the same distance away as the main part of your picture.

Perhaps the best insurance against a gray result when you shoot a snowy landscape is simply to use a fast film — at least ISO 400, or even ISO 800. Even if a point-and-shoot camera tries to cut back on exposure when it sees a lot of snow, these films are so light-sensitive that your point-and-shoot's exposure system "overexposes" the film, compensating for the underexposure that snow's high brightness can cause. (See Chapter 2 for more on film.)

With a digital point-and-shoot, on the other hand, any extra exposure beyond what the camera would ordinarily give the scene can cause the snow to look washed out or lacking in texture. So depending on your model, it may be better *not* to increase the exposure when you're shooting snow. The best advice: Try it both ways and see!

The Urban Scene: Cityscapes are Landscapes

Many, if not most, landscapes have manmade elements — buildings, cultivated fields, fences, domesticated animals. They're *human* landscapes. And in a way, cities and towns offer landscapes in which the human element has simply taken over. (Though nothing is as plaintive, photographically, as organic life poking its way through the steel and cement of a city — the lone tree on the corner of a city neighborhood or the leafy trellis on a city rooftop.)

Postcard views have made people think of cities in terms of skylines. But you can't always find (nor is it convenient to look for) a vantage point that encompasses all the big structures of a city. If you do, you probably need to do two things to get a good picture: Zoom your lens to a longer focal length to fill the frame with the buildings and make them seem a tighter cluster and then wait for warm, low-angle light. It's a bit of a cliché to shoot a skyline by setting sun, but the truth is that midday light reveals a skyline for the boring picture that it usually is. I'd never talk you out of a picture. But take my word for this: The most interesting cityscapes are usually taken *in* the city, not outside it!

Time of day is especially important in shooting cityscapes. Buildings in particular can throw large areas into shadow, making the difference between light and dark areas too extreme for your film and print to hold detail in both. But if you're traveling through a city, you may not have the luxury of studying the light and waiting for its best angles — for example, when the sun shoots lengthwise down a narrow city street, throwing its building facades into *high relief* (the effect by which details seem to stand out boldly in three dimensions). If, on the other hand, you're a regular visitor — or, for that matter, work in the city — keep your eye on lighting patterns and changes. And don't stop shooting on cloudy days. By eliminating or lessening the shadows created by a city's structures, they can actually make cityscapes more visually appealing.

Photographing city scenes with a point-and-shoot can pose a more serious limitation than light itself. You may find that your camera's lens — particularly if its zoom starts at 38mm, as many do — simply doesn't have a wide enough angle of view to show all of a building (or row of buildings) from top to bottom. Vertical composition is an obvious strategy here because it gives you more vertical coverage. (See the section "Should you shoot a horizontal or vertical?" earlier in this chapter.) But a better approach is not to insist on photographing a building from top to bottom.

Effective cityscapes can often show just a portion or fragment of a building, and its relationship to other buildings and the space around it. In fact, the closer quarters of cities invite you to isolate details of buildings and other elements, instead of trying to show the whole scene. You may even find yourself zooming in tight on things more often with city views than traditional landscapes.

Chapter 14

Have Camera, Will Travel

*W*hether a round-the-world voyage or a trip to the nearest state park, travel may be the ultimate photo opportunity. From moonlight on the Nile to the neon shimmer of Times Square, getting away from it all provides both new subject matter for your camera and the visual inspiration often needed to make your pictures better.

Who would think of taking a trip without a camera? Memories are the end product of the travel experience, and I can't imagine a better way to recall exotic destinations and exuberant times than with pictures — not postcards, but beautiful photographs steeped in local color. Think you can't make them? Think again. The single, simple trick to better travel photography is planning.

I don't mean just remembering to throw your point-and-shoot in the suitcase. I mean planning your journey specifically with photography in mind. This process includes looking ahead at the weather you may run into; seeking worthwhile photographic sites; bringing along enough (but not too much) equipment and supplies; and foreseeing photographic emergencies. Because logistics — packing bags, getting there, and so on — play such an important part in travel photography, the first part of this chapter focuses mainly on these practical concerns. Then later in the chapter, in "Scenes from a Voyage: What to Shoot, and How," I offer specific picture-taking tips. For some intriguing places to go, check out Chapter 20.

Planning Your Trip with Pictures in Mind

If you're plotting a vacation, start by choosing your itinerary, travel times, and even your destination with an eye to photography. This planning will pay off in better pictures. I know professional travel photographers who plan every minute of every day on the road — every shot of every roll weeks in advance.

Now that I have you in a cold sweat about this planning business, relax. You can't be so single-minded. You may have ten whole days away (if that), and photography must wait its turn. You'll also want romance, good food, physical fun, culture, fresh air, sun, and, of course, plenty of sleep. And, yes, some good photos. But most travelers aren't prepared to rise at four in the morning to capture an uncluttered street or the perfect sunrise.

Yet while photography may not be at the top of your vacation "to do" list, it shouldn't be near the bottom, either. The people who get the best vacation photographs do, indeed, plan ahead — incorporating picture-taking into many different travel activities (see Figure 14-1). They don't just ski; they ski and take pictures. (And bring the protective gear that they'll need for their cameras.) They don't just hike; they hike and take pictures. (And first pick up a guidebook to the best local trails.) This approach will net you good fun *and* good photos. Ready to start planning your next trip? Okay, start with getting to the right place — at the *right time,* by reading the next section, "Weather, Light, and Sites: Researching Your Destination."

Weather, Light, and Sites: Researching Your Destination

Picking a place to vacation is only the first step toward a great travel — and photography — experience. Now comes the homework part, a modest investment of your time that will pay off with great rewards later. Research the best times to go to your chosen destination. Find out what attractions and activities you want to experience. Here are some ways to get started:

 ✔ **Get acquainted with your destination's climate.** Will your destination be in the thick of monsoon season when you arrive? If so, consider postponing your trip until the weatherman forecasts better photography. If you go anyway, keep your gear properly weatherproofed as outlined in the sidebar, "Staying dry: What to do in rainy or humid destinations." Also remember that when the Northern Hemisphere is bathing in summer warmth, the Southern is shivering through winter. Don't arrive in Buenos Aires in July with only T-shirts and a bathing suit!

Figure 14-1: Whether dress-up (left, a Southern Belle in Charleston, South Carolina) or dress-down (right, the photographer's backpacking companion), travel offers terrific photographic possibilities.

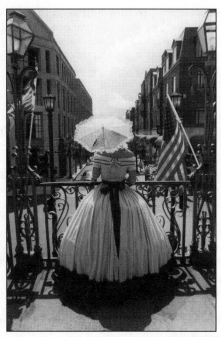

© Peter Kolonia

© James R. Fisher/courtesy Kodak/KINSA

✔ **Find out your destination's sunrise and sunset times during the period you'll be there.** Few things are as exasperating as scheduling a vacation in the Scottish Highlands at a time when the sun shines for all of four hours a day. You'll want plenty of daylight hours for outdoor shooting, remember, and will want to know when to catch the best light. After you've figured out when and where you're going, start collecting as many guide books and other resources as you can. And if you're doing research about your destination on the Web (more on that in a moment), be sure to make print-outs of useful information so you can take them along on your trip.

✔ **Establish "must see" (and "must shoot") items.** Find out as much as you can about what's going to be happening during your stay. Many towns, cities, counties, regions, states, and countries maintain Web sites for prospective tourists; they're usually packed with good tips. Visitors' bureaus often have their own sites as well as publications that they'll mail to you if you're not online. All these resources list local institutions and upcoming events, as well as contact information. Build your itinerary around photogenic locations and events — state and county fairs, parks, Civil War battle reenactments, museums, rodeos, pageants, and other natural or cultural points of interest. Then make your airline and hotel reservations accordingly.

✔ **Plan day trips and side excursions to flesh out your itinerary.** Even if you're going skiing, for example, I suggest finding out what visual diversions are available in the area surrounding the resort. A photographer friend of mine recently planned a ski vacation over the Christmas holiday, and it rained every day. He was glad the resort had more than its slopes to offer!

You can start your search for information about a travel destination on the World Wide Web. It may be the single most valuable resource for the traveling photographer — or should I say, the photographing traveler. At its most basic, the Web can give you a fix on your destination's weather. Dozens of online services provide free forecasts, including detailed weather maps for cities and other locations around the world. But the Web offers much more than weather. Say you're heading to Scotland. Enter the words "landscape photography in Scotland" or "travel photography in Scotland" or even "tips for taking pictures in Scotland" in a Web search engine and you turn up dozens of helpful contacts, not to mention lots of inspirational photos. In fact, some of the links will probably be to the Web sites of photographers who specialize in the area, and who may be generous enough to provide information about their pictures' specific locations.

It's also a good idea to make calls (yes, use the telephone!) to visitors' or tourists' bureaus. (Human beings can still provide inside information you *won't* find on the Web!) If you're headed to another state, find one through directory assistance in its capital city. If you're off to a foreign country, check with travel agents or in travel guidebooks for the location of the U.S. offices of that country's tourism agencies. Books are another great way to research your destination — and also a great resource to carry with you while traveling.

Packing for Pictures: What to Bring

As your departure date approaches, you need to start organizing in earnest. Make checklists. Checklists can save the day, and a lot of heartache. Write down everything you hope to photograph, including dates, times, and locations. Write down all the photo supplies you'll need, including film, batteries, and lens cleaning tissue. (While you're at it, list all the non-photographic items you'll need, including passport, maps, visas, medicines, electrical converters, and adapter plugs.) Checklists may seem like overkill, but if you've ever desperately needed a battery or a roll of film and been miles from a camera store, surely you have a sense of their worth.

Is your camera right for travel photography?

Just about any working camera is capable of great travel shots, if you use it smartly. If the point-and-shoot that you already own has served you reliably, it should work fine for your trip. I'm a firm believer in taking along the camera you know and trust rather than a shiny new model.

You'll still want to tune up your camera before you leave, especially if you haven't used it in a while. Here's what to do:

✔ **Get fresh batteries for your camera, even if the old ones seem fine.** (You can always save the old ones to use when you get back.) While you're changing batteries, check for leakage; if you spy any whitish residue, clean the inside of the battery compartment with a pencil eraser, as I describe in Chapter 1. If you use, or if your camera only takes, rechargeable batteries — often the case with digital point-and-shoot models, which rely more and more on proprietary batteries — it's not enough just to charge up the battery you have. You should probably invest in a second battery or set of batteries. (AA rechargeables are inexpensive, proprietary batteries more costly.) And don't forget to bring the charger on your trip! Most now switch automatically to European voltages, though you will probably need an adapter (readily available through Web sites specializing in travel supplies) for overseas wall outlets.

✔ **Blow out the inside of the camera to remove any dust.** (Try to use canned air from a photo shop, if possible.) Ditto the viewfinder and lens. If you have a digital point-and-shoot, you can even give the memory card slot a careful, gentle gust.

✔ **Check the lens for smudges.** Remove any with lens cleaning tissue or a special lens cleaning cloth. (See Chapter 6 for details.)

If you have two working cameras, I suggest bringing both along. Even if you're gung-ho about your digital point-and-shoot, bring along the old, familiar film camera (and some film!) just in case you have technical problems. At the very least, pack a couple of one-time-use cameras in addition to your regular point-and-shoot. These cameras are especially handy if you're traveling in conditions hazardous to your normal camera — either nasty weather or places where thievery may occur. And I suggest leaving your good camera at the hotel (especially if it's digital) if you're headed to a beach. Sand and salt water are real camera killers. But waterproof one-time-use cameras can even be taken into the waves.

Whether your camera is a new purchase or an old companion, bring its manual on your trip. In addition, make a "mode map" for yourself. (I tell you how in Chapter 4.) A mode map explains all the buttons and features of your camera in terms that *you* understand.

Staying dry: What to do in rainy or humid destinations

If you're planning an extended stay in a humid part of the world — a rain forest, perhaps — bring along a _desiccant_. Available in small packets, desiccants draw moisture out of the air. Silica gel is the most common; your local camera shop can probably get it for you. By keeping your camera and film in a plastic bag with the silica gel packet, you protect them from condensation — even fungus. Believe it or not, fungus can eat away both your lens's surface coatings and your film's emulsion.

Another useful item for rainy climates? Protective camera coverings. You can fabricate a "raincoat" for your camera from a plastic bag, or you can buy something more substantial from camera shops or catalog outfits. They sell special plastic shrouds that protect cameras from rain but allow full access to camera controls and the viewfinder. And if you have a digital point-and-shoot, you may want to consider purchasing a waterproof housing for your camera to protect its extra-sensitive electronics. See the sidebar "Trip shape: Buying a traveling camera," later in this chapter, for more on this.

And don't get stuck without extra batteries. Even the off-the-shelf batteries used by most 35mm and APS models and many digital point-and-shoots aren't readily available overseas, or are far more expensive over there. Here's another good general rule: Leave for your vacation with a fresh battery (or set of batteries) in your camera and bring at least one spare battery (or set of batteries) for each camera you're packing.

Test your camera before you leave!

I strongly recommend shooting a test roll of film well before your departure. Digital photographers are allowed to skip this part, since you can inspect your pictures right away. But be sure to look at them at full size _on the computer screen,_ because it's hard to tell if a picture isn't sharp on the camera's little viewing screen.

If you have a camera that works properly with slide film, you can do the test I describe in Chapter 2. Otherwise, use a short roll of ISO 400 color print film. Shoot pictures in bright light and in dim light. Shoot pictures with close subjects and with distant subjects. If the camera has a zoom lens, shoot pictures at several different focal length settings. Take flash shots at different distances, too. Try to use every feature on the camera — or at least every feature you think you're likely to use on your trip. If you're going somewhere sunny and plan to take lots of people pictures outdoors, for example, be sure to take some outdoor portraits with fill flash. (See Chapter 7 for more on fill flash.)

As you shoot the roll, listen to the camera. Does it sound "healthy"? If you hear odd noises that you haven't heard before — whining or straining sounds in particular — take heed.

Have your film processed and check the prints for sharpness and good exposure. If most of your prints have good color and lots of detail, you're on your way. If, on the other hand, you get back muddy prints or a lot of fuzzy pictures, you may need to repair or replace your point-and-shoot. Take the camera and test pictures to the folks at a local camera shop or minilab and ask for their advice.

All this testing may seem a bore, but it serves two purposes. First, it lets you discover problems with your camera before, not during or after, your trip. Second, it tests you; you'll be brushing up your camera skills. If your camera has some features that you don't understand, take the opportunity to reread your camera manual — or refer to Chapter 4! If something still confounds you, ask a knowledgeable friend or the clerk at the local camera shop.

Don't succumb to New Camera Syndrome

In those heady days before a trip, many travelers become convinced that they need a higher-tech, easier-to-use, and sexier camera for their long-awaited vacation. I've heard this sad refrain many times: "I just don't understand why the pictures didn't come out. . . . It's a *new* camera!" Alas, new cameras have been the ruination of much vacation photography. First, new devices can, and do, fail. Second, even if a new camera is working flawlessly, you may not fully grasp its operation. A button may end up doing something very different than you thought it did when you pressed it.

You may still want — or need — to buy a new camera before your trip. If so, buy it at least a few weeks in advance. (See the sidebar "Trip shape: Buying a traveling camera" for some tips.) If it shoots film, run a test roll through it as described above, then two or three rolls more of a variety of subjects. Shoot the types of film that you'll be using on your trip. If you've bought a digital point-and-shoot, overcome your fear of its newness and start using it *now*. Either way, you'll leave knowing the camera works, and understanding its features. You'll leave with peace of mind.

Roll model: Film for wanderers

Other things you'll need besides a working camera? Unless you're shooting digitally, lots of film — especially if you're going abroad. Overseas, even in big cities like London or Rome, you may not be able to find the latest generation of color print films. So don't plan on buying your film over there. When you buy in the United States, do so at a reputable dealer where film is properly stored. (Too much is at stake!) If you must purchase film on the road, check the expiration dates on the box and try to buy from a store with heavy volume and turnover.

Trip shape: Buying a traveling camera

Chapter 17 tells you what to look for in a new camera. But if you're shopping with travel pictures in mind, here are some specific things to think about:

✔ Consider a model that has a wide-angle focal length setting (28mm or 30mm on 35mm cameras, 24mm or 26mm on APS cameras), rather than the more common semi-wide-angle (38mm for 35mm cameras, 30mm for APS cameras). Wide-angle focal lengths are great both for sky-spanning landscapes and cramped interiors. Digital point-and-shoot models usually don't have much in the way of wide-angle capability, though nonzooming models tend to go a little wider than most zooming models. Consider buying a digital model that accepts a wide-angle adapter, which fits onto the front of the lens.

✔ Consider a weatherproof model. It will stand up better to those showers you're bound to get on your vacation and tolerates the inevitable spray on boat rides. If your trip takes you to swimming or snorkeling spots, consider a fully waterproof model. You'll have a hard time finding a waterproof digital point-and-shoot, so you might want to consider a model for which an *underwater*

housing is available. This is a tightly sealed, form-fitting plastic enclosure with oversized mechanical controls that physically connect to the buttons and dials on the camera inside. Underwater housings aren't available for all that many models, however, and they can be costly. A less expensive option is to buy an underwater "baggie" for your camera, which has a hard plastic "port" for the lens but is otherwise flexible enough to allow operation of the camera's controls. These accommodate a wide variety of camera shapes and sizes.

✔ Consider buying a different type of point-and-shoot if your current camera is in good working condition. If you own a good single-focal-length model, for example, you may want to get a 35mm zoom camera with a 28–80mm, 28–90mm, or 28–100mm lens. If you already own a good zoom model, you may want to get an ultracompact single-focal-length camera that slips into a pocket. And if you already have a good 35mm or APS model, maybe now's the time to consider a digital point-and-shoot, and use the trip as an occasion to make the transition, if it's something you've been wanting to do.

Price is another reason to buy your film in the United States. In very remote parts of the world, a roll can cost as much as $20 — and it may be way past its expiration date! Keep in mind, too, that in places with heavy tourist trade, such as the Caribbean, film prices are often higher because stores charge what the traffic will bear.

Which film should you buy and how much? As I say throughout this book, you should make ISO 400 film your standard film. But if this vacation is an important one (and what one isn't?), you may want to go with premium ISO 400 film from the major manufacturers rather than your everyday brand. (See Chapter 2 for more on premium films.) Also bring along several rolls of fast ISO 800 film — and consider the film a must if you plan to shoot with long zoom settings. You

should even factor in your destination: Bring more ISO 800 film if you're headed for foggy London Town or other spots that are frequently overcast, or if you foresee doing a lot of low-light pictures indoors and out.

In addition to color, consider bringing along a roll or two of chromogenic black-and-white film. (I discuss this film in Chapter 2.) Black and white can reinforce the other-worldly feeling that travel is all about, and shooting it makes you think harder about line, shape, texture, and composition — important matters when you're shooting architecture and landscapes.

How much film to buy? A good general rule is one roll of film for every day you'll be away. I'm talking about long rolls, of course — 36 exposures for 35mm cameras, 40 exposures for Advanced Photo System cameras. Using long rolls means you don't have to change film as often, and that you can carry fewer rolls.

Memory matters: How many megabytes?

If you're planning to do your travel photography with a digital point-and-shoot, then you don't have to worry about having enough film. No, you have to worry about having enough *memory.* Specifically, you need enough memory cards, or memory cards with sufficient capacity, to hold all the digital pictures you plan to take.

That's the bad news. The good news is that the price — per megabyte — of memory cards for digital cameras is dropping almost daily. This is true to varying degrees of all the different types of memory card now available. And unlike film, you can reuse memory cards simply by deleting the pictures they contain or erasing their entire contents. So even though the initial cost of a decent-capacity memory card might seem high, it's cheaper than film when prorated over years of picture-taking — unless you just don't take many pictures. See Chapter 15 for more on memory cards and digital point-and-shoots, but here's a quick strategy for travel.

The amount of memory you need to take along on a trip is a direct function of both how long you'll be away and the resolution of your digital camera. If you have a two-megapixel model, for example, you can fit roughly twice as many pictures on a given-sized memory card than with a four-megapixel model, other things being equal. Consult your camera's manual to find out how many pictures fit on a specific-sized memory card; most contain charts that indicate this for the camera's different resolution settings, including its maximum resolution — which for travel pictures you should be using anyway.

Once you've determined how many pictures fit on the card or cards you have — how many pictures, at the camera's full resolution, fit into the total megabytes of your available cards — then divide that number by the number of days you'll be away. If you want to be able to shoot the equivalent of a long roll of film each day, as I suggest to 35mm and APS photographers, then the

result should be somewhere in the neighborhood of 36 pictures. If it's way less than that, I suggest you buy an additional memory card (or cards) to make up the difference.

Let me simplify this. If you have a three- or four-megapixel model, consider bringing along at least 32MB of memory card capacity for each day you'll be away. That suggestion won't work for everyone, but it's not a bad starting point.

Some digital photographers actually bring a laptop computer on their travels so that they can download pictures to it at the end of a day of shooting. Then they simply erase their memory card or cards so that they can start fresh the next day. But for those of you who don't want to schlep along a laptop, or buy heaps of memory cards, here's another tactic: Save them to a portable hard drive.

These drives are sometimes called "digital wallets," and they aren't much bigger than a wallet — well, a PDA, anyway. When you want to clear pictures off a memory card so that you can do more shooting, you simply slide the card into a slot on the unit, press a button, and your pictures are transferred from the card. You can then erase the card for more pictures. These devices are small enough so that they can be carried with you during the day, allowing you to free up memory cards on an as-needed basis. Are they cheaper, in the long run, than buying more memory cards? That depends on your photographic habits — mostly, how many pictures you take. And given the cheaper-than-ever cost of memory cards, the answer may be no unless you take large numbers of pictures.

Don't pack it, bag it!

Do you really need a camera bag when traveling? It helps. The padding and water resistance of typical camera bags help protect your point-and-shoot, accessories, and other small items. And even with the compact bags now designed for point-and-shoot cameras, you can fit in a lot more things than cameras and film: maps, binoculars, sunglasses, and guidebooks, to name a few. Camera bags are also a reminder that you should be shooting. Guess who takes more pictures: The person who carries her camera in a camera bag or the person who carries her camera at the bottom of a suitcase?

When packing film in your camera bag, remove the plastic canisters from the boxes. The boxes take up too much space. If you're bringing more than one type of film, mark the type and speed of the film on the tops of the canisters. And if you're shooting more than one type or speed of film, keep each in separate camera bag pockets. Also keep exposed and unexposed films in different pockets or compartments.

Scenes from a Voyage: What to Shoot, and How

What should you photograph in your travels? The simple answer: As much as you can. Try to take pictures of every new place you go and every new person you meet — even if you don't see anything of particular visual interest. You can't predict what will evoke memories years from now, so get as much as you can on film.

Picking your subjects

Here's a good way to go about photographing a new place:

- **Start with the big and work down toward the small.** When you first visit a town, for example, take a few overall shots, zooming out to include as much as possible. Put family members or traveling companions in these wide shots (filmmakers call them *establishing shots*), but take some without your fellow travelers, too. When shooting traveling companions in front of famous landmarks, buildings, or scenes, vary your camera angle and your companions' stance. For some pictures, ask them *not* to look into the camera and *not* to smile. Change camera orientation, making both horizontals and verticals.

- **Move in and take some middle-distance shots of your location.** If your wide shot was the entire cathedral, take some pictures of doors, windows, and flying buttresses. Again, try to include people for scale. Unlike wide shots, middle-distance pictures can contain enough detail to tell a story — if you keep your eye open for human interest and even humor. Give clichéd subjects a new look by choosing unusual camera angles. An interesting vantage point can add energy to a quiet subject.

- **Finally, after you're finished with middle-distance shots, go for the details.** Start with objects. If you're shooting that cathedral, isolate its architectural components — decorative statues, door knobs, or stained glass (see Figure 14-2). Try to pick things that are representative of the larger subject (perhaps even a detail of a priest's robe). Keep your eye out for strong colors, interesting textures, and evocative light.

Don't just wait for *National Geographic* pictures to happen in front of you. They won't. *National Geographic* photographers often spend months in a single location, returning again and again to capture different light, different events, and different seasons. You don't have that luxury, and if you wait for the perfect picture, you won't finish the first roll you put in the camera. I know this from personal experience! What's more, the best pictures are often a complete surprise — not the ones you expect — when you get your prints back.

Figure 14-2:
After you shoot an overall scene (here, a Japanese market-place), take some close pictures, too. These pictures help fill in details — and are often the best shots in purely photographic terms!

© Allen Green

Digital photographers don't have to wait to get prints back, of course. They can look at their pictures right away on the camera's viewing screen. Even better, they may feel freer to take pictures because they don't have to buy film — and they can delete the pictures they don't like to make room for more on the camera's memory card. Just the ticket for travel photography, right?

A word of warning here: Be judicious in your deleting. First, it's not always easy to tell what's really a good picture on that little viewing screen. It can be hard to see people's expressions, for example, or even if they're blinking. (If your digital point-and-shoot allows you to zoom in, on the viewing screen itself, for a closer look at details of the pictures you've already taken, use this feature for a closer, more critical look!) Even at that small scale you can usually tell if a picture is really bad — if it's blurry, or you missed the moment, or the subject turned away too soon. But many pictures that first seemed ordinary or expendable on the viewing screen may look very different when you get home and look at them again, especially on the computer screen.

How do I know this? Because over the decades I've gone back and looked at old negatives and realized that a photograph I never even bothered printing is actually worth a closer print. My advice: Delete only the manifestly bad pictures, and wait till you get home to make the final edit. Bring enough memory (cards, or a laptop or digital storage device to which their contents can be transferred) so that you don't find yourself deleting potentially good or important pictures to make room for more.

Stay safe: Protecting your gear from theft

In less affluent parts of the world, especially big cities, even an inexpensive camera may attract the attention of thieves. Safeguard your camera in the following ways:

✔ Always keep your camera in your possession or view.

✔ Write down your camera's serial number and keep it in a safe place. This information can help prove ownership if your camera is stolen and recovered by police.

✔ Keep your camera in locked luggage or in the hotel safe, rather than leaving it out in your room.

✔ Beware of distractions. Thieves often work in pairs, one creating a distraction and the other swiping your camera or camera bag. If someone spills food on you or bumps into you, hold your camera tight.

✔ If your camera is stolen, don't replace it then and there. Cameras are usually more expensive elsewhere than they are in the United States. Make do with a one-time-use camera until you get home.

Shoot signs. They can make great, graphic photos, but they also help identify where you were and what you saw.

Bad weather can be good weather — for photography

Here's a big secret of professional travel shooters: Bad weather can be good weather, photographically speaking. The sun doesn't have to be shining for you to get great travel shots. Inclement conditions can add instant atmosphere to a photo. So rather than stay in your hotel room in a funk, go out with your camera — protected in a plastic bag or water-resistant case, of course. Night shots in the rain can be particularly beautiful, especially in places with lots of illuminated signage (Picadilly Circus, Times Square, the Ginza). When shooting at night, make sure that you've set your point-and-shoot to its slow-sync flash or flash-off modes (see Chapter 4) and look for interesting reflections.

Overcast is wonderful, too, especially for people pictures. Use the soft light of a gray day to take portraits of your traveling companions or the locals. Even heavy haze and mist can make lovely middle-distance landscapes and street scenes.

Photographing the locals

In some corners of the world, the people are as visually intriguing as the most spectacular landscapes — maybe even more so. Their daily garb and special costumes may be handsomely crafted and colorful, their faces deep wells of character (see Figure 14-3). Their ceremonies can be fascinating, too, if you're fortunate enough to be there for them. But often the easiest and most interesting people to photograph are men and women at work.

When they're working, people wear "public" faces. At work, they're generally less sensitive about being photographed. They may even be delighted that you find their occupation photogenic. The only jobs where this doesn't hold? The police and the military, except for Buckingham Palace guards of course.

Figure 14-3:
Even when the grown-up locals are suspicious of your intentions, children are usually thrilled to have their pictures taken. Photographing them may even help you engage — and shoot — their more reluctant parents.

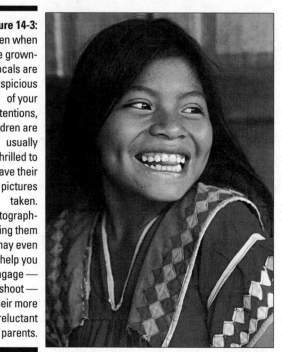

© Rick Sammon

When you're taking pictures in a different culture, be especially sensitive to others' privacy. Try to find out something about local attitudes toward photography *before* you begin shooting; the hotel staff is a good place to start asking questions. In some places, residents simply do not like to be photographed. Take their picture, and they won't hesitate to tell you their displeasure, in ways you'll understand whether you speak their language or not. In other locales, the locals will cooperate only if you tip.

Can airport X-rays hurt your film?

In the early days of airport baggage inspection machines, your unprocessed film stood a good chance of receiving a lethal dose of X-rays as it passed through the device — ruining your vacation photos. Today, security check-point machines are better-calibrated and seemingly less likely to cause damage. I know few photographers who have reported film damage from X-rays, but it may take the form of strange coloration, washed-out areas or bands of color, or even just a loss of crispness and color brilliance. But exercising a little caution pays off, especially now that a new generation of more powerful *checked-baggage* X-ray machines, able to detect plastic explosives, is being installed in airports around the world. What can you do?

✔ Politely ask to have your film hand-inspected at airport security check-points — going and coming — rather than have it X-rayed. Most airports are willing to comply, if begrudgingly. To speed up the process, have your film already removed from its boxes (which you should be doing anyway) and store it in a clear plastic bag for quick inspection. If you're going to request hand inspection, arrive a little early for your flight. If nothing else, ask for hand-inspection of high-speed (ISO 800) film. It's more vulnerable to X-ray damage.

✔ Never put film or loaded cameras in your suitcases. Checked luggage may get hit with harder, potentially more damaging radiation.

✔ If you think you may have trouble getting unprocessed film back to your destination unharmed, have it processed where you're visiting. Look for photo labs that are approved by the major film manufacturers. (See Chapter 3 for more on choosing a photofinisher.)

You can buy special lead-lined bags designed to shield film from X-rays. They work, but the blank spot they create on the inspector's monitor may lead him or her to request that you open the bag anyway. Also, repeated passes through X-ray machines may build up a layer of "fog" that lessens the color richness and "snap" of your pictures. If you can't *prevent* X-ray exposure, try to *limit* the number of exposures.

Part V
The Digital Domain

The 5th Wave By Rich Tennant

"If I'm not gaining weight, then why does this digital image take up 3MB more memory than a comparable one taken six months ago?"

In this part . . .

*W*ho knew that photographers would ever be able to make pictures without film? And I mean *good* pictures. Today's digital point-and-shoot cameras compete admirably with their 35mm and APS counterparts, producing picture quality that is more than acceptable for snapshot purposes — and, if they have enough megapixels, are even up to the challenge of an 8 x 10 print. We're still working out the bugs, but digital photography is likely to become the main way we take pictures over the next five or ten years.

In the meantime, photographic film is an excellent bridge to the digital world. Have your photofinisher scan your negatives, or scan them yourself, and the resulting picture files can go straight into your computer. Once they're in there, you can do exactly the same things with them that you can with pictures from a digital point-and-shoot: e-mail them as is to friends and family, for example, or manipulate them in ways both subtle and dramatic with easy-to-use image-editing software. Whether you get there with or without film, digital might just bring out your inner artist.

Chapter 15

Getting to Know Your Digital Point-and-Shoot

..

In This Chapter

▶ The pros and cons of digital point-and-shoots

▶ What digital photos are made of

▶ Memory cards: Where your pictures go

▶ Pixels, megapixels, and more megapixels

▶ Viewfinder versus viewing screen

▶ What's on the menu?

▶ When to erase?

▶ Digital zooming: a big no-no!

▶ Downloading made easy

▶ Downloading made easier: the memory card reader

..

*W*hen I attend big social events (school concerts) or visit places of public entertainment (theme parks), I count cameras. Sounds silly, I know, but it's my job. I take pictures, too, of course, but as I do I keep a rough tally of how many different kinds of cameras I see. I always see lots of one-time-use cameras, but they're usually outnumbered by reloadable point-and-shoots (mostly 35mm) of all shapes, prices, and levels of sophistication. Behind but gaining fast on both types of cameras are digital point-and-shoots. As of this writing, these filmless wonders are selling just as briskly as film-using models. Which tells me that when I'm counting cameras for the next edition of this book, digital models will probably beat out their 35mm counterparts.

I can understand why digital point-and-shoots have become so popular. They dispense with film, saving you money and sparing you the nuisance of frequent reloading. They give you an instant replay of what you've shot on their little viewing screens, allowing you to share the results with your subjects — and to look critically at your picture to see if you need to take another. Most significantly, since the last edition of this book, digital point-and-shoots have reached

a level of picture quality that, for most practical purposes, rivals what you'd get from a 35mm point-and-shoot camera — sufficient, certainly, for the 4 x 6-inch prints we're all accustomed to getting from our photofinishers.

There's the rub: printing. Once you get digital pictures into your computer, you can send them to someone else's computer by attaching them to an e-mail, so the recipient can see pictures you've taken just minutes before. You can upload them to your own virtual album on a "photo sharing" Web site, then invite friends and family to have an online look. You can even browse through your digital pictures on TV, either by plugging your camera directly into the TV's inputs (if it permits this) or by using a viewing appliance that accepts its memory card. But getting *prints* from a digital camera's picture files is easier said than done. Some photofinishers now offer printing directly from your digital camera's memory card, but this service — while it's bound to grow — is by no means universal.

One alternative is to send your picture files from your computer directly to a Web-based printing service. But even if you're willing to invest the needed computer time, the prints take days to get back (they come by mail), and their quality is less consistent than the ones your photofinisher makes from film (see Chapter 16). Another alternative is to print pictures yourself, on a photo-quality desktop printer. Printing at home is also a labor-intensive enterprise, but the good news is that you no longer *have* to get your pictures into a computer to do it.

And if you *are* comfortable with a computer but still aren't ready to take the leap to a digital camera, you don't even need to use a digital camera to do things digitally with your pictures. You can shoot the way you always have, with film, then tell your photofinisher to *scan* your processed negatives — converting each of them into a picture file. The photofinisher can either save the picture files on a CD that you pop into your computer's CD drive or send them to a Web site where you can view and download the files directly. If you're really ambitious and willing to spend more money up front, you can scan the negatives yourself on a desktop film scanner.

I cover all that in Chapter 16. In this chapter, I tell you how to get the most from a digital point-and-shoot camera. But first, a little background.

The Digital Details

Whether you take your pictures with a digital point-and-shoot or have the negatives from your film-eating point-and-shoot scanned, the resulting picture files aren't fundamentally different from the word-processing files you may deal with every day. The photographs are translated into, and stored as, the same sort of computer language used for documents, graphics, and spreadsheets. The main difference is that more digital information is needed

to create photographs than to reproduce letters and numbers. One picture is worth way more than a thousand words — perhaps an entire novel's worth of digital data.

However it's produced, a digital photograph is made up of tiny, organized little squares or rectangles called *pixels.* (Pixel is a contraction of the rather bland term *picture element.*) To picture how pixels work, imagine an intricate mosaic consisting of lots of small tiles. A single tile contains just one color or shade and doesn't offer a clue about what the whole mosaic represents. But when you group the tiles in an orderly fashion, and step back, they blend together to produce a recognizable image.

Likewise, a digital photo is formed by thousands or millions, of tiny, tilelike pixels. Each pixel contains only one color or tone, but when you view the image on your computer monitor or in a digital print, they come together to create a convincing representation of reality.

In color photography, the minimum amount of digital information needed to store a pixel's tone and color is three bytes, a term from the computer language called binary code. You've probably noticed that the ability of computer hardware to handle digital data is described in megabytes, often abbreviated MB. That's a million bytes of digital information — and computer files of photographic images are also often measured in megabytes.

All that said, digital point-and-shoots operate more or less like film point-and-shoots, and today's models closely resemble them (see Figure 15-1). They fully automate major camera functions, usually have a built-in flash that fires on its own in low light, and feature a choice of pushbutton- or dial-controlled modes. One noticeable difference is that most digital point-and-shoots have a small, TV-like screen on the back for composing and shooting pictures, looking at pictures you've taken, and viewing and adjusting the camera's menu. Otherwise you pretty much just press the button and, to invert the old Kodak slogan, the camera does the rest.

The biggest difference between film cameras and digital cameras is what's inside. Inside a digital point-and-shoot, where a frame of film would ordinarily lie in a 35mm or APS model, is an electronic light sensor not unlike the one in video camcorders. The flat surface of this *image sensor,* as I like to call it, is made up of millions of microscopically small pixels — those tiny digital picture elements I talk about at the beginning of this section. (Less expensive models may have just hundreds of thousands of pixels.) The image sensor's pixels are like little light-gathering windows. When the camera's lens focuses an image of the subject on the sensor (think of a movie projector throwing an image on the silver screen), each one captures a different combination of brightness and color. This image is then converted to digital form and saved in the camera's memory, usually on a memory card (see Figure 15-2). (For more on the memory card, see the sidebar, "Storing digital pictures: The memory card," later in this chapter.)

Storing digital pictures: The memory card

So you're taking pictures without film. Where do the pictures go? They get "saved" to the camera's memory, just the way you'd save a text file on your computer's hard drive. Some digital point-and-shoots even have a limited amount of built-in memory, sort of like a skimpy hard drive in a computer. But this memory usually takes the form of a small, removable wafer of plastic and silicon called a *memory card.* Memory cards are sometimes referred to as "digital film," but I don't like that term because they're really not filling in for film. Like film, the image sensor actually records the photo, and the memory card is just an easily transported picture-storage device.

Memory cards slide into a slot that's under a door or flap on the side of your camera. It's sometimes under the same door as the battery, most likely if your camera is a pocket-sized model that uses a proprietary rechargeable battery. In fact, just as with a battery, you have to be careful to insert the memory card in the correct orientation, which is usually indicated with a diagram on the card slot's door. (If it isn't, check your manual.) A memory card will slide all the way into the slot only if you have it correctly oriented. If you try to force it in the wrong way, you can damage it, or worse, the camera. (You can also damage the card by removing it while the camera is trying to store a picture on it; see the section "Taking Pictures with Your Digital Point-and-Shoot," later in this chapter.)

If there is no memory card in the camera, the viewing screen displays a message telling you so. The message disappears once you insert the card. Some models also alert you as soon as you open the compartment door. Some will even turn themselves off when the door is opened, to protect the card.

Memory cards are so small that they're easy to lose. When you take one out of the camera, don't just put it in a pocket. Put it in the little plastic case that it probably came in, and consider buying a small zippered wallet made for memory card storage.

Memory cards come in a number of different shapes and sizes called *formats.* By my count, as many as ten different card formats have been introduced since the dawn of digital point-and-shoots. Only a few have thrived, and your digital point-and-shoot probably takes one of them.

✔ **CompactFlash** (abbreviated CF) is the most common memory card format. It's also physically the bulkiest, though still smaller than a matchbook. CF cards actually come in two forms, Type I, which is accepted by most point-and-shoots, and the thicker Type II, which was originally created to hold more pictures and is found in pro-oriented models. The high-capacity Microdrive has the same size and shape as a Type II CF card, but actually incorporates a tiny, spinning hard drive.

✔ **Secure Digital** (abbreviated SD) is gaining fast in popularity. The card's postage-stamp dimensions have allowed manufacturers to create smaller, more pocketable digital cameras. Secure Digital cards are about the same size as, and are pretty much interchangeable with, the earlier MultiMedia Card (MMC). But among other improvements they incorporate a sliding lock switch that allows you to protect your pictures from being accidentally erased or written over.

✔ **Memory Stick** is Sony's proprietary card format, and any Sony digital point-and-shoot that doesn't save pictures directly on mini-CDs or floppy disks uses it. It has the proportions of a stick of chewing gum, only smaller, and comes in a few different versions. A few non-Sony cameras take it, and many Sony computers, TVs, PDAs, and video camcorders have a Memory Stick slot

for direct reading and viewing of the pictures on the stick, as well as recording pictures on it.

✔ **SmartMedia** (abbreviated SM) is not as small as the other cards but is the thinnest. Though there are many good SM-using cameras out there now, new models are unlikely because there's an inherent limit to how many pictures you can fit on the card. Camera lines that use SM cards are switching over to the xD-Picture Card.

✔ **xD-Picture Card** (abbreviated xD, of course) is the newest memory card format. Some of us hope it's the last, because an xD card is even smaller than an SD card — and very easy to lose. If you can't find your keys, xD could spell trouble.

Now that I've droned on about memory cards, I have to tell you that it doesn't matter all that much which card format your camera takes. The card is just a reusable storage and transfer device for digital photos — in effect, part of a closed-loop system. Each time you transfer pictures from it into your computer you'll probably be erasing its entire contents to make room for more. When you download pictures from the camera to the computer, the computer doesn't care what kind of card you have. You can do the same things with those pictures that you'd do with any others in your computer, because they're usually saved in the universally readable JPEG format. JPEG is sort of like the photographic version of Microsoft Word, except that it's not making Bill Gates even richer. (See the sidebar, "What does JPEG have to do with picture quality?")

What's more, commercial photofinishers who are able to make prints from memory cards accept virtually any card format. And a growing number of desktop printers feature a slot or slots for various memory cards so you can print directly from the card without involving your computer, which I cover in Chapter 16.

What matters more than the *type* of memory card you have is the card's *capacity* — how many digital pictures it will hold. This capacity is measured in megabytes, which I discuss earlier in this chapter. A megabyte is a million bytes of digital information. Don't confuse megabytes with megapixels. Megapixels is the term used to quantify the picture quality produced by a digital point-and-shoot, specifically how many million pixels reside on its image sensor. Megabytes refers to the size of a picture file, just as with a text document.

When you buy a digital point-and-shoot camera, a memory card comes with it. But it's usually not a very high-capacity card, because the photo industry wants you to go out and buy a bigger one, or two or three. And you should. The cards supplied with digital point-and-shoots usually fall in the 8- to 32MB range, next to useless for everyday photography with a mid-level model. (That's why some makers call them "starter" cards. They let you get started shooting, but not for long.) Card capacity basically doubles, continuing on to 64MB, 128MB, 256MB, 512MB, and one gigabyte (a thousand megabytes). Some new cards are coming in at two, three, and even four gigs, but you don't need them, and they cost as much as or more than a digital point-and-shoot.

I recommend buying, as your second memory card, one with at least 256MB capacity. If you have a higher-resolution digital point-and-shoot — say, four megapixels or above — you might consider a 512MB memory card. You can always get two 256MB memory cards, of course, and this way you won't be putting all your eggs in one basket. (Theoretically, one card could be at the photofinisher while the other is in the camera!)

The number of digital photographs you can actually store on a memory card depends on the size of the picture files. The bigger the picture files, expressed in megabytes, the fewer will fit on a card.

(continued)

(continued)

Figure 15-1:
The front of a typical digital point-and-shoot looks very much like a 35mm or APS model, with its lens and built-in flash. Turn it around, though, and the camera looks very different because of its viewing screen, used to shoot and "play back" pictures.

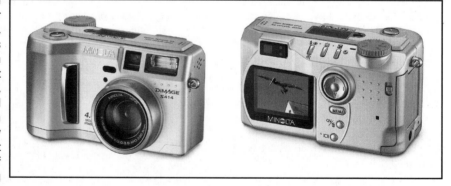

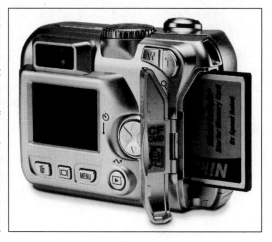

Figure 15-2:
Most digital
point-and-
shoots store
their
pictures on
a memory
card, which
usually slips
into a slot
under a
door on the
right side of
the camera.
Memory
cards can
be erased
and reused
once you've
transferred
their
pictures to a
safe
place —
usually, your
computer.

How Many Megapixels Do You Really Need?

In digital photography, _resolution_ is a measure of how many pixels make up a digital picture. It has become the holy grail of digital photography, as manufacturers compete to produce cameras with ever-higher pixel counts — the number of pixels in the camera's image sensor, which determines how many will be in the actual picture.

The resolution of most current digital point-and-shoots is measured in megapixels, a megapixel being a million pixels. Most current models have two-, three-, or four-megapixel resolution; inexpensive models may have around a megapixel or less, while more costly ones have four or five megapixels. A given camera's true pixel count is often an odd number, for example 2.15 or 3.2, but people in the know usually round it to the nearest million. The more pixels a camera has, generally the better the quality of its photographs, though other factors greatly influence picture quality.

How many megapixels do you need? It depends on what you want to do with your digital photographs. If you haven't already bought a digital point-and-shoot, I get into the specifics of shopping for one, including resolution, in Chapter 17. The thing is, more pixels isn't always better. More pixels cost more money. More pixels fill up a memory card faster, though you can always get a higher-capacity memory card (see the sidebar "Storing digital pictures: The memory card"). And more megapixels may not make any *visible* difference in the quality of your pictures.

If you don't need or want prints, and are instead content to look at your photos on a computer or TV screen, sharing them by e-mail or on the Web, then even two megapixels is a bit of overkill. You can get by with a megapixel or less. (Most such models actually come in at around 1.3 megapixels.)

If you want prints, you need more megapixels than that. If all you ever plan to make is 4 x 6-inch prints, then two megapixels is just enough — though depending on the camera and your own standards, you may get more satisfying 4 x 6 prints from a three-megapixel model. In my opinion, unless you can't afford the extra hundred bucks it's likely to cost, I'd get a camera with at least three-megapixel resolution if you want to make prints. In fact, more three-megapixel point-and-shoots are being sold than any other resolution category, a trend some industry pundits say is likely to continue. A three-megapixel model is up to the task of making very good 5 x 7-inch prints, and can do a serviceable job with 8 x 10s, though at that print size you'll probably notice the individual pixels that make up the image, which can give a slight jaggedness to the edges between things in the picture.

Which brings us to four and five megapixels. If you have one of these models, then print away. You can get very good 8 x 10s and, other factors considered, 11 x 14s too. Good five-megapixel models can even do passable 16 x 20s, in my experience — if you don't look too closely.

This is the sort of qualification that enters into the megapixel equation. The quality of your prints — whether you make them on your own desktop or have a photofinisher make them for you — depends not just on megapixels but on the quality of your camera's lens, image sensor, and image processing technology, not to mention the printer itself. And what's acceptable quality depends heavily on your own standards. The best way to find out how big a print your camera can handle is to make one that size and see if it looks good to you.

Setting the Resolution

With most digital point-and-shoots you can actually choose a *lower* resolution than the camera's advertised maximum, which is where it's set when you take it out of the box. You do this by entering the shooting menu and selecting the "Image Size" or "Resolution" option (see Figure 15-3). (See the section

"Using the Menu to Change Settings and Choose Modes," later in this chapter.) When you do that, you'll see a series of number pairs. A typical three-and-change-megapixel model might go like this:

- 2048 x 1536
- 1600 x 1200
- 1280 x 960
- 1024 x 768
- 640 x 480

Figure 15-3:
Most digital point-and-shoots offer adjustable resolution settings, selected with the camera's menu screen. The highest resolution (here, 2048 x 1536) is usually the one the camera comes set to.

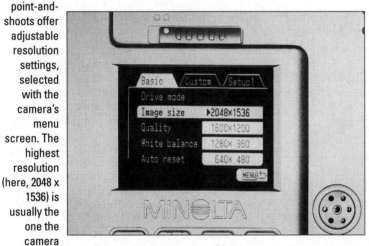

The highest number pair represents pretty much all the pixels available in the camera's image sensor. Multiply 2,018 (the sensor's long dimension) by 1,536 (its short dimension), and you come up with 3,145,728 pixels — about three megapixels. When you turn on your camera for the first time, it's usually preset to this top resolution level. As far as I'm concerned, you can leave it there.

If you want to make good prints — not necessarily now, but even sometime in the future — keep your camera set to its top resolution level. If you want smaller picture files to e-mail, you can always downsize them after the fact with computer software.

What does JPEG have to do with picture quality?

When someone sends you a photo attached to an e-mail, its file name's suffix is often *.jpg*. This means that a digital file format called JPEG has been used to *compress* the picture file so that it is smaller, in kilobytes or megabytes, but still contains the information needed to recreate a photograph on your computer screen (or, for that matter, in a print). This smaller size allows the picture to be sent more quickly over the Internet, and anyone with JPEG viewing capability (which is nearly anyone with a computer) can see it on the other end.

Digital point-and-shoots also use the JPEG file format to save and store their pictures on the camera's memory card. They do it for a somewhat different reason, though. Making the files smaller allows the camera to squeeze more pictures on the memory card.

In fact, most digital cameras give you a choice of two or three levels of JPEG compression. You often find these under the "picture quality" or "quality" mode in the camera's shooting menu. Confusingly, the levels go by different names in different cameras. Typical terms might be *standard* and *fine,* sometimes with a third, *economy* mode below fine; *normal, fine,* and *superfine;* even acronyms such as *HQ* (high quality) and *SHQ* (super high quality). Just remember that the finer or higher the setting, the less your camera's picture files will be compressed, and the bigger they'll be.

Why would you want bigger picture files? That just means less of them — fewer pictures — will fit on a card, right? Right. But files with *less* compression produce higher picture quality than files with *more* compression. That's why they call them fine or high quality, as opposed to normal or standard.

Less compression equals higher picture quality because in order to compress the file, the camera has to average its pixels, in effect. If two pixels in the sky of an outdoor shot are only a slightly different blue, JPEG considers them the *same* blue to save a pixel — and when the file is reopened (after you've got it into your computer, for example), those two pixels really *are* the same blue. The result is a loss of quality, or at least subtlety.

Which JPEG mode to set? For the best pictures — high-quality, decent prints — go with a high or fine setting. To fit more pictures on a card, or for pictures you only want to send by e-mail, set the standard or normal setting. Most digital point-and-shoots seem to come with the quality/compression set one notch below the highest level, and that's fine for most purposes. As you change the JPEG setting, you'll actually see a change in the little number that the viewing screen (or LCD panel) displays to tell you how many more pictures can be fit on your memory card. Reduce the setting, and suddenly you'll have a lot more pictures left! Get a bigger memory card so you don't have to worry so much about this.

A few digital point-and-shoots offer picture quality settings that are *not* JPEG, using file formats that involve little or no compression. These go by names such as TIFF and RAW. (Just what you need, more acronyms.) Don't set them unless you want to make really big prints with very high quality. These file formats eat up a ridiculous amount of space on your memory card, and for most purposes you won't be able to tell the difference between them and JPEGs. (Besides, you or people you e-mail the pictures to may be unable to open them.)

One last note. Don't confuse your camera's JPEG compression/quality setting with its resolution setting, often called the *image size* in your

camera's menu. Resolution is a measure of how *many* pixels are used to produce the picture. You see, you can also use the menu to set the camera so that it uses fewer pixels to begin with. And if you use fewer pixels, you'll *also* make a smaller-sized file, as you do when you increase the compression.

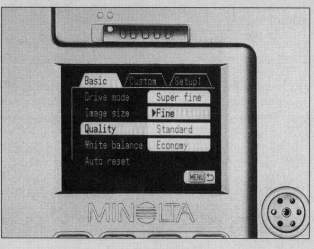

Setting a lower resolution level creates a smaller-sized picture file — that is, one that has fewer bytes, whether megabytes or just kilobytes (thousands of bytes). (You can also create a smaller file by lowering the "picture quality" level; see the sidebar, "What does JPEG have to do with picture quality?") When you do this, the camera doesn't use all its individual pixels; instead, it bunches the smaller pixels into bigger ones, perhaps using four to make one. The smaller file this produces means the camera can fit more pictures on a memory card. But how many times do I have to tell you? Get a bigger memory card, or two.

A better reason to set lower resolution is if you really don't expect, *ever*, to print a picture or pictures. (If this is the case, you probably have more camera than you need!) If you just want to e-mail pictures or put them on a Web site, and are satisfied just to look at them on a computer screen, go ahead and turn down the resolution. Here are a few suggestions:

- If you want to make good-quality 5 x 7-inch prints, set the camera to the 2048 x 1536 resolution. If you have a three-megapixel model, this will be your top resolution; if you have a four-megapixel model, it will probably be one notch down. This setting may also produce acceptable 8 x 10 prints, depending on other camera factors. If you expect to make lots of 8 x 10s and want them to be high quality, though, you should probably be shooting with a four-megapixel model left at its top resolution setting.

✔ If you want to make good 4 x 6-inch prints, set the camera at least to the 1600 x 1200 resolution. If you have a three-megapixel model, this will probably be one notch down. My advice, if you have a three-megapixel model, is to leave the camera at its top (usually around 2000 x 1500) resolution.

✔ If you want to make a picture that will only be viewed on a computer screen, but at a screen-filling size, the 1024 x 768 setting should be sufficient.

✔ If you want a picture that will be viewed at a small size on a computer screen, or on a standard (not HDTV) television set, 640 x 480 will do.

When you adjust the resolution downward, you'll see the little number on the viewing screen and/or LCD panel that tells you how many more pictures you can fit on the card go up and up. Set 640 x 480, and you'll be able to fit hundreds if not thousands of pictures on a decent-sized memory card. Enough said! There's no need to make the resolution issue any more complicated than that.

The Viewing Screen

On the back of all but the cheapest digital point-and-shoot cameras is a small, flat TV-like screen. In other photography books it's called an LCD screen or an LCD monitor, sometimes preceded by the word color. (LCD stands for liquid crystal display, the same basic technology found in digital watches and flat-screen TVs, not to mention new computer monitors.) I prefer to call it a *viewing screen,* which helps distinguish it from the smaller black-and-white LCD panel with which some digital point-and-shoots, and nearly all film cameras, display basic data.

Sometimes hinged and/or rotatable so you can keep your eye on it even when you're shooting at weird angles, the viewing screen is a multipurpose feature. Here's how it's used.

✔ **To compose and shoot pictures.** You can use the viewing screen to get a "live" image of your subject, composing with it the same way you do with video camcorders having swing-out screens.

✔ **To adjust camera settings.** Push a button, and the viewing screen displays a "menu" like the ones shown by VCRs and DVD players on your TV screen. You push buttons to scroll through the menu and make choices. (Keep in mind that operating controls for basic settings are usually found on the camera body, so you don't have to deal with the menu to change them.)

✔ **To "play back" pictures you've taken.** You can use the viewing screen to look at the pictures you've shot (but only the ones that are still on the memory card). The screen allows you to check and share your results

immediately — impossible with a film point-and-shoot. You just push a button to move from one picture to the next, and some models can display a grid of "thumbnails" so you can refer to several pictures at once, though they will be *very* small.

✔ **To erase pictures you don't want or don't like.** If, when you're reviewing pictures you've taken, you see one you don't like, you can get rid of it by pressing the camera's erase button (sometimes marked with a trash can symbol) and following the prompts. This frees up space on the memory card for another picture. But be sure to read the section "When To Erase Pictures?" later in this chapter.

Viewfinder versus Viewing Screen

When I take pictures with a digital point-and-shoot, my instinct — ingrained from years of shooting with 35mm cameras — is to put it to my eye. Holding the camera against my face gives me a feeling of security, both because it's familiar and because it helps keep the camera steadier. As I explain in Chapter 1, holding the camera steady is very important, one of several keys to getting consistently sharp pictures.

I can't deny, though, that it's fun to take pictures using a digital point-and-shoot's little viewing screen. As you hold the camera and its screen a foot or two away from your face, you almost feel as if you're looking at a finished, framed picture of your subject. And because your face isn't glued to the camera, you can look back and forth between the subject and the viewing screen. This can make it easier to choose the right moment when you're photographing people.

Just as with a regular viewfinder in an autofocus point-and-shoot, the viewing screen displays a focus point or points, and you use them the same way to make sure the camera is focusing correctly. (See Figure 15-4, and refer to Chapter 6 for more on locking the focus.)

If you have a video camcorder with a swing-out screen, the novelty of composing pictures this way may have already worn off. But there is a critical difference between shooting with your camcorder's screen and shooting with a digital point-and-shoot's viewing screen. When you hold either a camcorder or a camera away from your face, at arm's length, you're more likely to jiggle it; because it's not being steadied against your face, tremors from your hands and arms can become more pronounced. When you play back video this usually isn't that noticeable because the jiggle is part of a moving picture, and in many camcorders is smoothed out by a built-in image-stabilizing system. But if you jiggle a digital point-and-shoot too much while you're taking a picture, the picture will be unsharp, or even blurred.

Figure 15-4:
A digital
point-and-
shoot's
viewing
screen has
a focus
point or
points (here,
indicated
with
brackets)
just like a
viewfinder,
and you use
it the same
way to
control
where the
camera is
focusing
(see
Chapter 6).

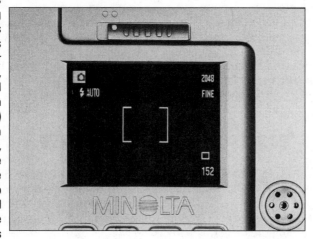

Don't worry about this if you're taking pictures with the camera's built-in flash, because the flash burst is short enough to freeze both motion in the subject and the jiggle from your hands. But if the light is bright enough to keep the flash from firing, you should take special care to hold the camera steady when you press the shutter button. This is critical if you've deliberately turned the flash off in dim conditions to capture the existing light. (See Chapters 7 and 8.)

I'm not trying to dissuade you from using the viewing screen to shoot. But unless you're really steady, you may want to avoid holding the camera at full arm's length. Try bracing your upper arms against your chest instead. This will place the camera closer to your face than you may be accustomed to having it, though — and if you need reading glasses to see clearly close up, like I do, arm's length may be necessary. Just remember: You can always use the viewfinder to compose if you're concerned about shaking the camera!

If you've read through this whole book to reach this chapter, you know that there are always exceptions in photography. Here are two more. One is that some digital point-and-shoots — especially those that try very hard to be small or that have an unusual design — *have* no viewfinder, only a viewing screen. With these models you have no choice but to compose with the screen, so steady as she goes.

Exception number two: When you're taking close-up pictures, *always* use the viewing screen, not the viewfinder, to compose. The viewing screen displays the image of the subject that the lens is actually focusing onto the camera's image sensor, whereas the viewfinder is a window separate from the lens. When you're at a reasonable distance from the subject, there's not much practical difference between what the viewfinder and viewing screen see. But as I explain in Chapter 5, the closer you get to the subject, the greater this discrepancy.

How close is too close to use the viewfinder? Sorry, but it depends on the construction of your camera. As a general rule, though, if you're shooting anything closer than a head-and-shoulders portrait of someone with your camera not zoomed way in, consider switching to the viewing screen. And if you find that the "framing" of close pictures taken with the viewfinder seems a little off, you may have to switch to the viewing screen *before* you get that close. You can find out more about the pros and cons of viewing screens in Chapter 17.

The Viewing Screen and Your Camera's Battery Life

I don't want to spoil your fun, but here's another reason not to use the viewing screen, at least not all the time. The viewing screen is the single most power-hungry feature on your digital point-and-shoot. It sucks the life out of batteries. The more you use it, the more often you'll have to put a fresh or recharged battery or batteries into the camera. The good news is that today's viewing screens are less demanding, electrically speaking, than their predecessors.

That said, if you're shooting blithely and the low battery icon suddenly appears on the viewing screen (or the LCD panel on the camera's top), and you don't have extra batteries or a fast charger on hand, *turn the viewing screen off and take pictures with the viewfinder instead.* This will let you shoot many more pictures with your remaining power than you'd be able to if you continue to use the viewing screen. This assumes, of course, that you have enough room for those extra pictures on your camera's memory card!

For a primer on batteries, see Chapter 1. Digital point-and-shoots have a wider variety of power strategies than film point-and-shoots, which tend to stick with small lithium cells or standard-issue AAs. Many digital point-and-shoot cameras use standard AA batteries, too, which is an enormous help if you run out of juice in Jalalabad. You can find AAs almost anywhere. But because digital cameras are getting smaller, many AA-using models now take just two batteries instead of four. This cuts your power supply in half.

If your digital camera uses AA batteries — especially if it uses only *two* AA batteries — try to buy lithium AAs rather than alkaline AAs. Lithium batteries cost substantially more than alkaline batteries, but they last about three times longer in my experience. As far as I can tell, they are no more expensive per picture than alkaline AAs. But they're worth paying more up front for the convenience of fewer battery changes and the reduced chance that your camera will quit on you when you're taking important pictures.

Then there are rechargeable AAs. These have come a long way since the last edition of this book, and because digital point-and-shoots go through batteries so fast, can save you a lot of money in the long run. Some cameras even come with rechargeable AAs and their own charger, which you plug into a wall outlet. Most good rechargeable AAs use a chemical technology called NiMH, which stands for Nickel Metal Hydride. (Look for the acronym.)

Of course, when rechargeable batteries run out of juice, you have to charge them. So buy an extra set of rechargeables and keep them charged up. That way, when one set runs down you can pop the other into the camera, and charge the depleted batteries while you keep shooting with the others.

If your rechargeable AA batteries run out of juice and you don't have a spare set, you can substitute regular AA batteries (alkaline or lithium!). When you're shooting, keep some with you just in case.

Because full recharging can take four hours or more, even with an extra set of batteries you may be pushing your luck if you're doing lots of shooting. The remedy: Get a fast charger, available at most hardware and drug stores as well as camera shops. (Yes, even if your camera came with one.) Many current chargers claim to rejuvenate NiMH batteries in an hour, and newer models are further reducing that time.

Pocket-sized digital cameras usually come with a proprietary rechargeable battery created for that particular model or a group of similar models. Often wafer-thin so that they can slide into the camera right beside the memory card (see Figure 15-5), these are usually lithium-ion batteries, and are recharged either in a charger that's supplied with the camera or in the camera itself. When fully charged, they can power the camera for a good number of pictures, but you still face the problem of running out of juice in the middle of shooting. These batteries sometimes take a while to charge, too, so I'd proffer the same tip I do for rechargeable AAs.

If your camera uses a proprietary lithium-ion battery, buy a second battery so that you can recharge one while the other's in the camera. Available as accessories, these batteries are significantly more expensive than AA rechargeables, but well worth it. And if your camera uses this type of battery but wasn't supplied with a charger (no fair!), get one for it. (It should also be available as an accessory.) Otherwise, you'll have to plug the *camera* in every time you want to charge the battery.

Figure 15-5:
Shirtpocket-sized digital point-and-shoots usually stay small by drawing their power from a lithium battery specifically designed for the camera. It often slides into a slot right beside the memory card.

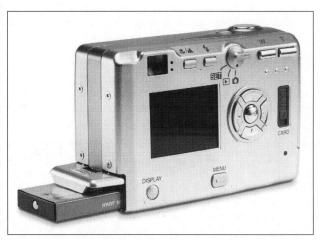

Quite a few models can be had with a *dock,* a little electronic cradle that stays hooked up to your computer's USB port. Slip the camera into the dock (which is sometimes supplied, sometimes an accessory) and it does double duty, allowing you to download pictures and recharge the camera's battery. Clever idea, but it still ties up your camera when you need a charge! (See the section "Downloading from a Digital Point-and-Shoot," later in this chapter.)

What's on the Menu?

Using a digital point-and-shoot's viewing screen to take pictures is a straight-forward affair. Using it to review pictures is almost as easy. But using it to adjust the camera's menu can be intimidating — though if you're comfortable with computers, PDAs, and the like, its scroll-and-select operation will proba-bly seem familiar.

If you're not ready to face the menu, take heart. Most digital point-and-shoot cameras come with the menu preset to various defaults (see Chapter 4 for more) that will work fine for most purposes. At the least, you may want to go in there and set the current time, unless you're one of those people who doesn't mind the flashing 12:00 on your VCR. Otherwise, you can just turn the camera on and start shooting, provided you have a memory card in place.

The way the menu is structured on digital point-and-shoots is as varied as the arrangement of their buttons. (Yes, I'm afraid you'll have to consult your manual.) The screen itself displays a series of line items identifying particular features with on/off, yes/no, or specific settings across from them. (See Figure 15-6.) But usually there are two or more *separate* menus on a digital point-and-shoot.

✔ **The shooting menu,** also called the *record* or *capture* menu, is the one in which you adjust such things as resolution, picture quality, ISO setting, white balance, and other refinements that have to do with taking and storing pictures. The number of these settings depends on the sophistication of your particular model.

✔ **The setup menu** is where you make choices about things that go on in the background, to borrow from computer terminology. These include the date and time, whether or not you want the camera to use its digital zooming capability (see the sidebar "Digital zooming: The shame of film-less photography," later in this chapter), whether you want the camera to beep (and even how loud), the brightness of the viewing screen, and even the menu's language. I now know that resolution is *définition* in French, *Tamaño* in Spanish, and *Auflösung* in German.

✔ **The playback menu** usually doesn't offer many choices, but among them may be the ability to view several smaller pictures all at once and the ability to set the screen to an automatic "slide show" of the pictures on your memory card.

Figure 15-6:
When you push the menu button on a digital point-and-shoot, its viewing screen displays lines of text representing camera settings; when you want to change a setting, you scroll to the line to highlight it.

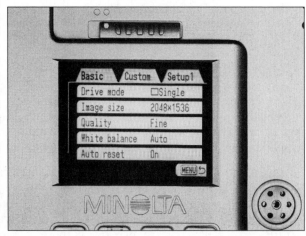

There are sometimes other, separate menus for specific modes, maybe one for movies. Yes, movies. Many digital point-and-shoots can take short video clips that are of lower quality than you'd get from a camcorder, but fun to e-mail. To shoot them, you usually just turn the main dial to the movie setting. After that you're on your own, 'cause I'm just a still-photo guy.

Sometimes you access a menu by first rotating your point-and-shoot's main dial to a camera icon and/or the word *auto* (for the shooting menu), the word "setup" (for the setup menu), or to a little right-pointing arrow (for the playback menu). (See Figure 15-7.) Then you push the menu button next to the viewing screen to make the menu appear. In other models, you push the menu button straight away, then use a four-way thumb control to the right of the viewing screen to select individual menus for shooting (again, often a camera icon), setup, and playback. Once you highlight the menu you want, you may have to push a button marked "OK" or "Set" to make it appear; in other models you push the center or right side of the four-way control (which I describe in the next section). Thoughtful models' viewing screens may prompt you as you go along.

Figure 15-7:
On some digital point-and-shoots you rotate a dial to set the camera for shooting, picture playback, and making basic settings; once you do, you push the menu button to access the menu for that mode.

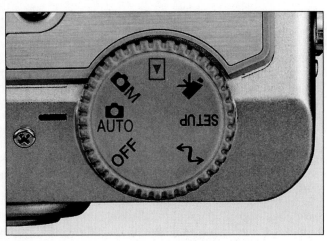

Using the Menu to Change Settings and Choose Modes

Once the menu you want is displayed on the viewing screen, you scroll through the items on it by using a four-way control to the right of the viewing screen. The control is designed to be operated with your right thumb; sometimes it's really just four buttons in a diamond pattern, sometimes a circular "rocker" switch. Whatever its design, it can be pushed in at the top (let's call it *up*), at the bottom (let's call it *down*), *left,* or *right.* Usually you scroll through menus by pushing it up and down, which causes each line of the menu to be highlighted in succession, with a change in color and/or brightness.

Once you've scrolled to a setting you want to adjust, you usually push the *right* button to select it. This activates a pop-up submenu of the different selections (see Figure 15-3 to see an example of a submenu). You then go back to the *up/down* buttons to scroll through *these* choices, and when you've highlighted the one you want, to set you either press the *right* button again, or press a separate *set* button, or push the whole four-way control straight in as if it were a single button. To opt out or back up to the previous menu level, you push the *left* button.

With some models you have to push a separate button, usually marked *function,* to access additional settings for shooting. On models in which you have to push a separate button (or slide a switch) to play back pictures, you have to push *that* button (or slide *that* switch), then push the menu button to get into the playback menu. Sometimes the up, down, left, and right of the four-way control do double duty as regular buttons when you're shooting, setting things like the flash mode or self-timer. They should be marked accordingly. Phew!

With some digital point-and-shoots, you *don't* have to select the item and turn off the menu before you resume shooting. You can simply leave your selection highlighted and touch the shutter button, and it's automatically set. The viewing screen immediately reverts to showing you the subject, and you can take a picture straight away.

I can't overemphasize that little if any standardization exists when it comes to making menu settings. If you've grown up in the world of Windows-style computer interfaces and programmable home electronics, you can probably feel your way through. If you haven't, well, then that makes two of us.

Earlier in this chapter I discuss when and why you might want to make adjustments to two prominent menu items, the resolution (see "Setting the Resolution" earlier in this chapter) and image quality (see the earlier sidebar "What does JPEG have to do with picture quality?"). On some digital point-and-shoots you can also adjust the ISO, which I suggest doing in Chapter 12 mainly for freezing action subjects more effectively. You can leave the *white balance* alone, as far as I'm concerned, set to its default "auto" mode — but if you can't help yourself, find out more about adjusting it in Chapter 9.

Digital zooming: The shame of filmless photography

I'm being melodramatic, but buyer beware: Digital zooming is no substitute for _real_ zooming. Real zooming is optical, done by moving glass elements within the lens to magnify or reduce the size of the subject on film or a digital point-and-shoot's image sensor. Digital zooming is accomplished by taking a smaller and smaller section out of the middle of the image sensor, and filling the frame — and the viewing screen — with just that piece. Digital zooming basically _crops_ the subject in the camera.

What's wrong with this picture? The more you zoom digitally, the fewer pixels make up the picture, and the worse its quality will be. You'll see a progressive loss of sharpness and smoothness in the image, though this isn't always readily apparent on the viewing screen. If you want to zoom, you should be using a camera with a real zoom lens. (See Chapter 17.) Even if you _have_ a camera with a real zoom (you can tell because the lens actually moves in and out), it may offer digital zooming to boost magnification beyond the limit of its focal length range. If this is the case, my advice is to go into the menu and turn off the digital zooming feature. Otherwise, the camera will automatically start zooming digitally when it reaches the limit of its optical zoom. And I'd rather have it stop there so you'll actually move _closer_ to your subject. (See Chapter 10.)

Once you get more comfortable with menu-setting, however, you may want to use the menu both to customize the camera (to turn off those incessant beeps and chimes, for example, or to make the LCD screen brighter) and to actually fine-tune the visual characteristics of your digital pictures. The latter may produce dramatic, obvious changes, creating intense, poster-like colors (posterization) or partially reversing tones (solarization). The following characteristics are more useful to tweak, if your camera lets you adjust them at all.

✔ **Sharpness.** Subtle in its effect, this adjustment futzes with the edges of things in a picture, making them stand out more. Increasing the sharpness setting creates the _illusion_ of greater sharpness, but it can also lessen the overall smoothness of an image. The settings are often called normal, high, and low, but you might find up to five numbered levels indicated with a plus or minus (+1, 0, -1). I would probably leave this setting at its normal position, but you can certainly experiment to see if increasing the sharpness level makes your pictures look crisper.

✔ **Saturation.** This controls the richness or brilliance with which colors are reproduced, and the settings are usually called normal, high, and low. (Sometimes black-and-white shooting modes are included here, because a black-and-white picture is completely desaturated.) I've had success with turning up the saturation; one model I've used has a "vivid color" setting that produces vibrant pinks and greens. But keep in mind that increasing color saturation can make a subject (particularly skin tones) look unnatural, and can even cause a loss of texture and detail in brightly-colored areas.

✔ **Contrast.** Basically the degree to which differences between shades or tones of your subject are reproduced, this setting is usually best left alone — at its normal position rather than high or low. If your digital prints always look a little flat and dull, though, try increasing it. A more likely application is in turning the contrast *down* when the subject is in very harsh light that might make it hard for your camera's image sensor to capture the full range of its detail.

Taking Pictures with Your Digital Point-and-Shoot

I really didn't have to include this section, but you were probably waiting for it. The business of taking pictures with a digital point-and-shoot is fundamentally the same as taking pictures with a 35mm or APS model, and the shooting advice in other chapters of *Photography For Dummies* just as relevant. Unlike a film camera, of course, you can switch whenever you want to playback mode to see the picture(s) you've shot. Most models briefly display a picture on the viewing screen right after you take it, and with some you can go into the menu to increase the duration of this time if you think it's too short. Anyway, since I've gone ahead and made this section, let me use it to give you a warning that didn't seem to fit anywhere else.

Never remove your digital point-and-shoot's memory card while the camera is recording — "writing" — a picture on it. This *write time* immediately follows the taking of the picture, and can last as long as several seconds. When it's writing a picture, the camera will either blink a light somewhere on its body (next to the memory card compartment, for example, or sometimes by the viewfinder) or display an icon on its viewing screen. (More often than not, this is an old-fashioned hourglass shape.) Check your manual to see how the camera tells you it's in the process of writing a picture to the memory card.

If you remove the card while the camera is recording a picture on it, you will damage or destroy the picture file, and you may damage the camera itself. And if you put a card in and then decide you don't want to use it, wait until the light goes out or the symbol disappears before you pull it out.

When to Erase Pictures?

If you take a picture with film, you've used that frame of film — and can't use it again. If you take a picture with a digital point-and-shoot, it doesn't "use up" your memory card. You can erase the picture, on the spot if you like, to make room for a new and presumably better picture. Great idea, right?

Yes and no. Since memory cards are reusable, you don't have to keep buying them the way you have to keep buying film. You can reuse them, like a VHS videotape. (Okay, so you've moved on to DVD.) But to reuse them you have to erase their contents, and the ease with which you can do this on a digital point-and-shoot camera is (in my opinion) a little dangerous. All you have to do to erase a picture is play it back on the viewing screen, push the erase button (usually marked with a trash can, like on a computer desktop), and when the screen asks if you really want to erase the picture, push the same button again or a separate "set" button.

Shot-by-shot, in-camera erasing is perilous. It's one thing to erase pictures from a memory card once you've looked at them on your computer screen or in a print, and put the ones you want to keep safely in a folder. Hey, that's called editing. But it's a different matter to erase pictures from the memory card *in the camera* just because you need space for more pictures.

Why? Because it's not always easy to tell if a picture is good when you're looking at it on the camera's teeny weeny screeny. Sure, you can tell if it's blurry, or if the person you were photographing was turning away when you pressed the shutter button, or if you missed the peak of the action. But it's much harder to read facial expressions and to evaluate the richness of detail in a photograph when you're viewing it at such a small scale. A picture that looks so-so on the viewing screen might, when you're back home seeing it on your computer or in a print, look very different — and might be a keeper after all.

So my advice is not to erase pictures on your memory card *when you're shooting* unless they are clearly no good. You might be throwing away a valuable or interesting moment. Instead, take along a big enough memory card to hold all the pictures you're likely to shoot. (Nag, nag.) Then wait until you're home to do the serious editing.

Downloading from a Digital Point-and-Shoot

So how do you get pictures from your digital point-and-shoot into your computer? You use the cable that comes with the camera, plugging one end into the camera and the other into a USB port on your computer. Your camera comes with a CD containing *driver* software that can be installed and used for this process, providing an interface with which the manufacturer has (I can only hope) simplified the process into a few easy mouse clicks. (The software will probably display thumbnails of the pictures on your memory card, without even being asked.) Transferring pictures to your computer in this way is called *downloading*.

TIP

Reading the cards

The biggest hassle with downloading pictures from your digital point-and-shoot is that every time you want to do it, you have to connect the camera to a USB port on your computer, usually on its hard-to-reach backside. For less than the price of a family outing to Bigger Burger, you can save yourself that trouble. You can get your pictures into your computer without even involving your camera in the process, let alone hooking up cables.

The second accessory you buy for your digital point-and-shoot — after a bigger memory card — should be a *memory card reader* for your computer (see figure).

Though it has no moving parts, a card reader behaves like an external drive — one with which your computer can read and retrieve picture files from your memory card. You leave the card reader plugged into your computer (usually into its USB port, and if you have a newer computer, there should be a few to spare). Then, every time you want to move pictures from your camera to your computer you just pull the memory card out of the camera (turn the camera off first) and slide it into the slot on the card reader. An icon for the card reader appears on your computer's screen, and you click on it to see icons of your picture files. You can double-click on the files to open them up for a nice, full-screen look, or you can save them simply by dragging and dropping them onto your desktop or into a folder. You don't have to go through any special software interface.

Card readers are inexpensive — $25 or less as of this writing. Be sure to get one for your particular card format — CompactFlash, Secure Digital, and so forth. For a little more money, you can get card readers that take two or more card formats (in fact, all the common formats), which you may want to do if you're thinking of getting a new camera down the road, or if someone else in the family has a camera that uses a different kind of memory card. The model shown here accepts both CompactFlash (the most widespread card type) and Secure Digital (the fastest growing).

After you've downloaded the contents of a card, you erase the images (which you can do in the camera or with the camera's own software) so you can start shooting again. Once the pictures are in the computer, you can view, manipulate, and output the pictures with a variety of imaging programs. That's what Chapter 16 is all about.

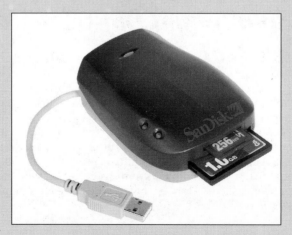

With most new digital point-and-shoots, though, you don't really have to use the supplied software to get pictures into your computer. Once you plug the camera in, the computer recognizes it as an external drive, displaying an icon for it on its own screen. You then double-click on this icon and retrieve picture files directly, dragging and dropping them where you want. Downloading is a no-brainer compared to operating the menu on your camera! But there's an even simpler, more convenient way to get pictures into your computer: with a memory card reader (see the sidebar "Reading the cards").

Chapter 16

What to Do with Digital Pictures?

There's a lot more to digital photography than digital point-and-shoots. In fact, you don't even *need* a digital point-and-shoot to be a part of it. You can turn your computer into a digital darkroom with two basic ingredients: image-editing software and your picture files. As I mention at the beginning of Chapter 15, those files can be created by scanning film you've already shot and processed, whether 20 years ago or today. Or they can be created by scanning the prints themselves, if you can't find the negatives or are too lazy to look for them. And once you've had your digital way with your pictures — or not — you can output them to your own photo-quality desktop printer, no photofinisher needed. Or you can have a photofinisher print them for you, either by uploading the files to an online printing service or burning them to a CD and dropping it off at the store.

The corollary to all of that is that if you *do* have a digital point-and-shoot, you *don't* need a computer to get prints. Once you've filled your camera's memory card with pictures, you can take it to a photofinisher to have the pictures printed — though at this point in time you may have to look around for a photofinisher in your area who offers this service. Even if you can't find one, chances are you'll be able to find a photo kiosk, a sort of vending machine that dispenses digital prints rather than candy bars. Slip your memory card (or a CD or floppy disk) into the correct slot on the kiosk and use its computer screen interface to print to your heart's content — unless there's someone in line behind you.

You can even make prints from your digital point-and-shoot *at home* without a computer. A growing number of inexpensive printer models now have built-in slots for printing directly from different types of memory cards. With other models, you can print by plugging a cable between the camera and a port on

the printer, using its viewing screen to choose the pictures you want. Some of these are even small models that create 4 x 6 prints exclusively. What a funny idea: You can buy a digital printer even if you don't have a computer!

Getting Pictures into Your Computer — Without a Digital Camera

Scanning is the bridge from film to digital. It's a process that turns photographs you've made on film — whether negatives or slides — into digital picture files that can be transferred to your computer for e-mailing, image editing, digital printing, and even archiving onto CDs. (More about that later in this chapter.)

A film scanner works in much the same way as a digital point-and-shoot, using an electronic image sensor to record a pattern of light and color formed on its surface, then saving it as a picture file. But instead of recording the image of a real scene formed by a camera's lens, the scanner's sensor records the image preserved on the film, which is focused on the sensor's surface by a lens inside the scanner. Rather than a rectangle of pixels as in a digital point-and-shoot, the sensor in a scanner is a single row of pixels that physically moves across the focused image to record it. That's why scanning a film or slide can take up to a minute or two, as opposed to a fraction of a second.

You can have your photofinisher scan your negatives (or slides), or you can scan them yourself with a desktop scanner — a computer peripheral that's easier to use than ever. Here are the details on these two options.

Having your photofinisher scan your film

Your photofinisher scans your film with machinery made specifically for high volume work. Because of its speed, such equipment is usually limited in the resolution at which it scans. Picture files made this way by your photofinisher may very well be as good as those from a digital point-and-shoot, and they're certainly cheap enough. But they may not capture the full detail of your original film. (Typical photofinishers can only scan 35mm and APS film.)

This is certainly not an issue if you just want to e-mail the pictures, or use them for other kinds of computer-screen display, or even make small (4 x 6-inch) prints. But if you want to make good-sized prints, say 8 x 10s, and/or use image-editing software to work on the pictures, the photofinisher's high-volume scans may not provide the quality you need.

In that case you might want to ask your photofinisher for higher-resolution scans. Tell her what size prints you want to make so that she can determine

what scanning resolution you need. Keep in mind that such scans will cost more than the high-volume kind, though you may be able to get them made from oddball film formats (great-grandpa's old negatives). And while a photofinisher ordinarily has two options in terms of how the scans are supplied to you, both of which are described later in this section, the second option won't work for high-resolution scans.

As for the everyday scans, you can ask the photofinisher to scan your film when you drop it off for processing, the cheapest way to go. Or you can bring in existing negatives, slides, and prints for scanning. When scanning is a la carte — not part of a standard develop and print order — it tends to be more expensive, per picture.

Here are a couple of ways that your photofinisher can get your scans back to you:

✔ **Putting picture files on a CD.** If the photofinisher puts the scans from your pictures on a CD (sometimes called a Picture CD), you just take the disk home and pop it into your computer's CD drive to get your pictures into your computer. Drag and drop the files into a folder or onto the desktop. If your computer doesn't have a CD drive, the photofinisher may be able to put the picture files on a floppy disk, but their quality will probably be less good than on a CD because of floppies' low storage capacity.

Can't find old negatives for pictures you want scanned? Then bring the *prints* to your photofinisher for scanning and storage on a CD. (This is a somewhat more expensive service.) Or you can scan prints on a photo kiosk (see Chapter 3 for details), versions of which are turning up all over, and not just in photo stores. Some of these can save the resulting picture files on a CD, good for long-term storage.

When you want scans of a roll of film you've just shot, you don't have to get prints from it if you don't want them. Tell the photofinisher that you only want the film developed, then scanned to a CD. If you just want to e-mail your pictures, work on them in an image-editing program, and/or print them yourself; you can save money this way.

✔ **Uploading picture files to a Web site.** The other thing your photofinisher can usually do with your picture files is to upload them to a "photo sharing" and printing Web site. There, they can be viewed by people you invite to see them, downloaded whenever you want for your own purposes, or even printed. In fact, friends and family visiting the site can order prints directly, so you don't have to go to the trouble or cost of making prints for everyone! You can also use this service if you shoot with a digital point-and-shoot, since your pictures are already in digital form!

Some mail-order photofinishers (see Chapter 3) will now process your film and, in addition to making and sending you prints, will immediately upload the pictures to their Web site for you to get an early look at. You (or friends and family) can order additional prints directly from the site.

Other views: Looking at digital pictures on TV

So you don't want to bother making prints from the pictures you've just taken with your digital point-and-shoot — at least not yet. But you want to share the pictures with friends and family right away, and they are too small for everyone to see on the camera's viewing screen. There's not enough room for everyone to gather around your computer, either. Fortunately, there's TV.

If your digital point-and-shoot has an AV-out jack, use the AV cable supplied with the camera to connect it to the same ports on your TV that you'd use to look at video from your camcorder. Set the TV to the correct channel and input for video, and set the camera to its playback mode. You'll be able to go through all the pictures with the same button you use to review them on your camera's viewing screen.

If your camera doesn't have an AV-out jack, or you're too lazy to plug it in, don't despair. You can buy small devices — call them memory card players — that you leave plugged into your TV (see figure). You simply slide a memory card into the correct slot and use the supplied remote control to view its pictures.

Still impatient? You can frame your digital pictures before you even get them printed. How is that possible? With a digital photo frame. It looks pretty much like a traditional stand-up picture frame of the sort you'd have on your dresser, but instead of containing a print it houses a flat, computer-like LCD screen. You slip your memory card into a slot on the side, and the frame displays any picture you want for as long as you like — or changes the picture automatically at intervals you specify. These Jetsonian devices are rather expensive, come in a couple of different sizes, and sometimes have interchangeable snap-on frames with different styling.

Scanning film and prints yourself

The cost of photofinishers' scanning services adds up over time. If you're loving what you can do with your pictures digitally but still want to continue shooting film, consider purchasing your own desktop scanner. These units are generally "plug and play" — totally simple in their installation and operation.

They come in models that accept negatives and slides, which are called *film scanners,* or prints and other "reflective" materials, which are called *flatbed scanners.* They are inexpensive enough so that your per-scan cost may be lower, over time, than using a photofinisher's scanning services repeatedly.

One caveat: Scanning at home is much more time-consuming than if your photofinisher does it for you. Before you buy, make sure you want to make *that* investment, too.

Once you install the scanner's "driver" software (which usually comes on a CD) and hook the unit up to your computer, you insert your film or print into the scanner. The software guides you through and controls the needed steps with a screen interface that may be easy to use, or may be a total pain. But the end result, displayed onscreen, is a picture file that you can stash for your various photographic purposes.

✔ **Film scanners** (see Figure 16-1) use your original negative or slide to create digital picture files. Though you can get expensive models for larger film sizes, most are designed for 35mm film, and a number of these can handle both 35mm and APS. To use the scanner, you place the negative strip (or the slide) into a slot, and the software prompts you through the steps needed to make the scan. Some models can scan multiple negatives (or slides) automatically once you load them in.

If you shoot APS film, a slip-in adapter cleverly automates the scanning on compatible models. You insert the processed APS cassette into a compartment, and the scanner automatically unfurls and scans the whole roll, displaying small images of every frame on your computer screen. Select a picture with the scanner's software, and the frame is automatically rescanned at a higher level of quality for printing and other purposes.

Figure 16-1:
A film scanner is a desktop computer peripheral that creates digital picture files directly from your existing negatives or slides — both 35mm and APS.

✔ There's a good chance you already have a **flatbed scanner** (see Figure 16-2) at home or at the office, and it's the way to go if you can't find (or don't want to be bothered with) your original negatives. Flatbeds look like scaled-down photocopiers, with a flat glass plate on which you place your original face-down. Most models are designed to accept up to 8½ x 11-inch prints, leaving plenty of room for a 4 x 6.

Using a flatbed scanner to create picture files is a pretty slow, painstaking process. If you want to do a lot of scanning from old snapshot-sized commercial prints, consider a model that automates the task. A couple of these can actually scan a small stack of 4 x 6-inch prints automatically, pulling them through one after the other like a sheet feeder on an office photocopier. You can also use scanners to digitize documents or nonphotographic images. (Your kids' artwork?)

A flatbed scanner can actually serve as a dual-purpose scanner, allowing you to scan 35mm film (negatives or slides) in addition to prints. Models with this ability accept a *transparency adapter* for the purpose; a few even have that feature built into their lids. A transparency adapter fits on top of the scanner's glass plate and has a built-in lamp that shines light through the film so the scanner can "see" it. Scanning film this way is a slower, more manual process than it is with a film scanner.

If you plan to scan only a few negatives or slides intermittently, though, doing so with a transparency adapter on a flatbed scanner will save you the greater cost of a separate film scanner. Just keep in mind that the transparency adapter itself will add to the cost of the scanner.

Unless you have a top-notch flatbed scanner, don't use it to scan 35mm film if you want to make big, high-quality prints from the resulting picture files. The picture quality may not be adequate.

Figure 16-2:
A flatbed scanner is a desktop computer peripheral that can create digital picture files directly from prints of varying sizes. Some models allow you to scan film as well.

Imaging Software: Digital Magic

Picture this. You get home from work and suddenly remember that tomorrow is your significant other's birthday — and the card shop is closed. (I hope for your sake you already have the present.) Are you worried? No. You just turn on your computer, click on your digital imaging software, and use it to call up a half dozen thumbnail photos of your sweetheart. You choose the best one and proceed to remove the oak tree that seems to be growing out of his or her head. (You may need to work on your composition; see Chapter 10!) You magnify the image and remove some blemishes. (I won't tell.) You replace that drab sky with a stunning sunset. You key in, with your favorite typeface, "I love you darling, don't ever change." Finally, you send the image by e-mail, use it to create a Web page for all the world to see, or fire up your digital printer to make an old-fashioned card — leaving it on the kitchen table, as if you'd planned things all along.

That remedial magic is made possible by digital imaging software, and specifically, *image editing* software. These special photographic programs allow you to perform everything from simple retouching to dramatic special effects on your pictures. And it doesn't matter how you get the pictures into your computer — with a digital camera, from a CD, or by scanning them straight into the computer yourself.

Digital imaging software comes in a huge variety of forms, from simple quick-fix programs that automatically sharpen your pictures and adjust their colors, to super-sophisticated programs that give you a level of photographic control far exceeding what was possible in the old-fashioned darkroom. Many *For Dummies* books now cover specific consumer-level imaging programs, which can cost as little as $25 and give you virtually everything you need to work with. Some of these programs come bundled with computers and computer peripherals, while others are even supplied free by photofinishers — on the same CD, in fact, on which they've stored your picture files.

Since these programs vary greatly in their capabilities and user interfaces, I can't give you specifics about using them in this short chapter. But here are just a few of the things they let you do with your pictures:

- **Retouching:** You can remove red-eye, wrinkles, dust, and scratches; adjust colors that are dull or off; and make pictures brighter or darker.

- **Resizing and cropping:** You can control the size at which pictures will print or be displayed, and reframe the subject to correct compositional errors.

- **Enhancing:** You can introduce special effects such as exaggerated or false color, blurs, textures, or creative distortion; even change a picture's background or seamlessly collage different shots together.

- **Special projects:** You can use straight or manipulated photographs to create greeting cards, calendars, flyers, announcements, invitations,

even T-shirt transfers and computer screen savers. Many digital imaging programs also include hundreds of "clip art" drawings and borders for decorating your pictures.

✔ **Archiving:** You can organize photographs into digital albums and access particular shots with easy indexing systems.

✔ **E-mailing:** You can send pictures to friends and family — electronically, of course.

All these programs are self-guiding, and many are truly all-purpose, offering e-mail, organizational, and printing capabilities in addition to retouching.

Getting Prints from Your Digital Picture Files

As I mention at the beginning of this chapter, you may be able to have your photofinisher make prints directly from the picture files on your digital point-and-shoot's memory card. And you yourself can upload those files to an online printing service that makes prints and mails them to you.

Uploading picture files to an online printing service is easier said than done. To get good prints, you need to upload files with decent resolution — at least two megapixels — and even when JPEG-compressed (see Chapter 15), such relatively big files may take forever to transmit by dial-up Internet service. If you want to get prints this way, you should sign up for high-speed Internet service, whether DSL or cable modem.

If you plan to use commercial photofinishing services of any sort for your digital photographs, I suggest revisiting Chapter 3 for tips on how to evaluate prints, and how to make prints better. You may not be starting with a negative, but many of the same considerations enter into the process.

If, on the other hand, you want to make prints yourself, you'll need to get yourself a digital printer. I'm not talking about the color printer that's been hooked up to your home or office computer for years. I'm talking about a *photo-quality* desktop digital printer (see Figure 16-3).

What's the difference between a regular color printer and a photo-quality printer? Take *inkjet printers,* which work by spraying microscopic drops of different-colored ink onto paper, and are by far the most common variety of desktop printer. A photo-quality inkjet printer creates its prints' colors by combining, in subtly variable proportions, six different colors of ink. A regular inkjet printer uses just four colors. In addition to the regular model's cyan, magenta, yellow, and black inks, a photo-quality printer adds a light cyan and a light magenta ink. (A couple of photo-quality models even add a seventh, gray

ink, making them especially good at black-and-white printing.) These extra colors help the printer produce a more authentic photographic quality — one that may be indistinguishable from prints made the old-fashioned chemical way.

Figure 16-3:
A photo-quality digital printer such as this inkjet model can produce prints that are indistinguishable from those made by a photo-finisher, and gives you direct control over the results.

So if you're serious about printing your photographs at home, whether from a digital point-and-shoot or from picture files made by scanning film, buy a photo-quality printer. These now cost as little as $100, even less with rebates. Why so cheap? Because printer manufacturers make their real money on paper and ink!

Don't be fooled by printers that call themselves photo-quality, or models a salesman describes this way, but that only use four ink colors. A real photo-quality printer has at least six ink colors, which is why it's also called a six-color printer.

What's more, don't worry about the printer's *dpi,* which stands for dots-per-inch. This is a measure of how many dots of ink it squeezes into a given space. A salesman may tell you that it's better to have more dots per inch if you want to print photographs. But beyond about 720 dots-per-inch you're unlikely to notice much improvement in quality — the dots are just too small for your eye to see — and no inkjet model I can think of has a lower maximum dpi than that. (The number of dots is actually adjustable.) A six-color printer with *lower* dpi would probably be better, for photographic purposes, than a four-color printer with *higher* dpi.

Crop shop: Digital photos and the 4 x 6 print

How did photofinishers settle on 4 x 6 inches (and before that, 3½ x 5 inches) as the size for their standard prints? Because that shape reflects the 2:3 proportions of a 35mm negative, eliminating the need to *crop* the image — to "cut off " one side or the other in order to make the image fit the paper.

If you've ever studied a digital point-and-shoot's viewing screen, though, you've probably noticed that its rectangular shape is not as elongated as that of a 35mm frame. In fact, a digital photograph's proportions are more on the order of 3:4. And this means that when a photofinisher (online or brick-and-mortar) makes a standard 4 x 6-inch print from your picture file, the whole picture doesn't quite fit. In fact, the 4 x 6-inch print shape usually crops a little off the top and/or the bottom of a digital point-and-shoot picture (it crops the picture's long dimension).

Most people don't seem to notice the loss. But if you find that your pictures look a little tight on the long sides — for instance, peoples' heads seem closer to the print's upper edge (again, in a horizontal composition) than they were to the upper edge of the frame when you took the picture — then you may want to compose a little more loosely in the future. (Maybe my begging you to fill the frame really worked.)

If you're viewing pictures on the computer screen, a digital photo's proportions aren't an issue; you see the whole thing. And it isn't a problem if you do your own printing. You can always trim a print if need be. And if you're making 8 x 10s, a digital point-and-shoot image usually fits *better* than one scanned from a 35mm negative. With the 35mm scan, the *short* sides must be cropped to fit the paper!

Some photo-quality printers create their prints with an entirely different technology than inkjet models. These *dye-sublimation* models use multicolored ribbons and, usually, heat to make special paper absorb cyan, magenta, and yellow dyes. However, dye-sublimation models that make prints as large as common inkjet printers (say, up to 8 x 10) are often many times more expensive. Dye-sublimation models that make *snapshot*-sized prints, on the other hand, are affordable, and they produce excellent picture quality. If small prints are all you want, give these models a serious look.

So, rather than break photo-quality printers down by their respective technologies, I prefer to do it by size. That way, you can decide what to get — if you need to buy a new printer for your photos — on the straightforward basis of whether you want big or small prints. If you want mostly 4 x 6 prints and only the occasional blow-up, consider getting a snapshot model, described later in this section, and going to a photofinisher when you want a bigger print of a special picture.

Don't buy a desktop printer for your photography thinking you'll be saving money. The cost of ink and paper are often more, per print, than what you'd pay at the photofinisher!

Here are a couple of choices you might find when shopping for a printer:

✔ **Snapshot printers.** These compact models are expressly designed to make the sort of small, family album-sized prints you're accustomed to getting from your photofinisher. Many produce prints in the same standard 4 x 6-inch or 3½ x 5-inch sizes; others make smaller prints that are similar in size to a Polaroid instant print. You load them with a stack of precut sheets of paper; with some models, you buy paper and ink in a single kit that's good for a specific number of prints, with just the right amount of ink. (Some of these use dye sublimation, while others use the same inkjet system as on bigger models.)

Though snapshot printers can be operated directly from your computer just like larger desktop models, their *raison d'etre* is often to *bypass* the computer. To this end, they incorporate slots for memory cards. The idea: You take the memory card out of your camera, put it straight into the printer, and choose the pictures you want to print. Or you can print them all. (Sometimes you need an adapter, which may be supplied with the printer, to make your particular memory card fit the slot.) You make your choices with pushbuttons and an LCD panel on the printer; the panel displays picture file names and numbers. Some models have little viewing screens like the one on your digital camera, so that you can actually see the pictures when you choose them. This makes the whole process easier.

Some snapshot printers can be operated on batteries, making them entirely portable. Bring one along on a trip and you can make prints on the spot from your digital point-and-shoot — allowing you to give them immediately to friends and family, or even the subjects of your travel pictures. (Now there's an incentive to pose for you.) You'll see wide variations in design when you shop for a snapshot printer. One new Kodak model functions as a camera dock; you place the camera (only certain Kodak models) in it, and the images can be printed directly to 4 x 6 size. You use the viewing screen on the camera itself to select the pictures you want to print. (Or you can print everything on the camera's card with the push of a button.)

✔ **Full-sized printers.** If you want to make bigger prints than 4 x 6 — blow-ups, as some film-weaned photographers still call them — then you need a full-sized desktop color printer. In fact, typical models go up to 8½ x 11, the standard stationery size, but you'll still need to get one even for 5 x 7-inch prints.

Fortunately, you can often get special hardware and software for these models (sometimes they even come in the box) that make it easy to get smaller prints when you want them. These include adaptations such as a special holder that accepts a four-inch-wide roll of paper, allowing automated 4 x 6 printing when used in combination with supplied software.

Unlike many snapshot models, most full-sized printers are designed to connect directly to your computer via USB cable. But like their snapshot counterparts, a number of them also incorporate slots for direct printing from various memory cards. This feature adds to the cost of the printer, but it streamlines matters if you want prints fast. Most widely available full-sized models use inkjet technology to print, so you'll have to keep stocked up on ink cartridges and inkjet paper, available at office supply stores and online. (Some home printers get best results with a printer when they use the manufacturer's own paper; in any case, definitely use the manufacturer's ink cartridges!) If you want to print straight from memory cards, and the printer lacks a viewing screen for choosing pictures, you may be able to buy a small accessory screen that plugs into the top of the printer.

If you don't have a built-in or accessory viewing screen on your printer, whether it's a snapshot or full-sized model, you'll have an easier time choosing pictures by first making an index print of the contents of the card. (This is usually an easy, one-button option.) You then refer to the file names and numbers under each thumbnail image on the index print to make your choices.

Archiving Pictures from Your Digital Point-and-Shoot

Printing at home, directly from memory cards, sounds like the perfect solution to getting prints from pictures you've taken with a digital point-and-shoot. Hurray, you no longer have to deal with negatives! Wait . . . that could be a problem.

If you do nothing but print directly from memory cards, and then erase the cards to make room for more pictures, the print is your only record of the picture. And I hate to tell you this, but inkjet prints in particular are notoriously subject to fading and discoloring — especially when they're on display, where light and airborne contaminants can accelerate the process.

Manufacturers have made great gains in the stability of their inks and paper; many claim their prints will last 25 years or longer when displayed under glass and not in direct light. But I've watched inkjet prints I've made and just stuck on the wall turn pink in three months. Dye-sublimation prints are generally more stable, but still don't have the lifespan of a well-processed print on a good conventional photo paper, which is what you get from a reputable photofinisher. Which reminds me: Prints your photofinisher makes from a digital point-and-shoot's picture files are ordinarily on the same paper used for printing photos shot on film, so they may actually last longer than the prints you make at home.

The ink used by inkjet printers may not be waterproof, or even water-resistant. One drop on a print and its ink may run or smear. Keep your inkjet prints away from water and out of damp environments. And sacrifice a print to check its water-resistance, so you know just how careful you need to be. (If the results are dire, you can buy commercial aerosol sprays to protect inkjet prints.) Dye-sublimation prints are more water-resistant than most inkjet prints. With either type of print, though, don't display pictures in locations that receive direct sunlight. You'll be surprised at how rapidly they discolor and fade!

Even if a print you make at home lasts 25 or 30 years, is that enough? For you, maybe, depending on your age. But not if you want your children to have full-color pictures with which to remember growing up.

Now, if you download the pictures from a memory card to your computer before or after you print them — or you're using your computer to actually make your prints, in which case they're already in there — they're safe. They're safe, that is, until your computer crashes and the picture files get corrupted. Or your computer dies and all your data, pictures included, is gone forever.

It's one thing to keep scans from your negatives in your computer; if anything happens to them, you can always go back to the negative for scanning and/or reprinting. (And unless you're scanning the negatives yourself, the picture files may have been on a CD from your photofinisher to begin with.) But if your photos are from a digital point-and-shoot, you absolutely, positively need to back them up, by copying the picture files to media that can be removed from your computer and put in safe storage.

You can use magnetic media — Zip disks and their relatives — for this purpose. But the "writable" CD is a more stable picture-storage medium, and if you have a newer computer it may well have a CD writer built in. If not, you can buy one as an accessory for your computer. *Burning* CDs, as it's often called, has become pretty commonplace, at least among the computer-savvy.

And if you're not a part of that crowd? Your photofinisher can save your digital point-and-shoot pictures to a CD when he's making prints of them, if he offers direct-from-memory-card services. And a number of photo kiosks, in addition to letting you make prints directly from memory cards, allow you to save the card's picture files straight to a CD. You can even get stand-alone CD writers that accept a memory card directly; you just put the card in a slot and, with a couple of button pushes, copy its contents on the CD. Great idea, but if you buy one of these, then you *really* must hate computers!

Part VI
The Part of Tens

The 5th Wave By Rich Tennant

In this part . . .

This part alone is worth the price of admission to *Photography For Dummies,* 2nd Edition, and proof that good things come in tens — or, in a few cases, elevens and twelves. Camera won't shoot? Try the ten things suggested in Chapter 20. Is the problem fatal? Read Chapter 17. My personal favorite is Chapter 19, a list of great places to take pictures. And in Chapter 18, I present ten simple ways to improve your point-and-shoot pictures. Does this whole book boil down to ten tips? You be the judge. Try all ten and see what happens to your photographs!

Chapter 17

Ten Things to Think about When Buying a Point-and-Shoot Camera

*I*f you're reading this book, you probably have a camera already. And chances are good that your camera has the right stuff to help you make better pictures — if you bring the right attitude and an intelligent eye to it. But after reading this book you may decide that to take the kinds of pictures you'd like to take — and to get the picture quality you want — you have to go out and buy a new point-and-shoot. Your old camera may be a bulky, compli-cated 35mm single-lens reflex (SLR) that you'd like to replace with something more compact and simpler to operate — a point-and-shoot camera that doesn't sit in your closet when you're at home, and stay home when you're off to occasions and on vacation.

Maybe you're already using a 35mm point-and-shoot but want to get a new camera with more features or creative options — extra flash modes or a longer-zooming lens. And some of you may be considering the purchase of a *second* point-and-shoot, perhaps a more full-featured model for specific kinds of subjects, a more pocketable model for go-anywhere convenience, or a digital point-and-shoot that will involve your computer in the photographic process, and let you kiss film goodbye. Whatever your reasons, this chapter tells you what to think about.

Don't Buy More Camera Than You Need

When you go shopping for your camera, don't let a salesperson talk you into buying more camera than you really need. If you want extra zoom power or added features, naturally you have to pay more. But don't fall for things that a salesperson says you'll grow into, when your intuition and photographic purposes tell you you'll never use them. How often do you really think you'll need an *intervalometer,* a mode for time-lapse photography? On the other hand, if such photographic exotica intrigues you, remember that moderately priced zoom models tend to have pretty advanced features anyway, because the point-and-shoot marketplace is so competitive.

Visit your newsstand to check out the major photo magazines and their comprehensive buying guides. (I recommend *Popular Photography.*) Ask snap-shooting friends which models they've been happy with. And be sure to check out the Web. Many online dealers provide customers with the opportunity to comment (good or bad) on models they've purchased, and may even help you narrow things down to particular models by asking you to fill in a few information fields. Just as useful, independent photo sites offer buying tips and full reviews of the latest models. (Try *www.popphoto.com.*)

How Much Do You Want to Spend?

The question of how much you want to spend dictates all other questions. Consider 35mm models, which have become a remarkable deal for the dough because of pressure from the dropping prices of digital point-and-shoots. If you want to spend $50 or less, then you probably can't get a zoom lens — so you don't have to figure out what zoom range you'd like. You'll get a single-focal-length (nonzooming) lens, and you probably won't get autofocus. I think autofocus is worth the extra money; you usually have to spend at least $75 to get it, and even then it may be on the rudimentary side.

With non-autofocus models (I call them fixed-focus, manufacturers call them focus-free) you have to worry about whether you're too close to the subject, because you must ordinarily stay back at least four feet to keep the subject sharp. (This is less of a problem with fixed-focus digital models, but there aren't too many of those.) With autofocus models, you don't have to worry — but you need to help the camera focus in the right place. (See Chapter 6.)

If you're willing to spend up to $100 or more on a 35mm point-and-shoot, you have a choice between a modest zoom camera — perhaps something with a 38–90mm lens — and a very good nonzooming model, which typically has a single-focal-length lens of 35mm or shorter. In many cases, I would vote for

the nonzooming model simply because you can do what the zoom does just by moving a few steps closer. (At this price, the nonzooming model's lens will also probably be faster — that is, have a larger window in its lens, the better to shoot by dim light — and sharper.) Tight portraits are another story, though, as I explain in the section "Do You Want a Zooming or Nonzooming Model?" later in this chapter.

Finally, if you're prepared to spend up to $200 (or even a tad more) on a 35mm model, you'll get a long-ranging zoom — one that goes out to 140mm or 160mm. But the waters are muddied here by designer point-and-shoots that cost three or four times that price and have single-focal-length lenses. With these models you're paying for professional-quality optics and camera bodies made of metal alloy rather than plastic. And you're paying for style.

Who Will Be Using the Camera?

Buying a top-of-the-line point-and-shoot for a teenager who just wants it for buddy pictures would be silly. And for a person with artistic yearnings to buy a discount store's blister-pack point-and-shoot would be pointless. The teenager should get the blister-pack model (especially because he is likely to lose or abuse it), or, if parents are feeling more extravagant, an under-$100, single-focal-length model with autofocus. And the artistic type should get the top-of-the-line model for its choice of modes and optical quality, though a gadget-loving snapshooter would be equally happy with such a camera.

The family documentarian can do her job — from shooting at-home candids to snapping family vacations — with a standard 35mm zoom model, say one with a 38–105mm lens. A shirtpocket model may make that job easier because it's so portable. Try to match special features to the intended user. A person with poor eyesight may appreciate a special model with an over-sized viewfinder because it's easier to look through. A rugged outdoors type may want a rugged camera — either a waterproof model or a weather-resistant, rubber-sheathed one. You can even get these in digital versions.

What Subjects Will the User Be Shooting?

Most people shoot a variety of subject matter, but some photographers have special passions that call for particular camera models or features. Someone with a penchant for architecture and landscapes, interestingly enough, may

be better off using a nonzooming (single-focal-length) model. A typical 35mm nonzooming model has a lens focal length of 35mm or shorter (often 32mm or 31mm, sometimes 28mm), which means the camera has a wider view that takes in more of a big subject than is possible with a zoom model starting at, say, 38mm. (With the Advanced Photo System, typical nonzooming, single-focal-length models have 24mm, 25mm, 26mm, or 28mm lenses; a typical zooming APS model may start out at 30mm, the equivalent of about 38mm in the 35mm format.) Ideal for that architecture or landscape fan: a zooming 35mm model that starts at 28mm, which would let him or her shoot the wide view and then zoom in for details to 70mm, 90mm, or beyond.

Portrait fans should be using a model that zooms at least to 80mm or 90mm, because you get a more flattering scale in facial features when you don't have to shoot from too close to the subject. For the same reason, digital point-and-shooters may want a 3X zoom, pretty common. And sports fans — even those whose ambitions extend only to little league — will probably want a camera that zooms to 135mm or beyond, though other drawbacks plague long zooming, as I explain in Chapter 5.

Do You Want a Digital Camera or a Film Camera?

This choice has become much tougher since the first edition of *Photography For Dummies*. Digital point-and-shoots have improved hugely in the quality of the pictures they produce, and have dropped sharply in price. For practical purposes, digital cameras now rival film cameras.

In my opinion, the big question has to do with getting prints, and how much effort you're willing to put into this task. If you've been spoiled by the habit of dropping off a roll of film at your local minilab when you start your errands and picking up 24 prints on the way home, a digital point-and-shoot can't provide that experience — as of this writing. A growing number of photofinishers offer on-premises printing from digital cameras' memory cards, but this service is not yet widespread. You can get around that problem by uploading files from a digital camera to an online printing service, but you won't get prints back for at least several days — they come by snailmail — and their quality is very inconsistent, in my experience. Besides, by the time you've downloaded pictures to your computer and uploaded them to the Web, you've invested a lot more effort than you would have in dropping off that little roll of film. Rest assured that the photo industry is working hard to make it easier to get commercial prints from digital cameras.

The alternative is printing at home on a desktop printer. Alas, this is even more time consuming and requires a certain amount of computer savvy. Even though good "photo quality" desktop printers now cost as little as $100, the ink and paper needed to make the prints themselves often cost more, per print, than commercial prints. There are desktop printers that let you side-step the computer, making prints directly from your camera and/or a memory card. This can help, especially when you don't want a print of every picture. Again, the photo industry is working on ways to make printing at home less intimidating, arduous, and expensive.

The price of digital cameras is far less of a deterrent than it was when this book first came out, but a digital point-and-shoot is still much more expensive than a film point-and-shoot. The $200 you'd spend on a full-featured 35mm model will get you a digital point-and-shoot with two-megapixel resolution (the bare minimum for acceptable 4 x 6 prints) and a 2X zoom (or maybe 3X). Or if you're willing to forego the zoom, the same price could get you three megapixels. Spend $250 or more, and you can have it both ways — three megapixels and a true 3X zoom. (Don't be fooled by "digital zooming," which I debunk in the section "Do You Want a Zooming or Nonzooming Model?") Price also depends on the actual size of the camera; smaller, pocketable models tend to be more expensive than normal-sized models with comparable picture quality. Still, I'm shocked at how quickly prices are falling on digital cameras.

Whatever a camera's price, when it comes to pixels, you get what you pay for. Generally, the more megapixels a camera has the more it costs, and the better the picture quality it will give you, though other factors such as lens quality also enter into that equation. How many megapixels do you really need? It depends on what you want to do with your pictures. If you don't want prints, but just want to e-mail pictures, share them on the Web, and look at them on a computer or TV screen, then you certainly don't need anything more than a run-of-the-mill two-megapixel model. A model with around one megapixel should do fine, and can now be had for $100 or less.

If you want to make prints, on the other hand, two megapixels is probably a bare minimum for a decent 4 x 6. If you want to make 5 x 7 prints or the occasional 8 x 10, three megapixels is a better bet. And if you want to make really good 8 x 10s, or even bigger prints, go for four megapixels. Five or six megapixels, now the top resolution available, may be overkill unless you have a very discriminating eye or make lots of big prints. Remember, too, that you can set most models so that they capture their images at lower resolutions, which create smaller picture files. This will let you fit more photographs on a given-capacity memory card, and the small files make for easier e-mailing or Web use — though you can always downsize a full-resolution file with software for such purposes.

Do You Want a 35mm Point-and-Shoot or an APS Point-and-Shoot?

The 35mm format is tried and true and delivers incredible image quality with today's color print films. But Advanced Photo System cameras may offer certain advantages over 35mm models, depending on your photographic needs and habits. The system's match-numbered cassettes and index prints — processed film stays rolled up in the cassette — make keeping track of your pictures much easier. They also make reprinting simpler. (See Chapter 8 for details.) And the system's frame-by-frame choice of three different print sizes lets you match print shape to subject. You can, of course, get 35mm models with a panorama setting.

If you like big blow-ups, however, 35mm has the quality edge because it's a larger piece of film. And 35mm films are available in a greater variety of types and speeds. The choice of APS models is also more limited than with 35mm (though all you need is one, after all). If you want a very full-featured model, you're more likely to find what you're looking for in 35mm.

Do You Want a Zooming or Nonzooming Model?

With a nonzooming model, the only way you can make a subject bigger or smaller in the frame is to change your distance from it — moving closer to make it bigger, away to make it smaller. With a zoom model, you can zoom the lens in and out to make the subject bigger or smaller in the frame, in effect composing by zooming. But zooming is not necessarily a good way to compose. Even if you want the convenience of a zoom model, you need to use your legs.

On the other hand, if you have a nonzooming model with a typical 35mm focal length lens (typical for 35mm), moving in close for a head-and-shoulders portrait may distort your subject — producing a "big-nose" effect. (See Chapter 11 for examples.) Zoom cameras that zip even to a modest 70mm or 90mm — or digital point-and-shoots that zoom to 2X or more — help prevent that effect by allowing you to shoot from farther away. If you shoot sports and other far-away subjects, go for an even longer-zooming model, as I explain in the next section, "What Zoom Range Do You Need?"

If you decide to buy a zoom point-and-shoot, don't buy one with a zoom range less than 2X — less than 35–70mm with a 35mm model, for example, or 30–60mm with an Advanced Photo System model. Anything less than that (for example, 38–50mm), and you're probably better off just moving in and out on your own steam. (See Chapter 5 for more on zoom ranges.)

Also, don't be fooled by the "digital zooming" touted on less expensive models. It has nothing to do with the lens; instead of magnifying the subject optically, the camera makes the subject progressively bigger in the frame by using a smaller and smaller area of the image sensor — essentially, "cropping" the subject in the camera. With digital zooming, the longer you zoom, the fewer pixels the camera devotes to the subject. And this means that the longer you zoom, the worse your picture quality will be. If you want to zoom, choose a camera with true *optical* zooming.

What Zoom Range Do You Need?

Point-and-shoot makers have long battled to see who can zoom the longest. They've realized, though, that taking 35mm models beyond the current limit of around 160mm or 170mm involves too many compromises. In fact, you should consider models that zoom beyond 105mm or 115mm only if you really need to shoot distant subjects that you can't get any closer to — perhaps boats at sea or a bush leaguer on a playing field. Zooming to 135mm to capture a face or an overall scene makes little sense. Most of the time, a few steps closer with your zoom at 105mm and you fill the frame just as easily — and without the exceedingly small lens aperture that makes longer zoom settings an even more likely cause of picture-blurring camera shake. (You can find out more about camera shake in Chapter 2.)

In my humble opinion, the most useful of all zoom ranges are those that start out at a true wide-angle focal length — 28mm in the case of a 35mm model. These cameras now run from 28–70mm to 28–130mm — a true wide-angle-to-telephoto focal length range. Starting out at 28mm rather than 35mm or 38mm can make all the difference in the world in your ability to capture a broad range of subjects. It gives you a much wider angle of view, so you can take in much more of a scene from a given position.

At 28mm (or its equivalent on an APS model, around 22mm), you can shoot tall buildings in a single bound, for example, without always having to back away so far that something else gets in the way. Or you can fit much more of a tight interior into the frame when your back is against the wall. The same goes for big landscapes: You can't back away much from that canyon rim or scenic pullout to include more of the scene, but if you have a 28mm zoom setting, you won't feel the need as often.

Yet zoom in to 90mm with your 28–90mm zoom, and you've got an ideal setting for flattering portraits. And, of course, you get a bunch of useful focal lengths in between.

What Features Do You Want?

Many cameras suffer from mode overload (see Chapter 4). They have more features than you would ever use. But you don't want to get caught with too few features, either. Look particularly at flash modes. Fill flash is pretty basic these days, but the less common slow-sync flash is also extremely useful, and lower-end models tend not to have it. Having a full range of flash modes actually lessens the need for more advanced features such as exposure compensation and backlight compensation, though these modes do give you extra control with atypical subjects. You may want to avoid models that forcibly combine red-eye reduction with slow-sync flash; even the most basic models seem to have some form of red-eye reduction, however, and it can be next to useless. (See Chapter 7 for more on red-eye reduction.) Refer to the modes with asterisks in Chapter 4 for genuinely useful modes.

Digital point-and-shoots offer entire subsets of features in their menu systems, but few of these should really dictate your choice of model. One that I keep my eye out for, though, is the ability to manually adjust the ISO setting. Digital point-and-shoots do this automatically, but some also let you set a fixed ISO, usually up to ISO 400. Setting a higher ISO can be useful for freezing action (see Chapter 12) and shooting in dim light without flash.

One major consideration in buying a digital point-and-shoot is how many megapixels you want. The more you have, the better your picture quality will be — though the picture quality you need depends on what you're doing with the pictures (see Chapter 15). And the more pixels you have, the more you'll pay. (See the section "Do You Want a Digital Camera or a Film Camera?")

Don't be fooled by a point-and-shoot's styling. Some models are handsome and some are homely, and you often pay more for good looks. But what matters is that the camera gives you the right lens for your needs and the features that you really want. Pretty pictures are better than a pretty camera.

Is the Camera Comfortable to Hold and Operate?

Take the model you're considering for a walk around the store, just as if you're trying on a new pair of shoes. (Don't buy a camera that the sales-person doesn't let you play with — batteries installed!) Can you get a firm grip on the camera?

Do your fingers and thumbs fall naturally into place on surfaces and controls? Is the zoom control easy to operate? Can you hold the camera steady? Does it feel too small or too big in your hands?

Because digital point-and-shoots don't need to accommodate a roll of film, some sport unconventional body designs — a vertical rather than horizontal shape, for example, or a swiveling arrangement that gives you more freedom in your shooting angles. Don't let this put you off; some of these designs are very comfortable and easy to hold steady once you get used to them.

Pretend to shoot some pictures with the camera just to see how responsive it is. Is there a noticeable lag between when you press the shutter button and when the camera fires? (Make sure that the flash is fully charged when you assess the camera's responsiveness; the camera won't fire until it is.) If a lag seems to exist, ask to see a different model and compare its shutter button action. Also, operate the zoom control to see how quickly and smoothly the lens zooms in and out. A quick zoom may make getting the shot faster, but it can also require more back-and-forth motion to get the exact focal length and composition that you want.

Is the Viewfinder Easy to Look Through?

On some point-and-shoot models, the viewfinder can be awkwardly placed and physically small. When you raise the camera to your eye, this placement may make finding the viewfinder difficult; you may have to wiggle the camera around to do so. That extra time may cost you the photo op that caught your eye. Also, are the viewfinder's edges easy and quick to see? If the viewfinder is hard to find or to see in its entirety, consider buying a model that has an oversized viewfinder. Designed specifically to help eyeglass wearers see the whole frame better, these models sometimes have the phrase "big finder" in them. However, they may be widely available only in cheaper, nonzooming models, so look and ask around.

Also consider the clarity of the viewfinder. Is it bright and sharp from edge to edge? Overall? If it doesn't seem sharp overall, does it have a *diopter control* (a small dial by the viewfinder) with which to adjust it to your individual vision? In a word, *compare*. Viewfinders can be very different. But, but. . . .

A new camera is like a new car: It takes some getting used to. A camera's viewfinder may seem hard to find at first, but the more you use the camera, the more quickly you can get your eye into position. A button or switch that seems awkward initially will probably, over time, feel more comfortable. No camera can be all things to all people!

How About the Viewing Screen?

Why didn't they think of it sooner? A digital point-and-shoot's viewing screen eliminates the need to press your eye against the camera to see the whole picture, or to squint the other eye, and you can look back and forth more easily between the subject and the camera while you're shooting. Good idea, right?

Yes, and no. The viewing screen does indeed show you what the lens sees, making it a more accurate way to compose when you're shooting close up to a subject. But even if you're prepared to take pictures with the camera held away from your face — and I've been known to worry that this arrangement makes it harder to keep the camera steady, increasing the chance that your hands' shakiness will blur the picture — a couple of things can make it hard to see what's on the screen.

One is your vision. If you've reached the age at which you need reading glasses, you may not want to have to put them on to take pictures because then everything else (your subject included) will be unsharp! Yes, if you don't want to put on your reading glasses you can hold the camera way out there, the way you do to read the paper — but then the small screen itself may be so far away that it's hard to see what's on it. Which brings me to the next point.

The viewing screens on digital point-and-shoots vary in size, and in general, the smaller the camera the smaller the screen. Don't get a camera with a screen that's so small you can't see it clearly — and so small that it's no fun to review and share pictures you've taken. Several digital point-and-shoot models now have unusually large screens to deal with this problem, but none is as large or easy to see as the flip-out viewing screens on camcorders.

Equally important: Can you see the screen clearly in bright light? If you're shopping in a camera store, ask to take the camera outside and have a look. Some screens can be very hard to see in sunlight, while others are specially designed by the camera's maker to be brighter in bright light. This isn't a big deal if your camera has a regular viewfinder in addition to its viewing screen; you can always use it instead to compose your pictures. (Turn off the screen so you don't waste power.) But it's a serious issue if your digital point-and-shoot has no regular viewfinder, only a viewing screen. If that's the case, or if you insist on composing with the screen, choose a model with a screen that's easy to see in bright light. Many screens now incorporate special technology that improves outdoor viewing.

If you like to take pictures from low and/or high angles, get a digital point-and-shoot with a viewing screen that swivels up or down. You tilt it up for low angles, down for high angles. This allows you to change your point of view yet still get accurate composition without squatting, lying down, or clambering up on something — simply by raising or lowering the camera with your arms.

Chapter 18

Ten Simple Ways to Make Your Pictures Better

*1*t really bothers me when people claim they're constitutionally incapable of taking good pictures — that they're not technical enough, not artistic enough, or just don't have access to good subject matter. Forgive me, but they're wrong on all counts.

I always make a case for the rich profusion of subject matter that surrounds each of us, from luminously quiet moments of family life to the play of light in backyards. You simply don't need exotic places or people to make great pictures. And, thanks to point-and-shoot technology, you don't have to be the slightest bit technical to get good picture quality. Exposure, focus, flash — you name it, it's all handled for you, and the results are remarkably consistent.

Which leaves the artistry of photography. Dare I say it? You don't even have to be artistic to take good pictures. You just have to use some visual intelligence. You have to think with your eyes, in a sense. And much of that visual thinking can be reduced to simple notions, a dozen of which I suggest in this chapter. But just to make things even easier for you, I include a condensed version of these tips on the tear-out cheat sheet just inside this book's front cover. Keep it with you when you're shooting and refer to it often. You'll be surprised — *shocked* — at the difference in your pictures!

These pointers apply to *any* kind of point-and-shoot, from fancy "designer" cameras to simple, one-time-use models — digital point-and-shoots included. You don't have to have a pricey point-and-shoot to make them work for you; you don't even have to have an autofocus model.

Capture the Moment

Not to co-opt Kodak, but most of personal photography is about moments. Keep in mind, though, that moments can be unique or everyday. Don't wait for a specific occasion to take your pictures; find the telling moments in seemingly ordinary events. Also remember that moments are by definition fleeting. To catch that perfect expression or charming interaction, you have to anticipate it — keeping your finger on the shutter button, your eye to the viewfinder, and your patience.

Don't Use the Viewfinder like a Gun Sight

I sometimes use the word "shoot" because it's a monosyllabic alternative to "photograph," though I know some nature photographers who refuse to use it because it equates photography with hunting. Yet shooting is an apt description of the way most picture-takers compose — by placing their main subject dead-center. (There might as well be crosshairs in the camera's viewfinder.) The most common instance of this is the way people's heads always seem to end up smack in the middle of the picture, with empty space above. For people pictures, vertical or horizontal, try placing heads near the top of the picture area.

Photographers often get so caught up in the moment they're trying to capture that they forget they're also putting a frame around it. Thinking about how to frame a subject when you're trying to capture a moment is a little like rubbing your stomach and patting your head at the same time. It takes some concentration! See Chapter 10 for more on composition.

Get Close

Try to fill the frame with your main subject. Most pictures suffer from the subject's being too small. In most cases, the best way to fix this — and the only way, if you have a nonzooming camera — is simply to move in closer. Unless you're shooting a tight portrait, zooming to fill the frame is often not a good idea. (See Chapter 10 for an explanation.) In fact, your own two legs are the most important photographic tool at your disposal: Use them to move in and out, and thus to control the subject's size in the frame.

If your point-and-shoot is a non-autofocus model — often called a "focus-free" camera — you shouldn't get closer than about 4 feet from your main subject. If the subject is closer than that, it will probably end up unsharp in the print. The same thing goes for one-time-use cameras.

Shoot from a Low or High Angle

There's nothing sacred about your own eye level. If you've ever stooped to shoot pictures of kids, you know this instinctively. Shooting from a child's-eye level helps you make more intimate contact. And with taller subjects, human or inanimate, aiming the camera up from a low angle can create an interesting monumental effect. (Again, legs are your tool here. Squat!)

Shooting from a high angle is a little trickier. You may have to get up on a wall or a car hood, or perhaps shoot from a deck or window. But even a little extra elevation on a subject can keep foreground and background elements from overlapping confusingly, and add depth to an image.

Use Flash Outdoors

Your point-and-shoot automatically fires its flash in dim light, but you shouldn't think of flash just as a way to add light to a subject when there isn't enough to shoot by already. Flash is actually a great idea when you must shoot in direct sunlight, because it "fills" the dark, unattractive facial shadows created by a subject's eye sockets and nose. Flash also helps brighten a "backlit" subject that would otherwise end up too dark.

On the other hand, if an outdoor subject has delicate lighting that you think might be overpowered by flash (rosy light at the end of the day, for example), don't use it. And if you're shooting a landscape, don't bother — it's too far away for the flash to make any difference. When in doubt, shoot pictures with *and* without flash and then compare the final results.

Use a Fast Film

Don't be talked into a print film that has a lower "speed" than ISO 400 unless you plan to make big blow-ups from it. Current fast films — ISO 400 or even ISO 800 — give you prints of exceptionally high quality. And their extra sensitivity

to light not only reduces the risk of slow, image-blurring shutter speeds, but lets you shoot without flash in a wider range of existing light. Just as important, it improves background detail in flash shots. Check out Chapter 2 for more on film speed.

A digital point-and-shoot doesn't use film, of course, but its image sensor's sensitivity to light is still measured by ISO numbers. Ordinarily it adjusts this sensitivity automatically, depending on the light level. But some models allow you to adjust their ISO setting manually, a useful feature. In Chapter 12 I suggest increasing the ISO number, for example, to trick a digital point-and-shoot into setting higher, more action-stopping shutter speeds. If your camera offers this ability, experiment with higher ISO settings; depending on what you shoot, you may want to leave the camera set to them.

Place the Main Subject Off-Center

Whether you're shooting a person or a mountain, try not to center the subject in the viewfinder unless you have a compelling compositional reason to do so. A centered subject makes the picture more static in feeling. A subject placed to one side of the frame usually creates a more dynamic design. Refer to Chapter 10 for more details on composition.

Move from Side to Side

A small shift sideways can make a huge improvement in a picture, preventing objects at different distances from overlapping horizontally and creating visual confusion. Study the viewfinder as you move to see how a change in lateral position can change the relationships among elements of the scene.

Experiment with the Horizon Line

Usually, anything is better than placing a landscape's horizon line midway up the frame. Put it at the bottom instead, and you can emphasize a sky, for a "big" effect. Place it near the top, and you can create a strong feeling of depth.

Take Lots of Pictures

Film is cheap, and digital pictures are free. Photography's great pleasure is that you can find out what works by trying it, for the cost of a 4 x 6-inch print.

Chapter 19

Ten Great Places to Take Pictures

*H*ow do you pick the top ten photo ops in America, a country with a staggering abundance of visual riches? By making the choices entirely personal. In no particular order, then, here are a few of my favorite places to take pictures. These spots also happen to be great places to just look. I mention this because to take good pictures, you have to be in touch with — and moved or amazed by — your surroundings. That's my opinion, anyway.

So before you raise the camera to your eye, study and experience what's in front of you. Look before you shoot. Your pictures will be better for it.

I've tried to choose spots that are accessible yet offbeat, and also to come up with a mixture of subject matter and photographic possibilities. Twelve different states are represented. You find landscapes, cityscapes, wildlife, flowers, roadside art, and architecture, too. But I've also chosen things that are within the reach of point-and-shoot cameras — wildlife that's close enough to capture with a point-and-shoot zoom lens, for example. One last word: Some of these places are fragile, so treat them kindly. As the photographic saying goes, take only pictures, leave only footprints.

Don't take pictures from your car! You will *never* get the best shot.

Chincoteague Island, Eastern Shore, Virginia

Is any image more romantic than a horse on a beach? If you'll settle for a pony, then Chincoteague is the place for you: According to local legend, the area's plentiful wild ponies descend from equine survivors of a sixteenth-century Spanish shipwreck. The animals are so fearless that they actually poke their heads into your car windows as you cruise through the Chincoteague National Wildlife Refuge, which is across a channel from the town of Chincoteague. No need for telephoto lenses here — but do get out of your car to photograph the winsome creatures! The refuge is at the southern tip of Maryland's Assateague Island National Seashore, a 40-mile stretch of beach and uplands where the ponies also roam.

Though you can see Chincoteague's ponies anytime, show up toward the end of July and you'll be able to photograph them taking part in the annual Pony Swim and Auction. Members of the local volunteer fire department *(saltwater cowboys)* herd ponies from the refuge into the water and across the channel to town. (Swimming ponies — what more could you want?) The foals and yearlings are auctioned off to benefit the department, and then the rest of the ponies swim back to the refuge. Chincoteague is just over three hours southeast of Washington, D.C.; for this year's Pony Swim and Auction dates, call the Chincoteague Chamber of Commerce at 757-336-6161.

Local chambers of commerce can be great sources of inside information about an area — and its photographic possibilities. Don't always go by what people at auto clubs say!

Cadillac Ranch, Amarillo, Texas

As you drive west out of Amarillo on Interstate 40, a surreal sight presents itself: In a working grain field, a neat row of ten old Cadillacs buried nose-down in the ground up to their passenger doors, their famous tail fins angled up toward the big sky of Texas. Called Cadillac Ranch, it's Stonehenge for the automotive era.

Created in 1974, the work grew out of a collaboration between oilman and art fan Stanley Marsh (who owns the land) and the Ant Farm, a group of architects in San Francisco. Each car represents a change in the Cadillac's tail-fin design from 1948 through 1964, when the fin had all but disappeared. The monument is designed to be taken in at cruising speed; after all, it sits along the former path of legendary Route 66. But to photograph it properly, you should pull into the service road, get out, and walk around so that you can work its eye-catching angles. (The Caddies' tilt in the ground matches the inclination of the sides of Egypt's Great Pyramid.)

Bryce Canyon National Park, Utah

To choose from among the five national parks that make southern Utah a natural wonder — Bryce, Zion, Arches, Canyonlands, and Capitol Reef — is like trying to distinguish between five perfect gems. But in terms of pure light, Bryce Canyon is the jewel in the crown, so it gets my photographic vote. Technically, Bryce isn't a canyon: It's a red-rock amphitheater, populated by thousands of water-hewn stone spires and pinnacles called *hoodoos*. The Paiute Indians dubbed Bryce "Red Rocks Standing Like Men in a Bowl-Shaped Canyon," but the hoodoos are more fantastically intricate than their matter-of-fact description suggests — more like pagodas, minarets, and temples (note the religious references). The rim approach is reminiscent of the Grand Canyon, but Bryce feels more intimate in scale. Get your camera and walk down into the amphitheater in mere minutes on the Queen's Garden trail or, if you're more ambitious, the Navajo Loop.

In the amphitheater, you discover the best thing about Bryce, photographically speaking: the way its eroded vertical surfaces scatter warm light every which way. Whether you're shooting a deep-green pinyon juniper against a red-rock wall or just a portrait of your companion against a background of hoodoos, the light is matchless. You can even break the old rule against shooting in the middle of the day (see Chapters 8 and 12) because you can easily find soft, reflected light — and open shade is more often warm in its light than cool, as it normally is. Two suggestions, one technical, one meteorological. If you're taking pictures in which light-colored rock fills the frame, consider setting backlight compensation or "plus" exposure compensation (if your camera offers these modes) to prevent underexposure. (See Chapter 8 for more on exposure compensation.) And if you visit Bryce in the winter, hope for a little snow — the icing on the cake.

Las Vegas, Nevada

From the sublime (Bryce) to the ridiculous, right? Why would I tell you to take pictures in the gambling capital of the world? Because it's the best place to fly to if you want to motor up to Bryce Canyon (Zion is even closer) — and because you'll be there anyway, you should take photographic advantage of its world-famous signage. Whatever you think of the way Las Vegas makes a living, there's no such thing as bad neon, and Las Vegas has the most and the best. If photography is about light and color, then its casinos are rich ground. Just don't blame me if you lose money!

Get out your camera, and you won't be tempted to gamble. A good time to shoot is late afternoon, toward dusk, when the neon really starts to stand out but enough daylight still exists to fill in details of buildings and give you a deep blue desert sky. But you can shoot at night, too. Use — ISO 800 film, or even ISO 1600, if you can find a roll; if your digital point-and-shoot lets you

manually adjust its ISO, go into the menu and set it as high as you can (usually ISO 400). If your camera's flash starts firing on its own (that is, in auto-flash mode), either turn it off or switch it over to slow-sync flash mode to mix in more existing light. If the sign's more than 15 or 20 feet away, though, just turn the flash off. (Check out Chapter 7 for more on flash modes.)

With slow-sync flash or no flash, try a few shots in which you deliberately move or jiggle the camera as you press the shutter button. This technique creates colorful streaks and blurs in pictures of neon, often reducing them to abstract patterns. Or try bulb or bulb flash mode, if your camera offers it; keep the shutter button pressed all the way as you move the camera and then release it after a second or two. (See Chapter 4 for more on these modes.) Be sure to visit Glitter Gulch, the older downtown area (north of the familiar "Strip") where casinos aren't also in the hotel business.

White Birch Forest, Pictured Rocks National Lakeshore, Michigan

Yes, the California redwoods are splendiferous. (That's a combination of splendid and coniferous.) But they're nearly impossible to do justice to with a point-and-shoot camera, unless yours gives you the wide view of a 28mm focal length. (Most don't.) The big trees are just too big. So if you love trees — and love to photograph them — let me point you somewhere else entirely: to the unsung and largely undeveloped Pictured Rocks National Lakeshore, along the south coast of Lake Superior on the Upper Peninsula of Michigan between the towns of Munising and Grand Marais.

In the park, on the northeastern end of Twelvemile Beach, is a forest of white birch trees that takes your breath away. A forest is dark, right? Not this one. Except for the occasional pine accent, it's solid white and full of light. When birch leaves turn yellow in the fall, it's even more spectacular. Follow the little road off the main (gravel) park road down to the Twelvemile Beach camping area (a fine place to pitch a tent, if I do say so myself) and stop along the way for pictures. Then take a walk on the white-sand beach and notice that Lake Superior feels different than the other Great Lakes, more like an ocean than a lake.

The Staten Island Ferry, Battery Park, New York

You get two great pictures, plus a free ride, from the famous Staten Island Ferry. One picture is of the southern tip of Manhattan, which in recent years

has amassed quite a few interesting skyscrapers — though the tragic absence of its two biggest makes it a poignant sight for those familiar with the view. The other picture is a classic, of the Statue of Liberty. You can shoot going and coming (just stay put when the ferry arrives at Staten Island, and ride back), but you may want to take your cruise late in the afternoon, when the sun casts warm sidelight on the buildings and then sets almost directly behind the statue. (Also check out the view up the East River, which includes the famous Brooklyn Bridge.)

Paradise Meadow, Mount Rainier National Park, Washington

This alpine meadow positively explodes with wildflowers — lupine, mountain daisy, Indian Paintbrush — from mid-July to the end of August. Parking is easy, and the area's trail system is excellent. If you get a cloudy day, count your blessings: It's usually *better* than direct sun for shooting flowers.

If the sun is shining when you visit Paradise Meadow, choose a small group of flowers and shoot them while a fellow traveler shades them with his or her body. (Shoot them in your own shade, if the angle is right.) This shading lowers the high contrast created by the sun and keeps color from being washed out.

Lucy the Elephant, Margate City, New Jersey

Over the years, most of my photographer friends have paid their pictorial respects to Lucy the Elephant. Lucy is a six-story wooden building in the shape of an Indian elephant, fully detailed in tin down to the *howdah,* a canopied saddle on her back. Now a National Historic Landmark, Lucy was built in 1881 by a real estate developer to lure prospective buyers to the area, and once served as a tavern until besotted patrons set her on fire. You can tour her insides for a small charge during the summer months. But her magnificent exterior is free for the photographing. You find Lucy at the corner of Decatur Street and Atlantic Avenue in Margate City, just south of Atlantic City on the Jersey shore.

Lucy is big. If you have a zoom point-and-shoot, set it to your shortest focal length (for example, 28mm, 35mm, or 38mm). This wider angle of view helps fit her all in — though you still have to back up quite a bit!

The Santuario de Nuestra Señor de Esquipulas, Chimayo, New Mexico

St. Francis de Asis, an eighteenth-century Spanish colonial church in the New Mexico farming town of Ranchos de Taos, is a photographic icon — its massive adobe buttressing having been the subject of many famous shooters. But tucked away on the "High Road to Taos" (Route 76 out of Española), in the village of Chimayo, surrounded by a juniper-studded adobe court, is a less photographed but equally picturesque Spanish colonial church, the Santuario de Nuestra Señor de Esquipulas. Thousands of pilgrims come for the curative dirt found in a small room behind the altar (a long story), so the church is full of cast-off crutches and religious artwork. A visual spectacle.

Anhinga Trail, Everglades National Park, Florida

The Everglades' Anhinga Trail — the first trail inside the park entrance, which is just 30 miles south of Miami — puts you about as close to wild subtropical animals and birds as you'll ever get. You follow raised pathways and elevated boardwalks though a swampy channel of tall marsh grass and open pools; along the way you see submerged and sunning alligators, crook-necked anhingas (black fishing birds) spreading their wings out to dry, and the ancient shapes of gar fish drifting below the surface. You can get reasonably tight shots of some of these exotic specimens with a 35mm zoom camera that goes to 105mm or thereabouts; 135mm 140mm will, of course, help you fill the frame even more. If your digital point-and-shoot has a typical 3X zoom, zoom it all the way in, and you'll do just fine.

The best time to visit — and definitely to photograph — is in late winter. (I've always gone in February or early March.) By then, the park's available water has dwindled into small sloughs such as that around Anhinga trail, so the animals tend to congregate there.

Chapter 20

Ten Things to Try If Your Camera Won't Shoot

*N*othing is more frustrating than spotting a picture-perfect subject and being unable to get your point-and-shoot to shoot it. Sometimes the camera just won't turn on; other times, it turns on but does nothing when you press the shutter button. This chapter offers some remedies for both those problems.

If none of these suggestions gets your point-and-shoot shooting, take it to a photo dealer. If the folks there can't solve the problem, your camera may have to be repaired. Just keep in mind that if you have an inexpensive or older model, buying a new one is often cheaper and easier — and also gives you a good opportunity to trade up. Before you buy, though, be sure to read Chapter 17 for some point-and-shoot buying tips.

Even if they're working properly, most 35mm and APS point-and-shoots let you shoot *when there's no film in the camera.* So don't go snapping blithely away only to realize — after all those great pictures — that your point-and-shoot was shooting blanks. If you haven't used your camera in a while, check the little window on the camera's back (35mm models only) to make sure that a cassette is in place. Or check the frame counter, which appears on the LCD panel or in a small, separate window, to make sure that it moves from one number to the next as you fire. If the frame counter is not moving, the film probably isn't advancing.

One bonus suggestion: If your camera starts up but then acts up, try turning it off and on again. Doing this is a bit like restarting a crashed computer: It sometimes clears the camera's electronics or software chips of whatever is troubling them.

Turn the Camera On Correctly

You may just be pressing the wrong button. Check your manual to find out which button is right. Also, make sure that you're pressing the button all the way in; sometimes you have to briefly hold it down to get the camera to react. Cameras that sport both dials and pushbuttons may start up only when you rotate the main dial to any position other than *off;* if your model has more than one dial, make sure that you're using the right one. And with models featuring sliding front panels, you actually turn on the camera by sliding out the panel to uncover the lens. The panel must click decisively into shooting position. If you accidentally push it back in as you clutch the camera to shoot, it turns off the camera.

Reload the Film

If a 35mm point-and-shoot doesn't engage the film properly, it won't let you take pictures. When this problem occurs, the camera usually flashes an *E,* for empty, on its LCD panel. (Models lacking LCD panels indicate this problem by not advancing the film counter to 1, remaining stuck on 0.) Open the camera back, take out the film, and load it again. (See Chapter 1 for specifics.) If you're using an Advanced Photo System model and inadvertently loaded an exposed or already processed cassette, the camera won't let you shoot either. Find an unused roll and load it instead.

Insert or Replace the Memory Card

If you're using a digital point-and-shoot, it won't let you take a picture unless it has a place to store it. A few models have a modest amount of built-in memory, but most store pictures on removable memory cards — so open the card door and slide one in. Your camera may also refuse to shoot if the memory card is filled to capacity with picture files, in which case you need to replace it with one that isn't full — or, if you don't have an extra, erase pictures on the card you're using to make room for more.

Replace or Recharge the Battery

Even when a battery or batteries are too weak to run the camera, they usually have enough power left to display or flash a low battery icon on the LCD panel — again, if it *has* an LCD panel. (For more about this icon, see Chapter 1.) Less expensive film models may not have an LCD panel; you may have to press a battery-check button, which lights up a lamp to tell you the battery is

okay. Otherwise, with them, the only way to find out whether your battery is the culprit is to change it. Many digital point-and-shoot cameras don't have a separate LCD panel, so look for the battery icon on the viewing screen.

Keep in mind that digital cameras are very hard on batteries. Whether yours takes one-shot AAs or rechargeables, low battery power is often the culprit when your camera won't let you shoot. Even the proprietary rechargeable batteries used by many new digital point-and-shoots can be short-lived, a problem that worsens as they age. (After many cycles they may not be able to hold a charge at all, and you will need to replace them.) So if you use rechargeables, it's even more important to have backup — a second set of rechargeable AAs or an extra proprietary battery, which you can buy as an accessory.

Make Sure the Battery Is Correctly Installed

If a battery is installed backward — that is, with the ends reversed — the camera can't get any juice out of it. If your particular model takes more than one battery, make sure all of them are right; just one incorrectly installed battery out of two, three, or four will put you out of business. (If your camera has an LCD panel, an incorrectly installed battery will cause its display to remain blank.)

You'll find printed or embossed insertion diagrams or symbols inside the battery compartment or cover, and occasionally on the outside of the compartment. They show you which way to orient the end of the battery with the bump on it, which is its positive (+) terminal; this can actually require some concentration, especially if your camera takes four AAs. See Chapter 1 for details.

Clean the Battery Contacts

If a battery has been sitting in your camera for a long time, minuscule leakage of its acidic contents may have corroded the battery compartment's *contacts* — the metallic points with which the camera draws power from the battery. Corrosion usually leaves a whitish powder, but may not always be visible.

To clean the contacts, get a pencil with a rubber eraser on the end, open the battery compartment, remove the battery, and vigorously rub the eraser against both the top and bottom contacts in the compartment. If your battery goes in lengthwise rather than sideways, rub the eraser against both the far terminal (the one deep inside the camera) and the terminal on the compartment cover or cap. Then blow out the eraser fragments. Now, replace the

battery with a new one. A battery that has already leaked is likely to do it again, gunking up your camera all over. Plus, a leaky battery will have lost some of its energy.

If you use your breath to blow out the battery compartment, rather than a blower brush or compressed air, shut your eyes to avoid getting corrosive dust in them. If you use compressed air (available at photo shops), keep the canister upright to avoid squirting propellant into the battery compartment!

Check the Flash-Ready Lamp

If you're shooting in dim light, make sure that the flash-ready lamp is glowing steadily. The flash-ready lamp is either on the viewfinder eyepiece or along the edge of the viewfinder frame as you look through the camera; it's usually red or orange. (Check your manual for its location and color.) If the lamp is *blinking,* the flash hasn't fully recharged — and the camera won't fire when you press the shutter button. (The exception to this is with a one-time-use model, which fires the flash even if it is only partially charged.) Wait to shoot until the flash-ready lamp glows steadily (especially important with one-time-use models!). If the flash takes a long time — ten seconds or more — to charge, you may need fresh batteries.

When your camera starts up, it automatically charges the flash — even when the light is bright — so it's ready in case you go inside or decide to use flash to fill dark shadows (see Chapter 7). So if you try to take a picture immediately after you turn the camera on, the charging cycle may prevent the camera from firing when you press the shutter button, especially if your battery is weak. Just wait a few seconds and then try shooting again. If you can get away with turning off the flash, subsequent shots won't be slowed by flash recycling time.

Step Back from the Subject

If you're too close to your subject, the lens on an autofocus point-and-shoot may not be able to focus it — and if the lens can't focus it, the camera won't fire when you press the shutter button. Most models tell you whether you're too close by rapidly blinking their viewfinder's focus-OK lamp, a little green light in the eyepiece. (Check your manual for its exact location, and the pattern with which it indicates this problem.) If you see this lamp flashing a warning, let up on the shutter button, move away from the subject a foot or two, and then try again. If the focus-OK lamp glows steadily, you should be able to shoot — provided the flash has recycled, of course!

Cameras without autofocus (focus-free models, as they're sometimes called) let you take a picture even if you're too close to the subject. In this event, the picture will be unsharp. Check your manual to find out how close you can get to the subject and remember not to get any closer.

Make Sure Your Digital Camera Has Finished Saving the Previous Picture

This process (much akin to saving a computer file on a hard drive or floppy disk) may take as much as ten seconds or longer after you shoot the picture — a time during which you can't take another. Many models display a special symbol on the LCD panel or the viewing screen (often of an old-fashioned hourglass) during the time that they're saving a picture. (See Chapter 15 for details.) The higher the camera's resolution (its number of pixels), the more time it may take to save a picture — and the longer you'll have to wait. You may be able to reduce that time by choosing a lower resolution setting. Unless you really want to take rapid-fire pictures, though, that's not a good idea because it reduces picture quality.

Fortunately, manufacturers of digital point-and-shoots continue to shorten this "write" time on newer models. And unlike older digital point-and-shoots, these models also need less time to "start up," so you can take a picture almost immediately after turning on the camera.

Rewind the Film and Insert a New Roll

It doesn't happen very often, but sometimes film snags on the cassette or the camera. This problem may be caused by physical damage to the cassette, which in my experience is more likely with 35mm than the Advanced Photo System. To rewind the film, push the midroll rewind button. (Check your manual for its location.) See Chapter 1 for details.

Appendix A

Photospeak: A Short Glossary

*P*hotography had its own jargon long before the high-tech buzzwords of the computer era. Naturally, more terms come into being as new camera and film technologies are introduced; digital photography has spawned a new generation of lingo, the basics of which are included in the following list. Many of the terms this informal glossary contains, though, are decidedly old-fashioned, so they're not just for impressing your friends. Use them with the old-timers at your local photo shop — correctly, of course — and their eyes will light up.

To save space for other important things, I keep the definitions short. Also note that I define only a few essential camera modes in this glossary. For a complete rundown of modes, see Chapter 4.

35mm: The type of film used by most point-and-shoot cameras, which is why they're called 35mm point-and-shoots. It comes in a cassette with a protruding film leader.

Advanced Photo System (APS): Newer camera and film technology that offers a choice of three print formats along with storage and reprinting conveniences.

Angle of view: The amount of a scene taken in by a particular lens focal length. Short focal lengths have a wide angle of view, allowing you to photograph a larger portion of the scene than long focal lengths, which have a narrow angle of view.

Archival: Describes any negative or print storage or display material that won't cause the photographic image to fade, stain, or discolor over time. Acid-free materials are archival.

Autoexposure: The system with which your camera automatically sets the lens aperture and shutter speed to get the correct amount of light to the film or (in a digital camera) the image sensor.

Autoflash: Flash mode in which the camera automatically decides whether or not flash is needed, turning the flash on in dim light and keeping it off in bright light. It's the default mode of most point-and-shoots.

Autofocus: Automatic focusing.

Backlight: Light coming from behind the subject. When light from behind is the main source, the subject is said to be backlit.

Backlight compensation: Adjustment of exposure to prevent the subject from turning out too dark when light is coming from behind it.

Black-and-white film: Film that reproduces the subject in shades of gray (and black and white, depending on the scene's contrast) rather than in color. Black-and-white film is available in conventional or chromogenic versions.

Camera shake: The unwanted movement passed along to your camera by involuntary hand and body tremors, it's a major cause of unsharp pictures.

Candid: An unposed, spontaneous photograph of a person or group of people.

Card reader: A small, drive-like device that you leave connected to your computer, it accepts a memory card for transfer of picture files to the computer. Eliminates the need to connect your camera for downloading.

Catchlights: Tiny highlights (bright spots) in a subject's eyes, caused by reflections of the light source.

CCD (charge-coupled device): Technical term for the tiny electronic image sensor that is the equivalent to film in most digital point-and-shoots. The CCD uses rows of microscopic cells to measure and record light energy, storing the pattern they create as digital information. CMOS (complementary metal-oxide semiconductor) is an alternative image sensor technology used increasingly in digital cameras.

Color print film: Film designed to produce a color negative from which any number of color prints may be made.

Color saturation: The relative brilliance with which a film (or print) reproduces the subject's colors. Films that deliver more intense colors are said to have high saturation.

Composition: The process of adjusting framing, camera position, and/or focal length to turn the subject into a visually appealing photograph.

Contrast: The degree of difference between a subject's tones, a function of its inherent shades and colors and also of the quality of light.

Correct exposure: The specific amount of light that must strike a given film to produce the best possible picture quality.

Cropping: Masking or otherwise shaping a photographic image to change its proportions.

Default: A mode, or group of modes, that a point-and-shoot always returns to after settings are changed for a particular shot or roll.

Developing: See *photofinishing*.

Diffused light: Light that has been softened by cloud cover or any other translucent element.

Digital: Pertaining to computer language and operation. A digital point-and-shoot captures and stores pictures without film, for direct use in computer software and printing applications.

Downloading: The process of transferring picture files from your digital camera to a computer; also, of transferring a digital file from the Internet to your personal computer.

DX code: The bar code on the side of a 35mm film cassette that automatically tells the camera what film speed (ISO) to set for correct light metering and exposure.

Exposure: The amount of light that strikes the film when you take a picture. Also, a frame of film — enough for one shot.

Exposure compensation: Found on relatively few point-and-shoots, this capability allows you to manually alter the autoexposure for specific effects and subjects.

Exposure latitude: The range within which a film can tolerate errors in exposure and still produce acceptable results.

Exposure value: Abbreviated EV, always with a plus or minus number attached, it indicates the degree of exposure change with exposure compensation or backlight compensation — for example, +1.5 EV, –0.5 EV.

Fast film: Film with a high sensitivity to light, reflected in its high ISO rating — usually ISO 400 and above.

Fill flash: (Also known as *flash-on.*) Flash mode in which the camera fires the flash for every shot. Fill flash can be used to soften shadows in bright outdoor light by filling them with light.

Film cassette: The small, lightproof housing in which film is supplied, and that you place in the camera to shoot. With 35mm, the film cassette is discarded after processing; with the Advanced Photo System, it's returned to you with the processed negatives inside.

Film leader: The short, half-width strip of film extending from an unexposed 35mm cassette; must be engaged in the take-up spool for a camera to advance the film.

Film speed: The measure of a film's sensitivity to light, film speed is indicated with an ISO number — ISO 400, for example. The higher the number, the more sensitive the film.

Film winding: (Also called *film advance.*) Moving a roll of film from one frame to the next for each shot, often by built-in motor.

Flash: Your point-and-shoot's tiny but highly useful built-in light source, the flash fires in an action-stopping burst and often has several different modes.

Flash-off mode: A mode in which the flash won't fire regardless of the light level. It may cause the camera to set a slow shutter speed.

Flash-ready lamp: A small light beside the viewfinder window, or next to the viewfinder frame or viewing screen, it blinks when the flash is charging and glows steadily when the flash is ready to fire. Usually red or orange.

Focal length: Technical term indicating how wide or narrow a section of a scene the lens includes in a picture (angle of view), and/or how big or small it makes the subject (magnification).

Focal length range: The run of focal lengths offered by a zoom lens. It's specified by the shortest and the longest, in millimeters — for example, 38–90mm.

Focus point: Small brackets, lines, or a circle in the middle of an autofocus point-and-shoot's viewfinder or viewing screen, it indicates where the camera is focusing.

Focus-free: (Also known as *fixed-focus.*) Term for point-and-shoots that have no autofocus capability. With these models, the lens's focus is preset at a medium distance that gives reasonably sharp results with any subject about four feet away and beyond.

Focusing: In-and-out adjustment of the lens to make the main subject sharp on the film or (in a digital camera) the image sensor.

Focus-OK lamp: (Also called an *autofocus confirmation lamp.*) A small light beside the viewfinder window that blinks when the camera can't focus a subject and glows steadily when correct focus has been achieved.

Formal: A photograph of a person or group of people made by mutual agreement, often with controlled lighting and a set-up background.

Frame: The rectangle you see when you look through a camera's viewfinder or at its viewing screen, used for composing the subject; or one picture's worth of film; or that thing you put your prints in.

Frame counter: The display that tells you how many shots you've taken, or are left, on a roll of film; on a digital camera, it indicates how many more pictures can be saved to the memory card. The frame counter may be located on the camera's LCD panel, in a small separate window, or on a digital point-and-shoot's viewing screen.

Frame lines: Light or dark lines or brackets just inside the viewfinder frame that indicate the area of the scene that will be recorded on the film. (Many point-and-shoots do not have frame lines.)

Frame numbers: Numbers printed by the manufacturer along the edges of 35mm film, or by the photofinisher on an index print or the back of a print. Frame numbers allow you to identify a particular negative for reprinting or blowups.

Grain: Tiny clumps of silver crystals that form the photographic image during film development, their pattern is sometimes visible in the print. The faster the film, the more visible the grain — but even fast films are now very fine-grained.

Hard light: Light that creates strong contrast and heavy shadows in the subject, usually from a direct source such as the sun or a lightbulb.

Icon: A symbol representing a specific mode or status, it's displayed on the camera's LCD panel or printed on its body.

Image editing: Using computer software to enhance, manipulate, and retouch digital images, whether from a digital camera or scanned from film or a print.

Image sensor: The electronic equivalent to film in a digital camera, it's the tiny rectangle of microscopic, light-sensitive cells with which the camera records the picture. (See CCD.)

Index print: Created by digital scanning, a print-sized sheet of tiny positive images of every shot on a roll. Used for storage, indexing, and reprinting reference.

Infinity lock: Often called landscape mode, this setting causes the camera to focus as far away as possible; especially useful to prevent misfocusing when shooting through windows.

ISO number: (Also see *film speed.*) Number that indicates a film's specific sensitivity to light; it's also now used to describe the (adjustable) sensitivity of the image sensor in a digital camera.

LCD (liquid crystal display) panel: Usually found on the top of a camera, it indicates camera status and settings. Not to be confused with the color LCD screen (also called an LCD monitor) used for shooting and reviewing pictures on a digital point-and-shoot, called a *viewing screen* in this book.

Lens: A cylinder of shaped pieces of glass or plastic at the front of a 35mm, APS, or digital camera, it projects a tiny image of the subject onto the film or image sensor.

Lens aperture: The window in the lens that lets light through to the film. Your point-and-shoot automatically adjusts this window's size, called the f-stop, to control the exposure.

Light meter: The built-in device that your point-and-shoot camera uses to measure light and determine the correct exposure settings.

Light source: The immediate origin of a scene's light, such as the sun or a window.

Locking the focus: Pressing and holding an autofocus point-and-shoot's shutter button halfway, to prevent the camera from refocusing incorrectly with your final composition.

Long focal length: See *telephoto focal length.*

Megapixel: One million pixels (see *pixel*), used as a unit of measurement to describe the resolution of a digital camera.

Megabyte: A million bytes of digital information, the unit of measurement generally used to describe the size of a picture file. (A byte is the amount of information needed to create or reproduce one color pixel.)

Memory card: The small plastic-and-silicon wafer on which most digital cameras store their pictures, it comes in a variety of types, physical sizes, and capacities (indicated in megabytes).

Menu: The software-like interface displayed on a digital point-and-shoot's viewing screen, it usually lists camera functions line-by-line; adjustments and selections are made by scrolling to and selecting individual items with push-buttons.

Midroll rewind button: Used for rewinding a roll of film before it's finished (that is, fully exposed).

Mode: A setting that causes the camera to perform a specific function or operation. See Chapter 4 for detailed definitions of specific modes.

Muddy: Term for prints that are lacking in detail, contrast, and color brilliance (often grayish or brownish).

Negative: Used to make a print, it's the visible form a picture takes after the film is processed. A negative's tones and (with color print film) colors are the opposite of what they were in the subject, but printing reverses them back to their original state.

Normal focal length: Focal length setting — usually around 50mm with 35mm models, 40mm with APS models — that helps reproduce the most natural-looking size relationships in a scene.

One-time-use camera: A model designed to shoot a single roll of film, it's available in specialized designs, and comes in both 35mm and APS versions. You turn in the camera itself to the photofinisher when the roll is done.

Panorama mode: A setting in which the camera produces an elongated image intended for the creation of a 4 x 10- or 4 x 11½-inch print.

Parallax error: The difference between what the lens sees and what you see through the camera's viewfinder; especially pronounced at longer focal lengths and with closer subjects.

Photofinishing: (Also called *processing.*) The business of turning your exposed film into negatives (developing) and your negatives into prints (printing) — or into any other usable, visible form. Photofinishing services, including printing, are also available for digital point-and-shoots.

Picture file: (Also called an *image file.*) The photographic equivalent of a text file, it's the digital file with which a photograph is displayed on a computer and/or reproduced as a print. It can be created without film with a digital camera, or by scanning film or prints.

Pixels: Short for picture elements, the tilelike bits of color and tone that form the image produced by a digital camera.

Positive: Opposite of negative, used to describe any photographic image that reproduces the subject's original tones and/or colors. A slide is a positive; a print is a positive.

Prefocusing: Same idea as locking the focus, but means using the technique to reduce shutter-button time lag when shooting a moving subject.

Print format: The proportions (height to width) or shape of a photographic print. The Advanced Photo System offers a choice of three print formats, selectable with a control on the camera itself.

Printer: Desktop computer peripheral designed to produce prints from picture files; should be a "photo quality" model for photographic purposes.

Printing: See *photofinishing*.

Processing: See *photofinishing*.

Quartz-date: Term for point-and-shoot models with the ability to imprint the date on photographic negatives; numbers appear permanently on the front of the prints.

Random Access Memory (RAM): The amount of active digital storage in your computer, RAM must be relatively high to allow work with photographs and digital-imaging software.

Resolution: Technical term for the measurement of photographic sharpness, it applies to lenses, film, and the image sensors in digital cameras. The resolution of digital cameras is often described in megapixels, for example two, 3.3, or four megapixels.

Rewinding: The process of retracting a roll of exposed film into its cassette before removal from the camera. Motorized on many models, rewinding starts automatically at the end of the roll or when you press the midroll rewind button.

Scanner: Desktop computer peripheral designed for scanning of film (film scanner) or prints and other reflective materials (flatbed scanner).

Scanning: The process of translating a photograph (negative, slide, or print) into an electronic form that can be used by computers.

Self-timer mode: A setting in which the camera delays taking a picture by a specified interval after you touch the shutter button.

Sharpness: The degree to which clear, distinguishable details of the subject are rendered in a photographic negative or print.

Short focal length: See *wide-angle focal length*.

Shutter button: The button that you press to take a picture. On autofocus cameras, the shutter button also activates and locks the focus when pressed halfway.

Shutter speed: The length of time (usually a small fraction of a second) that the window in a camera's lens stays open to let light through to the film. In a digital point-and-shoot, shutter speed is usually controlled by turning the image sensor on (so that it can record light from the lens) then off.

Single-focal-length: Term for lenses on nonzooming point-and-shoots. Because the focal length cannot be adjusted, you can only control the subject's size in the picture by physically moving yourself and the camera in and out.

Slide film: Film designed to produce a positive transparent image of the subject on the original film itself. Mainly intended for projection or scanning rather than printing, though prints can be made directly from slides.

Slow film: Film with relatively low sensitivity to light, reflected in its lower ISO rating — usually ISO 200 and below.

Slow-sync flash: (Also known as night, night scene, or night portrait mode.) This mode combines flash with a longer shutter speed to improve background detail in low-light flash shots.

Soft light: Light that creates delicate tones and pale or minimal shadows in the subject, such as from a cloudy sky or in open shade.

Software: Computer programs used to handle digital information, including the image editing software used with picture files.

Telephoto focal length: (Also called a long focal length.) A focal length setting — usually around 60mm (with APS) or 70mm (with 35mm) and beyond — at which the subject is magnified (appears bigger than normal in the frame).

Thumbnails: Small reference images of the shots on a roll of film or a memory card, appearing in an index print or on a computer screen.

Toggling: Pressing a pushbutton repeatedly to advance through a menu of modes, in order to choose and set one.

Tungsten light: Artificial light from household bulbs (halogen is a variation).

Uploading: Process of transferring picture files from your digital camera or computer to the Internet, often to online printing services or "photo sharing" Web sites.

USB: Common system for connecting digital cameras, card readers, and other peripherals to your computer.

Viewfinder: Window on the camera through which you see the rectangular frame used to view and compose your subject.

Viewing screen: (Also called an LCD screen or LCD monitor.) The small, TV-like screen on the back of a digital point-and-shoot with which you can compose pictures, review pictures you've taken, and adjust the menu.

Wide-angle focal length: (Also called a short focal length.) Focal length at which the lens takes in a relatively large section of the total scene. Most point-and-shoot zoom lenses start out at a wide-angle setting (38mm, 28mm), and most nonzoom models have wide-angle lenses (35mm, 32mm).

Wide-area autofocus: (Also called multibeam or multipoint autofocus.) An autofocus system in which multiple focus points cover a wider-than-usual area in the middle of the viewfinder. Wide-area autofocus allows the camera to focus subjects that are slightly off-center without the need to lock the focus.

Zoom lens: A lens of adjustable focal length. You zoom to increase or decrease the lens's magnifying power, making the subject bigger or smaller in the frame.

Zooming in: Setting a longer focal length on your zoom lens, to make the subject bigger in the picture.

Zooming out: Setting a shorter focal length on your zoom lens, to include more of the scene in the picture.

Appendix B

Manapsturers, Distributors, and Retailers

*I*n these days of discount stores, mass merchandisers, online ordering, and rampant catalog sales, the place you buy a camera (or any other photographic product) may not be much help when you need more information — or when things go wrong. Unless you cultivate a relationship with a friendly neighborhood photo shop, you may need to contact a product's manufacturer or distributor directly.

The following alphabetical list helps you make that contact. This list includes phone numbers and Web sites for most major U.S. suppliers of point-and-shoot cameras (35mm, Advanced Photo System, and digital models), plus manufacturers of films, batteries, digital products, and storage and display materials.

Manufacturers usually have technical or customer service departments that can answer your questions about camera operation, film performance, and other photographic matters. Most can also provide you with a replacement camera manual if you lose yours. And most now have online and/or paper catalogs of their consumer offerings, but if not, they can mail you brochures on specific products. You can usually request materials or assistance through the company's Web site, which nowadays is often the most complete source of information about its photographic products.

ACD Systems: Telephone (800) 579-5309 or (250) 544-6700; Web site acdsystems.com. Computer software for digital imaging.

Adobe Systems, Inc.: Telephone (800) 685-3507 or (408) 536-6000; Web site www.adobe.com. Computer software for digital imaging.

Agfa Consumer Imaging: Telephone (800) TRY-AGFA or (201) 440-2500; Web site www.agfaus.com. Film and one-time-use cameras.

Canon U.S.A., Inc.: Telephone (800) OK-CANON or (516) 328-5000; Web site www.usa.canon.com. Digital and film cameras, scanners, printers, accessories.

Casio Inc.: Telephone (800) 962-2746 or (800) 836-8580; Web site casio.com. Digital cameras.

Eastman Kodak Company: Telephone (800) 242-2424 or (716) 724-4000; Web site www.kodak.com. Film, digital and film cameras, digital photo products, batteries, photofinishing.

Epson America, Inc.: Telephone (800) GO-EPSON or (562) 981-3840; Web site www.epson.com. Digital cameras, scanners, printers.

Fuji Photo Film USA, Inc.: Telephone (800) 755-3854 or (914) 789-8100; Web site www.fujifilm.com. Film, digital and film cameras, digital photo products, photofinishing.

HP (Hewlett-Packard Company): Telephone (800) 851-1170; Web site www.hp.com. Digital cameras, scanners, printers, digital photo products.

Ilford Imaging: Telephone (201) 265-6000; Web site www.ilford.com. Film, digital photo products.

Jasc Software: Telephone (800) 622-2793 or (952) 930-9800; Web site www.jasc.com. Computer software for digital imaging.

Mail-order retailers

You can order cameras, film, digital products, and accessories by telephone (toll-free) or on the Web from the following companies, which ship the products directly to you by common carriers. Some have a complete line of photographic products; others specialize, as indicated. A number of these companies also sell photo books, both how-to and coffee table. Call or e-mail them for a catalog, or visit them online. Most offer overnight delivery service if you need stuff in a hurry.

If you do buy by mail order, know what you want in advance. Not all mail-order companies are prepared to give over-the-phone buying guidance — nor do the people staffing the lines necessarily have in-depth knowledge of the products they sell. Do your research by talking to friends about their cameras, reading photo magazines and buying guides, and visiting both manufacturers and nonproprietary photo Web sites. And abide by the following tips:

✔ **Avoid imported gray market merchandise, a specialty of mail-order suppliers.** Although gray market photo goods may be of the same quality as domestic goods, they carry a store or international warranty rather than a standard U.S. one. (If you ask, the salesman must tell you that a product is gray market.) If you have problems, getting warranty service may be more difficult.

✔ **Avoid the additional cost of extended warranties.** Although they extend the usual one-year warranty to three, four, or five years, these warranties are serviced by third-party repair companies of sometimes questionable stability *and* ability.

✔ **Don't let the salesperson sell you a different product than the one you want.**

✔ **Keep in mind that *you* may be charged a restocking fee if you return an item.**

✔ **Note that shipping and handling charges increase the bill; ask about them before committing to a purchase.**

✔ **Beware if merchandise is back-ordered; it may be weeks before you receive it.** Try to find a supplier that has the product in stock.

✔ **Always pay with a credit card.** Getting a refund is usually easier with a credit card purchase than one made with a check or money order.

Here are some mail-order retailers; specialized offerings are described.

Adorama, Inc.: Telephone (800) 815-1260 or (212) 741-0052; Web site www.adoramacamera.com.

Amazon.com: Web site amazon.com. Digital and film cameras, accessories.

B&H Photo-Video: Telephone (800) 947-9005 or (212) 444-6666; Web site www.bhphotovideo.com.

Calumet Photo: Telephone (800) 225-8638 or (630) 860-7447.

Camera World: Telephone (800) 226-3721 or (800) 222-1557; Web site www.cameraworld.com.

Light Impressions: Telephone (800) 828-6216 or (714) 441-4539. Archival negative and print storage materials, photo albums.

Porter's Camera Store: Telephone (800) 553-2001 or (319) 268-0104; Web site www.porters.com.

Ritz Camera: Telephone (877) 690-0099 or (800) 52-FOCUS; Web site www.ritzcamera.com.

Samy's Camera: Telephone (877) 297-1223 or (323) 938-2420; Web site www.samys.com.

Visual Departures, Ltd.: Telephone (800) 628-2003; Web site www.visualdepartures.com. Collapsible reflectors, specialized photo products.

Wolf Camera: Telephone (877) 690-0061; Web site wolfcamera.com.

JVC Company of America: Telephone (800) 252-5722; Web site www.jvc.com. Digital cameras.

Konica USA, Inc.: Telephone (800) 285-6422; Web site www.konica.com. Film, digital and film cameras, digital photo products, photofinishing.

Kyocera Electronics, Inc. (Contax, Yashica): Telephone (800) 526-0266 or (732) 560-0060; Web site www.kyocera.com (www.contaxcameras.com, www.yashica.com). Digital and film cameras, digital photo products.

Leica Camera, Inc. (Minox): Telephone (800) 222-0118 or (201) 767-7500; Web site www.leica-camera.com. Digital and film cameras.

Microsoft: Telephone (425) 637-9308; Web site www.microsoft.com. Computer software for digital imaging.

Microtek U.S.A.: Telephone (310) 687-5800 or (310) 687-5940; Web site www.microtekusa.com. Scanners and digital photo products.

Minolta Corporation: Telephone (800) 528-4767 or (201) 825-4000; Web site www.minolta.com. Digital and film cameras, scanners, digital photo products, accessories.

Nikon, Inc.: Telephone (800) NIKON-US; Web site www.nikonusa.com. Digital and film cameras, scanners, digital photo products.

Olympus America, Inc.: Telephone (800) 622-6372 or (631) 844-5000; Web site www.olympusamerica.com. Digital and film cameras, printers, accessories.

Panasonic Consumer Electronics: Telephone (800) 211-7262 or (201) 348-7000; Web site www.panasonic.com. Digital cameras.

Pentax Corporation: Telephone (800) 877-0155 or (303) 799-8000; Web site www.pentaxusa.com. Digital and film cameras, digital photo products, accessories.

Polaroid Corporation: Telephone (800) 343-5000 or (617) 386-2000; Web site www.polaroid.com. Film, digital and film cameras, digital photo products.

Print File, Inc.: Telephone (407) 886-3100; Web site www.printfile.com. Archival film and print storage materials and systems.

Ricoh Consumer Products Group: Telephone (800) 225-1899 or (800) 63RICOH; Web site www.ricoh-usa.com. Digital cameras.

Rollei U.S.A.: Telephone (973) 244-9660; Web site www.rollei-usa.com. Digital and film cameras.

Samsung Cameras: Telephone (800) 762-7746 or (201) 902-0347; Web site www.samsungcamera.com. Digital and film cameras, digital photo products.

Sanyo: Telephone (818) 998-7322; Web site www.sanyo.com. Digital cameras.

Sony Electronics Inc.: Telephone (800) 472-7669 or (201) 930-7796; Web site www.sony.com. Digital cameras, digital photo products.

Vivitar Corporation: Telephone (805) 498-7008; Web site www.vivitar.com. Digital and film cameras, digital photo products.

Index

• **F** •

• J •

• K •

FOR DUMMIES®

A world of resources to help you grow

TRAVEL

0-7645-5453-0

0-7645-5438-7

0-7645-5444-1

Also available:

America's National Parks For Dummies
(0-7645-6204-5)

Caribbean For Dummies
(0-7645-5445-X)

Cruise Vacations For Dummies 2003
(0-7645-5459-X)

Europe For Dummies
(0-7645-5456-5)

Ireland For Dummies
(0-7645-6199-5)

France For Dummies
(0-7645-6292-4)

Las Vegas For Dummies
(0-7645-5448-4)

London For Dummies
(0-7645-5416-6)

Mexico's Beach Resorts For Dummies
(0-7645-6262-2)

Paris For Dummies
(0-7645-5494-8)

RV Vacations For Dummies
(0-7645-5443-3)

EDUCATION & TEST PREPARATION

0-7645-5194-9

0-7645-5325-9

0-7645-5249-X

Also available:

The ACT For Dummies
(0-7645-5210-4)

Chemistry For Dummies
(0-7645-5430-1)

English Grammar For Dummies
(0-7645-5322-4)

French For Dummies
(0-7645-5193-0)

GMAT For Dummies
(0-7645-5251-1)

Inglés Para Dummies
(0-7645-5427-1)

Italian For Dummies
(0-7645-5196-5)

Research Papers For Dummies
(0-7645-5426-3)

SAT I For Dummies
(0-7645-5472-7)

U.S. History For Dummies
(0-7645-5249-X)

World History For Dummies
(0-7645-5242-2)

HEALTH, SELF-HELP & SPIRITUALITY

0-7645-5154-X

0-7645-5302-X

0-7645-5418-2

Also available:

The Bible For Dummies
(0-7645-5296-1)

Controlling Cholesterol For Dummies
(0-7645-5440-9)

Dating For Dummies
(0-7645-5072-1)

Dieting For Dummies
(0-7645-5126-4)

High Blood Pressure For Dummies
(0-7645-5424-7)

Judaism For Dummies
(0-7645-5299-6)

Menopause For Dummies
(0-7645-5458-1)

Nutrition For Dummies
(0-7645-5180-9)

Potty Training For Dummies
(0-7645-5417-4)

Pregnancy For Dummies
(0-7645-5074-8)

Rekindling Romance For Dummies
(0-7645-5303-8)

Religion For Dummies
(0-7645-5264-3)

Available wherever books are sold. Go to www.dummies.com or call 1-877-762-2974 to order direct